THE HOUSES OF ROMAN ITALY
100 B.C. – A.D. 250

THE HOUSES OF ROMAN ITALY
100 B.C. – A.D. 250

RITUAL, SPACE, AND DECORATION

JOHN R. CLARKE

UNIVERSITY OF CALIFORNIA PRESS
Berkeley *Los Angeles* *Oxford*

Published with the assistance of the
Getty Grant Program

University of California Press
Berkeley and Los Angeles, California

University of California Press, Ltd.
Oxford, England

Library of Congress
Cataloging-in-Publication Data
Clarke, John R., 1945–
The houses of Roman Italy, 100 B.C.–A.D. 250 :
ritual, space, and decoration / John R. Clarke.
p. cm.
Includes bibliographical references and index.
ISBN 0-520-07267-7 (alk. paper)
1. Architecture, Roman—Italy.
2. Architecture, Domestic—Italy.
3. Mural painting and decoration, Roman—
Italy. 4. Mural painting and decoration—
Italy. 5. Mosaics, Roman—Italy. 6. Mosa-
ics—Italy. I. Title.
NA324.C57 1991
728'.0937—dc20 90-48357
 CIP

76975

Printed in the United States of America
9 8 7 6 5 4 3 2 1

The paper used in this publication meets the
minimum requirements of American National
Standard for Information Sciences—
Permanence of Paper for Printed
Library Materials, ANSI Z39.48-1984. ∞

For Michael Larvey

CONTENTS

ILLUSTRATIONS

Unless otherwise noted, all color and black-and-white photographs are by Michael Larvey and all drawings are by the author.

PLATES
(following page xxxii)

1. Samnite House, atrium. View looking toward fauces, taken from loggia over tablinum.
2. Villa of the Mysteries, 5, southeast corner.
3. Villa of the Mysteries, 5, southwest corner.
4. Villa of the Mysteries, 16, east and south walls with scendiletti. View from western doorway.
5. Villa of Oplontis, 14, north, west, and east walls and floor.
6. Villa of the Mysteries, 2, north wall.
7. House of M. Lucretius Fronto, atrium *b*, north wall.
8. House of M. Lucretius Fronto, tablinum *h*, north wall.
9. House of M. Lucretius Fronto, tablinum *h*, south wall.
10. House of the Menander, 11, emblema with Nilotic scene.
11. House of Octavius Quartio, room *f*, west wall.
12. House of the Vettii, oecus *q*, east wall, fourth panel from south (goldsmiths).
13. House of the Vettii, oecus *q*, east wall, second aedicula from north (Apollo and Pythia).
14. House of the Vettii, oecus *p*, east wall, central picture, punishment of Ixion.

FIGURES

MAPS

PREFACE

This book began over ten years ago, when I decided to investigate the ways in which ensembles of mosaics, paintings, and stuccoes coordinated with the architecture of ancient Roman houses. It seemed at the time a fairly straightforward matter: I would study a representative group of houses at Pompeii, Herculaneum, and Ostia Antica through visits to the sites, photographs, drawings, and published sources. As my work developed both in the field and in my graduate seminars at the University of Texas, however, I began to realize how difficult it was to see these wonderful Roman interiors with Roman eyes. Studying Roman religious, social, and political institutions broadened my focus as I began to pursue the meanings of the wall paintings, mosaics, and sculpture found in these houses. This investigation naturally led me to pursue questions of taste and patronage.

None of this would have happened without the inspiration of colleagues, students, and friends. Among my colleagues, Mariette de Vos has been the most generous over the years, on many occasions drawing on her knowledge of the sites, the ancient literature, and modern sources. Andrew F. Stewart, Eleanor Greenhill, Brenda Preyer, Jerome J. Pollitt, Irving Lavin, Charles Edwards, Randy Swearer, Cynthia Shelmerdine, Ingrid Edlund-Berry, the late Frank Brown, and the late Kathleen Shelton all helped and encouraged me in this project. I learned much from my students; I particularly remember the lively discussions in my seminars on decorative ensembles in Roman art, and the contributions of Don Bacigalupi, Denise Barnes, Karen Bearor, Maria Elena Bernal-Garcia, Carol Farr, Katherine Crawford Luber, Wesley Tobey, and Carol Watts.

Many small grants helped support my research and writing. I wish to thank Yale University for a Griswold Humanities Fellowship, the American Council of Learned Societies for two Grants-in-Aid, and the University of Texas Research Institute for five separate research awards. Dr. David Tobey generously

provided much-needed photographic equipment for several campaigns. Jennifer Davis, assisted by Jeanine Caracciolo, prepared the plans and drawings for publication.

This project would have never come to fruition without the support of the Italian archaeological services. Dr. Valnea Santa Maria Scrinari provided permissions in the early stages of research at Ostia Antica; in recent years Dr. Anna Gallina Zevi, the current soprintendente, has helped in the final realization of the project. At Pompeii I also worked with two successive soprintendenti. Dr. Giuseppina Cerulli-Irelli cleared the way in the beginning, while the current soprintendente, Prof. Baldassare Conticello, has kindly helped further this project over the last five years.

The anonymous scholars who read this manuscript for the University of California Press deserve thanks for their helpful criticisms. In a study as broad as this, I am bound to have missed some pertinent scholarly discussions. I have included in my notes and bibliography items that I have used in preparing this book through its completion in May 1990.

In looking back over the past decade, filled with long and short visits to Italy, I must thank the many friends there who encouraged me and made my work all the more enjoyable: Luciano Santarelli, Carolyn Valone, François Uginet, Fausto Donato, Jeffrey Blanchard, and Fabio Pignatelli.

Michael Larvey, companion and friend, kept this book going through difficult times. Not only did he insist on the highest standards for the photographs he produced under challenging conditions, but he also always reminded me through his insightful comments just how important this project was. It is to him I dedicate this book: AMICO OPTIMO.

INTRODUCTION

The aim of this book is to put ensembles of Roman interior decoration back into context. Perhaps I should say "contexts," since it is not enough to describe a room—with its mosaic floor, painted walls, and ceiling—and explain the role of this decorative ensemble in the overall plan of the house. Nor is it enough to draw diagrams showing how the ensemble looks from one or another viewing position within the house. Careful study of the meanings of images in the paintings and mosaics is not enough. Even investigating the identity of the patron and his or her taste does not give these ensembles their full context. To put Roman interior decoration back into context one must pay attention to *all* of these issues. This is a tall order.

Ever since Roman interiors began to be discovered, starting in the late fifteenth century with Nero's Golden House (the *Domus Aurea*) in Rome, people have been fascinated by the painted, stuccoed, and mosaic decorations that once adorned ancient houses. These embellishments inspired generations of artists and decorators. Drawings, engravings, and photographs have attempted to record them. Archaeologists have carefully dated and classified them. Scholars have devoted great energy to plumbing the meanings of figural and decorative motifs and have even attempted to reconstruct lost originals of Greek art from the imagery included in Roman mosaics and wall paintings. The common tendency in all of these studies has been to consider these decorations in isolation. Whether working from the original, from drawings, or from photographs, such studies inevitably think away the "containers" of these decorations, the individual rooms of houses. Yet it is obvious that no matter how closely a wall painting or mosaic from a house adheres to a particular artistic style or system, a particular owner commissioned it, an individual executed it, and it was tailored to adorn a specific space. One must return to the houses where these decorations still exist to study the whole context.

This study attempts to understand context in several ways. First it approaches the question of how ancient interior decoration looked from the point of view of how it was experienced. But it is not the modern experience of these spaces that will provide the necessary information. We must experience the spaces with Roman senses. We must investigate as far as possible how the spaces that were decorated functioned in the lives of the people who lived in them. Ancient Roman texts that discuss the domestic rituals provide a framework for understanding Roman attitudes toward their houses, be they the late Republican *domus* or first-century luxury villas. Once we understand the kinds of activities that took place in the Roman house, we can investigate how spaces with specific roles functioned in a particular house. Immediately one must get more specific than simply naming the function of a room: *tablinum, oecus,* or whatever. One must study how that space fits with what we know about the owner of the house, how its design and imagery coordinate with other spaces in the same house, what changes redecoration, ancient and modern restoration, and decay have brought, and how it compares with other decorations of a similar date. Above all, one must investigate how someone would have experienced it: was it meant for a person simply walking through from one area to another or for an invited guest, seated on a couch, to inspect at leisure? What kind of views into and out of the space were arranged by the architect and emphasized by the mosaicist and painter? What was the sequence in viewing the imagery on floor or wall?

Because these questions are so many and so specific, when I began this research in 1980, I chose to focus on seventeen houses as case studies. My criteria were the facts that the houses contained well-preserved interior decorative ensembles, that they illustrated discrete periods and styles between 100 B.C. and A.D. 250, and that they had been published in some fashion. This last point has made it possible to concentrate on the issues relating to decorative ensembles, referring the reader to published sources for complete descriptions of all the archaeological finds and other kinds of specialized information. Naturally I have corrected mistakes where necessary and have challenged unlikely interpretations.

In this way I hope to add new, useful information to the existing synoptic discussions of systems of wall and floor decoration.[1] Although they have the

1. Useful surveys of Roman painting: Maurizio Borda, *La pittura romana* (Milan, 1958); Harald Mielsch, "Funde und Forschungen zur Wandmalerei der Prinzipatszeit von 1945 bis 1975, mit einem Nachtrag 1980," *Aufstieg und Niedergang der römischen Welt,* ed. Hildegard Temporini, pt. 2, vol. 12, no. 2 (Berlin, 1981), 157–264; Roger Ling, "Pompeii and Herculaneum: Recent Research and Future Prospects," in *Papers in Italian Archaeology,* vol. 1, pt. 2 (Oxford, 1978), 153–174. First Style: Anne Laidlaw, *The First Style in Pompeii: Painting and Architecture* (Rome,

advantage of exhibiting the range of possibilities within a given style or manner, such comparative surveys never give one a sense of how a specific decorative ensemble in a particular house fit into the lives of the people who commissioned it and lived with it.

Scholarship on the wall painting, mosaics, and stucco decoration in Roman Italy has for the most part divided very sharply between Pompeii and Herculaneum on the one hand and Ostia Antica on the other. Few scholars have dared to cross the artificial dividing line furnished by the eruption of Vesuvius in A.D. 79. One works either at Pompeii *or* at Ostia, never at both sites. Pompeianists decry the poor quality and decadence of Ostian painting; Ostianists point proudly to the wealth of black-and-white figural mosaics. I have emphasized the continuities in style and iconography between Pompeii and Ostia in an attempt to erase this line.

The reader will find a good deal of description in these pages. Although the assumption has always been that a picture is worth a thousand words, my experience has been that no amount of looking at a photograph will convey the experience of studying a wall or floor for a long time and under varying conditions of light. My field notebooks attest to my own discoveries as I returned again and again to the same houses over the years: a previously unnoticed detail seems to appear from nowhere, or traces of paint reveal a figure's outlines where I had noted a blank space. The ancient Roman who lived in these spaces when they were new and fresh took such details for granted, but we must work to recapture them.

This brings me to a more difficult, and sadder, goal of this book: to document, through descriptions, photographs, and drawings, wall painting and mosaics that future generations will probably never see. Although the methods of excavators in past centuries were deplorable, excavators of the twentieth century—armed with scientific conservation methods and photography, and believing full well that their finds would remain forever—have destroyed the most. As the exhibition *Pompei, 1748–1980* clearly demonstrated,[2] much of

1985); Second Style: Hendrick G. Beyen, *Pompejanische Wanddekoration vom zweiten bis zum vierten Stil*, vol. 1 (The Hague, 1938), vol. 2 (The Hague, 1960); Third Style: Frédéric Bastet and Mariette de Vos, *Proposta per una classificazione del terzo stile pompeiano*. Archeologische Studiën van het Nederlands Instituut te Rome, no. 4 (The Hague, 1979); Wolfgang Ehrhardt, *Stilgeschichtliche Untersuchungen an römischen Wandmalereien von der späten Republik bis zur Zeit Neros* (Mainz, 1987); all four styles: Alix Barbet, *La peinture murale romaine: Les styles décoratifs pompéiens* (Paris, 1985); Roger Ling, *Roman Painting* (Cambridge, 1991); post-Pompeian painting: Fritz Wirth, *Römische Wandmalerei vom Untergang Pompejis bis ans Ende des dritten Jahrhunderts* (Berlin, 1934).

2. Franca Parise Badoni, Irene Bragantini, and Mariette de Vos, *Pompei, 1748–1980: I tempi della documentazione*, exh. cat., Pompeii and Rome (Rome, 1981).

the wall painting and mosaics found in good condition in this century has disappeared, often without a drawing or photograph to document it. Whether because of neglect, inept restoration attempts, vandalism, theft, or disasters like the earthquake of 1980, much material has been lost at both Pompeii and Ostia. The black-and-white and color photographs reproduced here show the decoration of the case-study houses as it was in the 1980s; in many instances I have had to rely on photographs taken as little as twenty years ago to recover details that are by now gone forever.

The reader will find that in the list of figures I have followed the system devised by the Istituto Centrale per il Catalogo e la Documentazione for locating the rooms in each house and the paintings or mosaics in those rooms.[3] Both the plan of the house and the system for identifying its spaces—whether by letter or by number—are those of the excavator. (I have converted roman numerals to arabic equivalents.) Within each space the directions "north," "south," "east," and "west" locate each wall, and the same directions locate details on those walls. "House of the Vettii, room *e,* west wall, upper zone, south part," for example, is the upper left-hand part of the wall to the right of someone entering the room from its doorway, which is on the north wall. In a group of houses at Ostia oriented northeast-southwest, I have marked the plans with a conventional "north." The captions supplement this information rather than repeating it, emphasizing the significance of the illustration rather than its exact location. Nearly all the photographs taken expressly for this book by Michael Larvey include a standard meter marker measuring 160 centimeters: each white, black, or red segment on the standard marker measures 20 centimeters, for a total of eight units. One exception is figure 2, where the marker is exactly one meter in length. In several details a centimeter tape provides the scale. These uniform standards, both for locating the decorations and for indicating scale, should facilitate comparative analysis of the case-study houses.

The book begins with an investigation of the types of houses the Romans lived in and how they arranged their spaces to frame the rituals that took place in them. The second chapter surveys the changing fashions in interior decoration from about 100 B.C. to A.D. 250, paying special attention to the artists and workmen who designed and executed wall paintings and mosaics. The remaining chapters follow these fashions chronologically in the specific circumstances of the case-study houses. Their decorative ensembles demonstrate how individual considerations, such as a house's size and plan, planned views, or the

3. Irene Bragantini, Mariette de Vos, and Franca Parise Badoni, *Pitture e pavimenti di Pompei,* Repertorio delle fotografie del gabinetto fotografico nazionale. Istituto centrale per il catalogo e la documentazione, 3 vols. (Rome, 1981–1986).

patron's social class and interests, tailored the reigning styles to fit the circumstances.

I hope that what I have done will open the study of Roman decoration to broader human questions than past scholarship has asked. This book will have achieved its goal if it sparks new enthusiasm for Roman interiors among people who do not know them well and stimulates debate among those who do.

MAPS

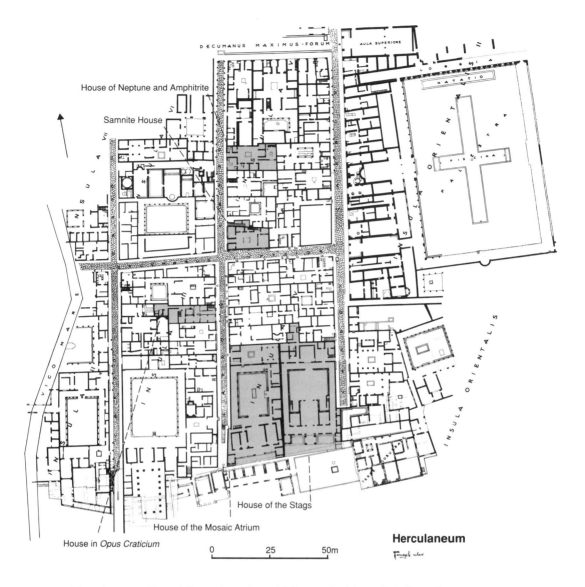

House of Neptune and Amphitrite

Samnite House

DECUMANUS MAXIMUS-FORUM

AULA SUPERIORE

House of the Stags

House of the Mosaic Atrium

House in *Opus Craticium*

0 25 50m

Herculaneum

MAP 1. Herculaneum. Plan of the ancient city, with houses in this study indicated.

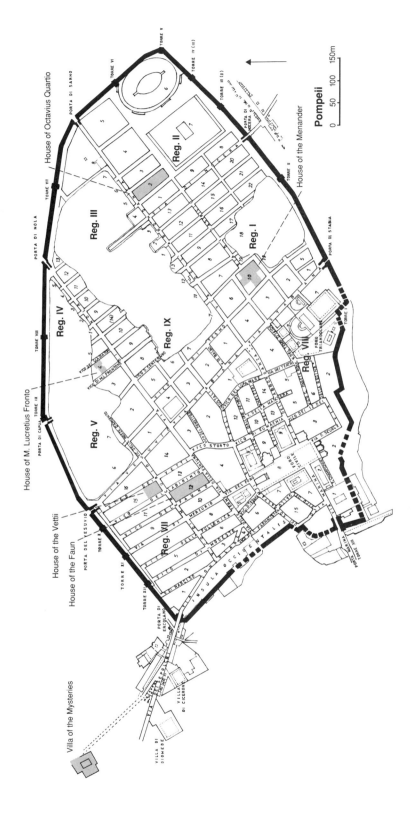

MAP 2. Pompeii. Plan of the ancient city, with the houses in this study indicated.

Pompeii

0 50 100 150m

House of Octavius Quartio

House of M. Lucretius Fronto

House of the Menander

House of the Vettii

House of the Faun

Villa of the Mysteries

Reg. I
Reg. II
Reg. III
Reg. IV
Reg. V
Reg. VI
Reg. VII
Reg. IX

PORTA DI SARNO
PORTA DI NOLA
PORTA DI CAPUA
PORTA DEL VESUVIO
PORTA DI ERCOLANO
PORTA MARINA
PORTA DI STABIA
PORTA DI NUCERA

TORRE V
TORRE VI
TORRE VII
TORRE VIII
TORRE IX
TORRE X
TORRE XI
TORRE XII

VILLA DI DIOMEDE
VILLA DI CICERONE

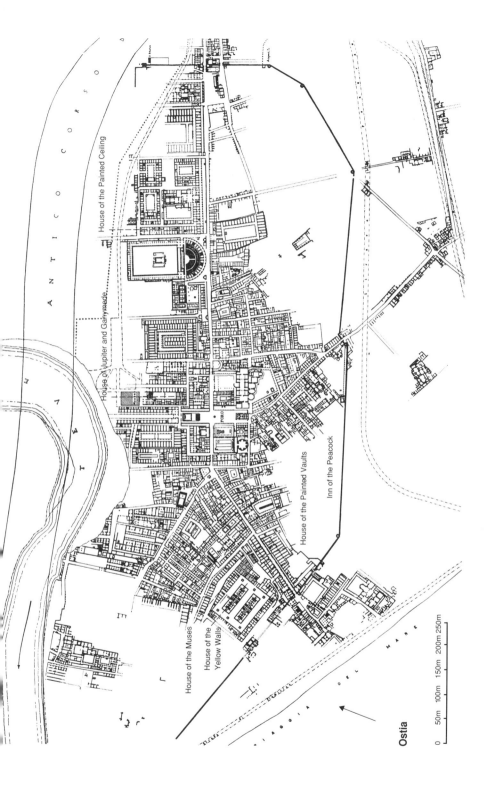

House of the Painted Ceiling

House of Jupiter and Ganymede

House of the Muses

House of the Yellow Walls

House of the Painted Vaults

Inn of the Peacock

Ostia

0 50m 100m 150m 200m 250m

MAP 3. Ostia. Plan of the ancient city, with houses in this study indicated.

PLATES

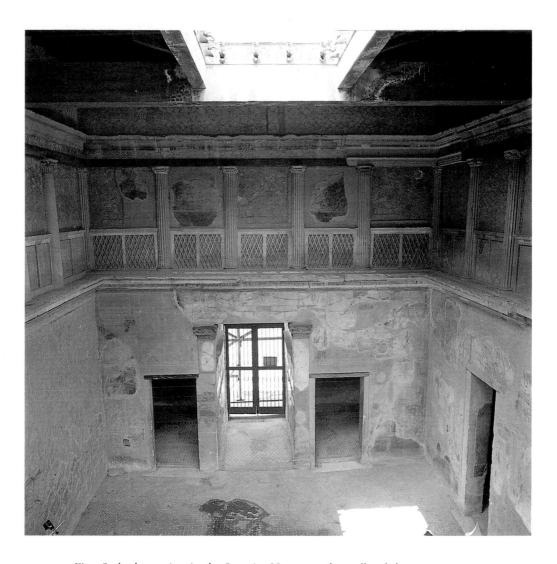

PLATE 1. First-Style decoration in the Samnite House on the walls of the fauces and in the loggia surrounding upper half of atrium.

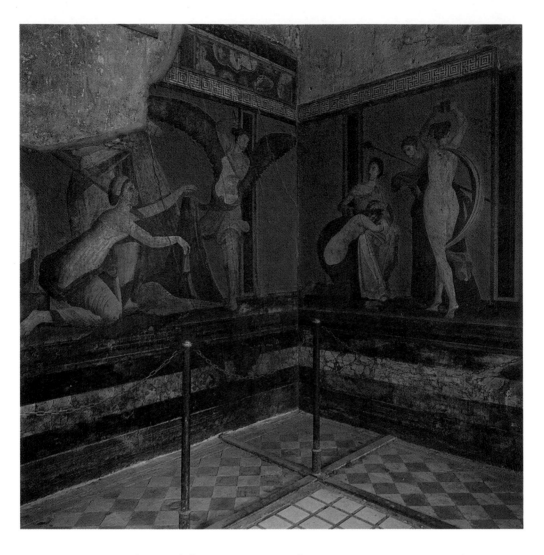

PLATE 2. A winged demon prepares to whip a woman across a corner of the Room of the Mysteries.

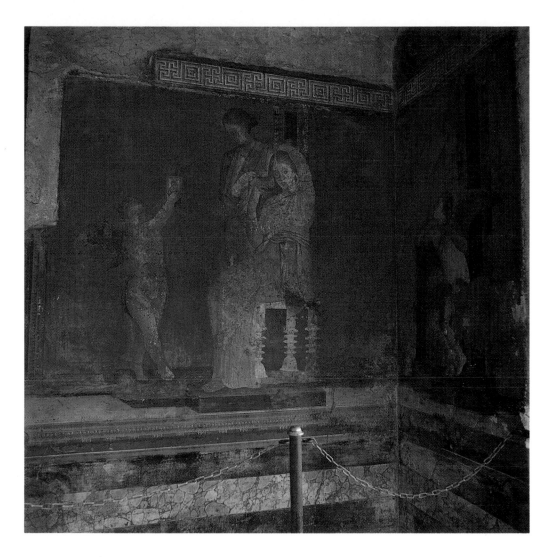

PLATE 3. Another corner composition in the Room of the Mysteries: an amorino holds a mirror for the young woman at her toilet while a second cupid looks on.

PLATE 4. Two different mosaic "bedside carpets" (scendiletti) and two different Second-Style architectural perspectives distinguish the two alcoves in this cubiculum.

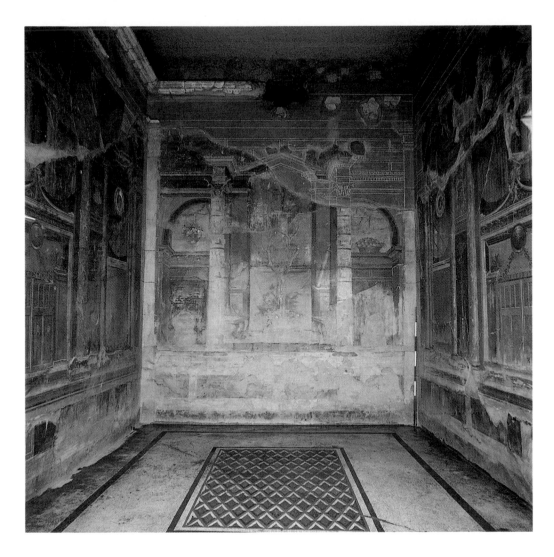

PLATE 5. A Second-Style triclinium combines a polychrome mosaic carpet with complex perspective views into temple precincts.

PLATE 6. An elegant Third-Style tablinum ensemble: a plain white mosaic floor complements black walls articulated with miniature elements.

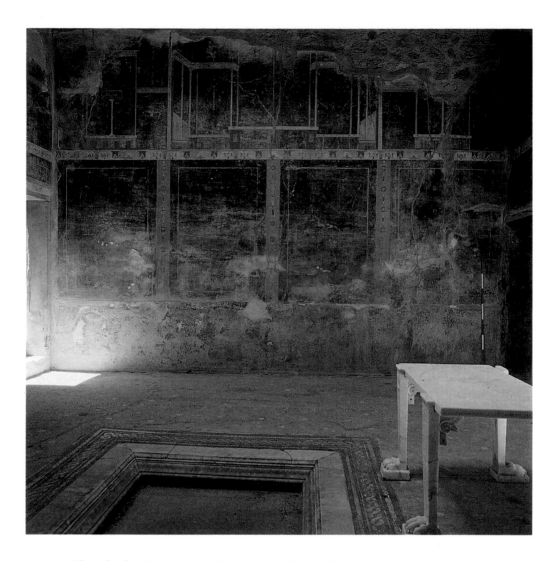

PLATE 7. This Third-Style atrium combines a black floor with black walls. At the right a marble table, or cartibulum.

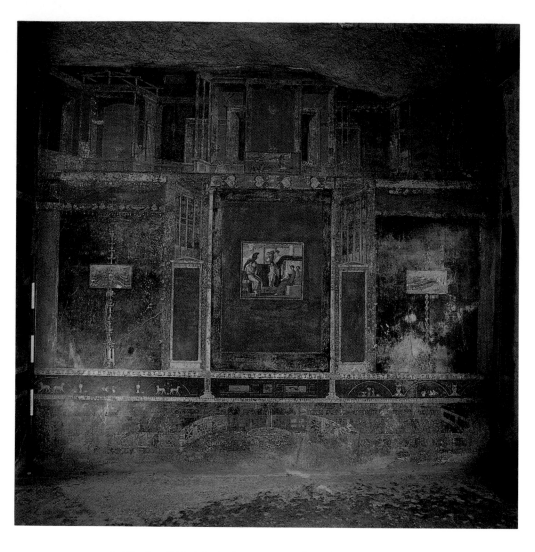

PLATE 8. The late Third-Style decoration of this tablinum includes a central picture of Mars and Venus. A fenced garden decorates the socle.

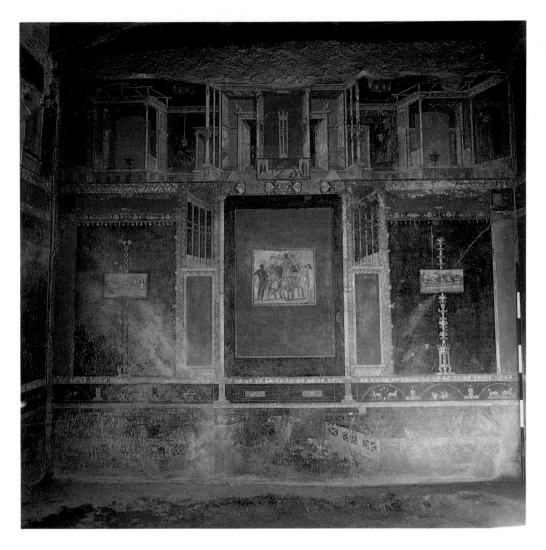

PLATE 9. The wall facing Pl. 8, with a central picture of Dionysus and Ariadne in a cart. Note landscape paintings on easels and the thin scaenae frons of the upper zone.

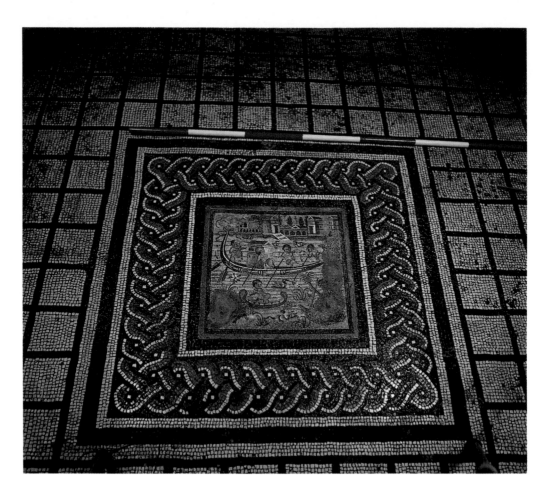

PLATE 10. The patron selected this emblema, depicting pygmies on the Nile, to insert into the Second-Style tessellated pavement of an oecus.

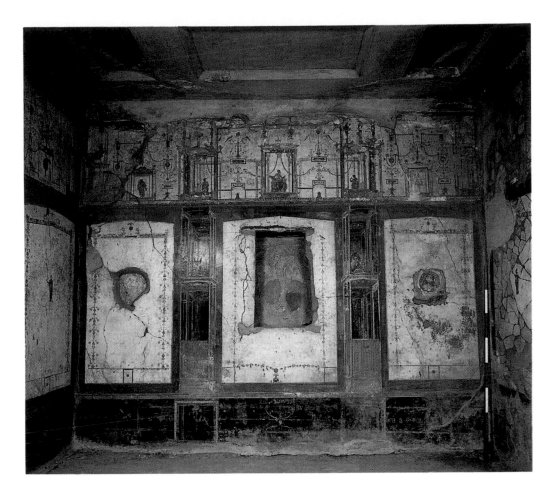

PLATE 11. This all-white oecus painted in the Fourth-Style Theatrical Man-
ner recalls high-quality decoration in Nero's Golden House in Rome.

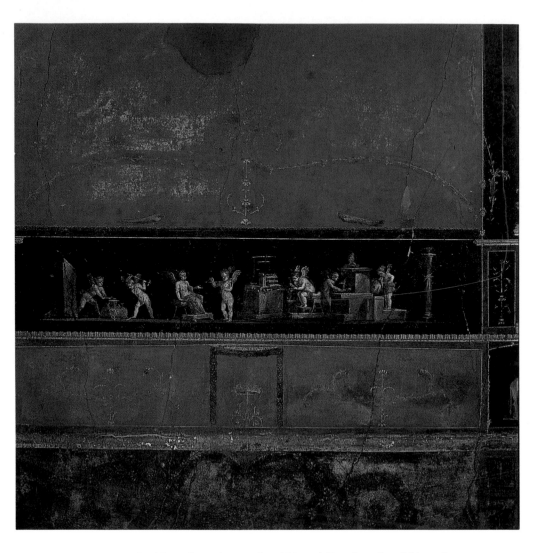

PLATE 12. Cupids and psychai work gold in a delicately painted frieze that divides the socle from the median zone of a Fourth-Style scheme.

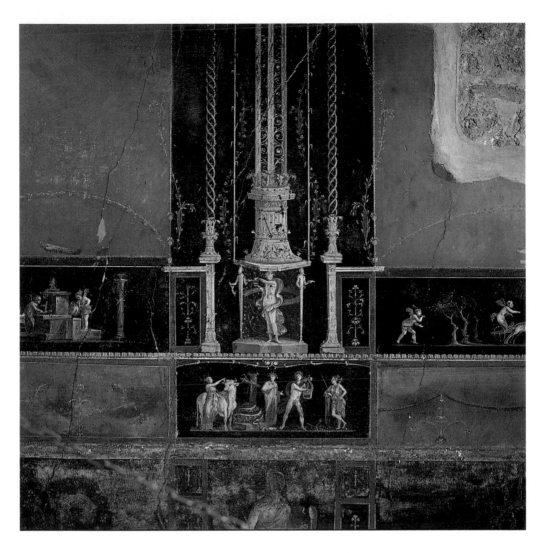

PLATE 13. Apollo and the serpent Pythia appear at the base of the ornate columns dividing successive panels in the same room as shown in Pl. 12.

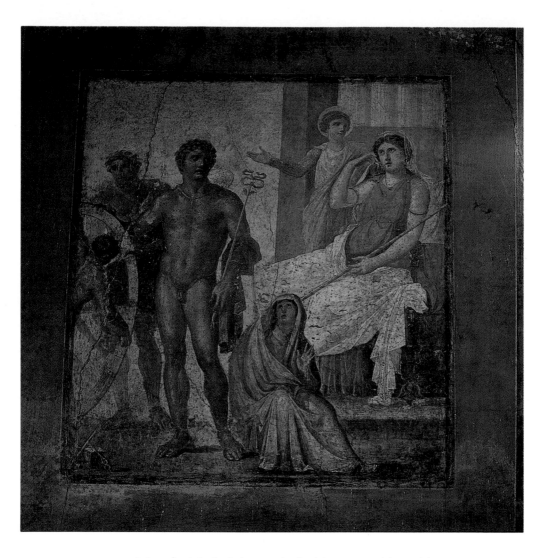

PLATE 14. Ixion, far left, is tied to a wheel with serpents, his punishment for lusting after Hera (seated, upper right). A nude Mercury oversees the punishment.

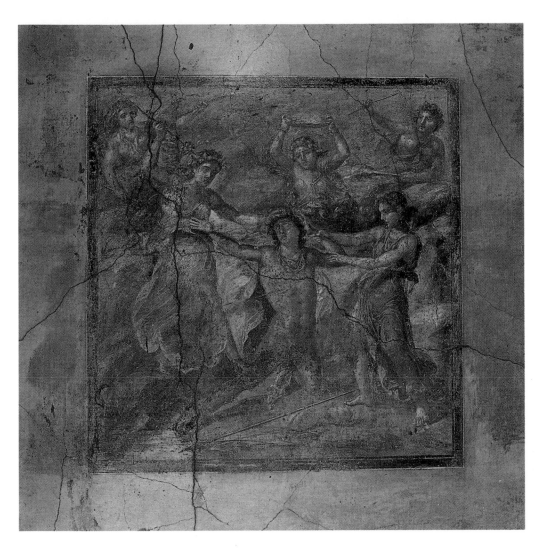

PLATE 15. Maenads tear Pentheus limb from limb, his punishment for spying on them.

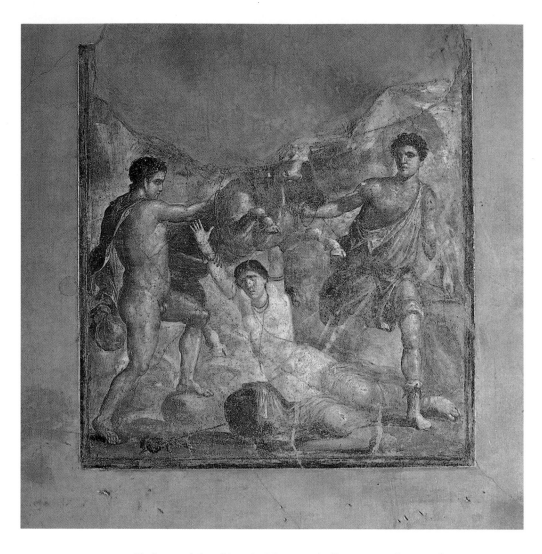

PLATE 16. Zethus and Amphion tie Dirce to a bull, avenging their mother, Antiope.

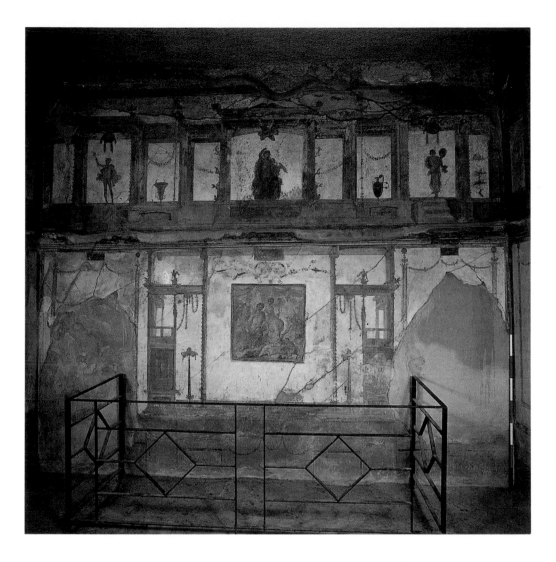

PLATE 17. An all-white Fourth-Style triclinium with an upper zone modeled on the scaenae frons (compare Pl. 11).

PLATE 18. The head of Athena in the center of this Fourth-Style ceiling appears right side up to the diner seated in the place of honor, at the back of the room.

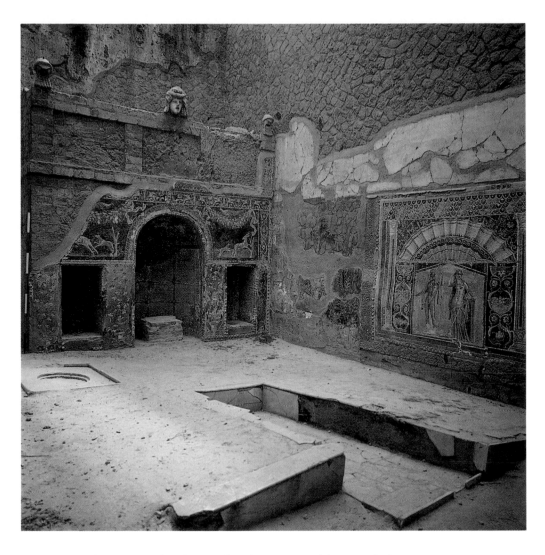

PLATE 19. A fountain garden decorated with mosaics and hung with theatrical masks, painting of garden scenery, and a tiny biclinium reproduce in miniature features of grand villas.

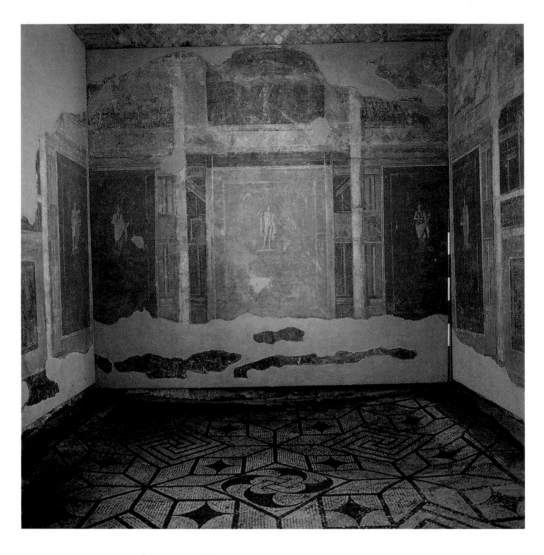

PLATE 20. This Room of the Muses (museion) combines a complex black-and-white carpet with a Hadrianic reprise of the Second Style of one hundred seventy years before.

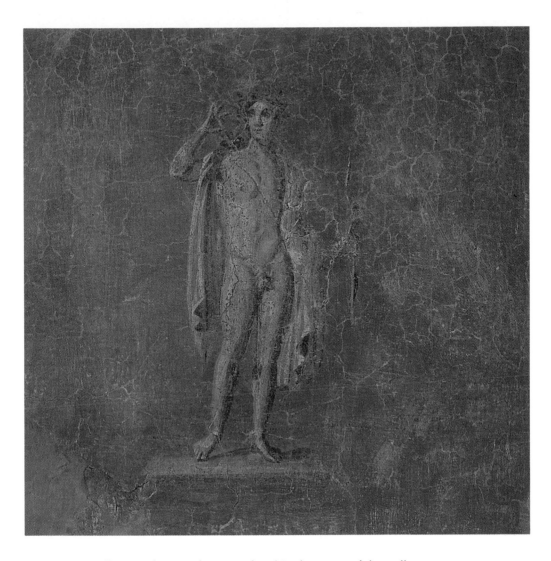

PLATE 21. Apollo as archer stands on a pedestal in the center of the wall.
His elongated proportions recall the sculpture of Lysippos.

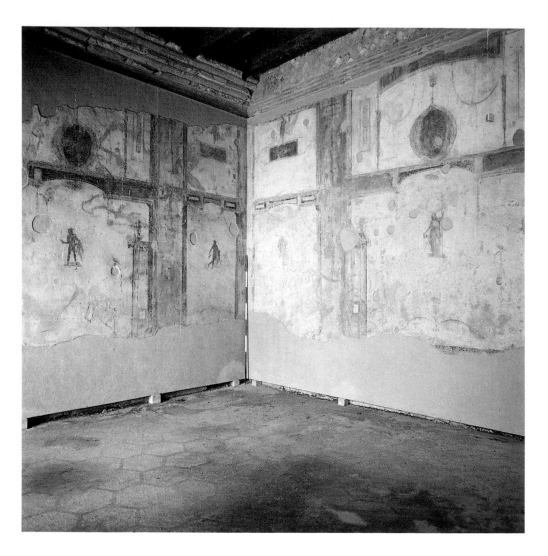

PLATE 22. This white-and-gold cubiculum recalls Fourth-Style Theatrical Manner decorations (compare Pls. 11 and 17).

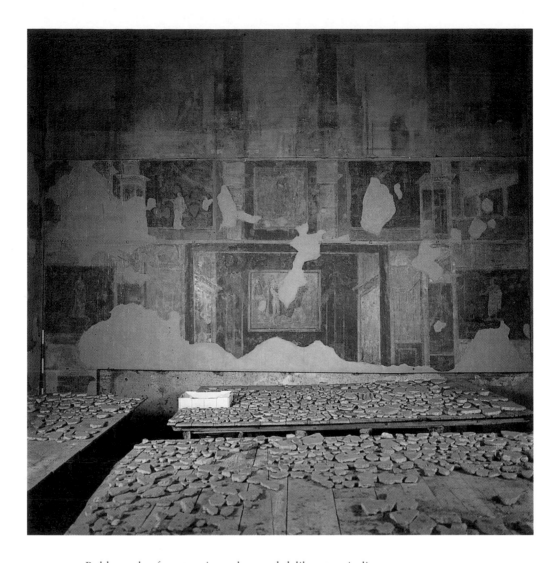

PLATE 23. Bold panels of contrasting colors and deliberate misalignments in this late Antonine decoration prefigure the Severan panel style while recalling the Fourth-Style Theatrical Manner of Fig. 135.

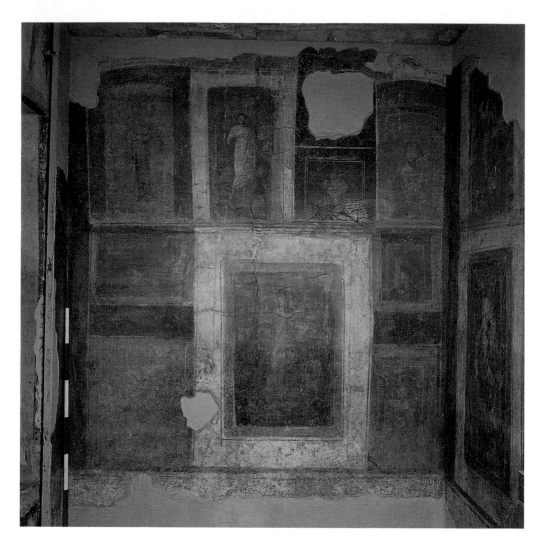

PLATE 24. The Severan panel style abandons the architectural armature for an all-over pattern of competing shapes.

CHAPTER ONE

SPACE AND RITUAL IN DOMUS, VILLA,
AND INSULA, 100 B.C. – A.D. 250

The architecture of the Romans was, from first to last, an art of shaping space around ritual."[1] This was as true for the Roman house as it was for the temple and the forum. Roman life was filled with rituals, no less so in the private sphere of the home than in the public arena. As might be expected, state religious and political ceremonies, documented not only by literature and inscriptions but also by scores of sculptural representations, are much better known than those of the home. Furthermore, the word "ritual" itself has extended meanings in the private sphere, because the Romans tended to think of each space in a house in terms of the ritual or activity that the space housed. For this reason, the meaning of "ritual"—in the context of the Roman house and as used in this book—is two-pronged. In its usual sense, it denotes formal, prescribed activity, often with religious purposes or rigidly ceremonial overtones. Its second sense is that of the habitual—yet not religiously prescribed—activity that took place in these spaces. Literary sources give us much information about the domestic rituals of worship of the household gods, ceremonies of coming-of-age, marriage, birth, and death; they describe secular rituals such as the visits of clients to the head of the house and the entertainment of guests at dinner parties. Still, we must interpret both prescribed and habitual rituals in terms of the spaces of the houses themselves. Here factors such as size, siting, and social class provide particulars. How, for instance, did a dining room in a small city house function—as opposed to that of a grand seaside villa?

One thing is certain from the analysis of the evidence. Literary sources and analysis of the houses themselves tell us that ancient Romans expended great care on the disposition and decoration of their domestic spaces because they valued spaces that were appropriately located and decorated to fit their assigned activity. Unlike our modern house, conceived as a refuge for the nuclear

1. Frank E. Brown, *Roman Architecture* (New York, 1961), 9.

family, located far from the factory or office, the Roman house was in no way private. It was the locus of the owner's social, political, and business activities, open both to invited and uninvited visitors. Because of this, the location, size, and decoration of each space formed codes that cued the behavior of every person under its roof, from intimates (the family, friends, and slaves) to distant clients.[2] This close connection between function and decoration reveals the minds of the ancient Romans as much as do their literature and great public art.

This chapter considers the types of houses that appear in Roman Italy in this creative period of the Late Republic and Early Empire, with special attention paid to the arrangement of their spaces and to the activities they housed. Examples have been chosen, where possible, from case-study houses included in later chapters, where the discussion expands to the particulars of how decoration was tied to function and to the viewer's perception of both individual rooms and suites of spaces.

SPACE AND RITUAL IN THE PATRICIAN DOMUS

Two sources allow us to reconstruct with some degree of certainty the patrician town house, or *domus*. One is Vitruvius's *De architectura,* written in the twenties B.C.[3] The architect carefully names the rooms and prescribes the functions of those rooms. His systematic treatise emphasizes the role of the architect in ensuring that the house and all of its spaces have proper proportions. In spite of his great attention to details, Vitruvius never provides a clear plan for the domus. This has come from our second source, the excavated Roman houses of Italy. Although their third-century B.C. plans were later modified, three houses excavated at Pompeii (the Houses of the Surgeon, of Pansa, and of Sallust) allow us to reconstruct the typical plan of the patrician dwelling described by Vitruvius (Fig. 1). Since the domus, like our modern row house or town house, has party walls on its flanks and an enclosed back area, its principal opening to the exterior is located on the street front. The Romans called this entryway the *fauces* (literally, "jaws"). Shop spaces for rent often flanked the fauces.

A long axis running from the fauces through the atrium, or central hall, to

2. "[T]he Roman house was a constant focus of public life: it was where a public figure not only received his dependents and *amici* (the two categories flow into one another) but conducted business of all sorts. His house was a power-house: it was where the network of social contacts was generated and activated which provided the underpinning for his public activities outside the house"; Andrew Wallace-Hadrill, "The Social Structure of the Roman House," *Papers of the British School at Rome* 56 (1988): 55–56.

3. For a careful analysis of Vitruvius's text in relation to the domus, see Lise Bek, *Towards Paradise on Earth: Modern Space Conception in Architecture: A Creation of Renaissance Humanism. Analecta romana Instituti danici,* supplement 9 (Rome, 1980), 168–170.

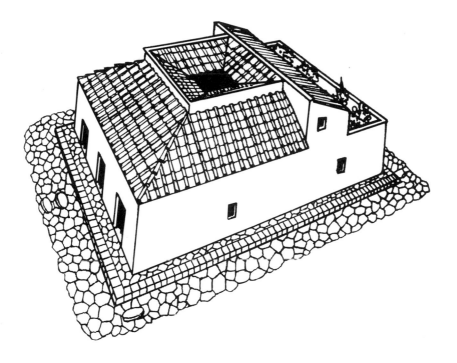

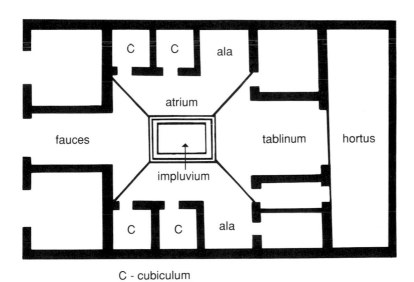

	C	C	ala	
fauces		atrium	tablinum	hortus
		impluvium		
	C	C	ala	

C - cubiculum

FIGURE 1. The patrician domus of the third century B.C. reconstructed in plan and axonometric view.

the main reception space, the *tablinum,* organizes all the house's interior spaces. Strangely, Vitruvius and other writers on the domus are silent on the subject of the fauces-atrium-tablinum axis, probably because it was such an obvious and invariant feature.[4] A number of compelling architectural forms emphasize the axis. The space of the fauces, which marks the axis from the point of entrance, is long and narrow. A central opening in the atrium's roof, the *compluvium,* was designed to funnel the rainwater from the roof into a basin below, the *impluvium* (Fig. 2). While the impluvium marks the axis by resting directly on it, the compluvium emphasizes the axis vertically, since it is of the same size and shape as the impluvium and is located directly over it. Rain falling from the compluvium into the impluvium makes their reciprocal relationship visible, yet the compluvium is also the source of light for the atrium and its dependencies. Its light reveals the extent of the atrium's tall spaces, while the movement of the sun marks the hours of the day. The impluvium, on the other hand, is both an axis marker and a symbol of the domus's independence from the outside world, for in the times before water was piped to houses the cistern it fed provided water for the family. What was the ritual that caused the Romans so strongly to emphasize the fauces-atrium-tablinum axis?

It was the *salutatio,* the visit by dependents, collectively called the *clientela,* to the paterfamilias, their patron or *patronus.* The "family" headed by the paterfamilias extended for social and economic reasons far beyond the immediate family members. The clientela included relatives who could not have the status of a paterfamilias, such as sons who had established independent households, all those who worked for the paterfamilias, including both slaves and freedmen (former slaves of the family), plus an assorted group of unattached persons who made the daily rounds of *salutationes* to assure their political and economic security.[5] The ritual of the salutatio secured the power and fortune of the paterfamilias through those who served his interests. This ritual structured the domus.

A client emerging from the tunnel-like confines of the fauces directly faced the goal of his or her visit, the paterfamilias, standing or seated at the end of the axis in the tablinum and dressed in the toga. A sequence of architecturally framed planes conducted the client's gaze to the paterfamilias in the tablinum.

4. "When reading the descriptions given by Roman authors of houses and villas, one is also struck by their disinterest in any exact definition of the ground plan"; Lise Bek, "Venusta species: A Hellenistic Rhetorical Concept as the Aesthetic Principle in Roman Townscape," *Analecta romana Instituti danici* 14 (1985): 140.

5. A. von Premerstein, "Clientes," *Paulys Real-Encyclopädie der classischen Altertumswissenschaft,* ed. George Wissowa (Stuttgart, 1894–1978), [hereafter *Pauly-Wissowa*], s.v; Timothy P. Wiseman, "*Pete nobiles amicos:* Poets and Patrons in Late Republican Rome," in *Literary and Artistic Patronage in Ancient Rome,* ed. Barbara K. Gold (Austin, 1982), 28–31.

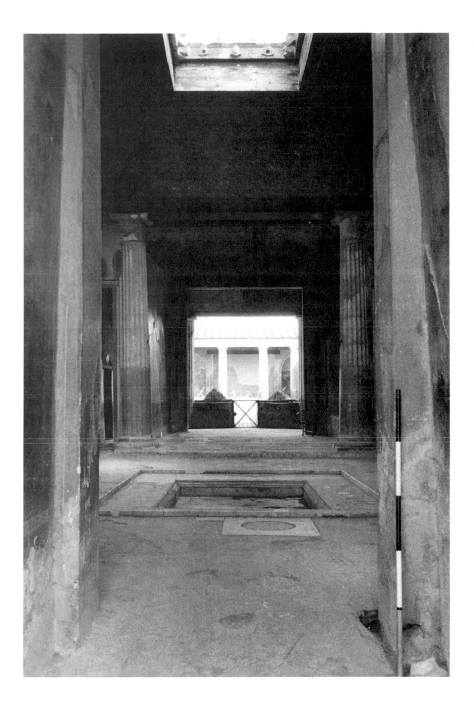

FIGURE 2. The architect created this long visual axis by using a series of symmetrical framing elements, even though the plan of the house (see Fig. 6) is irregular.

The first frame was that of the fauces, of narrow width, sloping upward, and having a relatively low ceiling. The doors of the domus were not flush with the street facade but were set well into the entryway and opened inward, to create a viewing position for the visitor.[6] From here a person would see the tablinum framed by the fauces' floor, walls, and ceiling. Engaged columns, engaged piers (*antae*), or painted decorative frames emphasized the opening of the tablinum, forming a second frame. Behind the tablinum a window or door created a third plane of focus, this time a framed view of the garden, or *hortus*, behind the tablinum. The impluvium, lit from above and sparkling with water, marked the axis but not the path, for to reach the tablinum the visitor had to walk around the impluvium, visually measuring the height and breadth of the atrium along the way. Moving off the axis, a person would be able to look into the *alae*, or wings, usually of the same height as the atrium and located at the back of the atrium, to the right and left of the central axis.

Facing all who entered through the fauces, the paterfamilias controlled the boundaries of his house. Some scholars have compared his position and control of the domus to that of the Etruscan and Roman soothsayers, or *haruspices*, who stood on the platform of the temple to define the physical boundaries (*templum*) of its sacred power.[7] Clear definition of the axis in front of this platform, and of the cardinal points to the right, left, and behind it, formed the basis of the reading of omens that was at the heart of Etruscan and Roman religion. As the chart shows (Fig. 3), the Etruscan deities were located in relation to the cardinal points, so that the *haruspex* had to position himself in space to read portents, whether they be lightning, the flight of birds, or the markings on a sacrificed sheep's liver.[8] Each zone of the 360° circle, defined by the half in front of the priest (*pars anterioris*) and the half behind him (*pars posterioris*), belonged to a deity.[9] If the temple in Roman times, raised on its high podium, was a viewing platform axially situated in a space bounded by its enclosure walls, the tablinum was the seat of power in the domus, controlling the axis of entry that formed its link with the business of the outside world.

The atrium also housed many family rituals, collectively called the *sacra privata*. Images of the family's ancestors hung in the atrium.[10] So far only one per-

6. Heinrich Drerup, "Bildraum und Realraum in der römischen Architektur," *Römische Mitteilungen* 66 (1959): 158–159.

7. Drerup, "Bildraum und Realraum," 148; Brown, *Roman Architecture*, 14–15.

8. Massimo Pallottino, *The Etruscans*, rev. ed. (Bloomington, Ind., 1975), fig. 5.

9. Kent Bloomer and Charles Moore, *The Body, Memory, and Architecture* (New Haven, 1977), 31–40, argue that all human beings understand their spatial position from a bodily sense of "up/down," "front/back," "right/left," and "here in the center."

10. Vitruvius *De architectura* 6.3.6, tells us that the *imagines maiorum* were displayed in the atrium at a height equal to the breadth of the alae; Rolf Winkes, "Pliny's Chapter on Roman Funeral Customs in Light of the 'Clipeatae Imagines,'" *American Journal of Archaeology* 83 (1979):

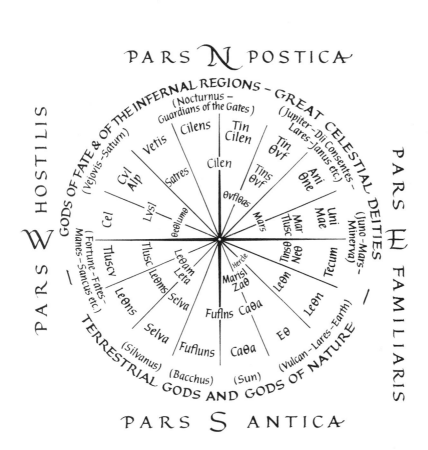

FIGURE 3. Deities located at the cardinal points in Etruscan divination (and the fundamental human sense of "in front of" and "behind") may have influenced the plan of the Roman house.

manent shrine to the cult of ancestors has been discovered (in the House of the Menander, discussed below), leaving one to suspect that they received offerings and prayers on portable altars. There is much greater evidence for the worship of the penates, the lares, and the *genius*. Although in earlier times worship of these deities took place at the hearth, where they received offerings of perfume, wine, and cakes, later this daily ritual took place at permanent shrines within the house. The plural form of the word "penates" indicates that they were an indistinct group; in fact, the word is used collectively to include all the house-

481–484; Mariette de Vos, "Funzione e decorazione dell'Auditorium di Mecenate," in *Roma Capitale, 1870–1911: L'archeologia in Roma capitale tra sterro e scavo*, ed. Giuseppina Pisani Sartorio and Lorenzo Quilici (Venice, 1983), 233.

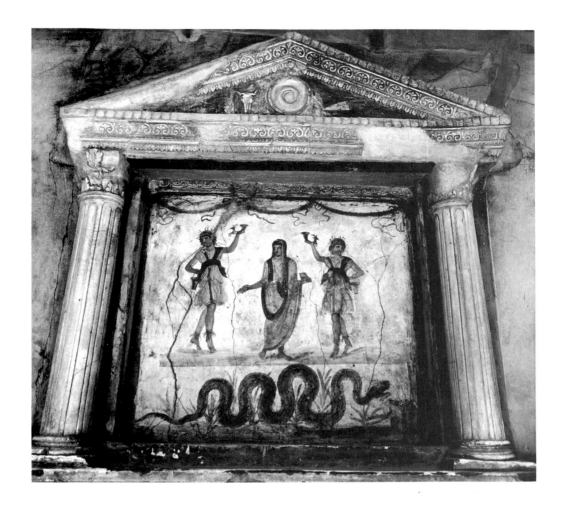

FIGURE 4. Lares and the genius of the paterfamilias in a lararium painting in a kitchen.

hold deities at Pompeii.[11] The lares were the most important, a fact underscored by the great number of shrines to the lares (*lararia*) found in houses in Pompeii and Herculaneum. They are almost always thought of in pairs and are represented as two young men wearing country clothes and carrying rhytons, or drinking horns (Fig. 4). In their most important festival the lares of the

11. Although the origins of the penates are unknown, they were probably the guardian spirits of the household storeroom. At Pompeii and Herculaneum, the term includes all deities worshiped

crossroads (*lares compitales*) were worshiped where one family's land joined another's.[12] The *lares familiares,* who protected the entire family (including the slaves), were united with the lares compitales in wedding ceremonies.[13] On Pompeian lararia the lares flank the genius of the paterfamilias. The genius is the spirit of the paterfamilias; he wears a toga, usually holds a *patera,* or libation bowl, and sometimes carries a cornucopia.[14] This deity stood for the principle of generation, linked in a very matter-of-fact way with the marriage bed, or *lectus genialis,* which was sacred to the paterfamilias. The genius, then, was a fertility spirit who guaranteed the continuation of the clan, or *gens.* The genius's feast day was the birthday of the paterfamilias.[15]

The presence of many lararia points to the rituals localized in specific spaces in the domus.[16] Usually located in a corner of the atrium (Fig. 5) or in the kitchen area, these shrines included, in addition to statues or paintings of the two lares and the genius, other symbols of good fortune, such as the serpent (see Fig. 4). The lares received a variety of offerings, including incense, spelt, grapes, garlands of grain, honey cakes, honeycombs, first fruits, wine, and even blood sacrifices.[17] At the lararium, the paterfamilias regularly prayed and offered sacrifice to the family lares. When a boy came of age, the rituals of his passage from boyhood to manhood, called the *sollemnitas togae purae,* took place at the lararium, under the atrium's high roof. The boy took off his *bulla,* or amulet,[18] and hung it as an offering in the lararium.[19] He then put on the

in the home. David G. Orr, "Roman Domestic Religion: A Study of the Roman Household Deities and Their Shrines at Pompeii and Herculaneum" (Ph.D. diss., University of Maryland, 1973), 34–44.

12. Daniel P. Harmon, "The Family Festivals of Rome," in *Aufstieg und Niedergang der römischen Welt,* pt. 2, vol. 16, no. 2 (Berlin, 1978), 1594–1595.

13. See below, note 22.

14. Orr, "Roman Domestic Religion," 78.

15. Harmon, "Family Festivals," 1595.

16. George K. Boyce, "Corpus of the Lararia of Pompeii," *Memoirs of the American Academy in Rome* 14 (1937). Orr, "Roman Domestic Religion," passim; David G. Orr, "Roman Domestic Religion: The Evidence of the Household Shrines," in *Aufstieg und Niedergang der römischen Welt,* pt. 2, vol. 16, no. 2 (Berlin, 1978), 1557–1591.

17. Orr, "Roman Domestic Religion," 23.

18. Propertius 4.1.131–132:

mox ubi bulla rudi demissa est aurea collo
matris et ante deos libera sumpta toga . . .

But when you took off the gold amulet
 and assumed the toga of freedom
Before your mother's gods . . .

The Poems of Sextus Propertius, trans. J. P. McCulloch (Berkeley, 1972), 206.

19. Persius *The Satires* 5.30–31:

cum primum pavido custos mihi purpura cessit
bullaque subcinctis laribus donata pependit

toga virilis, or man's toga. He also dedicated his beard to the lares.[20] A girl's coming-of-age was postponed to the night before her marriage. She dedicated symbols of her girlhood, including dolls, soft balls, and breast bands, to the household gods.[21] There were three different marriage rites, but all of them seem to have begun in the bride's home. After a wedding feast the bride was conducted to her new home. The bride carried three copper coins. To mark her passing from one family to another, ritual prescribed that she give one to the lar of the crossroads, one to the family lar of her new home, and one to her husband.[22] At her arrival at her husband's house, the bride anointed the door post and placed woolen bands on it as a sign of her domesticity; escorts then lifted her over the threshold. Once inside the house, the groom gave her fire and water, symbols of her new authority as materfamilias. Led to the lectus genialis, she reclined on her husband's chest. The next day she assumed her duties as materfamilias and presided over the household rituals.[23]

Wreaths on the door announced the birth of a child to the community; a flame was lit on the altar during the first precarious days of the infant's life. Soon after birth the baby was placed on the ground and lifted up by the father to signify his recognition of the child.[24] On the eighth day for a girl, on the ninth for a boy, the infant received its name; sacrifices were also made to purify the baby from pollution believed to come from the birth process.[25] Every year the birthday was celebrated with offerings of thanks, including sacrifices of cakes and the burning of incense and through customary gifts given to the person celebrating his or her birthday.

Rituals of death and mourning also took place in the atrium. The heir conducted the rites, seeing that the deceased was bathed, anointed with spices, and laid upon a couch adorned with flowers with incense burning before it. There was a ritual purification by water and fire of those who returned from the funeral, and during the nine-day period of mourning following the burial the heir

When, as a shy youth, I put off the purple gown
of boyhood, and its protection, and hung up my
amulet to the short-girt gods of the hearth

The Satires of Persius, trans. W. S. Merwin (London, 1981), 76.

20. Orr, "Roman Domestic Religion," 16.
21. Harmon, "Family Festivals," 1598.
22. Orr, "Roman Domestic Religion," 15.
23. Harmon, "Family Festivals," 1600.
24. The ritual may also stem from the belief that contact with the earth would strengthen the child, since all living things grow from it.
25. The conferring of the name was called the *nominalia;* the purification ritual was called the *lustratio;* and the day known as the *dies lustricus;* Joachim Marquardt and August Mau, *Das Privatleben der Römer* (Leipzig, 1886; reprint, Darmstadt, 1964), 28–61.

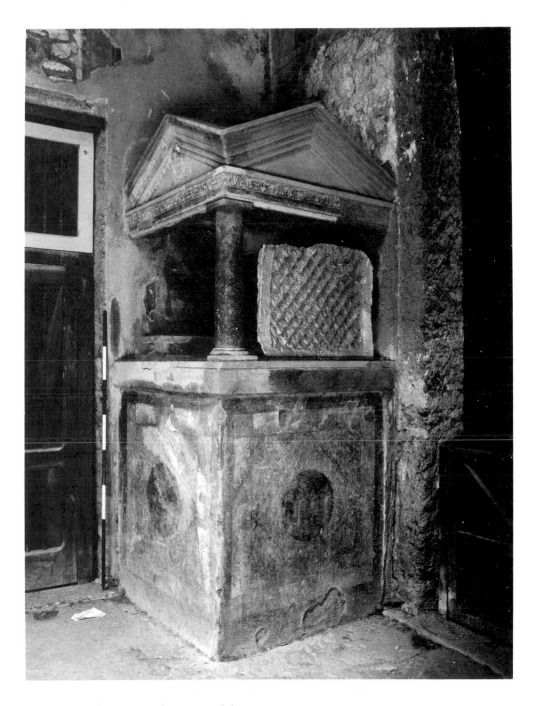

FIGURE 5. A lararium in the corner of the atrium.

purified the house through a ritual sweeping. At the end of the period of mourning there was a sacred meal, the *novendialis cena,* a convivial funeral banquet that was the first of an annual rite honoring the deceased person as one of the divine ancestors, or *divi parentes.*[26] The atrium, with its ancestral images, and the images of the lares and genius in the lararium, was as much a center of traditional family worship as it was a place to receive business and political clients. In this connection, it is significant that Vitruvius regards the domus as the framework for the responsible citizen's active life within the social pattern of the late Republican and Augustan era.[27]

In the original versions of the atrium house, all bedrooms or *cubicula* surrounded the atrium; each cubiculum had a single doorway opening to the atrium, the only source of light and air. The domus nearly always included a hortus beyond the tablinum. In fact, it was the light coming through the tablinum's back wall or door that marked and extended visually the house's long axis. Considering its importance in the rituals of Roman business and family life, the persistence of the fauces-atrium-tablinum configuration in later versions of the Roman house is not surprising. What is astounding is the variety of elements added on to this core in subsequent variations. Given the fact that the atrium saw so much traffic, the development of the back of the domus for quiet activities was a logical one. It was this area that became the new center for private rituals in the course of the second century B.C.

THE HELLENIZED DOMUS-WITH-PERISTYLE

With Rome's conquest of the east during the third and second centuries B.C. came the desire to embellish the domus with great colonnaded porticoes, larger and more elaborate than the venerable hortus. Whereas these peristyles had formed the central courtyard of Hellenistic houses like those preserved at Delos, Pergamon, and Priene, when transplanted to Roman Italy they became articulated gardens, located whenever possible on the fauces-atrium-tablinum axis in order to extend to the maximum the long view from the entryway.

Now that the peristyle enclosed bright sunlight and a garden, the atrium became a kind of formal anteroom for the reception of clients. New rooms with Greek names, arranged around the peristyle, served the private lives of those who lived in the house. Vitruvius tells us that whereas the vestibule (lacking in most Pompeian houses), atrium, and tablinum constituted the part of the house open to the uninvited public, the dining rooms, baths, and bedrooms were only

26. Marquardt and Mau, *Privatleben,* 378–385; Harmon, "Family Festivals," 1003.
27. Bek, *Towards Paradise on Earth,* 172.

for invited guests.[28] Andrew Wallace-Hadrill has recently demonstrated how this determined hierarchy of spaces—from public to private—reflects Roman social structure of the Late Republic and Early Empire.[29] Whereas the tablinum had doubled as a dining room, now there was a special room, called a triclinium, designed to hold the three couches (*klinai*) for Greek-style dining. Vitruvius specified the proportions of this U-shaped space: it should be twice as long as it was wide.[30] His discussion of oeci, rooms similar in shape to the triclinia, includes an important reference to the view *out* from the positions on the couches, suggesting that these rooms were used also for dining and that the view from these rooms was to be planned.[31] Suites of rooms with special purposes could be built off the peristyle. There could be a private bath suite, with a room for each function: a dressing room (*apodyterium*), tepid room (*tepidarium*), hot room (*caldarium*), and a cold room (*frigidarium*). Intimate rooms for daytime lounging and reading (*cubicula diurna*) were often located along the peristyle, as were open semicircular or rectangular apses (*exedrae*). Villas or houses boasting views had belvedere rooms, or *diaetae*. For private meetings the paterfamilias might make use of an elegant cubiculum, developed in grander houses and villas into a suite.[32] We see such cubiculum suites, consisting of a bedroom with two alcoves connected with an oecus, in the Villa of Oplontis (see Fig. 41) and the Villa of the Mysteries (see Fig. 28).[33]

The only limit on the luxury of the peristyle was the owner's purse. These spaces housed new rituals of leisure made possible not only by new wealth but also by the architects and artists who emigrated from the devastated east to find work in Italy.

The expansion of the domus with the addition of the peristyle helped solve another problem, that of housing the slaves. They were ubiquitous members of the wealthy household, arranged in a hierarchy of intimacy with the family members. Most intimate were personal slaves, such as the *cubicularii* (who slept on mattresses at the bedroom door), followed by cooks, nurses, secretaries, clerks, and doormen; they often functioned like doors and partitions, forming living buffers between the visitors and the members of the household.[34]

28. Vitruvius *De architectura* 6.5.
29. Wallace-Hadrill, "Social Structure," 43–97.
30. Vitruvius *De architectura* 6.3.8.
31. Vitruvius *De architectura* 6.3.10.
32. Wallace-Hadrill, "Social Structure," 59 note 44.
33. Alan M. G. Little, *A Roman Bridal Drama at the Villa of the Mysteries* (Kennebunk, Me., 1972), 3–5, for the Villa of the Mysteries; Lawrence Richardson, Jr., "A Contribution to the Study of Pompeian Dining Rooms," *Pompeii Herculaneum Stabiae. Bollettino dell' associazione internazionale amici di Pompei* 1 (1983): 61–71, discusses such linked suites as dining areas where women ate, seated, separated from the men; against which see Wallace-Hadrill, "Social Structure," 93 note 147.
34. Wallace-Hadrill, "Social Structure," 78–81.

Yet in the best residences their quarters—unimportant to the prestige of the owner—had to be concealed. A second peristyle with servants' quarters, or upper-story rooms in either atrium or peristyle, successfully removed the slaves from sight when their services were not required. Some city houses, like that of the Menander, made the slave quarters, kitchen, and latrine "disappear" by placing these spaces on a lower level, which included stables and rustic storage areas (numbers 29–34 on plan, Fig. 6).

In his discussion of the rooms off the peristyle, Vitruvius urges the architect to locate rooms to achieve the best possible conditions of light and temperature in relation to the times of the day and the seasons. Baths and winter dining rooms should be located on the west side of the peristyle; bedroom suites, libraries, dining rooms used in the spring and autumn should be on the east, and summer triclinia should face north.[35]

In testing the dicta of Vitruvius against the evidence of peristyle houses excavated in Roman Italy, several contradictions arise. Whereas Vitruvius urges that the peristyle be placed transverse to the atrium, a survey of existing houses shows that most peristyles continue the fauces-atrium-tablinum axis. The House of the Menander, in particular, has received much attention from scholars because both its plan and the view from the fauces evidence the care taken by the architect to maintain at least a visual axis in the process of adding a peristyle to the preexisting domus. Because the parcels of land acquired by the owner for the addition of the peristyle were irregular, a regular plan was impossible: there was no way to center the peristyle on the domus's axis. Working around this problem, the architect still managed to extend the axial view from the fauces, through the tablinum, to the extreme south end of the peristyle (see Fig. 2). To achieve this goal, he widened the spaces between the columns of the peristyle just past the tablinum to frame the axis, and terminated it with the cupping form of exedra 22.

Heinrich Drerup uses the House of the Menander as the prime exemplar of his concept of the "view through," or *Durchblick,* in his seminal article on pictorial space and real space in Roman architecture.[36] A series of framing devices located on the visual axis constructs the view through the House of the Menander: the widened space between the columns on the axis becomes a window when seen in combination with the low walls (*plutei*) between the columns and the architrave they carry.[37] Lise Bek refines Drerup's analysis of the visual axis as a spatial principle. Instead of Drerup's direct linear progression toward a visual goal, Bek sees an effect of symmetrically constructed planes lying one

35. Vitruvius *De architectura* 6.4.11.
36. Drerup, "Bildraum und Realraum," 145–174.
37. Drerup, "Bildraum und Realraum," 160–161.

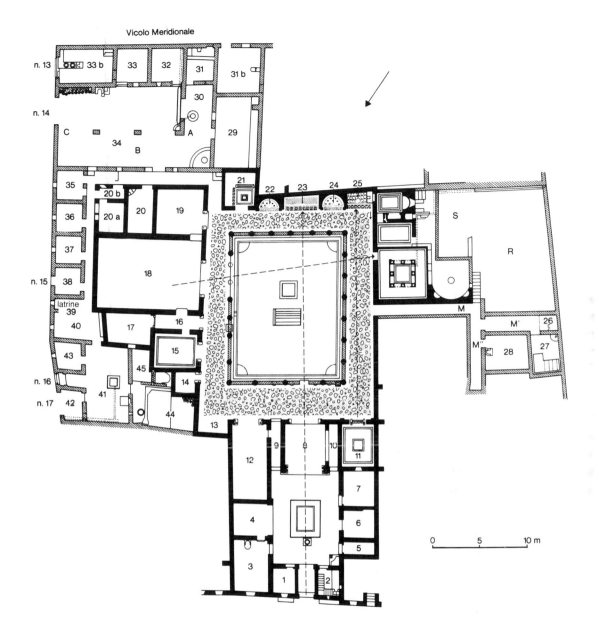

FIGURE 6. Plan of the House of the Menander.

behind the other, articulated by doors, windows, and columns located along the visual axis.[38]

If the visual axis from fauces through peristyle is a constant, other axes often cross it to emphasize a secondary or tertiary view. Again the House of the Menander serves to illustrate the point. Two rooms have special secondary views. An especially wide space between the columns of the peristyle in front of the great triclinium (18 on the plan, Fig. 6) forms a strong cross-axis to the dominant visual axis. Within the western cover of the peristyle the relationship between oecus 11 and exedra 25 establishes a third visual axis. Like the principal visual axis, these secondary axes articulated the values that the architect and the owner wished to communicate to the visitor. In the House of the Menander the principal axis emphasizes both the great size of the house and the symmetry of its parts. On both scores this visual axis cheats a bit. Bek has noticed that the space between the columns at the far end of the peristyle is less than that between those at the near end, thereby exaggerating the peristyle's depth.[39] Also, the house's actual lack of symmetry is evident from the plan but is much less evident to the viewer walking from atrium to peristyle. The secondary axis along the western peristyle shows how important the cult of the ancestors was to the owner: he even had the exedra sheltering the altar (25) decorated to imitate a venerable rural sanctuary. The axis of the triclinium (further accented by its distinctive roofline)[40] calls attention to its great size (the largest in Pompeii).

The rituals that took place in the rooms situated around the peristyle required a different kind of visual planning from that of the entrance sequence. Whereas the fauces-atrium-tablinum axis and the walk around the peristyle addressed the walking spectator, the triclinia, oeci, and exedrae were places where one rested—and looked out from his or her place on a couch. Dynamic, or walking, spaces announced the goal of the walk from the point of entrance, employing arranged views of the terminus to prompt the visitor as he or she progressed through the spaces. Decoration in these spaces, as we will see, was tailored to quick recognition of simple patterns rather than long, tarrying analysis. In static, or resting spaces, the view *out* was of primary importance. Decoration within this kind of space tended to be complex, requiring the viewer's prolonged attention.

The positions taken by guests on the three klinai in the triclinium are central

38. Bek, *Towards Paradise on Earth*, 183.
39. Bek, *Towards Paradise on Earth*, 185.
40. On the regal associations of the pediment, or *fastigium*, in the private house, see Wallace-Hadrill, "Social Structure," 61–64, but also the caution that the roof of this triclinium may be incorrectly reconstructed.

to Bek's arguments about what she calls "view planning" in domestic architecture. Strict etiquette surrounded the ceremony of the Roman banquet, beginning with an invitation that assigned the guest his or her place at the table, and thereby the person's rank at the function. Horace's famous satire on a comical dinner party demonstrates the disastrous consequences of the wrong seating arrangement.[41] There was space for nine persons on three klinai, placed in U-shaped order along the back and side walls of the dining room. Each couch had a name, indicating its position in the room. Looking into the room from its entry, the couch on the right was the *summus,* that against the back wall the *medius,* and the one to the left the *imus.* Romans dined reclining on these couches while supporting themselves on their left elbows, so that the most desirable space, both for its convenience and view out of the space, would be from the left of the central couch. The guest of honor received this so-called consular place (called the *locus consularis*—it was *imus in medio*), and the host reclined to his right (*summus in imo*).[42]

In her survey of rooms likely to have been used for dining at Pompeii and Herculaneum, Bek has attempted to demonstrate that the view out from the rear left-hand side is a favored one. From there one can best appreciate planned views of fountains, statuary, and gardens framed by a symmetrical arrangement of window and door frames, columns, or pillars. Like the fauces-atrium-tablinum axis, all of these planned views out of static spaces employed a sequence of frames and visual symmetry. But unlike the fauces-atrium-tablinum sequence, the view is not strictly axial, but oblique (Fig. 7).[43] Although not convincing in all particulars,[44] Bek adduces enough evidence for us to infer that the view out of these static spaces in the peristyle was important enough for the architect to move columns, plan gardens, site sculpture, and install fountains as centers of interest for those looking out, and, as we shall see, to substitute painted and mosaic decoration for these features when it was impossible to build them.[45]

41. Horace *Satires* 2.8.18–41.
42. Aug. Hug., "Triclinium," *Pauly-Wissowa,* s.v., and August Mau, "Convivium," *Pauly-Wissowa,* s.v. The boorish host Trimalchio overturns the rules and sits *summus in summo;* Petronius Arbiter, *Cena Trimalchionis,* ed. Martin S. Smith (Oxford, 1975), 66–67, commentary on ch. 31, 8.
43. Bek, *Towards Paradise on Earth,* 194; a repetition of the same arguments in her "Questiones conviviales: The Idea of the Triclinium and the Staging of Convivial Ceremony from Rome to Byzantium," *Analecta romana Instituti danici* 12 (1983): 82–88.
44. Franz Jung, "Gebaute Bilder," *Antike Kunst* 27 (1984): 99 note 142.
45. For an analysis of the relation of the *Durchblick* and the view from the *locus consularis* to painted iconographical schemes in the House of the Ancient Hunt at Pompeii (VII, 4, 48), see Jean-Paul Descoeudres, "The Australian Expedition to Pompeii: Contributions to the Chronology of the Fourth Pompeian Style," *Pictores per provincias: Aventicum V,* Cahiers d'archéologie romande, no. 43 (Avenches, Switz., 1987); 136–137, figs. 8–11.

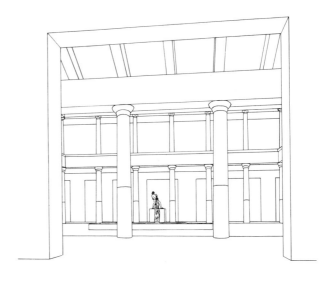

FIGURE 7. Plan and reconstruction of the guest of honor's view from the triclinium of the House of the Centenary.

But we cannot fully understand the rituals that called for decoration in the rooms of city houses without considering villa architecture. If the peristyle was a way of bringing the countryside within the party walls of city houses, the ideal and inspiration was to be found in the country estate.

VIEW VILLAS AND SEASIDE VILLAS

As the letters of Cicero and Pliny eloquently demonstrate, the aim of every wealthy noble was to have several villas, or country residences, preferably with views.[46] When located near the city, like the Villa of the Mysteries (see Fig. 63), they were called "suburban" villas. Built on a platform with a vaulted corridor (*cryptoporticus*) beneath, the Villa of the Mysteries must have commanded a panoramic view of the Bay of Naples. Its plan, that of the *villa suburbana* described by Vitruvius,[47] reverses the usual order of the city domus-with-peristyle so that the tablinum and the reception suites clustered around it can enjoy the view through their ample windows.

It is significant for the discussion of ritual to note the changes in the Villa of the Mysteries over its several phases. In the plan of the mid-first century B.C.,[48] the tablinum was the goal of the visitor, as in the domus, with the difference that the peristyle came first in the entrance sequence. Majestically rising in two stories, the original peristyle conducted the visitor around its perimeter before he or she entered the atrium. The tablinum lay on the axis as the goal, with the impluvium as axis marker, but a portico surrounding the tablinum and the rooms flanking it encouraged invited guests to enjoy a very different ritual from that of the salutatio: the walk, or *ambulatio*, around the upper portico. The views afforded from its high platform were the raison d'être of the villa and its architecture.

In the Augustan-period modernization the owner added greater emphasis to the view; he accomplished this through the addition of a large apsidal room beyond the tablinum that cut through the peristyle and extended to the edge of the villa's platform.[49] With its windows that framed views taken from the pan-

46. Cicero *Epistulae ad familiares* 3.1.2; Pliny the Younger *Epistulae* 2.17.
47. Vitruvius *De architectura* 6.5.3. Nicholas Purcell, "Town in Country and Country in Town," in *The Ancient Roman Villa Garden,* ed. Elisabeth B. MacDougall (Washington, D.C., 1987), 202–203, more fully defines the villa suburbana. He argues that the Romans perched their villas on platforms so that they could be better seen and admired (196–197).
48. Amedeo Maiuri, *La Villa dei Misteri,* 2 vols. (Rome, 1931), 1:37–40, 99–101; Maiuri believed that the villa originated in the second century B.C.; Lawrence Richardson, Jr., *Pompeii: An Architectural History* (Baltimore, 1988), 171–176, dates its original construction to the period of its mature Second-Style decorations.
49. Maiuri, *Villa dei Misteri,* 58, notes that the belvedere, constructed in the Augustan period, was being completely reconstructed at the time of eruption. Richardson, *Pompeii,* 176, places this

orama, this room epitomizes attitudes expressed by Cicero[50] and, later on, by Pliny.[51] It was not raw nature, but framed views of nature, that the cultured Roman sought. Two pavilions, or diaetae, were built into the corners of the former peristyle. Shaped like cubicula but furnished with windows, these little viewing pavilions stress specific views, this time for a person lounging on a daybed.

The Roman passion for the view into the landscape can be followed in developments in the literature from Cicero through Pliny the Younger.[52] Cicero's joking discussion with Atticus about the size of windows needed to achieve a view of the garden reveals the importance of the prospect from the room.[53] More than a century later, Statius's *Silvae*, two poems describing two villas belonging to his patrons, praise above all the views the rooms afford. Especially in his second poem in book two,[54] dedicated to Pollius Felix's Sorrentine villa, the reader imagines a walk from shore to summit through rooms ever more ingenious in their capturing of specialized views.[55] In the second century Pliny the Younger's descriptions of his Laurentine and Tuscan villas stress neither their layout nor their geometry but the presence of enticing views from all the rooms. It is important that none of the literary sources discussing views from villas praise what in modern terms is called the panorama; raw nature must be framed by the room and its windows for the view to be delightful. Architectural intervention is a necessary part of these constructed views.

If Vitruvius considered the placement of rooms and their function to be part of a civic ideal, Pliny defines their function and usefulness according to the time of day and the season. Decor for Vitruvius was part of the well-ordered life; for Pliny it was "the medium of a private fiction."[56] The villa added a new experience to those of the city house. To the view of the whole building from the point of entrance (the fauces-tablinum-peristyle view) and the views out of individual rooms located around the peristyle, the view villa incorporated framed views of landscape features. The Vitruvian category of decor gave way to the poets' concept of *amoenitas,* or "pleasantness," a change fully realized during the course of the first century of our era. Now the poets praised the

construction in the post-earthquake period, even though its mosaics and wall construction match that of the Third-Style mosaics in the diaetae.

50. Bek, *Towards Paradise on Earth,* 173.
51. Drerup, "Bildraum und Realraum," 171.
52. Eleanor Winsor Leach, *The Rhetoric of Space* (Princeton, N.J., 1988), passim.
53. Cicero *Epistulae ad Atticum* 2.3.2.
54. Publius Papinius Statius *Silvae* 2.2.
55. Bettina Bergmann, "Painted Perspectives of a Villa Visit," in Elaine Gazda, ed., *Roman Art in the Private Sphere* (Ann Arbor, Mich., 1991), 49–70.
56. Bek, *Towards Paradise on Earth,* 180.

charming place, the *locus amoenus*. This change in values had many effects on decoration, but they were probably not to be seen in the fabulous villas of the very wealthy—villas that commanded real views—but in the modest houses of the middle class, where paint, stucco, and mosaic decoration created fictive views where there were none.

Some city houses were able to enjoy real views. Among the more dramatic city houses with views are the House of the Mosaic Atrium and the House of the Stags in Herculaneum; they share a party wall that runs down the middle of the city block they occupy. Like the Villa of the Mysteries they command a view from a platform, but the platform is the rampart of Herculaneum's former city walls (see Figs. 141 and 147). Constructed several decades later than the additions to the Villa of the Mysteries, both houses enthusiastically embrace the view, but in different ways. In the House of the Mosaic Atrium, the fauces-atrium-tablinum axis ends in the tablinum, while a garden bounded on three sides by a covered walkway ends in a great oecus oriented toward the view. The stronger axis is the one toward the sea; its conflict with the fauces-tablinum axis is never fully resolved, yet through a window in the atrium's wall the visitor can at least glimpse what visual pleasures await if he or she is invited to step down into the covered portico to enjoy the rest of the house.

If Vitruvius saw the atrium as a necessary part of the villa, Pliny regarded it as an old-fashioned requisite.[57] In the House of the Stags the architect suppressed the atrium to create a magnificent oecus that was the first in a series of framed views leading to a platform above the sea. As we will see, both of these urban view villas at Herculaneum, blessed with splendid vistas, have relatively tame decorative schemes in wall painting and pavement systems so as not to compete unduly with the views out of their rooms.

There is evidence for a "view mania" also in Pompeii, where in the last decades of the first century B.C. houses with multiple stories along Pompeii's high escarpment abandoned the traditional domus plan to take advantage of the ocean view.[58] But all of these in the end were city houses. One partially excavated seaside villa, that of Oplontis near Pompeii (see Fig. 41),[59] furnishes some

57. Drerup, "Bildraum und Realraum," 161.
58. Ferdinand Noack and Karl Lehmann-Hartleben, *Baugeschichtliche Untersuchungen am Stadtrand von Pompeji* (Berlin, 1936), passim.
59. Alfonso De Franciscis, "La villa romana di Oplontis," in *Neue Forschungen in Pompeji,* ed. Bernard Andreae and Helmut Kyrieleis (Recklinghausen, 1975), 9–10, identifies the site as ancient Oplontis on the basis of the Tabula Peutingeriana, a fourth-century map. See also Wilhelmina Jashemski, *The Gardens of Pompeii, Herculaneum, and the Villas Destroyed by Vesuvius* (New Rochelle, N.Y., 1979), 289–314, with an up-to-date fold-out plan of the villa; Arnold de Vos and Mariette de Vos, *Pompei Ercolano Stabia,* Guida archeologica Laterza, no. 11 (Rome, 1982), 250–254.

details of rituals of the very wealthy whose luxury seems to have inspired so many petit-bourgeois imitations in Pompeii and Herculaneum.

Although the core of the Villa of Oplontis dates to around 50 B.C., it expanded laterally along the shore in later additions.[60] Paintings of such seaside villas, particularly those in the House of M. Lucretius Fronto (see Fig. 75), provide an idea of their appearance. Long porticoes facing the ocean, often of two stories, are frequently arranged symmetrically around a central feature, either a semicircular cupping form or a large hall. Although the seaward disposition of the central hall at Oplontis will never be known, since it was cut by the building of the Sarno Canal in the eighteenth century, the approach from the land is clear. An imposing hall (21 on the plan, see Fig. 41), entirely open to the avenue of approach, juts out from porticoes to its right and left. It looks like a monumental gateway, or *propylon,* since it is supported on its open side by two great columns and corner piers, in this way marking a long visual axis extending to the atrium. Yet this entry hall is not physically accessible to the spaces on that axis. Instead, its back is pierced by a large window opening to an enclosed garden, or *viridarium* (20), exposed to the sky and painted (redundantly) with plants and fountains. The atrium (5) lies yet farther behind this visual axis, preceded by a large transverse space (4). To reach the atrium from the north side of the villa, the visitor had to walk along the long, narrow, unlit corridors that flank rooms 21 and 20. This ritual of entry, although owing much to the combination of straight visual axis and circuitous path that characterized the experience of walking from fauces to tablinum in the domus, has become more complex in this grand villa. The process has become one of finding the axis visually, then losing it in the dark corridors, only to realign oneself with the visual axis in the comforting symmetry of the traditional atrium.[61] Although the mechanism of the framed visual axis is the same as that of the domus, or a domus-with-peristyle like the House of the Menander, the process of attaining the focus of that axis is much more complex. Although we do not know what view completed this grandiose visual axis, it must have been the ocean—framed, to be sure, with columns, piers, and windows.

Another important instance of a succession of framed—but physically unattainable—views enlivens the series of rooms bordering the western porticus of the swimming pool (*natatio*). Oecus 69, with two framed columns on the side facing the pool, forms the central axial element of the suite. Windows on the long sides of this oecus provide views of unroofed rooms 68 and 70, inac-

60. John R. Clarke, "The Early Third Style at the Villa of Oplontis," *Römische Mitteilungen* 94 (1987): 293–294, figs. 1–2.

61. Vincent Scully, *The Earth, the Temple, and the Gods,* rev. ed. (New York, 1969), 210–212, discusses a similar process of losing and finding the axis at the Roman Sanctuary of Fortuna Primigenia at Praeneste.

cessible yet painted, like room 20, with plants, birds, and fountains, here against a yellow-gold ground. The same system of windows framing views of painted garden rooms—open to the sky—articulates the smaller oeci 74 and 65. Clearly the architect was mirroring nature in theatrically lit painted tableaux that mimicked the real garden views visible through other windows.[62] He created a contrast between both light and shade and the actual and the fictive garden. The consciousness of view planning evident in the Villa of Oplontis helps explain more modest features encouraging similar experiences of axiality and the view of framed features in urban houses.

Rituals of reception and of leisure, but on a grand scale, characterize the spaces of the Villa of Oplontis. One need only consider the sixty-meter swimming pool on the eastern extremity of the excavated area, or the large bath suite on the western part, to imagine the extent of the original villa and its wealth. In the context of this study, Oplontis is a precious, though incomplete, source for understanding the models that inspired the ambitious decorative schemes of the middle and lower classes.

THE VILLA AS MODEL FOR MIDDLE-CLASS HOUSES

Not every Roman lived in an ancestral domus or splashy villa. Particularly after the middle of the first century of our era at Pompeii and Herculaneum a great number of city houses were remodeled to imitate villas, but in miniature. This phenomenon, examined in depth by Paul Zanker,[63] often resulted in packing a great number of disparate and uncoordinated villa features into modest spaces. But instead of clearly framed views of distinct features like the fountains, statuary, and swimming pool at Oplontis, the visitor found a hodge-podge giving out mixed signals about the function and meaning of both individual spaces and the house as a whole.

Zanker cites the House of Octavius Quartio (see Fig. 108) as the prime exemplar of the "miniature villa."[64] The view from the fauces ends not in a tablinum, for there is none, but in a doorway leading to a three-sided portico surrounding a little garden (g). Having reached this area of the house, the visitor has entered a realm of mixed metaphors and hyperbole. To the left is the principal oecus (h), its larger entry focused, by means of a pavilion, upon a long canal that runs the length of the building lot. It is fed by a second, transverse canal running between two unusual spaces: at the west end is a small pavilion-

62. Jashemski, *Gardens of Pompeii*, 306–314, figs. 470–475.
63. Paul Zanker, "Die Villa als Vorbild des späten pompejianischen Wohngeschmacks," *Jahrbuch des deutschen archäologischen Instituts* 94 (1979): 460–523.
64. Zanker, "Villa als Vorbild," 470–480.

like white room (perhaps a diaeta) outfitted as a little shrine, or *sacellum,* while at the east end there is an outdoor *biclinium* (a dining area with two couches). Zanker counts many built elements taken from villa architecture: the canal, or *euripus,* allusive to the Nile; the rear peristyle with oecus; the little temple or *aedicula* with images of Diana; and the biclinium with fountain. Add the many small-scale statues along the upper canal evoking gods as diverse as Isis, Dionysus, and the Muses, plus five different painted cycles on the exterior walls (see chart, Fig. 114), two painted friezes from different epic sagas in the oecus, allusions to Isis in the sacellum, and one has an excellent example of the kind of bad taste that Cicero had decried a hundred years before.[65] While Cicero, aristocratic patrician, rejected statues of bacchants, Mercury, Mars, and Saturn as thematically unsuitable for an exedra dedicated to cultural pursuits, the owner of the House of Octavius Quartio built miniature grottoes, fountains, sanctuaries, and canals—and adorned them with statuary and frescoes allusive to a whole panoply of mythic cycles and religions.[66]

How did the ancient viewer experience such miniature villas? From the point of entrance into the peristyle garden, at the tablinum position, a person could walk either to the right or left. To the left he or she would encounter the smaller side entrance of the great oecus (*h*), probably used for both reception of business clients and convivial feasts. To the right the visitor would pass to the diaeta/sacellum (*f*), taking in the paintings both within the room and on its exterior. From here the view of the upper canal focuses on the biclinium (*k*). Statuary lined both sides of the canals, as it filled the little peristyle's garden. Making his or her way through this crowded Disneyland the viewer might also notice the big frescoes on the exterior walls. The next goal would probably be the oecus itself, commanding the carefully arranged view of the lower garden and its three-stage canal. A little bridge crosses the upper canal to reach the pavilion that marks the beginning of this long axis; beneath it, on the lower level, hides a little grotto sacred to Diana. Characteristically, the grotto is too small for a person to enter; it is an allusion to the great grottoes that graced large villas. Similarly, the canal may have doubled as a fish pond, the *piscinae* so important to Cicero and other villa owners.[67] One's walk though the lower garden included other surprises: the elaborate fountains that punctuate the canal and a statue of a hermaphrodite.

Other examples of villa imitations cited by Zanker, although less extensive than the complex of the House of Octavius Quartio, nevertheless document a

65. Cicero *Ad Fam.* 7.23.2.
66. For a critique of Zanker's position, see Jung, "Gebaute Bilder," 71–73.
67. John H. D'Arms, *Romans on the Bay of Naples* (Cambridge, Mass., 1970), 44.

new use of space stemming from new desires on the part of the patrons. If what had meaning in the large villas sinks to mere decoration in Pompeian gardens, it is because a new class, that of the entrepreneurial freedmen, was socially most active in this period. Like the rich former slave Trimalchio in Petronius's *Satyricon*,[68] these new bourgeoisie imitated the wealthy aristocratic upper class in their desire for the material trappings of wealth. The garden architecture, sanctuaries, fountains and resting spots, picture galleries, real and painted statues, landscape views, and even painted wild animal parks (*paradeisoi*) were all ways of possessing a bit of the luxury villa.[69]

HOUSES OF THE LOWER CLASS

Vitruvius, who liked to make such distinctions, clearly states that those with modest means had no need of magnificent vestibules, tablina, or atria because it was their lot to call upon others and not vice versa.[70] The clientela, consisting of freedmen, artisans, and owners of small businesses, often lived in smaller houses with spaces arranged around a covered atrium surrounded by rooms on two stories. The tenacious survival of the atrium in the face of increasing urban density in Pompeii and Herculaneum is all the more remarkable in that it is a relatively space-wasting configuration. Rarely, however, can one find all the rooms of the domus in these "mini-atrium" houses.[71] The abiding feature is the fauces-tablinum axis, but rooms tend to be arranged asymmetrically around it, suggesting that for this class practical uses of the other rooms around the atrium were more important than their representational symbolism.

Placement of the house's humble spaces, such as kitchens, latrines, and slaves' quarters, is much less predictable in these smaller houses than in the large houses and villas, where clear separation is the rule. In the House of the Menander (see Fig. 6) considerable space is dedicated to these rooms, but they are out of sight, at a basement level; the Villa of Oplontis housed slaves on two stories around a large peristyle, inferior in decoration and construction technique to the opulent areas to either side of it (see Fig. 41).[72] But in small houses, the kitchen, the latrine, and the slaves' rooms occur in the margins of the reception spaces, smaller in size, often with lower ceilings, little light, and poor deco-

68. John H. D'Arms, *Commerce and Social Standing in Ancient Rome* (Cambridge, Mass., 1981), 97–120; Wallace-Hadrill, "Social Structure," 43–44, 97.
69. Zanker, "Villa als Vorbild," 519–522.
70. Vitruvius *De architectura* 6.5.1.
71. Jung, "Gebaute Bilder," 73–77, discusses the small number of full-fledged atrium houses at Pompeii.
72. De Franciscis, "Oplontis," pls. 38–39.

ration. In the House of the Prince of Naples they take up the ill-lit right side and back of the atrium.[73]

At both Pompeii and Herculaneum, particularly after the disastrous earthquake of A.D. 62, experimentation arrived at more rational but less traditional solutions that dispensed with the atrium entirely.[74] In a clever plan the architect of the House in Opus Craticium at Herculaneum fit two apartments and a shop with workrooms into the space of a narrow atrium house (see Fig. 159). Here the rituals of work blended with those of rest, dining, and entertainment because of the "railroad car" arrangement of many rooms. On the ground floor, for instance, the axis defined by the entrance at number 10 begins at the street with a shop leading to three work or work/living rooms behind (9–7). Room 6 opens to the area under the stairs (5), which lead to two dining/sleeping rooms on the second floor. Another street entrance, at 14, gives access to the same stairway and upper-floor rooms. Light for all of these spaces comes from the central light well at 4. This disposition of spaces with thin partition walls made it easy to reassign their use for more than one tenant, and the upper rooms that have windows on the little courtyard are not without some degree of privacy and grace. The same could be said of the separate apartment occupying the remainder of the upper story, reached by an independent stairway at 13. Although the corridor connecting the landing with the balcony is dark, the street-side rooms are light and airy. The decoration of the house, as we shall see, was of relatively good quality—aesthetic compensation for the tenant who had to make do with somewhat crowded and makeshift spaces.

SURVIVAL AND LOSS OF SPATIAL PATTERNS IN THE INSULAE OF OSTIA

A highly satisfactory and uncannily modern solution to urban density developed in Rome during the first century A.D. Employing brick-faced concrete with vaulted support and covering systems, the multistory, multifamily apartment house, or *insula,* replaced the domus and most of its spatial patterns. With sturdy apartment buildings rising as high as five stories, crowded Roman cities expanded vertically instead of horizontally. Because Rome itself has been continuously inhabited, few of these insulae survive, but Ostia, Rome's supply city during the heyday of the empire, is filled with these dwellings, most of them excavated in the twentieth century.

73. Volker Michael Strocka, *Casa del Principe di Napoli (VI 15, 7–8).* Deutsches archäologisches Institut, *Häuser in Pompeji,* vol. 1 (Tübingen, 1984), passim; Wallace-Hadrill, "Social Structure," 86.

74. James E. Packer, "Middle- and Lower-Class Housing in Pompeii: A Preliminary Survey," in *Neue Forschungen in Pompeji,* ed. Bernard Andreae and Helmut Kyrieleis (Recklinghausen, 1975), 133–146.

Many studies have attempted to establish a typology for the insulae of Roman Ostia.[75] Perhaps the most successful is that of James Packer, who finds prototypes in the covered atrium house (*atrium testudinatum*) at Pompeii and Herculaneum and in houses combined with shops or workshop areas.[76] More important for this study of decorative ensembles is the function of the spaces included in the various types of insulae. Carol Watts has proposed a "pattern language," or typology, of recurring spatial configurations and spatial experiences, for a group of domus and insulae at Pompeii, Herculaneum, and Ostia Antica.[77] Watts has demonstrated that although certain characteristic patterns were lost in the change from the domus to the insula, other patterns persisted. Patterns of the domus that do not survive in the insula include the long axis providing a view through its spaces (the "visual axis" discussed above), the varied ceiling heights, and the system of illumination from compluvium and peristyle. Two enduring patterns with special relevance to decorative ensembles are those of spatial hierarchies and "entrance experience." Spatial hierarchies, ranked from the most to the least important spaces in the domus, remained in the insula—even though the locations of the tablinum-equivalent, triclinium-equivalent, and cubiculum-equivalent changed. Both the placement and the relative sizes of spaces would provide cues to a person visiting a flat in an insula. Here mosaic pavements, along with the decorations of painted and stuccoed walls and ceilings, play an important role in signaling the relative importance of each room; wall, ceiling, and floor decoration express each room's relative importance in the insula as much as do the shapes and locations of the spaces.

In the absence of literary sources describing social, business, and religious rituals that took place in the insula, case-by-case analysis of the archaeological remains must provide likely answers. Arguments for the function of spaces and rooms must be based on careful on-site study. One must also be cautious about naming these spaces. Given the adaptability of the construction technique, a great variety of plans is possible. Two enduring problems, provision for circulation and for light, were solved in a variety of ways in the insulae. Windows on the exterior brought light and air from the street, and when party walls prevented exterior windows, the insulae's rooms opened to courtyards and light wells.

75. Phillip Harsh, "The Origins of the Insulae at Ostia," *Memoirs of the American Academy in Rome* 12 (1935); Guido Calza et al., *Scavi di Ostia*, vol. 1, *Topografia generale* (Rome, 1953); Paolo Chiolini, *I caratteri distributivi degli antichi edifici* (Milan, 1959), 65–69; Axel Boëthius, *The Golden House of Nero* (Ann Arbor, Mich., 1960); Russell Meiggs, *Roman Ostia*, 2d ed., with corrections (Oxford, 1975), 239–247.
76. James E. Packer, "The Insulae of Imperial Ostia," *Memoirs of the American Academy in Rome* 31 (1971): 62.
77. Carol Martin Watts, "A Pattern Language for Houses at Pompeii, Herculaneum, and Ostia" (Ph.D. diss., University of Texas at Austin, 1987).

Even more space saving for insulae closed in with party walls on three sides was the so-called *medianum* plan.[78] In the House of the Yellow Walls (see Fig. 188), the medianum, a well-illuminated, covered courtyard (3 on the plan) with a bank of three high windows opening on the street, provided light and circulation for all the rooms. Although we will analyze this and other houses individually later in this book, a glance at the plan of this apartment suggests new relations between static and dynamic spaces from those encountered in the domus and its variations at Pompeii and Herculaneum. For one thing, a person entering the generous entry hall at 1 has no axial view through the complex. Instead the visitor would have an oblique view of the medianum, with light streaming in from the left, and a view of the doorway to the larger of the two reception spaces, room 7. Once the visitor reaches the medianum, a dynamic distribution space, the hierarchy of functions becomes clear. Whereas their position on the less well-lit side of the medianum announces that 4 and 5 are private rooms, certainly cubicula, the opposite set of circumstances identifies rooms 7 and 8 as reception rooms. They are well lit, each with three windows on the street, and their doorways answer each other across the medianum's space, creating a visual axis between the two rooms. Further analysis reveals the function of room 7 to be that of a triclinium, both because of the disposition of the mosaic floor, meant to be seen from two couches, and because of its relation to room 6, perhaps intended as a kind of kitchen or pantry space. As we shall see, the decoration of these spaces in the House of the Yellow Walls provides even clearer signals about the function of the spaces and the activities that took place there.

This new language of brick-faced vaulted architecture also served the wealthy patron in Rome and at Ostia. The best example to illustrate functional patterns is that of the House of the Muses (see Fig. 163), whose elegant spaces surround a spacious arcaded courtyard. Here most of the traditional rooms of the domus-with-peristyle can be found around the courtyard, with the added advantage that the sturdy concrete construction sustained upper floors for servants' quarters or for tenants, provided with separate street entrances. A visual axis employing the by now familiar device of successive, symmetrical, framing elements connects two important rooms, room 15, an oecus, with room 5, a small salon dedicated to Apollo and the Muses. The mosaic program distinguishes dynamic and static spaces, the more complex mosaics also emphasizing visual axes. Corridor 7 creates a pocket of privacy for interconnecting rooms 8 and 9, most likely a bedroom suite. The insula challenged the architect both to accommodate the occupants' rituals and to signal each room's function for the

78. Gustav Hermansen, *Ostia: Aspects of Roman City Life* (Alberta, 1981), 35: definition of the medianum.

visitor. As close analysis of six representative Ostian insulae will show, these architects succeeded quite well in attaining these objectives. It is interesting in this connection that Axel Boëthius has shown how the insula pattern has survived in modern Mediterranean cities, demonstrating the practicality and versatility of this ancient Roman solution to the problems of urban density.[79]

This chapter has established that the manifold rituals—both prescribed and habitual—that took place in the Roman house found expression in specific architectural forms. Despite the diverse shapes that the house's dynamic and static spaces took, several elements remained constant: emphasis of the visual axis in dynamic spaces; planning of the view out from static spaces; and the careful differentiation of public space from private space. As Bek points out:

> The universal quality appears . . . in the canonical disposition of the rooms, for instance in the entrance sequence and in the relative constancy in the representation of the complete visual image. Owing to this and to the stability of the social pattern, the pattern of private representation in its various aspects is also . . . of a form that was to a certain extent commonly applicable. Because of this element of recognition the participants in the ceremonial would have been enabled to carry out the roles allotted to them without difficulty in given situations in any house, as a client or dominus, host or guest, since the accepted order of precedence formed the invariable condition for the distribution of roles. There were no passive spectators, all participated actively through visually taking possession of the room.[80]

If a house's spatial layout is a system that programs the behavior of all the persons who use it, what role does decoration play in this system? Examination of the general aspects of ritual and space in the Roman house suggests the thesis of this book, that in each house the ensembles of painted, stuccoed, and mosaic decoration participated in a coding process that modified, emphasized, and often personalized ritually defined spaces through perspective, color, and the meanings of images included in the decorative schemes. The following chapter considers the chronologically successive styles of painted and mosaic decoration in terms of their formal development, paying special attention to technique, working methods, and how each style of decoration addresses the viewer, that is, how the viewer perceives the decoration. In this way the reader will be prepared to "enter" the case-study houses in the following chapters with a good understanding of the general stylistic, compositional, and perceptual problems that belong to each historical system of decoration.

79. Boëthius, *Golden House of Nero*, 129–185.
80. Bek, *Towards Paradise on Earth*, 202.

CHAPTER TWO

STYLES OF DECORATION,
100 B. C. – A. D. 250

Mention of the "Four Styles" to the scholar of Roman art conjures up a century-long debate concerning the classification and dating of Romano-Campanian wall painting, that is, the painted decoration of buildings found in and around Rome and Naples between 100 B.C. and the eruption of Vesuvius in A.D. 79. Indeed, August Mau's astute observations about stylistic change in wall painting have formed the solid foundations for a century of archaeological studies.[1] If anything, the use of Mau's typology has become overrefined, so that critics of recent studies devoted to the individual styles might justly ask if the artisans who painted Pompeian walls were urged by the gods to change their painting manners and repertories of motifs on a yearly basis to satisfy modern scholars intent on an ever-more-precise chronology.[2]

Ours is a different goal. While we will endeavor to outline clearly the changes that allow us to date specific wall paintings— and mosaics—to distinct, stylistic phases, our emphasis will be on the effect of these decorative styles upon the spaces they adorn and upon the viewer. Related to these questions of spatial modification and perception are the practical aspects of planning and executing frescoes, stuccoes, and mosaics. In several cases observations on techniques and division of labor lead back to literary sources naming specific styles and artists.

As part of our project to integrate what we know about the well-documented decorative ensembles of Pompeii with the much less well-preserved ones from Ostia, this chapter follows decorative systems beyond the period of the Four Styles through the middle of the third century.

1. August Mau, *Die Geschichte der dekorativen Wandmalerei in Pompeji* (Leipzig, 1882).
2. See Introduction, note 1, for full citations of surveys by Borda, Mielsch, Laidlaw, Beyen, Bastet and de Vos, Ehrhardt, Barbet, and Ling.

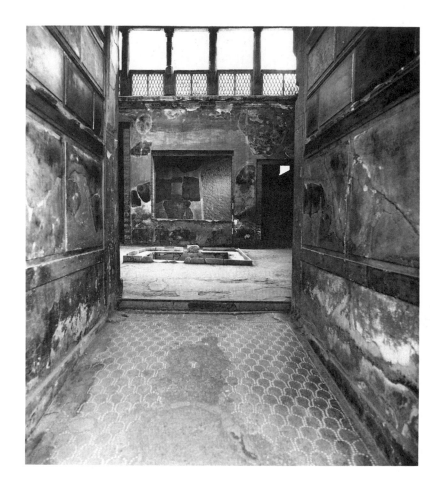

FIGURE 8. View from the fauces of the Samnite House: the red opus signinum floor coordinates with the First-Style walls.

FAUX-MARBLE AND THE
COLONNADED PAVILION BEFORE 100 B.C.

The systems for decorating the interior surfaces of the Roman house developed logically from the construction technique. Houses were built on a "slab" made of pounded earth and cement, and all the walls of a house, both exterior and interior, were made of stone and cement coated with plaster. Because there were few, if any, windows to the exterior, wall surfaces tended to be continuous and unbroken. Two basic approaches characterize the decoration of walls: the

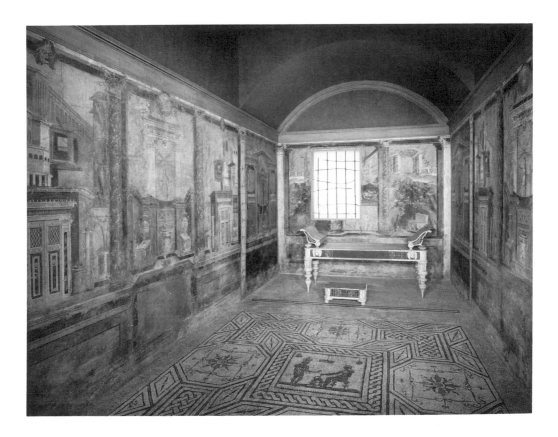

FIGURE 9. The painter of this mature Second-Style cubiculum used perspective to transform the room into a colonnaded pavilion, with scenes opening up "behind" the walls.

boundaries of each space could be emphasized as solid surfaces by sheathing them in real or painted imitations of precious colored marbles (the First Style, Fig. 8), or they could be opened up with perspective schemes seeming to recede behind the physical boundary of the wall (the Second Style, Fig. 9). Similarly, the cement floors could either be decorated as flat surfaces, or elaborately framed illusionistic pictures could be inset into them.

Daniela Scagliarini, in her analysis of space and decoration in Romano-Campanian painting, points out that whereas the First Style seeks to create spaces that are uninterrupted and tied together, the Second "pierces" the walls through illusionistic perspective, a point easily understood by comparing an axonometric drawing of a First-Style ensemble (Fig. 10) with one of the Second

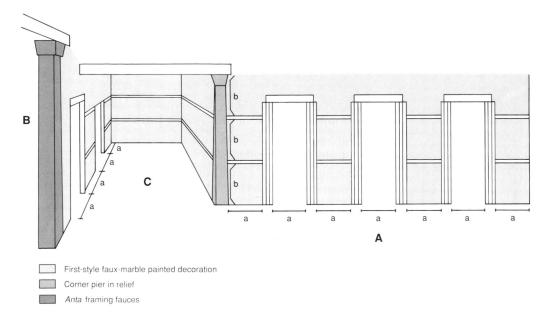

B

C

A

First-style faux-marble painted decoration

Corner pier in relief

Anta framing fauces

FIGURE 10. The First-Style's system of piers at openings frames walls "built" with blocks of stone to unify all the spaces in a house.

Style (Fig. 11).[3] In the First-Style decorations, imitation marble blocks in relief articulate all wall surfaces in three zones, with special framing elements (antae) at openings. In Second-Style schemes, columns painted in perspective appear to hold up an architrave. By spacing these columns or bearing elements regularly around the walls of a room, the painter created a kind of colonnaded pavilion, because between the columns the viewer often sees landscapes or foreshortened architectural prospects opening up "behind" the wall.

Whereas First-Style decoration is logical, the Second Style requires a certain suspension of disbelief on the part of the viewer. Although the trompe l'oeil architecture is believable in the middle and upper zones of the wall, it fails to convince the viewer where the painted walls meet each other at corners, or where walls meet floors. At these points the illusionistic columns which appear to support the architrave get awkwardly "folded" to fit into the corner, or the painted orthogonal of column and pilaster bases "crease" where wall meets

3. Daniela Corlàita Scagliarini, "Spazio e decorazione nella pittura pompeiana," *Palladio* 23–25 (1974–1976): 7–10.

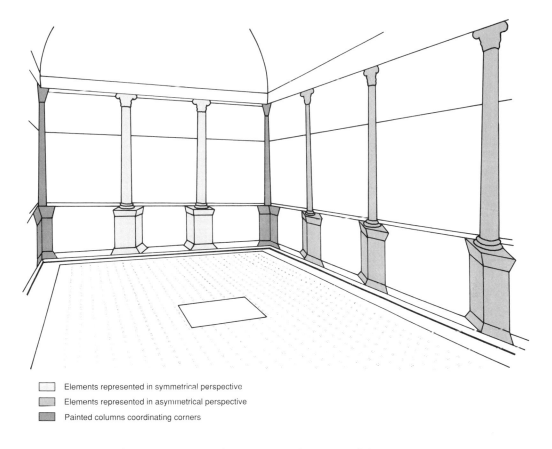

Elements represented in symmetrical perspective
Elements represented in asymmetrical perspective
Painted columns coordinating corners

FIGURE 11. A single perspective vanishing point in the center of the rear wall dictates the orthogonals of all three walls in the early Second-Style system of asymmetrical perspective.

floor (Fig. 12). In these areas the illusion inevitably breaks down. Analysis of a few examples predating the Second Style reveals that the corner and floor problems appeared at the outset and were never solved.

Representations of the colonnaded pavilion occur in Etruscan tomb painting. In the Tomb of the Lionesses (ca. 520 B.C.), the great Doric columns that support the funeral tent (thus converting this windowless room into a viewing pavilion for the funeral dances painted on the rear wall)[4] are folded into the corners. There the illusion that they are three-dimensional columns breaks

4. See R. Ross Holloway, "Conventions of Etruscan Painting in the Tomb of Hunting and Fishing at Tarquinii," *American Journal of Archaeology* 69 (1965): 341–347.

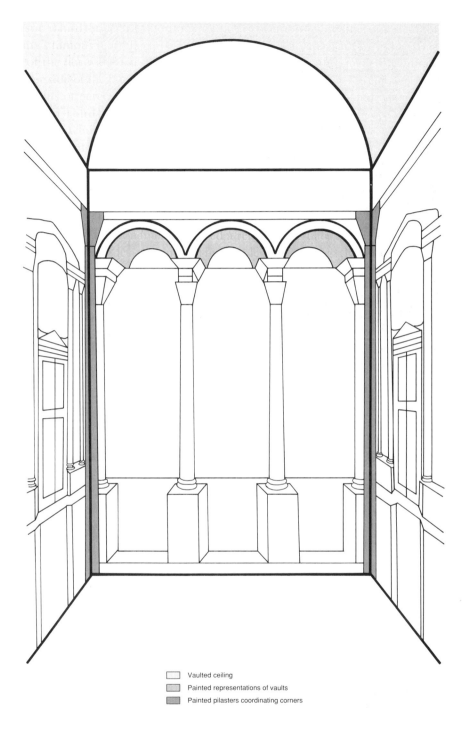

Vaulted ceiling

Painted representations of vaults

Painted pilasters coordinating corners

FIGURE 12. Individual architectural perspectives differentiate spaces within this Second-Style room.

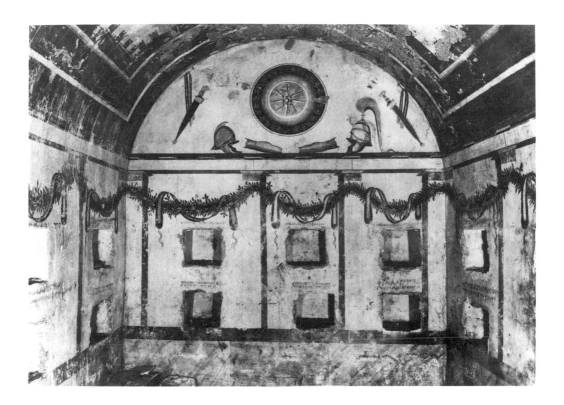

FIGURE 13. A mid-third-century B.C. Greek tomb with a system of asymmetrical perspective.

down. The same problem nags the paintings from the Tomb of Lyson and Kallikles in Macedonia, dated to ca. 250 B.C., where some features of what will emerge later in Italy as the Second Style are present (Fig. 13).[5] The wall is divided into two horizontal zones—the lower one forming a podium or platform on which the piers of the upper zone rest. Orthogonals and shading enhance the effect that the tomb chamber is an open, pier-supported pavilion. And there is the representation of garlands draped between pilasters and of armor hanging from nails or resting on the tympanum. However, comparison with the Roman Second Style, in a room like the cubiculum from Boscoreale (see Fig. 9),

5. Charalambos I. Makaronas and Stella G. Miller, "The Tomb of Lyson and Kallikles," *Archaeology* 27 (1974): 248–259; Klaus Fittschen, "Zur Herkunft und Entstehung des 2. Stils," in *Hellenismus in Mittelitalien*, Kolloquium Göttingen 1974, ed. Paul Zanker, *Abhandlungen der*

reveals a much more complex and sophisticated project. Complex perspectives create architectural views opening "behind" the actual wall plane, filled with perspectival representations of architectural stage backdrops (*frontes scaenarum*), images of theatrical masks, fountains, statuary, and still lifes. The Tomb of Lyson and Kallikles is at most an example of the raw armature upon which the complex, sophisticated perspectives of the mature Second Style of ca. 60–40 B.C. were elaborated. Both rooms share the return of the viewer's disbelief as the eye scans the corner pilasters and the meeting of those pilasters with the pavement underfoot.

In her discussion of the Tomb of Lyson and Kallikles (conceived independently of Klaus Fittschen's earlier essay), Phyllis Lehmann concludes that since "the Hellenistic Architectural Style or Proto-Second Style antedates the Pompeian examples of the Second Style by at least two centuries, . . . the Second Style may no longer be considered as a purely Roman creation."[6] The same has been said for the faux-marble techniques of the Roman First Style. Vincent Bruno's examination of the origins of the First Style shows that concurrently with the Proto-Second Style there also existed the Hellenistic Masonry Style in wall painting, predecessor of the First Style of Romano-Campanian painting.[7] According to Lehmann, this Proto-First Style coexisted with the Proto-Second from the mid-third century onward.[8] Both styles, but in chronological succession, appear on the walls of Roman houses.

The Proto-First and the Proto-Second Styles may really be one thing—trompe-l'oeil masonry, columns, and moldings in two forms, plain plastered and fancy painted. Furthermore, there is a world of difference between the painting of tombs and public monuments in Greece and that of providing suitable painted wall decoration for the houses of the middle and upper classes living on the Bay of Naples and in Rome. By the first century B.C. these styles achieve a degree of sophistication and complexity ranging far beyond their Greek and Etruscan prototypes.[9]

Akademie der Wissenschaften in Göttingen 97 (1976): 541, fig. 1; Stella G. Miller, "Macedonian Tombs: Their Architecture and Architectural Decoration," in *Macedonia and Greece in Late Classical and Early Hellenistic Times*, ed. Beryl Barr-Sharrar and Eugene N. Borza, Studies in the History of Art, no. 10 (Washington, D.C., 1982), 153–171; R. A. Tomlinson, "The Ceiling Painting of the Tomb of Lyson and Kallikledes at Lefkadia," *Ancient Macedonia* 4 [Thessaloniki] (1986): 607–610. Professor Miller is preparing the full publication of this monument.

6. Phyllis Williams Lehmann, "Lefkadia and the Second Style," in *Studies in Classical Art and Archaeology: A Tribute to Peter Heinrich von Blanckenhagen*, ed. Günter Kopcke and Mary B. Moore (New York, 1979), 229.

7. Vincent J. Bruno, "Antecedents of the Pompeian First Style," *American Journal of Archaeology* 73 (1969): 305–317.

8. Lehmann, "Lefkadia," 229.

9. Burkhardt Wesenberg, "Römische Wandmalerei am Ausgang der Republik: Der zweite pompejanische Stil," *Gymnasium* 92 (1985): 475–76, also disagrees with Lehmann on Lefkadia

ELABORATION AND ILLUSIONISM
IN FIRST-STYLE PAINTING, CA. 200–80 B.C.

From its eastern origins, the First Style spread through Italy in the second century B.C. and lasted until about 80 B.C. It imitated costly marble masonry with inexpensive plaster and paint, thereby introducing into the private house the wealth and status associated with the palace and temple. The "illusion" in the First Style is therefore a rather literal one; like faux-marble techniques used to this day, it succeeds if the viewer is fooled into believing that painted plaster walls are really constructed in or sheathed with precious marbles. Rather than being work for painters, the First Style was carried out by stuccoists, skilled in applying and carving plaster to make the fluted pilasters, moldings, and capitals that substituted for ones sculpted from marble.[10] These architectural elements formed the basis of the credibility of First-Style schemes: the successive rows of marble blocks and moldings of the socle, median zone, and upper zone were framed by pilasters and capitals placed at doorways and openings to rooms. All of these elements received the colors of bright and expensive marbles and were carved and modeled with the same moldings found in ashlar masonry walls. Rather than being a painting style, the First Style is really a plaster cast of architectural forms.[11]

Nevertheless, there is a greater degree of illusionism in Roman First-Style decoration than in Greek examples. Toward the end of the second century B.C., minor figural features that had been molded in stucco are painted illusionistically,[12] and in Roman houses the often fantastically veined vertical marble panels, or *orthostates,* are elevated to the median zone of the wall as showy centerpieces. This would be disastrous for a wall built of real blocks of marble, where logic and the laws of physics demand that the heaviest blocks be placed lowest. Since the faux-marble orthostates of the Roman First Style have no real architectural function, they could be raised up so that they cleared the furniture and could be easily seen. Such raised orthostates also appear in Early Second-Style schemes like that of the House of the Griffins, discussed below (see Fig. 14).

as a Greek Second Style, since it has no developed spatial sense. He also takes issue with Fittschen, "2. Stils," 539–557, who proposes that the Second Style is based on real Greek architecture (see discussion below).

10. Eugenio La Rocca, Mariette de Vos, and Arnold de Vos, *Guida archeologica di Pompei,* ed. Filippo Coarelli (Milan, 1976), 66.

11. De Vos and de Vos, *Pompei Ercolano Stabia,* 340.

12. See Mariette de Vos and Archer Martin, "La pittura ellenistica a Pompei in decorazioni scomparse documentate da uno studio dell'architetto russo A. Parland," *Dialoghi d'archeologia* 2, no. 2 (1984): 131–140, for the documentation of a painted figural frieze in a First-Style decoration (now lost, from House VI, 14, 40).

Because of the one-to-one correspondence of the components of First-Style systems to the solid surfaces of rooms, their corners, and their openings, they make no special demands on the viewer who perceives them. Because they lack the trompe-l'oeil perspective constructions of the Second Style, there is no favored viewing position. In its neutrality First-Style wall decoration leaves the viewer free to notice the volumes of the individual spaces and especially the visual axes discussed in the previous chapter.

If First-Style domestic interiors aim to impress the visitor through their imitation of the public architecture of temples, basilicas, and gymnasia, because their vocabulary of forms is limited to the imitation of marble models, they do little to distinguish one room from another. In the First Style the visitor must infer the function of a room not from changes in the lavishness of decoration between a peristyle and a cubiculum, but rather from the size and position of the room within the plan of the house. The variety of motifs and illusionistic effects of the Second Style allow the patron and painter to differentiate and rank spaces with extraordinary subtlety.

FIRST-STYLE MOSAICS AND MOSAICISTS

Houses of the First Style, like the Samnite House in Herculaneum, usually received simple cement pavements decorated with geometric designs outlined in rows of tesserae. These could be either black (*lavapesta*) or red (*cocciopesto*, called *opus signinum*) cement. Their simple, allover designs imitated carpets and were often arranged, like carpets, in the center of a room with borders or runners at the edges of the space, as in the tablinum of the Samnite House (see Fig. 27). Such pavements made no particular appeal to the viewer's attention other than the occasional emphasis of the center of a room.

However, in the latest phase of the First Style (ca. 100–80 B.C.) there was a surprise in store for the viewer, for, coupled with the relatively flat faux-marble decoration of the walls, there were often illusionistic pictures on the floor (see Pl. 10 and Fig. 91). These pictures were prefabricated in a workshop using extremely small colored tesserae (1–5 mm), specially shaped and arranged by the mosaicist to imitate the individual brushstrokes of a painting. The appearance of these brushstrokelike rows of tesserae gave this technique its name, *opus vermiculatum*, or "wormlike style." Executed by specialists on marble or terracotta trays, these paintings in stone were portable. Called *emblemata*, or insets, they would be chosen by the patron and carried to the site for installation into a usual mosaic floor worked in much larger tesserae of regular cubic shape (0.5–1.0 cm). The use of uniform cubic tesserae gave the floor a regular gridlike pattern reminiscent of weaving, so that this ordinary type of mosaic got the name *opus tessellatum*, or "woven style."

The number and size of the emblemata vermiculata depended only on the patron's pocketbook. The wealthy House of the Faun at Pompeii, for instance, had numerous emblemata and boasted the great Alexander mosaic, the largest mosaic in the opus vermiculatum technique, measuring 2.17 meters x 5.12 meters (8′ 10 3/4″ x 16′ 9 5/8″). Illusionistic mosaics in the House of the Faun also marked boundaries between spaces. A threshold band of theatrical masks marked the transition from the fauces to the atrium, while a panel depicting the flora and fauna of the Nile separated the pavement of the atrium from the exedra holding the Alexander mosaic.

Because the emblemata were prefabricated, the work of paving the floors of the house was divided between ordinary mosaicists and specialists. It was enough for the mosaicists to leave an unpaved area of the correct dimensions to receive the emblema. Because the emblemata were portable, the patron could rearrange them or take them along with the furniture when moving to another house.

Whereas the geometric pavements in red or black cement made few demands on the viewer, use of illusionistic emblemata created curious problems. The mosaic-picture insets on floors required a certain suspension of disbelief—particularly because they could be walked on. They constituted an illusionistic "hole" in the flat surface underfoot.[13] Because their imagery would make sense only when seen right-side up, they forced the viewer to stand in front of them. The viewer also had to stand close up, since from afar the oblique angles of vision made the imagery on the floor unintelligible. These two conditions for viewing the emblema created an axis of approach and viewing within a room much stronger than that of allover or even centered decorative schemes.[14]

During the period of the Second Style of wall decoration (80–30 B.C.) the illusionistic emblema declined in popularity and was replaced by geometric designs. Although these, too, were colored and often illusionistically shaded, because they lacked figures and backgrounds, they competed much less strongly with the complex architectural perspectives designed to open up the space.

ASYMMETRICAL PERSPECTIVE AND THE VIEWER
IN SECOND-STYLE PAINTING

The House of the Griffins on the Palatine in Rome, dated to 80 B.C., is the earliest example of the Second Style in Italy.[15] The decoration of cubiculum II (see

13. Irving Lavin, "The Antioch Hunting Mosaics and Their Sources: A Study of Compositional Principles in the Development of Early Medieval Style," *Dumbarton Oaks Papers* 18 (1963): 185–186.

14. John R. Clarke, *Roman Black-and-White Figural Mosaics* (New York, 1979), 5–7.

15. Giulio Emanuele Rizzo, *Le pitture della Casa dei Grifi,* Monumenti della pittura antica scoperti in Italia, sec. 3, Roma fasc. 1 (Rome, 1936).

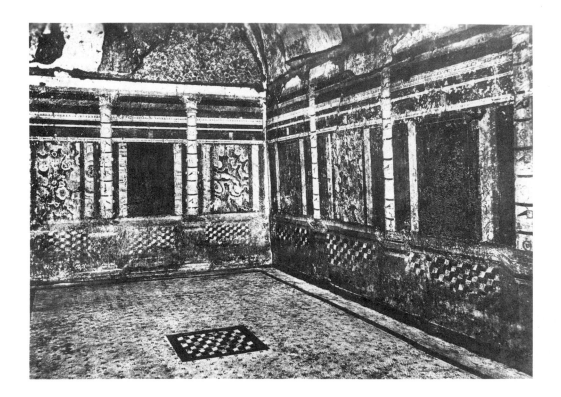

FIGURE 14. Both the emblema and the socle share the motif of trompe-l'oeil cubes in perspective. The emblema marks the optimum viewing point for the perspective scheme on the walls.

Fig. 14) far surpasses the simple scheme of the Tomb of Lyson and Kallikles in the complexity of its architectural perspectives and in the integration of wall and floor decoration. In this barrel-vaulted room evenly spaced columns resting on individual bases "support" an architrave. Orthogonals define these column bases and make them seem to stand in front of the actual wall surface. Furthermore, the shading system of the columns themselves both contributes to their three-dimensionality and coincides with the direction of the actual light source. A curious aspect of the orthogonals is that those of the right wall slant to the left, in the same direction as those on the right half of the back wall, and the scheme is reversed for the left wall and the left half of the back wall. In other words, there is only one vanishing point, in the center of the rear wall. Analysis of the orthogonals and shading in the Tomb of Lyson and Kallikles reveals the same perspective structure.

Study of this phenomenon reveals that it is common in systems of the early (80–60 B.C.) and mature (60–40 B.C.) phases of the Second Style. Josef Engemann coined the term "asymmetrical perspective" to describe these schemes in which a colonnade is made to wrap around the perimeter of a room.[16] It is asymmetrical because there is no vanishing point toward which orthogonals converge in the middle of the right or left walls. Instead, in Engemann's terms, a single colonnade, with all orthogonals converging on the center of the rear wall, has been "folded" into the corners. Burkhardt Wesenberg's explanation,[17] developed by Scagliarini,[18] proposes that in spaces decorated with asymmetrical systems, the viewer is meant first to look at the back wall from the room's axis of entry. The viewer then walks in along the longitudinal axis of the room. Reaching the goal of the axis, he or she will then turn around and look *out* to the real colonnade outside the room's space. Standing, or resting on the kline, the viewer would then see the fictive colonnades of the side walls, foreshortened with orthogonals slanting toward him, *and* the real colonnade of the peristyle outside the entryway of the room. Systems of asymmetrical perspective that imply a two-stage viewing pattern with a view back out of the space to real colonnades are illustrated in Fig. 15. Particularly interesting is the arrangement of the oecus of the bath of the House of the Cryptoporticus, where a painted scene in symmetrical perspective replaces the view out to a real colonnade.

Rooms painted in asymmetrical perspective address the viewer in a programmatic way. In the House of the Griffins a person entering cubiculum II (see Fig. 11) would progress along the room's long axis, prompted by both the convergence of the orthogonals on the back wall and the placement of an emblema with a design in cut marble (*opus sectile*) marking that axis. The socle that runs around the room between the columns is painted with the same motif as that of the emblema, a design of trompe-l'oeil cubes in perspective. The perfect point for appreciating both the convergence of the colonnade in perspective and this motif shared between socle and emblema is marked by the emblema itself. Turning around, still standing on or near the emblema, the viewer will see the colonnades of the right and left walls in a perspective that would be completed by the real colonnade (not preserved) outside the room.

With the mature phase of the Second Style this kind of address to the walking or static spectator becomes even more insistent. Since each view opening up

16. Josef Engemann, *Architekturdarstellungen des frühen zweiten Stils. Römische Mitteilungen*, Ergänzungsheft 12 (1967), 67 note 280.
17. Burkhardt Wesenberg, "Zur asymmetrischen Perspektive in der Wanddekoration des zweiten pompejanischen Stils," *Marburger Winckelmann-Programm* (1968): 102–109.
18. Scagliarini, "Spazio e decorazione," 9, 23.

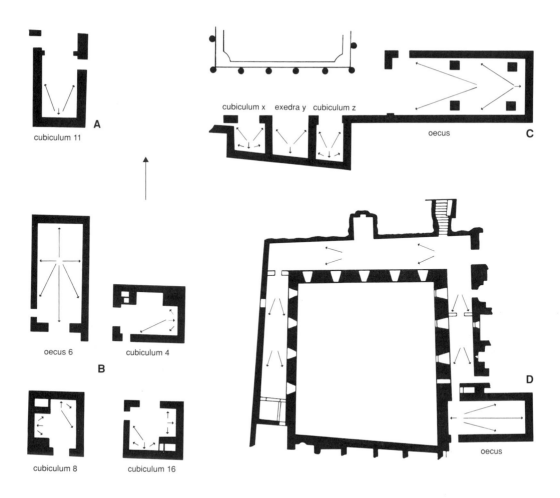

FIGURE 15. Orthogonals in the wall painting "position" the viewer who wishes to see the perspectives resolved.

behind the fictive colonnade has its own vanishing point, the viewer is to position him- or herself on axis with that vanishing point. Otherwise the viewer will experience perspective deformation.[19] In the Boscoreale cubiculum, for example (see Fig. 9), although the fictive columns and piers (of two different types) appear at regular intervals and appear to hold up the architrave, the refined perspective constructions between the columns and piers grab the

19. Scagliarini, "Spazio e decorazione," 10.

viewer's attention. There are three different kinds of scenes. On both side walls of the deep anteroom space painted doors mark the vanishing point for virtuoso renditions of sanctuaries surrounded by city houses. On the side walls of the alcove, or space for the bed, appear sanctuaries, with the peristyles visible behind their precinct walls; all orthogonals converge on the central round temple (*tholus*) of the deity inside the precinct. The alcove's back wall, although interrupted by a window, is painted to represent a rocky landscape crowned with a pergola and opening to a spring beneath. To appreciate each of these images, the viewer would need to stand on the room's long axis and then assume positions on the axes defined by the vanishing points of each.

THE SECOND-STYLE PAINTER

A most important aspect of such asymmetrical perspective systems was the skill of the artist responsible for their design and execution. This painter was above all one who collaborated with the architect, since his work would modify the perception of the house's spaces; he also worked closely with the mosaicist and the stuccoist, for they provided and articulated the decorated surfaces that he had to incorporate into the design of the painted walls and ceilings. He had to have an excellent knowledge of perspective; he needed to have at his command a repertory of still-life subjects and the architectural orders (with their ornament); he had to be able to produce the effects of light and shadow as they appeared on the various objects: colored marbles, gilded tracery, theatrical masks, ritual vessels, and glass bowls of fruit In short, the painter of the early and mature Second–Style wall was a master artisan if not an artist in the modern sense of the term. It is unlikely that he received his training in Roman Italy; he would have studied in Alexandria or Athens or in one of the important cities of Magna Grecia. He was proficient in the trompe-l'oeil scene painting of the Hellenistic theater and perhaps had studied illusionistic paintings by the great masters of the fourth century B.C. And he worked alone, certainly in the conception and drafting of his schemes; helpers could articulate ornamental details.

Two small drawings of architecture, found on the east wall of the atrium of the recently discovered Villa of Oplontis, give some insight into the working methods of such an artist. Executed in brown paint on the first stratum of plaster, they are divided into squares with red paint. Because of their small size the excavator rules out the possibility that they are *sinopie,* or guidelines painted on the penultimate layer of plaster: "instead they are sketches traced by the painter as a first and rapid notation of motifs which he would then have had to

develop on the other walls of the Second Style."[20] The artist who painted the Second-Style walls of the triclinium of the House of Ceres (Pompeii I, 9, 13) made a sketch of a capital in yellow ocher, without, however, the grid of squares.[21] In both cases the artist was sketching his perspectives or illusionistic details on a small scale, testing his ideas before laying out the decorative scheme of a whole wall or a whole room.

From sketches the design was transferred to whole walls, perhaps by dividing the sketch in a grid of squares and the wall into the same number of larger squares. We know that painters used grids to lay out wall painting. Cicero provides us with indirect evidence when he writes of the architect Diphilus: "Some day or other he will learn to use the plumb bob and the tape."[22] In some cases the grids traced with the plumb line and the square can be directly observed. In Room 25 of the Villa of Oplontis the losses of secco overpainting revealed a grid painted in yellow ocher marking the centers of the successive stripes making up the moldings of the faux-marble orthostates depicted on the wall. It is interesting to note that rather than defining boundary lines marking the end of one color and the beginning of another, this grid defines center lines for the elements of the decorative scheme.[23] Whether he used the "proportional squares" method, full-size cartoons, or a combination of ocher grids and freehand drawing, the painter of Second-Style perspectives was able to achieve precise copies of the same scheme for opposite walls, as in the Boscoreale cubiculum (see Fig. 9), where right and left walls are in mirror reversal.

From the grid the actual sinopia, or underdrawing, was constructed, usually in porphyry red. One such sinopia appears under the mature Second–Style perspectives of the west wall of oecus 43 of the House of the Labyrinth at Pompeii.[24] Another can be seen in the ceiling of the east alcove of the Villa of Oplontis (see Fig. 49). In the House of Caesius Blandius figures of herms holding up garlands, visible in the late Second–Style oecus to the west of the tablinum,

20. Alfonso De Franciscis, "La villa romana di Oplontis," in *Neue Forschungen in Pompeji,* ed. Bernard Andreae and Helmut Kyrieleis, 15.

21. Mariette de Vos, "Scavi nuovi sconosciuti (I 9,13): Pitture e pavimenti della Casa di Cerere a Pompei," *Mededelingen van het Nederlands Instituut te Rome,* n.s. 3, 38 (1976): 64.

22. Cicero *Epistulae ad Quintum Fratem* 3.1.2. *Columnas neque rectas, neque e regione Diphilus collocarat. Eas scilicet demolietur. Aliquando perpendiculo et linea discet uti* (The columns Diphilus had placed were neither perpendicular nor opposite each other. He will, of course, have to pull them down. Some day or other he will learn to use the plumb bob and the tape). Translation follows Cicero, *Letters to Quintus, Brutus, and Others.* Loeb Classical Library, vol. 4 (Cambridge, Mass., 1922). The *Letters to His Brother Quintus* were translated by W. Glynn Williams.

23. John R. Clarke, "The Early Third Style at the Villa of Oplontis," *Römische Mitteilungen* 94 (1987): 274–275, fig. 4.

24. Licia Vlad Borelli, "Le pitture e la tecnica della conservazione," in *Pompei, 1748–1980: I tempi della documentazione,* ed. Irene Bragantini, Franca Parise Badoni, and Mariette de Vos, exh. cat., Pompei and Rome (Rome, 1981), 85, fig. 4; Licia Vlad Borelli, "Sinopia," *Enciclopedia dell'arte antica. Supplemento* (1970), s.v.; *Bollettino dell'Istituto centrale del restauro* (1967), fig. 66.

were blocked out in porphyry red; the painter then filled in the details of their clothing and limbs, covering the underpainting.

In view of the rapid diffusion of the complex illusionistic perspectives of the Second Style in Italy, it seems likely that many artists were imported as soon as the style became popular. Arnold and Mariette de Vos suggest that whereas the First Style was work for stuccoists rather than for painters, it would have been the theatrical scene painters, *pictores scaenarii,* who contributed to the scenographic aspect of the Second Style. They would have instructed the first teams of wall painters.[25] These first teams would have been organized in groups of assistants under a master or by a contractor with his dependents, either slaves or freedmen.[26]

Recently scholars have challenged the long-standing notion, elaborated by Beyen,[27] that the Second Style emerged from the stage decoration. Lehmann argued that the Boscoreale cubiculum pictures the grounds of a Roman villa rather than the tragic, comic, and satyric sets from the theater,[28] whereas Engemann developed the notion that indigenous artists developed Second-Style paintings as representations of real buildings.[29] Fittschen rightly rejects Engemann's theory of indigenous development; for him the Second Style originates in wall painters' imitation of the precious materials and elaborate architectural forms of Hellenistic palaces.[30] Eleanor Leach proposes that Boscoreale belongs to a genre of "porticus" paintings that represent the extravagant architecture of the villas of the very rich, linking the genre to a workshop that executed the paintings of the Villas of Boscoreale, Oplontis, the Mysteries, and the House of the Labyrinth.[31] In her view the "stage pattern" coexisted with the "porticus pattern" as alternate schemes offered by workshops to the patrons.[32]

Leach's analysis has the advantage of connecting the porticus pattern with a particular workshop working for prosperous patrons around Pompeii who would have wished to impress visitors with walls mimicking the flamboyant excesses of plutocrats. Whether of the porticus or scaenae frons type, the Second-Style painter was creating a kind of stage setting for the owner and his

25. La Rocca, de Vos, and de Vos, *Pompei,* 66.

26. La Rocca, de Vos, and de Vos, *Pompei,* 63.

27. Hendrick G. Beyen, *Pompejanische Wanddekoration, vom zweiten bis zum vierten Stil* (The Hague, 1938), vol. 1, esp. figs. 28–33, 51–55, 59, 70–71b, 74–76, where he constructs frontes scaenarum on the basis of Second-Style wall paintings.

28. Phyllis Williams Lehmann, *Roman Wall Paintings from Boscoreale in the Metropolitan Museum of Art* (Cambridge, Mass., 1953).

29. Engemann, *Architekturdarstellungen.*

30. Fittschen, "2. Stils," 539–557.

31. Eleanor Winsor Leach, "Patrons, Painters, and Patterns: The Anonymity of Romano-Campanian Painting and the Transition from the Second to the Third Style," in *Literary and Artistic Patronage in Ancient Rome,* ed. Barbara K. Gold (Austin, 1982), 153.

32. Leach, "Patrons, Painters, and Patterns," 154–159.

guests. Mariette de Vos summarizes both the nature of the modern debate about the origins of the Second Style and the ancient texts that reveal the pretentious self-image of the Late-Republican aristocrat:

The appearance of theatrical backdrops in private spaces should be related to the public duties of the owners, convinced—like the Hellenistic dynasts (Curtius 9, 6, 21; Plutarch, *Demetr.* 41), and Augustus himself (Suetonius, *Aug.*, 99)—that their activity consisted in playing a role on the political stage and that Tyche-Fortuna gave each person his role (Bion of Borysthenes, fr. 16; Lucian, *Nigr.*, 20). On the other hand Alföldi believes that the *scaenae frons* displayed by the Hellenistic dynasts in the throne room and in the staging of court ceremonies in a political setting, once introduced into Italy, along with princely luxury (*regificus luxus*) by the Roman generals of the Late Republic and reflected in wall painting, was theatrical and unpolitical (*spielerisch-unpolitisch*). Many ornamental motifs in the decoration of houses of the first centuries B.C. and A.D., which are symbols of power and the *tryphe* (luxury) guaranteed by a dynasty, go back to the milieu of the Hellenistic court: the cornucopias, the globe and the eagle on table-holders (*trapezophoroi*) and in the paintings in the cities of Vesuvius.[33]

Even when employed in the relatively small spaces of cubicula and oeci, designed for private entertainment, high Second-Style decoration conveyed feelings of privileged luxury.[34] Unlike the ploddingly consistent faux-marble of the First Style, Second-Style decorations could articulate all a house's spaces on a sliding scale of richness and luxury, from the simple fictive colonnades of fauces, atrium, and peristyle walls to the complex, richly ornamented perspectives of intimate spaces. It is clear, then, that the Second Style's penchant for grandiose display and regal associations fit the mood of the Late Republic. Per-

33. Mariette de Vos, "Tecnica e tipologia dei rivestimenti pavimentali e parietali," in *Settefinestre: Una villa schiavistica nell'Etruria romana*, ed. Andrea Carandini and Salvatore Settis, 1: 83, citing Andreas Alföldi, "Gewaltherrscher und Theaterkönig. Die Auseinandersetzung einer attischen Ideenprägung mit persischen Repräsentionsformen im politischen Denken und in der Kunst bis zur Schwelle des Mittelalters," in *Late Classical and Mediaeval Studies in Honor of Albert Mathias Friend, Jr.*, ed. Kurt Weitzmann (Princeton, N.J., 1955), 35, author's translation. Timothy P. Wiseman, "*Conspicui postes tectaque digna deo*: The Public Image of Aristocratic and Imperial Houses in the Late Republic and Early Empire," in *L'urbs: Espace urbain et histoire* (*I^er siècle av. J.-C.–III^e siècle ap. J.-C*). Collection de l'Ecole française de Rome, 98 (1987), 393–399, emphasizes the overlap of sacred and private architecture in Rome, taking his cue from Filippo Coarelli, "Architettura sacra e architettura privata nella tarda repubblica," in *Architecture et société*. Collection de l'Ecole française de Rome 66, (1983), 192: "[T]he public part of the private house of the late Republican aristocrat is an ideal expansion of public architecture, which was in the care of the aristocrats."
34. Fittschen, "2. Stils," 543 note 74; Andrew Wallace-Hadrill, "The Social Structure of the Roman House," *Papers of the British School at Rome* 56 (1988): 71–72.

sonal political clout, accompanied by a regal personal image, and sustained by shifting alliances and intrigue, was the order of the day.[35] When the Second Style becomes simpler and more staid in its last phase, it may be in response to the sober code of behavior that Augustus advocated for public figures.

VITRUVIUS AND THE NEW AESTHETICS OF
LATE SECOND-STYLE WALL PAINTING, CA. 40–20 B.C.

Despite his avowed devotion to Augustus, Vitruvius bristled at the changes in wall painting that he witnessed. In *De architectura*, Book 7, Chapter 5, he describes the development of the Second Style from the First: "Then they proceeded to imitate the contours of buildings, the outstanding projections of columns and gables; in open spaces, like exedrae, they designed scenery on a large scale in tragic, comic, or satyric style."[36] The cubiculum from the Villa at Boscoreale illustrates the salient characteristics of the mature Second Style of Vitruvius's description. The side walls of the anteroom probably represent the comic setting, the side walls of the alcove the tragic, and the rocky garden and grotto the satyric.[37] The representation of elaborate trompe-l'oeil architecture converts this small room into a kind of gazebo. For the viewer who is willing to suspend disbelief for a moment, a pastoral arbor, complete with grottoes and a spring, a temple precinct with a two-story peristyle surrounding a sacred tholus, and a colorful cityscape all open behind the actual wall plane. Mature Second-Style walls like this one belong to the middle of the first century B.C. By the time Vitruvius was writing (ca. 30–20 B.C.), this solid, perspective-based fictive architecture was fast disappearing, much to the conservative military engineer's displeasure.

> But these subjects which were imitations based upon reality are now disdained by the improper taste of the present. Monstrosities rather than definite representations taken from definite things are painted on the plaster. Instead of columns there rise up stalks; instead of pediments, striped panels with curled leaves and volutes. Candelabra sustain representatives of shrines

35. Leach, "Patrons, Painters, and Patterns," 157; Wallace-Hadrill, "Social Structure," 72; Filippo Coarelli, "Discussione: lettura ed interpretazione della produzione pittorica da IV sec. a. C. all'ellenismo," *Dialoghi di archeologia* 3rd ser., vol. 2, no. 2 (1984): 151–155, asserts that the Second Style's representations of sacred or public architecture were created for the political *nobilitas* who had clients.
36. Vitruvius *De architectura* 7.5.2.
37. For illustrations see Lehmann, *Roman Wall Paintings from Boscoreale*, 82–131; pls. X–XXXIII.

[*aedicularum*] and above the summits of these, clusters of thin stalks rise from their roots in tendrils with little figures seated upon them at random. Again, slender stalks with heads of men and of animals attached to half the body. Such things neither are, nor can be, nor have been. On these lines the new fashions compel bad judges to condemn good craftsmanship for dullness.[38]

Vitruvius attributes people's acceptance of the new decorative conventions in wall painting to their understanding, so "darkened by imperfect standards of taste,"[39] that they accept that which cannot exist in reality.

It is doubtful that Vitruvius is representative of progressive and vital thinking during the early Augustan period. The very discussion following his outburst discloses a possible motive for it: to allow him to plea for representational art against the new abstraction which had taken over in house decoration. Vitruvius advocates a commonsense art that *looks* like something. In particular, he wanted architectural perspectives that convince us of their ability to do what traditional Greek architecture does in reality: support weight in all the variations of post-and-lintel construction. A sense of propriety and the ideal that art conforms to nature should persuade Vitruvius's reader to abandon the excesses of the new, fanciful representations of architecture. When one realizes that Vitruvius's diatribe is based on his seemingly naive conception that the only proper decorative schemes are those that create convincing illusionistic architecture, his reasoning seems reactionary, based on old-fashioned Greek concepts.[40] After all, no one ever believed that a windowless wall actually opened to the idyllic, sacred, or urban architecture pictured there. Like the decoration of ceilings and floors, even the highly illusionistic perspectives on the walls articulated flat surfaces.

Fortunately, high-quality wall painting, dated with some accuracy to the period between 30 and 20 B.C., illustrates the very changes decried by Vitruvius. The central oecus of the so-called House of Livia on the Palatine formed part of Augustus's own residence (Fig. 16). It announces the most fundamental and long-lasting change in wall decoration: the abandonment of asymmetrical perspective. Instead of the regularly spaced columns—including ones folded into corners—defining the room's perimeter and appearing to support the architrave, a single central feature becomes the focus of each wall. This is the aedicula, a pavilionlike structure with columns supporting a pediment.

38. Vitruvius *De architectura* 7.5.3–4 (author's translation, after Loeb, 2:104–105).
39. Vitruvius *De architectura* 7.5.4.
40. Jerome J. Pollitt, *The Art of Rome, ca. 753 B.C.–337 A.D.: Sources and Documents* (Englewood Cliffs, N.J., 1966), 127.

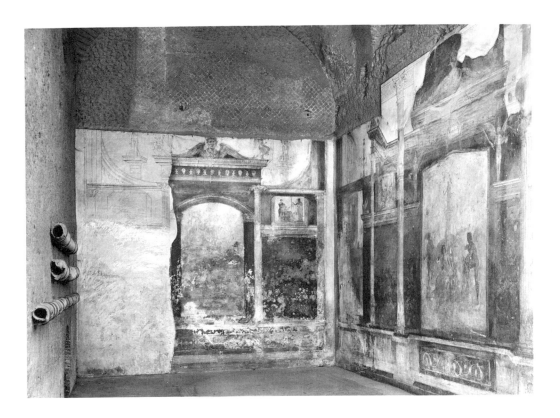

FIGURE 16. Aediculae with mythological pictures located in the center of each wall weaken the late Second Style's system of the wrap-around colonnade.

When schemes of asymmetrical perspective passed out of fashion in the late Second Style the master artist's task became easier. He no longer had to work out a wrap-around perspective scheme that would fit the size and shape of each individual room. Instead he made the orthogonals converge in the center of each wall.[41] This so-called symmetrical perspective system encouraged the viewer to look at each wall separately, the eye drawn to the aedicula—and to its center of interest: the painting that the aedicula framed. This late Second–Style approach shifted the viewer's attention from the perspective system designed for the whole room to a single axial focus for each wall, with the per-

41. Even in asymmetrical systems illusions of depth had been limited to the middle zone of each wall, where the fictive depths depicted as opening up behind the actual wall surface were safely separated from telltale joins with other walls, the floor, or the ceiling—the physical points where actual architecture was most apt to betray the fictive. For further discussion of this aspect of

spectives resolved on that axis. When views of architecture do appear "behind" the wall, as in the tablinum of the House of Livia, the artist arranged them symmetrically in slots to right and left of the central aedicula, further emphasizing the autonomy of each wall's perspective system.[42] From this point forward in Roman wall decoration, the central aedicula dominated almost every wall-painting scheme.

With the paintings from the Villa under the Farnesina in Rome (ca. 20 B.C.),[43] the architecture begins to thin dramatically, perspectives become simpler and shallower, and new elements—the ones that Vitruvius complains about—appear. A whole panoply of Egyptianizing ornament, already present in the House of Livia and found in more developed form in some rooms of the House of Augustus,[44] seems to take precedence over the architecture. Carefully painted lotus-bud capitals and friezes, palmettes, rosettes, and symbols of the cult of Isis appear everywhere. A detail of cubiculum B illustrates the changes (Fig. 17). Particularly interesting are the pictures on easels flanking the aedicula, the emphasis on linear ornament, and the absence of views into architecture "behind" the wall plane. As in the House of Livia, the painting in the aedicula now provides the spatial depth once achieved by architectural perspectives in the mature Second Style. The wall paintings of the Farnesina villa represent the last phase in the transition to the Third Style. Most characteristics of the Third Style are present in one form or other: central aediculae, attenuated architecture, avoidance of perspectives that pierce the wall, all-black rooms, love of miniaturistic details, Egyptianizing motifs, and the proliferation of painted representations of pictures. If the transition is clear, the precise beginning of the Third Style is a matter of controversy. One firm date seems to be the paintings of the tomb chamber of the Pyramid of Caius Cestius in Rome, completed in 15 B.C. Unfortunately, the paintings are not of high quality. Wall paintings from the Villa of Agrippa Postumus at Boscotrecase, near Pompeii, are of the highest quality but of uncertain date.[45]

Roman wall painting, see Sheldon Nodelman, "Roman Illusionism: Thoughts on the Birth of Western Spatiality," *Art News Annual* 37 (1971): 27–38.

42. Giulio Emanuele Rizzo, *Le pitture della 'Casa di Livia,'* Monumenti della pittura antica scoperti in Italia, sec. 3, Roma fasc. 3 (Rome, 1936); Filippo Coarelli, *Guida archeologica di Roma* (Verona, 1974), 141–144. See also rooms 5, 11, 13, 14, and 15 of the House of Augustus in Gianfilippo Carettoni, "La decorazione pittorica della Casa di Augusto sul Palatino," *Römische Mitteilungen* 90 (1983): 323–419.

43. Irene Bragantini and Mariette de Vos, *Le decorazioni della Villa romana della Farnesina,* Museo Nazionale Romano 2, 1: Le pitture (Rome, 1982).

44. Carettoni, "Casa di Augusto," figs. 9–14, 16; pls. 105–107; color plates 3.2, 14.3, 16.1–2.

45. Volker Michael Strocka, "Die römische Wandmalerei von Tiberius bis Nero," *Pictores per provincias: Aventicum V.* Cahiers d'archéologie romande, no. 43 (Avenches, Switz., 1987), 30–31.

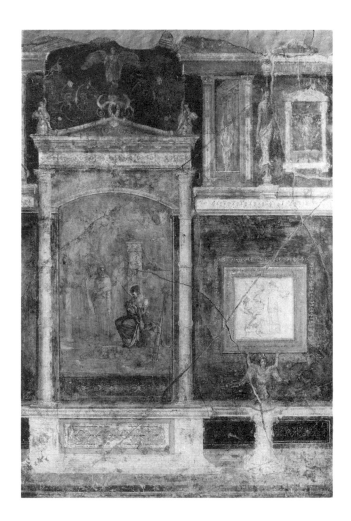

FIGURE 17. An ornate aedicula frames a reproduction of a fourth-century B.C. painting while easels support monochromes in the archaic style of the sixth century in this late Second-Style scheme.

Analysis of a detail of the red cubiculum (no. 16) from Boscotrecase (Fig. 18) shows how the tendency to flatten the wall went to its extreme. One has to search for an indication of foreshortened architectural members because every element of the scheme—socle, aedicula in the middle zone, and architectural members in the upper zone—has become a preciously detailed miniature. There is no illusion of fictive architectural members projecting forward or receding behind the actual wall plane. If this Third-Style scheme restores the wall to its actuality as a flat surface, it is because it has systematically eliminated illusionistic perspectives. Only in the central picture does illusionism reign, in a miniature pastoral landscape floating on a white ground.

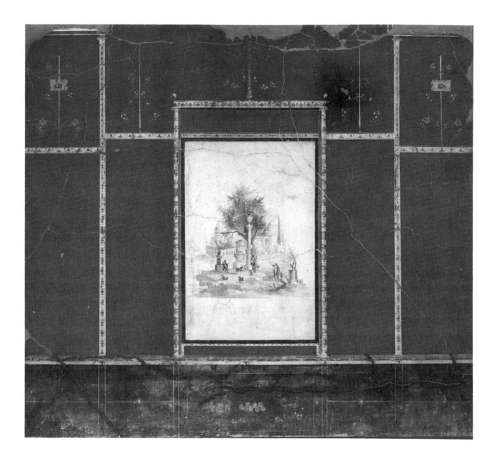

FIGURE 18. In the early Third Style, architectural perspectives all but disappear into ribbonlike bands framing the central picture and dividing the wall into flat planes of color.

WHO INVENTED THE THIRD STYLE?

In light of the long-lasting effects the new style was to have on Roman decoration and division of labor, the question of the invention of the Third Style becomes an important one. Who was the first artist to flatten the wall radically and to make a picture, or pictures, the object of the viewer's attention? Peter von Blanckenhagen, following H. G. Beyen,[46] attributes ownership of the Villa

46. Hendrick G. Beyen, "Les *domini* de la Villa de la Farnesine," *Studia varia Carolo Guilielmo Vollgraff a discipulis oblata* (Amsterdam, 1948), 3–21.

under the Farnesina to Agrippa and Julia. He then links this villa in Rome with the one at Boscotrecase, which Agrippa would have willed to his posthumously born son. The Farnesina would have been decorated on Agrippa's return to Rome in 19 B.C.:

> The atelier must have been the outstanding one of its time; it could boast work "by appointment of the court." Here were the best and the most advanced painters leading the way towards a new form of decoration in spite of Vitruvius' and perhaps other conservatives' denunciation. Protected and perhaps encouraged by the Emperor's daughter and her husband, the most progressive and talented among these painters became the founders of what we call the Third Style. One of these, probably the finest, was again commissioned to work for the Imperial family, this time as a leading painter in the Campanian villa near Boscotrecase belonging to the just deceased Agrippa.[47]

Von Blanckenhagen continues, characterizing this unknown artist through his works and assigning the landscape on the north wall of the red room and the painting of Polyphemus to his own hand, while relegating to assistants the execution of the other landscapes. Because he was a painter of the imperial court, he was widely copied in Pompeii: "a painter of the most elegant and sophisticated set at the Imperial court where Ovid and his taste ruled supreme."[48] In this way von Blanckenhagen charts the transmission of the Third Style to Pompeii and identifies an artistic personality—in fact, two—the Farnesina painter and the Boscotrecase painter.

Bastet, however, questions the evidence for Beyen's and von Blanckenhagen's dating of Boscotrecase.[49] In the scheme proposed by Bastet the earliest Third-Style decorations date to 20–10 B.C. (phase Ia, "initial Third Style") and do not include those of the Villa at Boscotrecase, dated to A.D. 1–25 (phase Ic, "in full force").[50] And recently Robert Lloyd has proposed that the villa belonged not to Agrippa and Julia but to A. Crispinus Caepio, proprietor of an imperial brick factory.[51]

Bastet uses as examples the House of Livia, the Farnesina, and the Aula

47. Peter H. von Blanckenhagen and Christine Alexander, *The Paintings from Boscotrecase*, *Römische Mitteilungen*, Ergänzungsheft 6 (1962): 59–60.

48. Von Blanckenhagen and Alexander, *Boscotrecase*, 60.

49. Frédéric Bastet and Mariette de Vos, *Proposta per una classificazione del terzo stile pompeiano*. Archeologische Studiën van het Nederlands Instituut te Rome, no. 4 (The Hague, 1979), 8–9. See review by Peter H. von Blanckenhagen, *American Journal of Archaeology* 86 (1982): 307–308.

50. Bastet and de Vos, *Terzo Stile*, 45–47, 134–135 (Synoptic Table); similarly Strocka, "Wandmalerei," 30, who dates Boscotrecase to the first decade of the first century A.D.

51. Robert B. Lloyd, "The Aqua Virgo, Euripus, and Pons Agrippa," *American Journal of Archaeology* 83 (1979): 193–204.

Isaica for his account of the transition from the Second to the Third Styles.[52] Furthermore, Bragantini and de Vos, in their recent publication of the decorations of the Farnesina, postulate a single workshop in Rome under the patronage of Augustus and Agrippa; it would have produced the paintings of these very houses. The Egyptianizing elements noted by the authors in these houses point to the triumph of Augustus and Agrippa in Egypt. The innovations brought in by this workshop initiated the Third Style[53] and were copied at the time in Campania.[54]

Taking a literary approach to the problem of the authorship of the Third Style, Roger Ling explores Pliny the Elder's account of Studius, a painter of the Augustan period who was the first major figure in a new genre of landscape painting.[55] It is worth quoting the full passage in translation here:

> Nor must Studius, active during the time of the Divine Augustus, be cheated of the praise he deserves. It was he who first instituted that most delightful technique of painting walls with representations of villas, porticoes and landscape gardens, woods, groves, hills, pools, channels, rivers, coastlines— in fact, every sort of thing which one might want, and also various representations of people within them walking or sailing, or, back on land, arriving at villas on ass-back or in carriages, and also fishing, fowling, or hunting or even harvesting the wine-grapes. There are also specimens among his picture of notable villas which are accessible only through marshy ground, and of women who, as the result of an agreement, are carried along on the shoulders of men who totter along beneath the restless burdens which are being carried, and many other lively subjects of this sort indicative of a sharp wit. This artist also began the practice of painting representations of seaside towns on the walls of open galleries, thus producing a charming view with minimal expense.[56]

After linking Pliny's account with a similar one from Vitruvius, Ling characterizes this artist's contribution: his role was "the bringing to perfection of a

52. Bastet and de Vos, *Terzo Stile*, 17–23.
53. Bragantini and de Vos, *Farnesina*, 30–31.
54. Bragantini and de Vos, *Farnesina*, 50–60, figs. 28–51. Other examples in the region destroyed by Vesuvius can be added to this phase of transition from the Second to the Third Style in Rome. At Pompeii: Casa di Obellio Firmo IX, 14, oecus 3 and cubiculum 5; House V, 1, 14–15; Caserma dei Gladiatori V, 5, 3, triclinium *n;* Casa di Fabio Rufo VI, *Ins. Occ.* 40, cubiculum 7; Casa di Paquio Proculo I, 7, 1, oecus 18. At Torre Annunziata: Villa di Oplontis, cubiculum 25, room 10*bis.* At Herculaneum: Casa dell'Albergo III, 19, tepidarium 13.
55. Roger Ling, "Studius and the Beginnings of Roman Landscape Painting," *Journal of Roman Studies* 67 (1977): 1–16.
56. Pliny the Elder *Naturalis historiae* 35.37.116–117. The translation here comes from Pollitt, *Art of Rome*, 116–117. "Studius," rather than "Ludius" or "Spurius Tadius" has been used here; see Ling, "Studius," 1–2.

whole genre of peopled architectural landscape in wall painting."[57] Boscoreale (dated by Ling to the years before 40 B.C.), Oplontis 14 ("slightly later than Boscoreale"), the House of Livia ("30–25 B.C."), the Farnesina ("ca. 20 B.C."), and Boscotrecase figure in his characterization of Studius and his new genre. Ling also suggests that Studius may have been the founder of one of the leading ateliers which decorated the three houses thought to be connected with the imperial family (the House of Livia, the Farnesina, and Boscotrecase).[58]

However, analysis of the landscape paintings from the sites mentioned by Ling reveals a great variety in the size of the figures relative to the landscape setting and in the point of view of the landscape representation itself, whether seen close up, as in the House of Livia (see Fig. 16), or as an isolated and faraway miniature island (see Fig. 18). It seems that almost any illusionistic picture could serve the new aedicular scheme that first appears in the House of Livia. Whether Studius was responsible for the attenuated architecture which so annoyed Vitruvius or whether he only painted the landscape pictures in the new central aediculae we will probably never know. We do know that the reduction of trompe-l'oeil architecture and the new emphasis on the aedicular picture brought about a division of labor that permitted specialists in picture painting to ply their skills in relative independence from the wall decorators who created the settings for their pictures.

DIVISION OF LABOR IN THIRD- AND FOURTH-STYLE PAINTING

This emphasis on pictures instead of perspectives in the aedicula-based wall schemes of the Third Style allowed division of labor in carrying out the work. In place of the single painter of Second-Style schemes who had to tailor his trompe-l'oeil illusions to each room, two individuals were called upon to execute the decoration of the Third-Style room: a wall painter and a picture painter. One man, or one man with his crew, prepared the plaster of the wall, divided it into three horizontal zones with a central aedicula, and painted everything but the pictures. Another man was responsible for painting the pictures in the aedicula and smaller ones, if any, on easels or in medallions. It seems likely, even though the terms appear three centuries later, that the painter of the pictures is the *pictor imaginarius* of the *Edict of Diocletian on Maximum Prices* of 301, and that the wall painter is the *pictor parietarius*.[59] The

57. Ling, "Studius," 7.
58. Ling, "Studius," 11.
59. Tenney Frank, *An Economic Survey of Ancient Rome*, vol. 5 (Baltimore, 1940), appendix, with translation of the *Edictum Diocletiani de pretiis rerum venalium* by Elsa Rose Graser, on

difference in their skills at the time of Diocletian was reflected in their wages: the imaginarius earned twice that of the parietarius.[60]

We know something of how the work was carried out from evidence in the walls themselves. The techniques used to paint Pompeian walls required that most pigments be applied to wet plaster, since they were incorporated into the plaster, or carbonated, when the plaster dried. Millard Meiss has noted the parallels between so-called *buon fresco* techniques in the Renaissance and those employed in Pompeii.[61] Close examination of frescoed walls in raking light reveals sutures or seams; they are the joins between successive days' work. The area of wet plaster that can be painted in a day is called a *giornata*, and it will vary according to the difficulty of the painted decoration. Meiss and, more recently, Pappalardo[62] discuss sutures around the figures of the Second-Style Dionysian frieze of the Villa of the Mysteries (see Pls. 2 and 3), indicating that work may have progressed at the rate of a figure a day. This, of course, was an especially difficult commission, requiring considerable skills.

Work progressed faster on more ordinary walls of the Third and Fourth Styles, where two kinds of seams are visible. The first type is horizontal: generally one finds two horizontal seams coinciding with the divisions between upper and median zones and between median and socle zones. According to Meiss, these are scaffolding lines, or *pontate*.[63] Two rooms in the House of the Sacello Iliaco (I, 6, 4), unfinished at the time of the eruption,[64] demonstrate this working method. In the triclinium (*a*) the excavator noted piles of plaster and marble dust on the floor, indicating that work was going on at the time of the eruption. The upper and median zones were finished, but the socle was incomplete, in accordance with Vitruvius's directions that the work of wall painting should proceed from top to bottom.[65] In cubiculum (*d*) the Fourth-Style scheme was completed in the upper zone, but the painters never returned to finish the median and socle zones. The thin layer of fine plaster applied to the upper zone to receive the pigments was beveled along its bottom edge so that

338–339. This interpretation is followed by La Rocca, de Vos, and de Vos, *Pompei*, 63. For a new, but unlikely, account of this distinction, see Flemming G. Andersen, "Pompeian Painting: Some Practical Aspects of Its Creation," *Analecta romana Instituti danici* 14 (1985): 113–128.

60. Alix Barbet, "Quelques rapports entre mosaïques et peintures murales à l'époque romaine," in *Mosaïque: Recueil d'hommages à Henri Stern*, ed. René Ginouvès (Paris, 1983), 49, for a slightly different interpretation of the same source.

61. Millard Meiss, *The Painting of the Life of St. Francis in Assisi* (New York, 1962), 6–7.

62. Umberto Pappalardo, "Nuove osservazioni sul fregio della Villa dei Misteri," *La regione sotterrata dal Vesuvio: Studi e prospettive*, Atti del Convegno Internazionale, 11–15 November 1979 (Naples, 1982), 599–634.

63. Meiss, *Painting*, 6.

64. Volker Michael Strocka, "Ein missverstandener Terminus des vierten Stils: Die Casa del Sacello Iliaco in Pompeji (I 6, 4)," *Römische Mitteilungen* 91 (1984): 125–140, believes that these paintings do not represent the last stage of the Fourth Style.

65. Vitruvius *De architectura* 7.3.3–5.

the seam would be well hidden by the final layer of plaster on the median zone.[66]

If the horizontal seams, or pontate, visible today on walls of the Third and Fourth Styles represent successive working campaigns, the painting of one zone on a wall of a modest-size room would require a day, so that in most cases the pontata is the same as the giornata. It has been suggested that the tripartite horizontal division of the wall that begins with the Third Style and is maintained well into the third century of our era grew out of the practical necessity of working the wet plaster in calculated giornate.[67]

Frequently combined with this tripartite vertical division is a three-part vertical division of the wall, so that the wall is divided into nine parts. Carol and Donald Watts have recently suggested that such nine-part divisions were attained by application of a proportioning system called the "sacred cut" that could be calculated easily using stake and line.[68]

The other type of seam found on Pompeian walls surrounds individual pictures, like those in the central aediculae and on easels in the tablinum in the House of M. Lucretius Fronto (see Pls. 8 and 9). Walls complete in their Fourth-Style schemes, but lacking their pictures, indicate that the pictures were painted last, after the parietarii had finished. A Fourth-Style room in the House of the Sacello Iliaco, cubiculum (b^2), was completed save the central picture of the right wall, awaiting the imaginarius.[69]

If these seams demonstrate the temporal order and division of the work between nonspecialists and specialists, guidelines incised into the penultimate plaster layer reveal a more direct approach to decoration than the ocher grids of the Second Style. Lines, sometimes impregnated with color, were stretched and snapped into the wet plaster to define verticals (using the plumb bob) and horizontals. Workmen employed the compass to get true circles and to divide circles into the petals making up rosettes, as is evident in a detail from a Fourth-Style room of the House of M. Lucretius Fronto (Fig. 19). Even the outlines of figures were often incised into the wet plaster.[70]

66. Vittorio Spinazzola, *Pompei alla luce degli scavi nuovi di via dell'Abbonzanda,* 2 vols. (Rome, 1953), 1:448, fig. 515.

67. La Rocca, de Vos, and de Vos, *Pompei,* 57; Arnold de Vos and Mariette de Vos, *Pompei Ercolano Stabia,* Guida archeologica Laterza, no. 11 (Rome, 1982), 339.

68. Carol Martin Watts, "A Pattern Language for Houses at Pompeii, Herculaneum, and Ostia," (Ph.D. diss., University of Texas at Austin, 1987), 264–274. See also Donald J. Watts and Carol Martin Watts, "A Roman Apartment Complex," *Scientific American* 255, no. 6 (December 1986): 132–139, for a convincing demonstration of how the "sacred cut" was employed on larger scales, such as the plan of a whole house, or on smaller scales, such as the proportion of mosaic floors and of the central picture within the design of a whole wall.

69. de Vos and de Vos, *Pompei Ercolano Stabia,* 104–105.

70. de Vos and de Vos, *Pompei Ercolano Stabia,* 339; Claudine Allag and Alix Barbet, "Techniques de préparation des parois dans la peinture murale romaine," *Mélanges de l'Ecole française de Rome, Antiquité* 84, no. 2 (1972): 935–1069.

FIGURE 19. The painter used a compass to incise guidelines into the
wet plaster.

The economy of the division of labor brought in by the Third Style is now
clear. Because the designer of Second-Style walls had to carry the illusion of the
fictive colonnade around all the walls of a room in a convincing fashion, he
could not entrust such specialized work to ordinary wall plasterers and paint-
ers. In contrast, only rudimentary knowledge of perspective was needed for the
single-wall, shallow perspectives of the Third and Fourth Styles, so that rela-
tively inexpensive and unskilled workers could bring the painted decoration of
a room to near completion before the more expensive specialist needed to be
called in.

A good Third- or Fourth-Style picture painter would have had at his command a broad repertory of subjects (probably recorded in a sketchbook), ready to be painted on commission onto otherwise fully painted walls. These pictures embraced a wide range of historic styles, so that they often reflected a connoisseur's approach to collecting the art of the past. For example, in cubiculum B of the Villa under the Farnesina the artist has recalled a Greek model of the fourth century B.C. for the aedicula and one of the archaic period for the flanking easel pictures (see Fig. 17). The artist of the pictures decorating the tablinum of the House of M. Lucretius Fronto (ca. A.D. 40–45) was able to provide a painting of Mars and Venus for the north wall and one of Dionysus and Ariadne on a cart for the south wall (see Figs. 73 and 74). On fancy easels to either side of these central pictures this painter composed landscapes with villas.

NEW AESTHETICS AND DIVISION OF LABOR
IN THIRD- AND FOURTH-STYLE MOSAICS

The new techniques and decorative motifs that begin to appear in mosaics around 20 B.C. parallel the changes in taste and labor organization that occur in wall painting. Both polychromy and the three-dimensional decorative motifs it served disappear in favor of flat black-and-white designs.[71] Although this two-dimensionality did not necessarily imply a less-skilled labor force, it did represent an aesthetic choice. Instead of the colored and shaded trompe-l'oeil meanders and cubes in perspective (see Fig. 46), which begged the question of the floor's flatness, Third-Style mosaics are emphatically two-dimensional. Like the walls, they reduce spatial illusionism to a minimum in favor of miniaturism and a great variety of new patterns springing from frank experimentation.

Substitution of black and white tesserae for the often delicately colored designs of Second-Style mosaics simplified the working procedure. Excavation of a mosaic floor of 50–30 B.C. from the Roman Villa at Francolise revealed that a repeated element—a polychrome hexagon—was prefabricated on a bench or in a workshop and transferred on cloth or wood into the penultimate cement layer. Preparation of this cement layer (called the *nucleus*) included impressing laying-out lines to determine the hexagonal border surrounding the prefabricated hexagons, dividing these laying-out lines into a regular grid so that the hexagons could be regularly spaced, and adding guidelines for the actual laying of the tesserae of the borders.[72] In the case of complex designs of 40–30 B.C. in the Villa at Settefinestre, a line snapped in the wet penultimate mortar layer

71. For a survey of new mosaic motifs appearing at this time, see Bastet and de Vos, *Terzo Stile,* 107–117.
72. M. Aylwin Cotton and Guy P. R. Métraux, *The San Rocco Villa at Francolise* (Hertford, 1985), 100–104, fig. 13, 110, and pl. XXIX.

was then painted in red and yellow to guide the mosaicists.[73] With the black-and-white technique, the painting or imprinting of laying-out lines and grids remained,[74] but the prefabrication of complicated motifs and the guidelines to ensure that tesserae laid around the prefabricated elements would come out right were no longer needed.

For parallel changes in *figural* floor mosaics, we must turn to the private bath complex of the House of the Menander at Pompeii, and to other bath complexes dated to the end of the first century B.C. A group of figural pavements clusters around the bath mosaics of the House of the Menander. I have described elsewhere the way in which mosaics of the Early Silhouette Style are conceived and constructed in terms of the uniform, cubic tesserae of the opus tessellatum technique.[75] The dolphins and swimmer of the caldarium of the bath in the House of the Menander (see Fig. 103) are chromatically reduced equivalents of those found in the *sudatio* of the lower level of the House of the Cryptoporticus.[76] Later, but perhaps by the same workshop, are the purely black-and-white representations in the threshold and in the bath of the Domus Blandi.[77]

As with the new decorative mosaics, the important common element in all these figural mosaics is that both figures and the surrounding decorative elements are worked in the same cement bed. No longer are the decorative schemes of a floor produced first, leaving the center unpaved for the insertion of the emblema (as in Fig. 91 and Pl. 10). Now that the floor was done all of a piece and at one time in a uniform technique employing precut cubic units, the division of labor between the artist responsible for the elaborate polychrome emblema (who may have been called the *musivarius*) and the common floor pavers who executed the black-and-white areas (who may have been called *tessellarii*)[78] was no longer necessary. There were probably men in a workshop or on a crew who excelled in making figures. At first their repertory was lim-

73. de Vos, "Tecnica e tipologia," 1:72, fig. 82, with a list of sinopie for mosaics of the first century B.C., p. 86; fig. 104, Rome, Museo Nazionale, inv. 125533*bis*, preparation for meander mosaic with modular grid imprinted with cord and painted sinopia; see also figs. 105 and 106.
74. Ciro Robotti, "Una sinopia musiva pavimentale a Stabia," *Bollettino d'arte* 43 (1973): 42–44, figs. 1–5.
75. Clarke, *Mosaics*, 60–61.
76. Erich Pernice, *Die hellenistische Kunst in Pompeji: Pavimente und figürliche Mosaiken* (Berlin, 1938), pl. 20.
77. Pernice, *Mosaiken*, 61–62; John R. Clarke, "The Origins of Black-and-White Figural Mosaics in the Region Destroyed by Vesuvius," in *La regione sotterrata dal Vesuvio: Studi e prospettive*, Atti del Convegno Internazionale, 11–15 November 1979 (Naples, 1982), 661–688, esp. figs. 2 and 12; John R. Clarke, "Mosaic Workshops at Pompeii and Ostia Antica," *Acts of the Fifth International Colloquium on Ancient Mosaics*, Bath, England, 5–12 September 1987 (in press).
78. Both terms appear late and are difficult to interpret. *Musivarius*, or *musearius: museiarius* is first used in an inscription of the first or second century (*Corpus inscriptionum latinarum*, vol. 6, no. 9647), and next in the same passage of the Edict of Diocletian on Maximum Prices cited above,

ited, consisting of marine subjects such as dolphins, anchors, ithyphallic Negroid swimmers, octopi, and hybrid sea creatures, like hippocamps and Tritons. Some special shaping of tesserae was necessary for the execution of such figures, but certainly not the kind of miniaturist's skill needed to translate the brushstrokes of painting into rows of tiny, subtly hued tesserae—a skill necessary for the costly emblemata vermiculata. Cost could be kept low by employing nonspecialists to decorate floors with black-and-white mosaics, and local workmen, rather than imported artists and artisans, could be used. Just as the new working methods of the Third Style must be characterized as a native Italian approach to wall decoration, so the black-and-white mosaic in this period reveals an aspect of the Romanization of a Hellenistic decorative system.

VIEWING THIRD-STYLE ENSEMBLES

If Second-Style representations of spatial depth in both floors and walls made unusual demands on the viewer, requiring special viewing positions and acceptance of trompe-l'oeil perspectives, the Third-Style ensemble relaxed these demands by asserting the flatness of floors and walls.

The change to the black-and-white mosaics in opus tessellatum technique brought about the unification of the entire floor surface as a flat spatial limit, a plane to be walked upon rather than one with a picture on it to be looked into. By excluding polychromy, mosaicists avoided competition with the colored designs of walls and ceilings. Imagery, too, asserted the flatness of the floor. In most spaces allover decorative patterns prevail. Only in barrel-vaulted spaces do full-fledged figural compositions occur, and then usually in bath spaces.[79] In general, designers recognized that harmony between walls and floors required that the functional nature of these surfaces be acknowledged in the choices of decorative imagery.

The viewer's attention, no longer diverted by busy polychrome patterns or pictures on the floor, focused on the walls with their individual pictures. Characterized by its efficient division of labor between the painters of the wall with its architectural perspectives and the person responsible for the individual pictures inserted into that wall, the Third Style also permitted the patron far greater liberties in the selection of pictures and motifs than the narrowly focused, theater-derived Second-Style system. It is reasonably accurate to say

note 59. There the musivarius is paid 60 denarii a day, the *tessellarius* 50, the *pictor parietarius* 75, and the *pictor imaginarius* 150. Doro Levi, "Mosaico," in *Enciclopedia dell'arte antica* s.v., suggests that the musivarii made the emblemata and the tessellarii the decorative borders around the figural emblema. See also I. Calabi Limentani, "Musivarius," in *Enciclopedia dell'arte antica*, s.v.
 79. Clarke, *Mosaics,* 3–18.

that these pictures, once chosen by the patron (presumably from the artist's sketch- or pattern-book) were inserted into otherwise finished walls. Although the picture, framed in wood, could be inserted into the wall in the manner of a mosaic emblema,[80] in most instances the picture painter built up the plaster to the level of the surrounding painting and painted the picture into fresh plaster on the spot.[81] In the Third and Fourth Styles the picture painted on the wall stands for a real panel painting hung on the wall. The elaborate aedicula framing the illusionistic picture, which is characteristic of late Second- and early Third-Style decoration, is never quite abandoned; the aedicula becomes attenuated, as in the tablinum of the House of M. Lucretius Fronto (see Pl. 9), but never lost. What increases in importance and number are the pictures painted on the wall.

With the proliferation of such pictures, the viewer's task changes from attempting to think away the actual spatial limits of the wall and ceiling surfaces in the Second Style to bit-by-bit examination of the images depicted within all the frames on the flat wall. Spatial illusionism of a comprehensive sort, the kind that includes the spectator's eye-level line and viewing position in its scheme, is gone. In its place come rich iconographical systems and complex religious and philosophical meanings surrounding the subject matter of the pictures on the wall. The viewer is now meant first to see the whole of a single wall, with its aedicula in the middle, then to come closer and look at the pictures on that wall one at a time and to take in the miniaturistic details of their frames.[82]

If the First Style's seemingly substantial marbles and moldings attempted to transform the house into the image of great public buildings, and the Second Style's grandiose, lavishly ornamented colonnades and sanctuaries depicted spaces fit for a king, the Third Style's picture galleries presented the owner as a person of culture, connoisseur of the great Greek masterpieces. In keeping with the new civic-minded sobriety promulgated by Augustus, the Roman citizen kept a quiet private profile, in sharp contrast to the lavish personal display and bombast of the Late Republic.[83] Both artist and patron must have conceived schemes like that of the tablinum of the House of Livia and cubiculum B of the Farnesina as imitation *pinacothecae*. During the Augustan age these buildings were key to the new policy of public display of works previously owned and sequestered by the wealthy.[84] The designers of Third-Style imitation pinacothecae must have followed the conventions of the model: elaborate aediculae

80. Ten examples have survived at Pompeii; see La Rocca, de Vos, and de Vos, *Pompei*, 63.
81. La Rocca, de Vos, and de Vos, *Pompei*, 63–67; de Vos and de Vos, *Pompei Ercolano Stabia*, 339.
82. Scagliarini, "Spazio e decorazione," 12.
83. Leach, "Patrons, Painters, and Patterns," 166.
84. Leach, "Patrons, Painters, and Patterns," 159–167; followed by Wallace-Hadrill, "Social Structure," 73.

frame the paintings, fanciful easels hold them, and small pictures with two shutters that can be opened and closed (*pinakes*) occupy ledges in the upper zone (see Figs. 16 and 17).

In essence, the aesthetics and viewing patterns for the Third Style, and for those walls of the Fourth and later styles that are based on the individual picture as a modular unit of design, differ little from those of today in our own interior decoration. In the modern period people of similar class and pocketbook to the ancient Pompeians buy pictures to make groupings or arrangements on walls that are conceived as flat surfaces to be adorned. The basic difference, of course, is that while our pictures hang on the wall, the Pompeian walls, pictures and background alike, were executed in fresco technique on wet plaster. The permanence and expense of such mural painting must have encouraged the ancient owner or patron to select his or her pictures carefully. Of course, rearrangement of pictures was impossible without replastering and repainting the whole wall.[85] When we consider that the owner chose not only the *form* of the imitation pinacotheca but also the *style* and subject matter of the paintings themselves, we have a further index of his or her tastes.

THE LATE THIRD STYLE, A.D. 25–45

If the early Third Style totally closed the wall, treating it like the flat plane that it was and reserving illusionism for the central pictures, the late Third Style begins to reopen it through thin, fantastic architectural elements in slots flanking the aedicula or, more irrationally, as separate, miniature stage fronts located in the upper zone. To the restricted palette of black, red, and white characteristic of the early phase are added light blue, sea green, and gold. New decorative motifs, such as candelabra, Dionysian wands (thyrsi), and garlands appear, carried out with a clear taste for the linear, miniaturistic elaboration.[86]

PTOLEMY PHILADELPHUS AND THE FOURTH-STYLE TAPESTRY MANNER, A.D. 45–79

Rather than constructing temporally successive phases, recent scholarship has favored dividing the Fourth Style into decorations with coherent diagnostic characteristics, which I call "manners."[87] First appearing in decorations of

85. Likewise, it was difficult to preserve favorite images when redecorating without cutting them out of the wall, since the level of the new plaster would be higher than that of the old stratum which contained the cherished picture.

86. de Vos and de Vos, *Pompei Ercolano Stabia*, 344.

87. Mariette de Vos, "Primo stile e maturo quarto stile negli scarichi provenienti dalle macerie del terremoto del 62 d. C. a Pompei," *Mededelingen van het Nederlands Instituut te Rome 39*

around A.D. 45, the Tapestry Manner may precede the Plain Manner and the Theatrical Manner by about a decade. The Tapestry Manner employs the motif of the hanging carpet with carefully executed borders (Fig. 20). These "carpet borders" (called by some "filigree borders"), although derived from textiles, constitute a diagnostic trait for all Fourth-Style walls.[88] Flying figures or pictures decorate the centers of these tapestries, which often hang from large, gold candelabra or from thin, multistoried pavilions that create a perspectival slot behind them. Sometimes the tapestries effect startling contrasts with their large fields of red and gold or light blue and black. As in the Third Style, central pictures abound, with a preference for brightly colored scenes representing dramatic moments in the mythological or heroic cycles.[89]

Scholars have connected the Tapestry Manner with Ptolemy Philadelphus, ruler of Egypt between 285 and 239. Athenaeus's description of Ptolemy's entertainment pavilion demonstrates how important tapestries were in the luxurious decorations characteristic of the Hellenistic period:

This roof was draped with a circular canopy in scarlet edged with white, covering the middle of it; while on either side it had beams concealed by tapestries with white stripes draped voluminously about them; between the beams were painted panels set in order. Of the columns four were shaped like palm trees, but those which stood in the middle had the appearance of Bacchic wands (*thyrsi*). . . . Inside, the pavilion was surrounded by Phoenician curtains, . . . also there were tunics of cloth of gold and most beautiful military cloaks, some having portraits of kings woven in them, others depicting subjects taken from mythology. . . . In the spaces between the recesses were left niches in which were set up Delphic tripods of gold. . . . On the couches were spread purple rugs made of wool of the first quality, with pile on both sides; and over them were counterpanes embroidered with ex-

(1977): 29–47; Irene Bragantini, "Tra il III e il IV stile: Ipotesi per l'identificazione di una fase della pittura pompeiana," in *Pompei, 1748–1980: I tempi della documentazione*, ed. Irene Bragantini, Franca Parise Badoni, and Mariette de Vos, exh. cat., Pompei and Rome (Rome, 1981), 106–118; Mariette de Vos, "Die Casa di Ganimede in Pompeji VII 13, 4: Pavimenti e pitture: Terzo e quarto stile negli scarichi trovati sotto i pavimenti," *Römische Mitteilungen* 89 (1982): 315–352; Volker Michael Strocka, *Casa del Principe di Napoli (VI 15, 7–8)*. Deutsches archäologisches Institut, *Häuser in Pompeji*, vol. 1 (Tübingen, 1984), 35–41; Strocka, "Ein missverstandener Terminus," 137; William Carthon Archer, "The Paintings in the Alae of the Casa dei Vettii and a Definition of the Fourth Pompeian Style," *American Journal of Archaeology* 94, no. 1 (1990): 95–123.

88. Archer, "Definition of the Fourth Pompeian Style," prefers the term "filigree border"; Claudine Allag and Alix Barbet, "Les bordures ajourées dans le IV style de Pompei," *Mélanges de l'Ecole française de Rome, Antiquité* 93 (1981): 917–942, for a compilation of the abundant mutations of the motif; see also Ulrike Riemenschneider, "Pompejanische Ornamentbänder des vierten Stils," *Boreas* 9 (1986): 105–112.

89. de Vos and de Vos, *Pompei Ercolano Stabia*, 344.

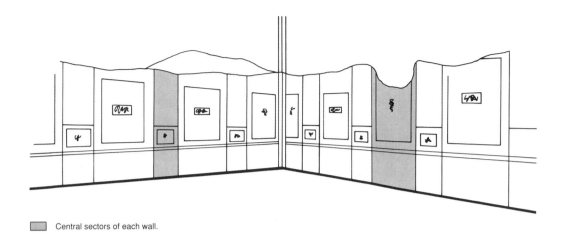

Central sectors of each wall.

FIGURE 20. A series of textile panels creates a repeating pattern in the Fourth-Style Tapestry Manner.

quisite art. Smooth Persian carpets covered the space in the middle trodden by the feet, having beautiful designs of figures woven in them with minute skill.[90]

Several elements of the Tapestry Manner occur in Athenaeus's account: painted panels alternating with tapestries, columns in the shape of thyrsi and palms, textiles with portraits (perhaps in medallions, as often occurs in Fourth-Style decorations) and mythological scenes, and Delphic tripods in gold as recurring infilling ornaments. Given the temporal distance between Athenaeus and Ptolemaic Egypt (Athenaeus was writing around A.D. 200) as well as the span between 250 B.C. and A.D. 45, when the Tapestry Manner appears, it is unlikely that these Fourth-Style schemes were directly inspired by accounts of Ptolemy Philadelphus's pavilion. Instead, the Tapestry Manner represents a painted version of decorations in the houses of the very wealthy that, like Ptolemy's pavilion, employed richly figured tapestries, fanciful columns, Delphic tripods, and the like.

Whatever its origins, the Tapestry Manner represents a new decorative conceit that held great appeal for patrons tiring of the chilly rigors of the flat, min-

90. Athenaeus Sophistes *Deipnosophistae* 5.196a–197c; Ellen E. Rice, *The Grand Procession of Ptolemy Philadelphus* (Oxford, 1983), 138–150, argues convincingly that Athenaeus, although

iaturistic Third Style. In addition to the associations with the grandeur of Ptolemy's famous tent, the Tapestry Manner offered greater variety in the treatment of the flat wall. The perspective views provided by the stacked pavilions on either side of the taut tapestries interrupted the walls' flatness (see Fig. 143).

In terms of perception, the Tapestry Manner introduced a compromise not available in Third-Style schemes, where one had the choice of either a synthetic view of the whole wall or a close-up, analytic view of its details. Now the viewer could inspect the walls in sectors defined by the stacked pavilions between tapestries. This division of the wall into sectors provided a variety of more or less equivalent viewing stations for the spectator (see Fig. 20).[91]

There are bold changes in color schemes as well.[92] White or red upper zones and ceilings, often decorated with airy aediculae made of lacy carpet borders in gold, or taut metallic ornaments, offered a relaxed alternative to the sparse and often barely legible decoration of Third-Style upper zones. Room 38 of the Villa of Oplontis offers a good example of a red Tapestry Manner room dating to A.D. 45–55 (see Fig. 87).

THE PLAIN MANNER

The Plain Manner emphasizes the wall's flatness by dividing it geometrically into a patchwork of colored panels arranged horizontally and vertically. In place of the perspective slots at either side of the taut textiles of the Tapestry Manner are conventionalized ornamants like candelabra and incense burners. The Plain Manner instead activates the wall by juxtaposing the colored panels themselves, in white, black, bright red, and porphyry red.

Although the Plain Manner is somewhat facile, it would not be accurate to characterize it exclusively as a poor person's version of the Fourth Style. On the other hand, when practiced by workshops of relatively poor quality engaged in decorating lower-class houses, like the workshop of the via Castricio discussed by de Vos,[93] the Plain Manner's appeal to the householder of meager means is obvious.

writing about A.D. 200, accurately reproduced the part of Kallixeinos's lost text, *About Alexandria*, which he quotes in his *Deipnosophistae*.

91. Scagliarini, "Spazio e decorazione," 13.

92. Wallace-Hadrill, "Social Structure," 74–75, posits a hierarchy of color in the Fourth Style, on an ascending scale from white, the least expensive option, through yellow and red ocher, to the rarest colors: cinnabar red, blue, and black. Since he bases his claim on a very few examples, the usefulness of this hierarchy is doubtful. The same applies to two other hierarchies he proposes, those of motifs and frameworks, on 75–76.

93. Mariette de Vos, "La bottega di pittori di via di Castricio," in *Pompei, 1748–1980: I tempi della documentazione*, ed. Irene Bragantini, Franca Parise Badoni, and Mariette de Vos, exh. cat., Pompei and Rome (Rome, 1981), 119–130.

Wall decoration of the Plain Manner depended for its aesthetic effect on contrast of color and shape rather than on the alternation of flatness and spatial slots used in the Tapestry Manner. When well executed, particularly in combination with the black or red cement or white tessellated floors, this manner conveyed restrained elegance.

NERO, FABULLUS, AND THE FOURTH-STYLE THEATRICAL MANNER

The Tapestry Manner and the Plain Manner seem quite tame in comparison with the exuberant Theatrical Manner. Its salient characteristic is the scaenae frons, or stage front, consisting of a shallow podium surmounted by a median zone composed of adjacent, stacked aediculae, topped by yet another stage front in the upper zone (see Fig. 135). The Theatrical Manner converts the flat wall into a kind of slotted screen in which each aedicula or opening frames a limited perspective view, often suffused with a hazy white light that grays architectural members in atmospheric perspective. Upper zones tend to be evanescent and airy, rendered throughout in indistinct whites, golds, and grays. Theatrical too are the figures descending staircases within these stage fronts; sometimes, as in the House of Pinarius Cerialis, actors play recognizable parts on the stage.[94]

Despite the Theatrical Manner's delight in architectural illusionism, it does not signal a full-fledged return to the Second Style. Whereas the Second Style depended on making the viewer believe that its fictive columns and pilasters supported the ceiling, the Theatrical Manner's architecture supports nothing. Views through the stage front's aediculae provide local, bracketed spatial release; they are not extensive enough to induce the viewer to believe she or he is standing in a portico looking out at the landscape or into a sanctuary. Assertively flat decoration interspersed among the aediculae—such as pictures in central aediculae, stretched tapestries with flying figures, monochrome panels, and faux-marble socles—keep returning the viewer to the wall as a spatial limit. If anything, the Theatrical Manner signals an eclectic summation of elements of all three previous styles, from the imitation marbles of the First Style to the architectural conceits of the Second to the miniaturism and central aedicular pictures of the Third.

As with the Tapestry Manner, there is no single viewing station in the Theatrical Manner; the proliferation of points of interest entices the viewer into examining the entire wall, feature by feature. While it is true that the scaenae frons serves as an armature to give the figural and decorative elements logical

94. Illustrated in Gilbert Picard, *Roman Painting* (New York, 1968), 73 and 74–75.

FIGURE 21. A lost scaenae frons decoration from Nero's Golden House, A.D. 64–68.

slots, and symmetrical repetition of color and motifs balances the visual field, the effect is one of an allover pattern rather than one with a single focus of interest. When combined with important central pictures, as in the Ixion oecus of the House of the Vettii, the viewer comprehends the wall painting in two stages. The first view identifies the meanings of the central pictures. The second view takes in the imagery arranged in sectors or slots in the more or less uniformly activated wall surfaces (see Fig. 135). This "something for everyone" approach oversteps the boundaries of restraint and miniaturism of the Third Style yet provides much more latitude in choice of subjects than the standard sacred groves and temple precincts of the Second. The Theatrical Manner's allover pattern evolves into the panel styles typical of the second and early third century.

Scholars have associated the Theatrical Manner with Nero (A.D. 54−68) for good reason, since his own Golden House in Rome had many decorations based on the scaenae frons (Fig. 21), slotted with stacked aediculae resting on a shallow stage podium. The emperor's well-known enthusiasm for the theater probably encouraged decorators in search of novel effects.

Another figure haunts the tradition of the Theatrical Manner, the enigmatic Fabullus (or, in a variant manuscript, Famullus), Nero's court painter.[95] Fabullus's manner, described in the practically untranslatable words *floridus humidus,* can only be deduced from examination of the poorly preserved evidence of Nero's Golden House (64−68) and his Domus Transitoria (60−64). Nicole Dacos's characterization of his manner and that of another artist working on the decorations of these palaces, based on careful techniques of formal analysis, gives us some notion of Fabullus's style.[96] Often described as "impressionistic," Fabullus's rapid manner created sharp contrasts of highlight and shade distinct from the prevalent system of gradual tonal modeling. Highlights take abstract, irrational forms, like the zigzag, in their description of glancing light and reflections. This manner appears in both wall painting and mosaics at Pompeii and Herculaneum.[97]

With good reason art historians have applied the term "baroque" to the painting and architecture of the period of the Fourth Style.[98] A symptom of the

95. Pliny the Elder *Naturalis Historia* 35.37.120, gives: "fuit et nuper gravis ac severus idemque floridis tumidus pictor Famulus."

96. Nicole Dacos, "Fabullus et l'autre peinture de la Domus Aurea," *Dialoghi di archeologia* 2, no. 2 (1968): 72−87.

97. Clarke, *Mosaics,* 65, who calls Fabullus's manner, translated into mosaic, the "Neronian Fluid Highlights Style."

98. Peter H. von Blanckenhagen, *Die flavische Architektur und ihre Dekoration* (Berlin, 1940).

showy taste is the proliferation of stucco moldings in the Fourth Style. Sober, white, and rectilinear in the Second and Third Styles, they appear with friezes of animals and palmettes in the Fourth, painted in red and blue. Often a wall will be both framed at the top of the upper zone with one such molding and then divided again between the median and upper zone with a second stucco molding, as in the Cyparissos room of the House of the Vettii (see Fig. 136). Stuccoists made these figural designs with wooden molds which they pressed into the still-wet plaster.[99]

TRADITION AND CLASSICISM IN HADRIANIC STYLES

Anyone attempting to characterize post-Pompeian decoration runs the risk of creating classifications according to style and architectural systems based on relatively scanty evidence.[100] If we can speak of styles and substyles or manners because of the abundant preserved wall painting and mosaics predating the eruption of Vesuvius in A.D. 79, we can extrapolate only from a few well-preserved houses or walls after that date. Nevertheless, several period styles can be distinguished because of their resonance with the stylistic characteristics of contemporary sculpture in the round and in relief.

Characterized by the revival of the forms of fifth-century Greek classical art, the Hadrianic period has been called "A Chapter in the History of Greek Art."[101] If the painted, stuccoed, and mosaic decoration of Hadrian's own villa at Tivoli had been better preserved, it would have provided a much clearer notion of the characteristics of Hadrianic decoration.[102] As matters stand, two distinct Hadrianic styles can be distinguished. One derives from the illusionistic architectural schemes of the Second Style (see Pl. 20), with fictive columns ap-

99. On stucco technique, see Roger Ling, "Stuccowork," in *Roman Crafts*, ed. Donald Strong and David Brown (New York, 1976), 209–221; Roger Ling, "Gli stucchi," in *Pompei 79*, ed. Fausto Zevi (Naples, 1979), 145–160; Ulrike Riemenschneider, *Pompejanische Stuckgesimse des dritten und vierten Stils* (Frankfurt, 1986).

100. For example, Fritz Wirth, *Römische Wandmalerei vom Untergang Pompejis bis ans Ende des dritten Jahrhunderts* (Berlin, 1934), employed a formal-descriptive approach, based on a simplistic interpretation of Alois Riegl's evolutionary scheme, which caused his analysis to fall into serious chronological and interpretative difficulties.

101. Jocelyn Toynbee, *The Hadrianic Style: A Chapter in the History of Greek Art* (Cambridge, 1934).

102. See Hetty Joyce, *The Decoration of Walls, Ceilings, and Floors in Italy in the Second and Third Centuries A.D.* (Rome, 1981), passim, and Hetty Joyce, "The Ancient Frescoes from the Villa Negroni and Their Influence in the Eighteenth and Nineteenth Centuries," *Art Bulletin* 65, no. 3 (1983): 423–440.

pearing to support the architrave. Slots with shallow architectural perspectives, like those of the Theatrical Manner, open up the wall in small areas, and monochrome panels with figures or paintings provide axializing accents. In terms of perception, this Hadrianic reprise of the Second Style prompts the viewer to stand in the center of the room to take in the architectural construction, then to investigate each figure or picture on its axis. In comparison with the Theatrical Manner, the Hadrianic architectural style is measured, restrained, and sober, and encourages a calm, contemplative response from the viewer. And unlike the Second Style, the Hadrianic architectural style avoids deep centralized perspectives so that it does not require the viewer to center him- or herself on axis with the vanishing point.

The second Hadrianic style stems from the aedicular schemes of the Fourth-Style Tapestry Manner (see Pl. 22 and Fig. 172). It too provides slots of stacked aediculae that frame monochrome areas, often decorated with garlands, filigrees, and other miniaturistic decoration suggestive of embroidery. On these panels delicately painted figures frequently appear. The viewer's perception of a room painted in the Hadrianic aedicular manner is a more unified one than for a room in the full-blown Tapestry Manner because of its restrained (often monochrome) color scheme and the shallowness and delicacy of the aediculae themselves. In this manner the central sector of the wall, framed by the aediculae, is often wider than its flanking sectors. Yet because this central sector contains a figural element little different from those of the side panels, the viewer perceives the decoration in vertical sectors rather than in relation to the axial center of each wall.

We have a much better sense of the Hadrianic style in floor mosaics, well documented both at Ostia and at Hadrian's Villa. Two styles, both dependent on linear outlining systems, characterize figural mosaics.[103] Purely decorative mosaics likewise emphasize a wealth of linear detail, delighting in complex geometric patterns of carefully laid black tesserae on a white ground, like the mosaic of room 5 in the House of the Muses, or the floors of the "Hospitalia" at Hadrian's Villa.[104] As we shall see, analysis of the decorative mosaics in their architectural contexts reveals that their patterns often emphasize the axis of entry and viewing axes within their spaces.

Hadrianic ceiling decoration, in both stucco and fresco, like the decoration

103. Clarke, *Mosaics,* "The Draftsmanly Style," 69–74, and "The Hadrianic Classicizing Style," 74–78.
104. Salvatore Aurigemma, *Villa Adriana* (Rome, 1961), 179, fig. 185, 181, fig. 189; Marion E. Blake, "Mosaics of the Second Century in Italy," *Memoirs of the American Academy in Rome* 13 (1936): pl. 11, fig. 2.

of floors, favored clear linear designs on a single-colored ground. Such was the original scheme of the monochrome yellow room 4 of the House of the Painted Vaults (see Fig. 184).[105]

EARLY ANTONINE STYLES, A.D. 138–160

The early Antonine period saw the further development of repetitive aedicular decorations, often in all-white or all-yellow rooms.[106] In rooms 4–6 of the House of the Yellow Walls, the aediculae are painted against red vertical panels, and tiny landscape pictures adorn the yellow panels they frame (see Fig. 190). A similar scheme, but without the panels, appears in rooms 5 and 6 of the House of the Painted Vaults (see Fig. 186).

Although, as in the Hadrianic systems using stacked aediculae, the early Antonine versions place some stress on the center of the wall, the insistent pattern set up by the alternation of the bright red and yellow panels encourages the viewer to see the wall as an allover pattern. Only with some effort will the viewer come closer to look at the landscape panels or the details of the aediculae themselves.

Although it cannot be seen as a separate manner, but as a tendency that develops in this period, architectural members in rooms 11–12 in the House of the Painted Vaults support a lunette zone on each wall with representations of statues on pedestals in front of porphyry red and gold panels (see Fig. 181). In the following period these panels gain further autonomy, until in the Severan period they constitute an autonomous style.

Mosaic decoration changes little in this period. Some new decorative motifs are introduced, but workmanship and technique generally are maintained at Hadrianic levels.

LATE ANTONINE STYLES, A.D. 161–193

The best-preserved example of late Antonine painting, in room 4 of the House of Jupiter and Ganymede (see Pl. 23 and Fig. 203), has many features of the Theatrical Manner of a century before, but with a difference. Now the flat panels that punctuate the architectural armature shift in their vertical alignment, and figures that were once carefully anchored to architectural slots or placed in

105. Bianca Maria Felletti Maj, *Le pitture della Casa delle Volte Dipinte e della Casa delle Pareti Gialle*, Monumenti della pittura antica scoperti in Italia, sec. 3, Ostia fasc. 1–2 (Rome, 1961), fig. 6.
106. Joyce, *Decoration*, 26–33, 104–105, calls these "modular aedicular."

the centers of tapestry panels now break away from their framing edges: they float unmoored above or in front of their panels.

Such deliberate misalignments and detachments have important consequences for the viewer. At first glance the wall system's organization in the usual horizontal and vertical divisions seems clear, the general effect being one of a brightly colored patchwork of architectural slots and panels symmetrically arranged around the axis of the central aedicula and its picture. But with time the viewer realizes the autonomy of both the panels and the figures floating before them, and these discrepancies cause the eye to attempt to match elements on the right side of the central axis with those on the left. There is vertical matching as well, as the eye travels from the median zone to the upper zone and back, attempting to resolve the misalignments of panels. Until this point, no matter how complex the decorative system, absolute symmetry ruled for schemes of individual walls. With the nascent Panel Style in the House of Jupiter and Ganymede comes a daring experimentation with asymmetry, activating the wall with units that teasingly approximate, but fail to fit into, a symmetrical, grid-based structure.

This period also sees a rather straightforward reprise of the Hadrianic architectural style in the House of the Painted Ceiling (see Fig. 196). Although solid, illusionistically painted columns reappear, they rarely support anything other than decorative elements atop their capitals. Added to the porphyry red and gold panels introduced in the early Antonine period are bright blue panels. Monochrome rooms, particularly yellow rooms with skeins of aedicular perspectives, garlands, and tiny landscape pictures, seem to have remained in fashion, if room 9 of the House of Jupiter and Ganymede is any gauge (see Fig. 210).

ARCHITECTURAL, PANEL, AND LINEAR STYLES
IN THE SEVERAN PERIOD

The tenacity of the tradition, established in the first century B.C., of using illusionistic architecture to divide wall surfaces is evident from its final appearance in the Severan period (see Fig. 215). Although the columns do not seem to have held architraves that "supported" the ceiling, elements such as theatrical masks on ledges and illusionistic doors testify to the antiquity of the sources.

The Panel Style carries the experiments witnessed in the House of Jupiter and Ganymede to their logical conclusion, doing away with architectural armatures entirely in favor of a system built of individual panels of varying shapes and sizes pieced together to cover the wall (see Pl. 24). These panels

hold figures taken from the old repertory of pans, maenads, poets, and philosophers that had been mined repeatedly during the second century. The Panel Style is significant for its deliberate trespassing and disassembly of the rectilinear grid of straight horizontal and vertical lines that had been the basis of all previous wall systems. Deliberate irregularities such as panels "hung" slightly askew or their asymmetrical distribution on the walls may also be the basis for the Severan Linear Style discussed below.

In terms of the viewer's perception, the Panel Style is the style of the wandering eye, for the axializing architectural constructions that stabilized the gaze on the center of the wall and on its horizontal zones have been jettisoned. Although there are general patterns in the disposition and colors of the panels and correspondences from one wall to another, gone are the symmetry and mirror reversals of previous times.

Black-and-white mosaics undergo a parallel revolution in the Severan period. Decorative designs based on lines, whether straight or curved, disappear in favor of the juxtaposition of black shapes and white shapes that compete for attention much in the same way as the panels of the Panel Style (see Figs. 213 and 214). Figure-ground reversals in interlocking designs produce vibrating optical effects.

Most daring of all painted schemes is the Severan Linear Style. On a monochrome white ground, stripes in red and green, drawn without aid of plumb bob or straightedge, make up a tracery of pseudo-architectural members such as aediculae and architraves (see Fig. 225). In turn they frame more carefully painted central motifs, often depicted in green, red, and white. The effect of optical vibration of the complementary colors, red and green, coupled with the wild pattern of linear skeins against the white ground, is as overwhelming as it is revolutionary.

Although there are too few good examples of Severan decoration remaining to judge, the presence of three different hands in the Inn of the Peacock suggests that the division of labor between imaginarius and parietarius still held. With the Linear Style this division is even more probable, since once the wall was whitened, the parietarius could complete all the striping in preparation for the imaginarius's addition of the central motifs in added secco.

This overview of styles of painted and mosaic decoration should aid us in our investigation of the case studies of individual houses that follows. Now we can ask, with our expectations based on this overview, how decoration signaled the functions of a house's spaces, how it modified them, and how it coordinated suites of spaces. With a notion of how the viewer perceived the spaces of a house and their systems of decoration, we can assess the particular effects

of specific decorative programs. Knowing more about how architect and work-men carried out decorative ensembles, we can expect signs of their collabora-tion. Finally, knowing the choices available in a particular period, and realizing that a particular individual chose the decorations for his or her house, we can investigate the question of patronage through study of personalized imagery on walls, ceilings, and floors.

CHAPTER THREE

DECORATIVE ENSEMBLES OF THE LATE REPUBLIC, 100–30 B.C.

Pompeii and Herculaneum, the towns where our case-study houses of the Late Republic lie, had different social and economic structures. It is worth considering some details of society and economics in these towns as background to the possible social and economic status of their owners.

Through Pompeii's long and checkered history, the city retained its importance in both commerce and agriculture (Map 2). Located on a high volcanic escarpment a hundred feet above the ocean and bordered by a navigable river (the Sarno), Pompeii was a trade node between the inland cities, particularly Nola and Nocera, and the coastal cities and islands of the Mediterranean. It was surrounded by fertile, well-managed farms that produced fine wine and oil; these were owned by many local aristocrats living in Pompeii. Pompeii's greatest prosperity was perhaps in the late Samnite period (third and second centuries B.C.), when the completely Hellenized Samnites built fine houses and public monuments. By the second century these were decorated in the First Style. It is significant that some private houses in Pompeii were equaled neither in much larger contemporary Italian cities nor in the Hellenistic east. Paavo Castrén notes that in its later (First-Style) phase of ca. 110 B.C., the House of the Faun was much larger than the royal palace at Pergamon, indicating that the owners must have been very rich men by standards of their time.[1]

Not everyone in the Samnite period lived in large houses. Studies of land use at Pompeii provide a profile of the kinds and sizes of houses people of different social classes lived in. Two-thirds of the city was devoted to private housing. Arnold and Mariette de Vos have divided the existing houses into three class-categories. The domus-with-peristyle category varied in size between 3,000 square meters (9,750 sq. ft.) and 450 square meters (1,463 sq. ft.) and belonged to the local aristocracy, made up of landowners and rich businessmen.

1. Paavo Castrén, *Ordo populusque pompeianus: Polity and Society in Roman Pompeii*, Acta Instituti romani finlandiae, no. 8 (Rome, 1975): 40.

Artisans, small businessmen, and freedmen lived in smaller houses, between 350 square meters (1138 sq. ft.) and 120 square meters (390 sq. ft.). These were the covered atrium houses mentioned above. The poorest class lived either in rooms behind their shops or in a mezzanine above the shops.[2]

Precisely at the time the Second Style found its earliest formulation in the House of the Griffins in Rome, Pompeii suffered a political and economic blow. During the Social War Pompeii sided with Italian allies who fought to gain full Roman citizenship. As a consequence of being allied with the losing side, Pompeii lost its autonomy in 80 B.C. and became a colony. It was perhaps Sulla's nephew who renamed the city "Colonia Cornelia Veneria Pompeianorum" after himself and Sulla's (and the Pompeians') favorite goddess, Venus.[3] Veterans and pro-Sullan factions took over a degree of the local aristocracy's power and property, although it seems that the confiscated land was never completely allotted to the veterans, with much of it reverting to the hands of a smaller number of rich landowners.[4] This post-colonization period is precisely the one in which the Villa of the Mysteries received its mature Second-Style decoration. Economic and social struggle probably had little effect on the owners of the Villa of Oplontis, a few kilometers from Pompeii. They constructed the Second-Style core of their seaside estate from the ground up beginning in about 50 B.C. It seems, then, that although politically the Sullan colonization caused a radical but temporary change in the municipal life of Pompeii, little changed from an economic and cultural standpoint. The thoroughgoing Romanization of Pompeii occurred later, in the Augustan period.

Less is known about the society and economics of Herculaneum (Map 1), and it is impossible to speak of the average sizes of houses there, since an area only one-eighth the size of Pompeii has been excavated (5 vs. 40 hectares). One can state with some certainty, however, that in general the houses at Herculaneum were smaller. As a suburb dependent on Naples, its own economy was relatively stagnant, probably based on fishing.

The Samnite House, as its name suggests, records in its fine First-Style decoration a period of greater wealth at Herculaneum. By the time of the eruption in 79, this house's original area had been drastically reduced. The wealthy seemed to have settled close to what is now the excavated area of the town, however, which includes part of the forum and the theater. The Villa of the Papiri, for example, contained about one hundred bronzes and an extensive

2. de Vos and de Vos, *Pompei Ercolano Stabia*, 333–334; James E. Packer, "Middle- and Lower-Class Housing in Pompeii: A Preliminary Survey," in *Neue Forschungen in Pompeji*, ed. Bernard Andreae and Helmut Kyrieleis (Recklinghausen, 1975), 141.

3. Castrén, *Ordo populusque pompeianus*, 52.

4. Castrén, *Ordo populusque pompeianus*, 53.

library of papyrus rolls. For the affluent owners of nearby villas, Herculaneum was a vacation spot on the beautiful Bay of Naples.

THE FIRST STYLE IN THE HOUSE OF THE FAUN

Because most evidence for decorative ensembles of the First Style in Roman Italy comes from the sites buried by Vesuvius in A.D. 79, it is important to note that the First-Style decoration we can study from those sites was already quite old at the time of the eruption. The ancient Romans valued these venerable decorative ensembles and often went to the trouble of restoring them when damaged rather than redecorating in the style in vogue at the time.[5]

This was true in the House of the Faun at Pompeii, where owners preserved decoration of the First Style for about two hundred years (Fig. 22). Excavated between 1830 and 1832, it is an extraordinarily large and luxurious house, occupying 3,050 square meters, an entire insula in the sixth region. Its major decorative scheme, of the late second century B.C., consisted of First-Style painted stucco walls imitating luxurious marble revetment, and lavapesta and opus sectile floors adorned with costly mosaic emblemata, worked in the opus vermiculatum technique. At the time of its excavation, this decorative program was in sufficiently good state for it to be studied as a whole. Unfortunately, after the mosaic emblemata were removed (they are presently in the Museo Archeologico Nazionale in Naples), the remaining walls and floors were not protected from the elements, and the house was mistakenly bombed by the Allies in the Second World War. We can make up for these losses to a certain extent, thanks to the *envois*, that is, the highly finished architectural renderings, in china ink, crayon, and watercolor washes, carried out shortly after the house's excavation by François-Florimond Boulanger (in 1839) and Alfred Normand (in 1849–50), two *pensionnaires* of the Ecole des Beaux-Arts.[6] With their aid we can get a notion of how the house's surfaces were decorated.

Boulanger's longitudinal section of 1839 runs on an axis from the fauces through the exedra of the Alexander mosaic (no. 37), showing actual states of the walls of the fauces, atrium, first peristyle, exedra of the Alexander mosaic, and the second peristyle. Boulanger provides further details of the Alexander exedra in an east-west section; one of Normand's drawings details the exedra's east wall.

5. Anne Laidlaw, *The First Style in Pompeii: Painting and Architecture* (Rome, 1985), 42–46, for the preservation of First-Style decoration in houses.

6. Ecole nationale supérieure des beaux-arts, *Pompéi: Travaux et envois des architectes français au XIXᵉ siècle*, exh. cat., Naples and Paris (Rome, 1980), 240–245, figs. 83–86.

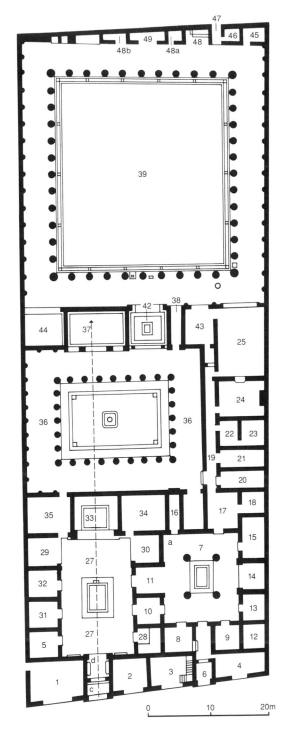

FIGURE 22. Plan of the House of the Faun, with visual axis marked.

The House of the Faun's facade of tufa blocks was punctuated with six openings—four for shops and two for entrances into the house.[7] In the sidewalk outside the principal entrance tesserae of colored limestone spell out the greeting HAVE. Triangles of limestone and colored slate pave the vestibule floor; door jambs and capitals are of tufa. The doors of the fauces opened outward to prevent damage to the First-Style stucco decoration of the upper zone: a little temple with four columns that was originally supported by consoles (now vanished) in the shape of sphinxes and lions.

A dramatic visual axis from the fauces permitted the visitor to look through the atrium and through a broad window in the tablinum into the first peristyle.[8] Features treasured by the owner marked this visual axis. The unusual placement of the bronze faun in the center of the impluvium gave novel emphasis to the visual axis, and the exedra containing the Alexander mosaic was its eventual goal. The path to the Alexander mosaic was considerable: over 50 meters (162.5 feet) long, and the actual walking distance considerably longer, since the visitor invited to view the mosaic would have had to walk around the tablinum and circle half of the first peristyle to arrive at this important exedra.

Rich decorative motifs on floors and walls marked the spaces along the visual axis. The sill facing the atrium contained a fine figural mosaic with tragic masks in a garland of flowers and fruit.[9] The atrium itself was unusually splendid, since recent hypotheses would restore it with a fictive gallery above the high doors of the ground floor, perhaps employing the Ionic half-columns found at the time of the excavation stored in the second peristyle.[10] The First-Style Samnite House in Herculaneum has this kind of loggiate atrium on a much smaller scale (Pl. 1). The impluvium today retains its pavement in rhombs of colored slate, with the bronze faun dancing in its center. To complete the picture, we must imagine a wooden lacunary ceiling, perhaps gilded, high above.

Although the tablinum's wall decoration is poorly preserved, the cut-marble (opus sectile) floor in white travertine, black slate, and green limestone presents a rich pattern of cubes in perspective. This choice of an abstract decoration rather than a figural emblema may indicate that the owner preferred to think of this tablinum as a dynamic space rather than a static one, since both alae and

7. The east entrance is a later modification.

8. See Lise Bek, *Towards Paradise on Earth: Modern Space Conception in Architecture: A Creation of Renaissance Humanism. Analecta romana Instituti danici,* supplement 9 (Rome, 1980), fig. 67.

9. Now in the Museo Archeologico Nazionale, Naples. Erich Pernice, *Die hellenistische Kunst in Pompeji: Pavimente und figürliche Mosaiken* (Berlin, 1938), pls. 73–74.

10. A. Hoffmann, "Ein Rekonstruktionsproblem der Casa del Fauno," *Bericht Koldewey-Gesellschaft* (1978): 35–41; Laidlaw, *First Style,* 32 note 24.

the triclinia that flank the tablinum received costly emblemata vermiculata, meant to be seen from a single, static viewing position.

The path to the first peristyle behind the tablinum is a relatively narrow corridor to its left. The peristyle's First-Style decoration answers the columns on the outboard side with engaged pilasters in its inboard wall—the perfect decorative system for a dynamic passageway space, unaccented and therefore requiring no stops along the way to view it. From Boulanger's rendering one can see that four columnar elements framed the opening of the Alexander exedra. Two red fluted columns on individual bases stood to right and left of the exedra's axis, complemented by two matching pilasters wrapped around the actual opening. A mosaic threshold band with a Nilotic landscape continued this framing on the floor. Within the exedra was the Alexander mosaic; unlike the other emblemata in the house, it was executed on the spot, employing more than a million and a half tesserae.

Viewing the Alexander mosaic in its original architectural setting must have been problematic at best. Although the columnar framing of the exedra and the Nilotic scene mark it off from the rest of the peristyle, nothing prepares the viewer for the enormous, perspectively complex picture on the exedra's floor.

As discussed in chapter 2, it is a paradox that copies of famous paintings executed in tiny mosaic tesserae constituted the only illusionism in First-Style ensembles. The Alexander mosaic, because it occupied 80 percent of the exedra's space, exaggerates the problem of how a person must be positioned in order to comprehend the imagery on the floor. In order to see and understand even an average-sized emblema, the viewer must stand in the center of the emblema's lower edge; in this position the picture is right-side up. In most rooms the emblema is centered on the room's axis of entry. Irving Lavin has shown that mosaicists were aware of the demands the illusionistic picture on the floor made on the viewer's position, and that ultimately designs using individual emblemata were abandoned in favor of allover designs.[11] But in the period of the First and Second Styles the Romans preferred the spatial disruption and neck-craning viewing of illusionistic mosaic emblemata on the floor over the use of pictures painted into the frescoed walls.

From Normand's longitudinal section of 1850 one can see that the First-Style decoration of the Alexander exedra was special, signaling the importance of the space. The socle of the exedra was painted with a representation of drap-

11. Irving Lavin, "The Antioch Hunting Mosaics and Their Sources: A Study of Compositional Principles in the Development of Early Medieval Style," *Dumbarton Oaks Papers* 18 (1963): 187–189, 252–254.

ery, and the central zone had imitation ashlar masonry with a figural frieze in stucco.[12]

The rich decoration of the House of the Faun, and the Alexander mosaic in particular, raises questions of patronage. Who commissioned the original decorative scheme? Today it is believed that the presence of an honorific base with a dedication in Oscan of the aedile Satrius found near tablinum 35 would assign ownership of the house to the Satrii, an old Campanian family that seems to have fallen into obscurity for many years after the arrival of the Sullan colony, probably disenfranchised. They returned to political life in Pompeii only in its last period.[13]

FIRST-STYLE ENSEMBLES IN THE SAMNITE HOUSE

Decorative ensembles still extant in the Samnite House in Herculaneum show how the design principles of the First Style were applied in modest spaces (Fig. 23). Although the Samnite House is about one-sixteenth the size of the House of the Faun,[14] its decorative scheme is not without elegance and refinement.

Located on the southwest corner of Insula V, the Samnite House got its name from the Oscan inscription SPUNES LOPI, found in room 2. Originally constructed around the end of the third century B.C., the house underwent considerable changes in its long life.[15] Most dramatic among these was the sale of its peristyle and garden; the House of the Large Portal now occupies this space, and several of the Samnite House's peristyle columns appear in its fauces. At this time, in the late second or early first century, a partition in *opus incertum* filled in the original openings from the tablinum to the peristyle. It was at this time that a loggia of Ionic columns was added to increase the atrium's height, probably to compensate for the space lost in the sale of the peristyle and garden. As in the House of the Faun, and in the galleried atria in the houses of Delos in this period,[16] the Samnite House's loggiate atrium made it into a kind of royal hall—but in the private domain—intended to impress the visitor, whether peer or client (see Pl. 1). The history of Roman interior decoration is filled with examples of overreaching, sometimes exaggerated schemes intended to associate the owner with the wealth and power he or she never had. The

12. For details on this and other First-Style decorations in the House of the Faun, see Laidlaw, *First Style*, 172–207.
13. de Vos and de Vos, *Pompei Ercolano Stabia*, 164.
14. House of the Faun, ca. 3,050 m²; Samnite House, ca. 190 m²; but much of the area of the House of the Faun consists of walled-in gardens rather than covered rooms.
15. Amedeo Maiuri, *Ercolano: I nuovi scavi, 1927–1958* (Rome, 1958), 1:197.
16. Philippe Bruneau, *L'Ilot de la Maison des Comédiens*. Exploration archéologique de Delos, no. 27 (Paris, 1970), figs. 2, 29, 30 (Maison des Comédiens); fig. 80 (Maison des Tritons).

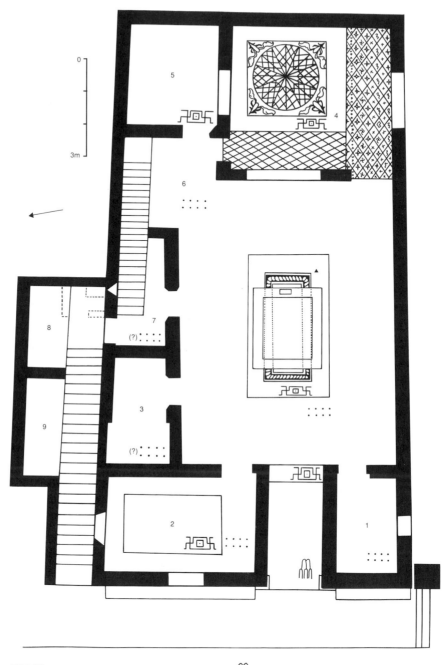

0

3m

Meander with squares ⌐⊡⌐ ⋮⋮ Evenly spaced rows ⋀⋀⋀ Linear scales ▲ Black tesserae used in "braided" border.

FIGURE 23. Plan of the Samnite House, with mosaics indicated.

modern visitor who is surprised at the vertical expansion of space and the refinement of the Samnite House's loggia receives a message consciously embedded by the owner who commissioned this grandiose space for a very small house.

The Samnite House got smaller still after the earthquake of A.D. 62. The loggia, entirely flat on the south side, where it is one and the same with the house's perimeter wall on the street, was filled in on its west and north sides as well, to make room for a second-story rental apartment. A second doorway piercing the once-regal facade opened to a staircase giving access to these rooms. The walls of room 2 were repaired, a new marble impluvium was built over the original in cocciopesto,[17] and—most telling for the impression of the house today—all of the First-Style decoration save that of the fauces was repainted in the Fourth Style.

Today the facade reflects the compromises of these conversions. The added doorway with a small window above is sadly out of scale with the original grand entryway, as is the window between the two doorways added in the final remodeling.[18] A balcony adding space to the upper-story rooms, like that of the House in Opus Craticium across the street, further cuts the facade. Traces of pigment in the facade indicate a two-tone color scheme of a red socle extending to eye level with gold above. If the Samnite House's facade commands attention today, it is because of the main doorway, majestically framed by piers four meters high that form antae and support a dentil range on their Corinthian capitals (Fig. 24). Carved of tufa, these richly ornamented capitals fairly burst with vegetal forms. Even the sidewalk in front of the Samnite House announces its original patrician pretensions, paved in pebbles with a bench for the waiting clientela.

Entering the fauces, the visitor's axial view of the tiny tablinum is framed by carefully orchestrated decoration (see Fig. 8). Its floor slopes upward toward the atrium, with white tesserae set into the cocciopesto in a pattern of outlined fish scales.[19] At the inner limit of the fauces, a threshold band in a meander design with alternating swastikas and squares (as well as a step up) announce the atrium.

Accompanying this pavement in dark red and white is the First-Style decoration of the fauces' walls. The areas where the door's two battens would have rested when open are practically undecorated, articulated in large white vertical panels. Beyond these rise the faux-marble blocks in three registers, the top register consisting of rectangular ashlars skillfully stuccoed and painted to re-

17. Maiuri, *Ercolano*, 201.
18. The window's extreme height matches that of the second doorway, suggesting that they may be contemporary.
19. For the *squame delineate* pattern, see Maria Luisa Morricone Matini, "Mosaico," *Enciclopedia dell'arte antica: Supplemento* (Rome, 1970), s.v.

FIGURE 24. Piers with carved capitals begin the First-Style framing system of the Samnite House.

semble blocks of red, green, white, and speckled marble (that is, porphyry, *verde antico*, alabaster, and *portasanta*).[20] The faux-marble blocks support dentil ranges matching the one over the entryway.

Above them extend landscapes, best preserved on the north wall (Fig. 25). Painted in the period of the Second Style, the landscapes seem to have been an afterthought, since even when in pristine condition they would have been diffi-cult to read. In this passageway a viewer could hardly be able to contemplate their spatial and symbolic complexities. What remains suggests a sacro-idyllic landscape. On the left appears an eight-columned temple front bordering a body of water interrupted by a large column or monument; to the right are two female figures, a sacred tree within a fence, and another shrine. As Maiuri notes, the landscape's pale colors can scarcely compete with the rich colors of

20. Maiuri, *Ercolano*, 200.

FIGURE 25. The landscape panel and the representation of a lacunar ceiling are Second-Style revisions of the Samnite House's First-Style fauces.

the faux marble.[21] Furthermore, the landscapes are the largest figurative panels in the house. Landscapes like these appear in several Second-Style decorative ensembles in this study, always placed well above the viewer's head.[22]

Another Second-Style substitution appears in the fauces' ceiling, an illusionistic representation of the actual lacunary or cross-beamed ceiling that must have originally accompanied the faux-marble revetment of the walls. In its fragmentary, faded condition it fails to convince the viewer of its architectural role, but like the Second-Style ceilings preserved at Oplontis (see Figs. 48

21. Maiuri, *Ercolano*, 201.
22. Examples illustrated here include those in the tympanum of the north alcove in cubiculum 11 at Oplontis (see Fig. 50) and in the atrium of the Villa of the Mysteries (see Fig. 29). This tradition continued into the Fourth Style, for instance in the atrium of the House of the Menander (see Fig. 89).

and 49) and in the Villa of the Mysteries (see Fig. 38), it originally must have lent a note of color and variety to the ensemble.

The threshold band on the floor and the framing pilasters and capitals of the antae mark the passage from the fauces to the atrium. Important passageways framed like this signal the end of one space and the beginning of another: similar framing systems occur around major doorways off the atrium, like that of the tablinum or the alae. They are essential to the illusion of First- and Second-Style ensembles, since both styles must convince the viewer that fictive architectural members are real. The fictive piers at major entryways would be needed to support the beam over the opening in actual post-and-lintel construction. In the First Style the piers represented in stucco and paint frame openings and close or complete the rows of orthostates and ashlars making up the room's walls.[23]

A simple pattern of white tesserae laid on the bias forms a grid pattern on the atrium's red cement floor. Two bands of a meander with swastikas and squares surround the impluvium, ending in a fine black-and-white tessellated two-stranded braid executed in much smaller tesserae. The alignment of signinum and tessellated designs suggests that the atrium floor was laid in the first century B.C., perhaps when the atrium received its new elevation and loggia. These bordering bands surround what was originally a signinum impluvium (see Fig. 23) and do not line up correctly with the first-century A.D. marble impluvium.[24] If the overall effect of the atrium floor is that of a carpet, then the impluvium is much like a bordered emblema. Perhaps the original signinum impluvium had an elaborate design like the rosette in the impluvium of House VI, 14, 39 in Pompeii.[25]

As in the other rooms of the house, this simple signinum floor once accompanied First-Style walls like those of the fauces. The combination of these red cement floors with imitation marble walls reflects an economic compromise, since a wealthy patron like that of the House of the Faun could afford to pay for cut-marble or mosaic pavements decorated with emblemata. A similar repertory of designs accompanies the First-Style decoration preserved under triclinium 18 of the House of the Menander. Maiuri's reconstruction of the Samnite House (Fig. 26) gives a sense of this once impressive ensemble.[26] Height, geometric rigor, and the dynamics of post-and-lintel construction employing

23. Daniela Corlàita Scagliarini, "Spazio e decorazione nella pittura pompeiana," *Palladio* 23–25 (1974–1976): 4–7, figs. 1–4; Laidlaw, *First Style*, color reconstruction of the House of Sallust in frontispiece.

24. This does not seem to have concerned the house's inhabitants but has apparently disturbed modern restorers (possibly those of Maiuri's team), who felt compelled to fill in the gaps with fragments of similar signinum.

25. Pernice, *Mosaiken*, 152.

26. Maiuri, *Ercolano*, 2: pl. 18 (reconstruction drawing by R. Oliva).

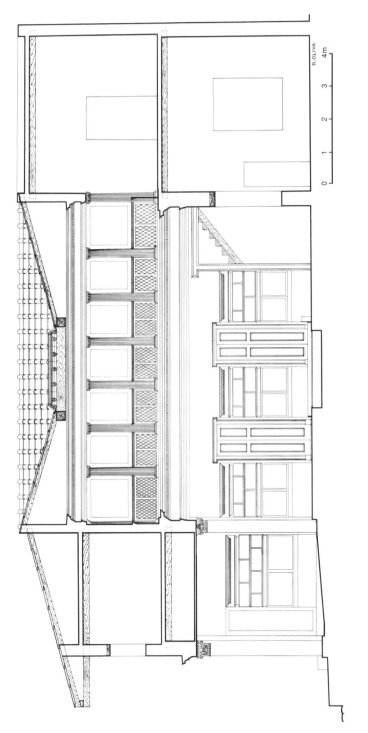

R.OLIVA

0 1 2 3 4m

FIGURE 26. Longitudinal section reconstructing the unity of the Samnite House's First-Style scheme.

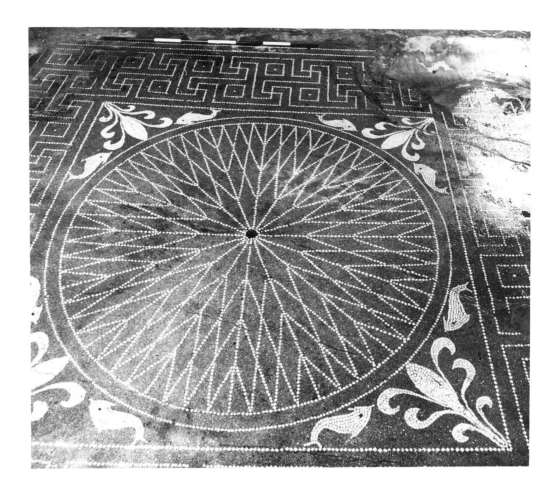

FIGURE 27. A concentric design of white tesserae in red cement (opus signinum) forms the focus of the tablinum's pavement.

marble blocks, piers, and columns make this atrium both spatially expansive and restrained in color and surface.

All of the First-Style features work together to unite fauces and atrium (and originally all the rooms of the house). The framing antae, the supporting horizontal blocks of socle, orthostates, and ashlars, and even the dentillated cornices correspond in both spaces. In the atrium this imitation architecture (now replaced by Fourth-Style painting) supported, in turn, the half columns of the loggia, visually united by latticework fences (plutei) between them. The patron must have been pleased with the impressive and finely articulated vertical vol-

ume of space the First-Style decorators achieved through these means; they created an effect powerful even today.

The tablinum of the house, room 4, is interesting for its pavement (Fig. 27), since most of its wall painting is lost. Two runners frame the central rosette of this room; one, with a lozenge pattern, extends along the room's west wall and meets a similar runner extending along the room's south wall at the entrance from the atrium. This second runner exhibits cruder workmanship: the lozenges are wider and it is difficult to discern the pattern of the decorative motifs in their centers. Assuming errors on the part of both ancient and modern restorers, the original pattern can be reconstructed with a regular sequence of central motifs.

Within these framing runners, set off by two bands of the same meander pattern used for the fauces' threshold, appears the room's centerpiece, a rosette of radiate lozenges. A tiny bronze disk set directly into the cement marks the rosette's center. At each of the four corners between the rosette and its square frame is a motif consisting of a palmette flanked by heraldic dolphins. This figural motif executed in white tesserae closely parallels the Silhouette-Style mosaics of Pompeii, dated to about 30–20 B.C.[27] If this signinum pavement with tessellated decoration is contemporary with the other pavements in the Samnite House, then all the pavements would date to the remodeling of the house that included the Second-Style landscape paintings and the ceiling of the fauces.

Maiuri believed that room 2, to the left of the fauces, was the triclinium,[28] since an emblemalike square decorated with a meander design interrupts the allover grid of the signinum floor to mark the area where the dining couches would have been placed.

Although in its present state none of the rooms of the Samnite House has exactly contemporary floor and wall decoration, existing ensembles in the fauces and atrium provide an invaluable glimpse of rare First-Style decorative ensembles. Its elegant fauces and soaring atrium must have consoled the owner who gave up a peristyle and garden at some time in the late second century B.C. And the renewal of the First-Style decoration and all of the signinum pavements in the house around 30 B.C. must have improved the Samnite House's appearance. Even the extensive remodeling of the mid-first century A.D. that further diminished the house's living space was not without refinement, as its surviving Fourth-Style wall paintings still eloquently attest.

27. John R. Clarke, *Roman Black-and-White Figural Mosaics* (New York, 1979), 58–62; John R. Clarke, "The Origins of Black-and-White Figural Mosaics in the Region Destroyed by Vesuvius," in *La regione sotterrata dal Vesuvio: Studi e prospettive*, Atti del Convegno Internazionale, 11–15 November 1979 (Naples, 1982), 661–673.
28. Maiuri, *Ercolano*, 205.

The discussion of the Villa of the Mysteries in chapter 1 focused on the layout, entrance sequence, and views to the landscape from atop its vaulted platform. Within the villa individual rooms and suites of rooms of the Second Style with well-preserved ensembles of wall, floor, and ceiling decoration also address the viewer, often in novel and thought-provoking ways.

This Second-Style decoration was part of a reconstruction around 60 B.C. (Fig. 28).[29] On the one hand the patron wished to increase the villa's economic utility by enlarging the peristyle area with slaves' quarters and wine presses so that it functioned like a farm villa, or *villa rustica;* on the other hand the same owner added to its luxury by enlarging and redecorating in the finest manner the rooms around the atrium and tablinum.

The atrium's decoration, though not well preserved, marks the beginning of a long tradition of landscape decoration that forms one of the several threads of continuity throughout the three hundred years of wall decoration surveyed in this study. Two panels on the north wall retain enough details to identify their watery settings (Fig. 29): they are scenes along the Nile, closely paralleling details in the great Barberini mosaic from Praeneste.[30] A hundred years later similar landscape panels adorn the same wall position in the atrium of the House of the Menander in Pompeii (see Fig. 89), and yet another hundred years later reduced versions of similar landscapes decorate the monochrome rooms of the House of Jupiter and Ganymede (see Fig. 210) and the House of the Yellow Walls at Ostia Antica (see Fig. 190).

Four suites of rooms painted in the Second Style surrounded the atrium and tablinum. Two of equal area consisted of a cubiculum with an adjoining oecus, with a second, separate cubiculum opening to the atrium (see Fig. 28). Only the southwestern suite, rooms 3, 4, and 5, remains, its counterpart (rooms 11–13) having been remodeled about sixty years later in the Third Style. The particularly tall cubiculum 16 opened onto both the north portico via large folding doors and through a secondary door connecting to a corridor. Opposite cubiculum 16, on the other side of the atrium, is the grand triclinium 6, open to the south portico. Opposite its eastern wall, reached by a step down from the atrium of the villa's bath, is cubiculum 8. The patron who desired this division of the rooms surrounding the atrium may have designated special uses for the

29. Amedeo Maiuri, *La Villa dei Misteri*, 2 vols. (Rome, 1931), 1:37–40, 99–101, and Pernice, *Mosaiken*, 55–58, place the earlier phase in the second century B.C.; Lawrence Richardson, Jr., *Pompeii: An Architectural History* (Baltimore, 1988), 171, proposes that the Villa of the Mysteries was constructed of a piece after 80 B.C.

30. Giorgio Gullini, *I mosaici di Palestrina* (Rome, 1956), pl. 1.

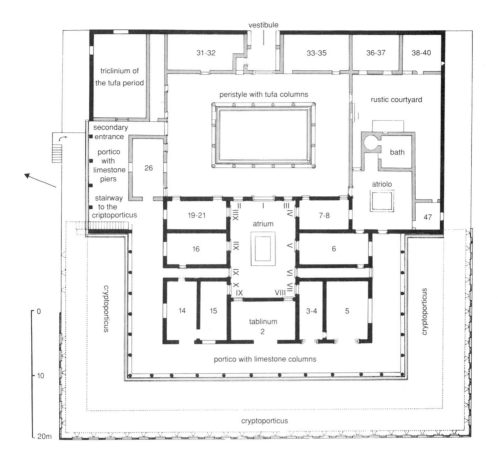

FIGURE 28. Plan of the Villa of the Mysteries in the period of the Second Style, ca. 60 B.C.

four suites. Alan Little has suggested that cubiculum 16 may have functioned like the tablinum, used by the paterfamilias for receiving the clientela. Rooms 4 and 5 would have been reserved for the *domina*, or woman of the house; ceremonies preparing the family's brides for their weddings would have taken place in the famous room of the frieze. The destroyed northwestern suite would then have been reserved for the private use of the paterfamilias, and the triclinium, 6, situated near the kitchen, would be for dining.[31] Although highly conjectural, Little's hypothesis is supported by the differences in the quality of deco-

31. Alan M. G. Little, *A Roman Bridal Drama at the Villa of the Mysteries* (Kennebunk, Me., 1972), 3–5, 9–10.

FIGURE 29. This landscape painting formed part of the Second-Style decoration in the atrium; it was located above the height of the doorways.

ration among these Second-Style rooms, with the best ensembles in rooms 5 (with its figural frieze and slate and marble floor), 4, 16, and 6. Simpler schemes adorned cubicula 8, 3, and 15. The few remains of the original scheme of rooms 11–13 indicate that its decoration was on a par with the best rooms.[32]

Concept, color, and design bind cubiculum 4 to oecus 5. Both opened originally only to the western portico, toward the view of the Bay of Naples, and they also communicate with each other through a small doorway. The Second-Style painted architecture in both rooms creates a shallow stage for the figures with a bright cinnabar red background. The Dionysiac subject matter of cubiculum 4 is a prelude to the great frieze of oecus 5.[33]

Cubiculum 4 is an *amphithalamos,* a bedroom with two alcoves (Fig. 30). Although both alcoves were later pierced with rude openings, enough of the original scheme survives to understand its original effect. The existing ensemble eloquently illustrates how changes in floor and wall decoration divide the function of the anteroom from that of the alcoves, where the beds were placed. A cut-marble pattern of triangles in black and white defines the anteroom. Polychrome *scendiletti* mark the thresholds of both alcoves. Whereas

32. Maiuri, *Villa dei Misteri,* 1: plan, fig. 20; 187–191, figs. 75–78.
33. Maiuri, *Villa dei Misteri,* 1: 166.

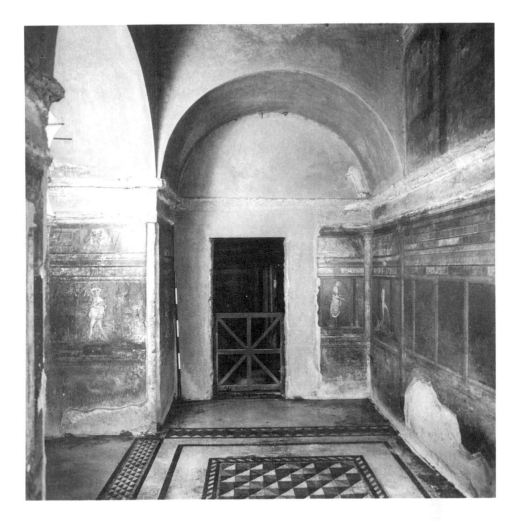

FIGURE 30. Both wall and floor decoration differentiate the alcoves and anteroom of cubiculum 4. The Dionysiac figures form a prelude to the adjoining Room of the Mysteries.

the anteroom's wall painting consists of illusionistic marble revetment, the alcoves open to shallow stages that support the representations of statues. Above this cinnabar-red zone appear pictures with twin shutters, the pinakes mentioned above. The statues represent well-known Dionysian themes: Dionysus leaning on a satyr, dancing maenads, a dancing satyr, Silenus, and a priestess. Both surviving pinakes represent scenes of sacrifice: a nighttime scene of a man offering a pig to Priapus in a rustic setting and a woman offering cakes to Dionysus.

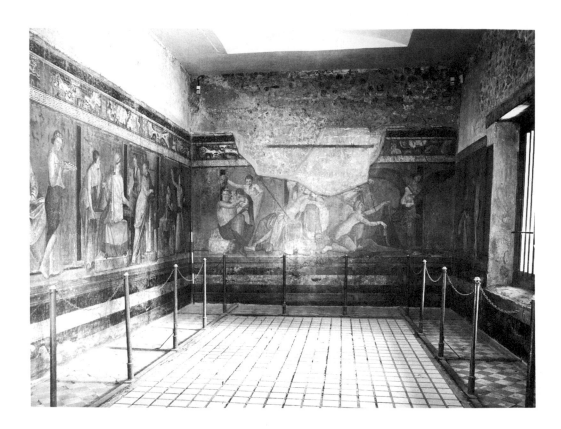

FIGURE 31. The Room of the Mysteries seen from the peristyle.

Viewer Address in the Room of the Mysteries Vitruvius includes the term *megalographia signorum,* or monumental painted representations of statues, in his summary of current fashions in wall decoration.[34] The frieze of near life-size figures arranged around the perimeter of the room of the Mysteries, as well as the monumental figures from the contemporary Villa at Boscoreale,[35] provides striking examples of megalography. Vitruvius's cryptic mention hardly prepares the viewer for the exotic, highly allusive, and beautifully painted tableaux that seem to speak, pulling the viewer into a drama that both begs and

34. Vitruvius *De architectura* 7.5.2. Little, *Villa of the Mysteries,* 9, notes that: "*signorum megalographia* . . . meant a traditionally impressive style consisting of figured subjects which were based on well-known sculptural types. . . . By this combination of a technical term drawn from the Greek vocabulary of painting, *megalographia,* with the Latin term for statuary, Vitruvius possibly meant to suggest a decorative adaptation to Roman taste of an already established earlier tradition."
35. Phyllis Williams Lehmann, *Roman Wall Paintings from Boscoreale in the Metropolitan Museum of Art* (Cambridge, Mass., 1953), 23–81.

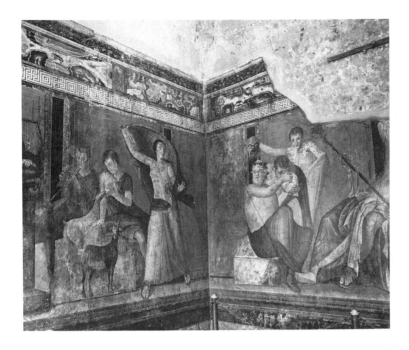

FIGURE 32. A startled woman and a group of a Silenus and two
young pans span a corner in the Room of the Mysteries.

defies interpretation. All is flux. The characters and their actions fluctuate be-
tween the realm of mortals and that of the gods and demigods. Even the view-
ing pattern alternates between a sequence (and therefore a narrative) arising
from a clockwise reading of the figural groups and a timeless, fixed, axial focus
on the image of Dionysus and Ariadne that confronts anyone entering the
room from the portico (Fig. 31).

I would suggest that the two kinds of viewing—from the room's axis and
clockwise—as well as the lack of a coherent narrative, are intentional solutions
to the wall painter's problems in designing a megalography that would fit the
space. No matter how astounding the images are in themselves, this was the
decoration of a U-shaped oecus having a major entryway from the portico, a
minor doorway in its northwest corner (where the "sequential" pattern starts),
and a large window interrupting the south wall. Scholars who have assumed
that the frieze is a copy have proposed various compositional schemes for the
"original." However, analysis of the frieze as it exists in the Villa of the Myste-
ries proves that the painter designed the composition specifically for this space.
How else can we explain the effective composition of the corner groups: the
startled woman and the old Silenus with satyrs (Fig. 32), the winged flagellator

FIGURE 33. The complex interplay of gazes among the figures and
with the viewer illustrates the frieze's multivalence.

and her victim (Pl. 2), and the bride at her toilet and an admiring cupid (Pl. 3)?
Despite the arguments to the contrary,[36] not only these mutually responsive
corner figures but also the central, axial tableau of the drunken Dionysus re-
clining on Ariadne's lap are tailor-made for this space. When viewed as wall
decoration in a decorative ensemble including floor and ceiling, these empty
corners make good sense. The elegant carpet of white (*palombino*) marble dia-

36. See especially Little, *Villa of the Mysteries*, 13–16, who attempts to rearrange the figures
into a more "harmonious" composition; see his illustration in the frontispiece.

FIGURE 34. Dionysus, focus of the decoration, ignores the viewer and the other figures in the frieze.

monds outlined with black slate stops short of the walls, its edges lining up with the voids left in the corners.[37] If the restoration of a semivaulted ceiling is correct, the floor and ceiling borders mirrored each other.

Herbig's diagram of the figures' gazes beautifully illustrates the complex interactions among the figures themselves and between the figures and the spectator (Fig. 33).[38] A person entering the room would have immediately focused on Dionysus and Ariadne proclaiming the theme of the room: the ecstasy of both Bacchic intoxication and love. But while Dionysus's *body* is casually, drunkenly open to our gaze, his face, with his upturned eyes fixed on his lover, ignores the viewer (Fig. 34). The group of Dionysus and Ariadne is not anomalous: throughout the frieze the viewer, alternately addressed and ignored because of the figures' gazes and spatial placement, becomes alternately participant and mere spectator. Furthermore, some of the figural groups represented

37. Scagliarini, "Spazio e decorazione": 8 and fig. 11, 17.
38. Reinhard Herbig, *Neue Beobachtungen an Fries der Mysterienvilla in Pompeji: Ein Beitrag zur römischen Wandmalerei in Campanien* (Baden-Baden, 1958), fold-out plan at back.

in the frieze were oft-repeated stock types. In the image of Dionysus and Adriadne, for instance, the ancient viewer would have recognized a sculptural group diffused throughout the Hellenistic world.[39]

If the viewer then begins to sort out the meaning of the figural frieze by looking for a sequence of actions, he or she will turn to the north wall, where a pattern of left-to-right reading begins at the little door to room 4 (Fig. 35). A veiled woman "walks into" the scene of a matron looking over the shoulder of a nude boy who reads from a scroll. A second walking figure, this time a pregnant woman carrying a tray of offering cakes, walks toward a scene of ritual washing, where the protagonist, her back to us, draws a veil from a box held by one servant with her left hand. Another servant pours water over her right hand, presumably to wash the leaves she holds for use in a religious ceremony. This second servant is partially hidden by a tableau from the world of the demigods: Silenus plays the lyre while a pan watches a *panisca* giving suck to a kid. The north wall ends with the imposing figure of a woman in violent contrapposto, her cloak billowing up behind her head, with her right arm thrown upward in a gesture of surprise or terror.

Two scenes frame the central image of Dionysus and Ariadne on the rear (east) wall. Another Silenus, this time seated, holds a cup (of wine) while a young pan gazes into it and another holds up a comic mask. One and a half scenes complete the wall on the right (south) side of the divine couple. Three figures help with the unveiling of the phallus. The kneeling figure lifts the veil while two standing figures assist (their upper bodies are not preserved).[40] The female demon with her stick poised to strike reaches across the corner of the room to her victim, on the south wall, her head nestled in the lap of a woman who looks back across the corner at the demon. The nude dancing woman may be the flagellant rejoicing after her whipping. Following the break of the window, the scene of the woman at her toilet folds into the southwestern corner; one of her attending cupids holds up a mirror while the other, with bow in hand, admires her from the entryway (west) wall. On that same wall, but on the opposite side, appears the isolated figure, often called the domina. She appears to survey the frieze from a calm distance.

In a recent article Gilles Sauron counted thirteen interpretations of the Dionysiac frieze, and added yet another.[41] In several readings, beginning with

39. Margarete Bieber, "Die Mysteriensaal der Villa Item," *Jahrbuch des deutschen archäologischen Instituts*, vol. 43, pt. 1, no. 2 (1928): 301, figs. 3 (cameo in Vienna) and 4 (coins from Smyrna). Herbig, *Mysterienvilla*, figs. 31–32, illustrates two terra-cotta figures of Dionysus and Ariadne in the same pose; they are from a grave at Myrina and date from the second century B.C.

40. Although Little, *Villa of the Mysteries*, frontispiece and passim, sees and restores only one figure here, close inspection reveals the torsos of two female figures.

41. Gilles Sauron, "Nature et signification de la mégalographie dionysiaque de Pompéi," *Compte rendus des séances de l'Académie des inscriptions et belles-lettres* (1984): 151–174.

I II III IV

V VI VII VIII

IX X

FIGURE 35. Drawing of the figural frieze in the Room of the Mysteries.

Macchioro[42] and elaborated by Little,[43] the same woman goes through successive stages of Orphic or Dionysiac "initiation."[44] For Little, who follows Bieber's interpretation of the room as a place for nuptial rituals,[45] the woman entering in the peplos is a bride-to-be about to be initiated into the mysteries of Dionysus. The boy is reading sacred texts, and the pregnant woman carries a sacrifice of cakes (as in the sacrifice scene in room 4). Next, the "initiate" carries out her ritual lustration, and then, in the midst of the apparition of the two Sileni and their companions, is startled to see the unveiling of the phallus and the flagellation scene. She nevertheless undergoes this ritual whipping and emerges a joyous, dancing maenad, who then soberly dresses for her wedding. Some would see in the domina the bride-to-be become a matron.

Sauron, identifying Dionysus's partner as his mother, Semele, and the domina as a priestess, interprets the frieze as two parallel stories, the myth of Semele and the life of the priestess.[46] His reading sequence, although correctly beginning with the image of Dionysus and his companion, thereafter requires the viewer both to have a detailed and obscure knowledge of the cult and to jump from wall to wall while recognizing parallels between divine and human activities. Bastet has recently offered an imaginative, if incredible, new interpretation.[47]

All strict readings that attempt to pin down the meaning(s) of the mysteries frieze ignore both its sources and its purposes. The wall painter responsible for the decorations of this room responded to the patron's or patroness's wishes by calling upon a well-known repertory of stock types and combining them in a composition that harmonized with the dimensions and illusionistic Second-Style decorative scheme that he worked out for the whole villa. His sources were most certainly in Hellenistic painting of the fourth or third centuries B.C., transmitted by fellow wall painters through several centuries by means of copy books.[48] The mysteries of initiation into the cult of Dionysus were successful ones, since their content was never betrayed by any written source that has come down to us; this fact alone rules out the possibility that room 5 presents a series of scenes documenting an initiate's experiences. It is more likely that the depicted scenes formed part of semipublic pageants or tableaux accompanying

42. Vittorio Macchioro, *Zagreus: Studi sull'orfismo* (Bari, 1920), 60–65, states that room 5 served for Dionysiac rituals. He believed that the Villa of the Mysteries, still not fully excavated, was a basilica of the Orphic cult.

43. Little, *Villa of the Mysteries*, 9–10.

44. Maiuri, *Villa dei Misteri*, 128, insists that the scenes are simultaneous, not chronologically successive.

45. Bieber, "Mysteriensaal," 298–330.

46. Sauron, "Nature et signification," 151–174.

47. Frédéric Bastet, *"Fabularum dispositas explicationes,"* *Bulletin antieke Beschaving* 49 (1974): 206–240, summarized in de Vos and de Vos, *Pompei Ercolano Stabia*, 248–250.

48. On the style and shortcomings of this copyist/wall painter, see Ranuccio Bianchi-Bandinelli, *Storicità dell'arte classica* (Florence, 1950), 1:146–151.

festivals of Dionysus. Flanking Dionysus and Ariadne on the back wall, for instance, are the three sacred symbols of Dionysus's power: wine, mask, and phallus.[49] Representations of women in bridal costumes serve to relate this realm of Dionysus with that of his female devotees and perhaps to marriage—a central event in the life of most patrician women.[50] Yet even knowing these references, in antiquity the frieze could hardly have appeared as original or unique. The fact that images in the frieze, such as the drunken Dionysus resting on Ariadne, the woman with the cakes,[51] the women unveiling the phallus,[52] and the dancing maenad,[53] appear in other media and throughout the ancient Mediterranean underscores our painter's approach to the composition.[54] He combines related images. He alludes but does not narrate, juxtaposing images of mortals with creatures of myth and religion. The magic of the frieze, both in antiquity and today, lies in its very multivalence.

Asymmetrical Perspective and Functional Division in Triclinium 6 If in oecus 5 a person gets caught up in complex viewing patterns because of the enigmatic figural frieze with several possible viewing patterns and figures gazing at each other and the viewer, in triclinium 6 the constructed perspectives of the illusionistic architecture provide clear messages. Among mature Second-Style schemes, however, triclinium 6 is unusual. Three, rather than two, separate perspective schemes divide its space between anteroom and dining area, while there is only one pattern in a single mosaic carpet on the floor.[55] The rear wall's scheme centers on an illusionistic door probably inspired by the real door (left over from the First-Style atrium scheme) originally piercing the wall at this point. Rather than continuing this perspective to the side walls, the designer introduced a second motif of regularly spaced columns against a flat marble-revetted wall. At the halfway point of the side walls this scheme in turn changes to a colonnade festooned with garlands and open to the sky above a marble wall (Fig. 36).

49. Bieber, "Mysteriensaal," 308.

50. In addition to references in Bieber, "Mysteriensaal," passim, and Little, *Villa of the Mysteries,* passim, Laetitia La Follette has presented a convincing case for the identification of Roman bridal costumes throughout the frieze (unpublished paper presented at the Colloquium on Ancient Mosaics and Wall Painting of L'Association internationale pour l'étude de la mosaïque antique, Baltimore, 28 April 1989).

51. Represented in the room behind the peristyle in Pompeii IX, 14, 4, the House of Obellius Firmus, Pompeii; Bieber, "Mysteriensaal," fig. 15.

52. Represented in a terra-cotta Campana relief in the Louvre, in Bieber, "Mysteriensaal," fig. 7, and in a mosaic from Djemila (Algeria), in Herbig, *Mysterienvilla,* fig. 30.

53. A stock figure that also appears in the House of Lucretius Fronto (see Fig. 74).

54. Jacobus Houtzager, *De grote wandschildering in de Villa dei Misteri bij Pompeii en haar verhouding tot de monumenten der vroegere kunst* (The Hague, 1963), attempts to trace every possible source for the figures, with mixed success.

55. Compare Oplontis 14, below, p. 119.

FIGURE 36. Two Second-Style decorative systems articulate the long wall of the triclinium.

This last perspective construction turns the room's corners and continues over the entryway. Here we can observe a curious flaw in mature Second-Style schemes of asymmetrical, or wraparound perspective discussed in chapter 2 (Fig. 37). The consoles supporting the cornice are painted in perspective so that they appear to recede from the point of view of someone who has entered the room, viewed the rear wall, and then turned around to face the entryway and portico beyond. This view out to the portico would also be the principal one for diners when the couches were in place. But because the consoles' orthogonals slant in opposite directions on the side walls, when their fore-shortening is maintained on the entryway wall they meet in a trapezoidal con-figuration—the same irrational perspective that spoils the consistency of the

FIGURE 37. Converging consoles over the entryway reveal the illogic of asymmetrical perspective.

Tomb of Lyson and Kallikles mentioned above (see Fig. 13). This detail seems not to have bothered either painter or patron, perhaps because the fictive colonnade of the side walls harmonizes so nicely with the real one of the portico.

Functional Division in the Ensembles of Cubiculum 16 Cubiculum 16, together with cubiculum 11 of the Villa of Oplontis, provides a clear picture of how the wall painter, stuccoist, and mosaicist coordinated their skills to differentiate areas with separate functions within the same space.[56] Of the two cu-

56. John R. Clarke, "Relationships between Floor, Wall, and Ceiling Decoration at Rome and Ostia Antica: Some Case Studies," *Bulletin de l'Association internationale pour l'étude de la mosaïque antique* 10 (1985): 94–95; John R. Clarke, "The Non-Alignment of Functional Dividers in Mosaic and Wall Painting at Pompeii," *Bulletin de l'Association internationale pour l'étude de la*

bicula, room 16 of the Villa of the Mysteries is by far the more elegant and imposing, probably because its decoration was adapted to a First-Style room with a particularly tall elevation. It was a bedroom with two alcoves with ample light and air available through the large folding doors that opened to the portico. (Plaster casts preserve the configuration of the doors.)

Entering the minor doorway, from the villa's transverse corridor, one is struck both by the room's height and the dramatic orchestration of wall, floor, and ceiling designs to differentiate and articulate the spaces (Pl. 4). A mosaic carpet with a pattern of red and black crosses defines the circulation space of the anteroom. Two contrasting scendiletti meet at right angles at the closet separating the two alcoves. Their designs, in colored tesserae, differ greatly, one being a sober pattern of step triangles, the other an alternation of large diamonds and squares. They coordinate closely with the Second-Style scheme of the wall painting to divide the anteroom from alcove spaces; the porphyry red and green pilaster folded around the outside corner of the closet meets these two carpet bands on the floor. In the photograph one can see similar pilasters, folded into the inside corners of each alcove.[57] Whereas the walls of the anteroom, regularly divided by these same pilasters, have a coloristically rich but relatively simple scheme of illusionistic faux-marble revetment, the painted architecture of the two alcoves is both daring in conception and impressive in its detail.

Four elegant Corinthian columns support a triple point-loaded arcade in the east alcove.[58] This scheme is a kind of flash-forward in time, since this bold form appears in imperial architecture only in the Severan period.[59] Between the columns, cinnabar red orthostates topped with a frieze of finely detailed consoles support colored ashlars—an illusionistic version of the faux-marble relief of the First Style. This east wall of the alcove "opens" the space very little, to a bit of painted blue sky under the carefully foreshortened wooden lacunary vaults that the columns support. Above illusionistic doors painted on the north and south walls of this same alcove perspective views open, masked by the usual scallop of black curtains hanging between the columns.

mosaïque antique 12 (1989): 313–321; Alix Barbet, "Quelques rapports entre mosaïques et peintures murales à l'époque romaine," in Mosaïque: Recueil d'hommages à Henri Stern, ed. René Ginouvès (Paris, 1983), 43–44; Olga Elia, "I cubicoli nelle case di Pompei," Historia 6 (1932): 412–417.

57. For a discussion of the use of folded pilasters and columns in the illusionistic weight-and-support system of Second-Style schemes, see above, chapter 2, pp. 34–38.

58. For excellent photographic and graphic documentation of this and the south alcove, see Josef Engemann, Architekturdarstellungen des frühen zweiten Stils, Römische Mitteilungen, Ergänzungsheft 12 (1967): 76–79, pls. 18–19 (east alcove); pls. 20–23 (south alcove).

59. John Ward-Perkins, Roman Imperial Architecture (Harmondsworth, 1981), 456, fig. 309, for an example of the point-loaded arcade at Diocletian's Palace, Split; arcuated colonnades occur in domestic architecture at Pompeii in the Casa della Fortuna and the Casa degli Archi.

FIGURE 38. Regularly spaced holes in this Second-Style latticework ceiling in cubiculum 16 indicate the original placement of gems or stucco rosettes.

The stucco cornice that these fictive architectural members carry is in two parts, a small band below in low relief with a deeply projecting dentillated molding above. At the outside corner, over the supporting pilaster and serving as a springing for the stucco frames of the alcoves, the upper molding projects at their intersection. Preserved parts of the east alcove's ceiling suggest that it was a lattice pattern shaded in pink, cinnabar red, and porphyry red, perhaps with light blue trim (Fig. 38). Holes at the intersections of the lattice pattern may have held nails supporting, in turn, stucco rosettes;[60] otherwise these holes may have once contained gems.[61]

Room 16's south alcove features a tholus or round temple appearing behind a richly revetted marble wall. Two sets of columns rest on the same podium: four large, fluted columns with composite capitals support an architrave that

60. For stucco latticework and rosettes of the late Second Style, compare tepidarium *g* of Pompeii I, 6, 2, the House of the Cryptoporticus, illustrated in Harald Mielsch, *Die römische Stuck-reliefs, Römische Mitteilungen*, Ergänzungsheft 21 (1975): 17–18, pls. 1–2.

61. A practice documented in wall painting of the Second Style and in the Fourth-Style ceilings of Nero's Domus Transitoria in Rome. See Ranuccio Bianchi-Bandinelli, *Rome: The Center of Power* (New York, 1970), 134, fig. 140.

FIGURE 39. Columns projecting forward from the wall (*en ressaut*) and carrying sections of architrave enliven the Second-Style scheme.

arcs over the tholus, while a group of four similar but smaller columns supports a second order. Arranged in pairs, these smaller columns hold up a richly ornamented architrave that juts out from the wall at either side of the tholus. Like the point-loaded arcade of the east alcove, these columns supporting the jutting *ressauts* (lengths of entablature) preview an architectural feature that makes its debut in imperial architecture under Nerva and the Flavians.[62]

62. Nerva's Forum Transitorium, in Heinz Kähler, *The Art of Rome and Her Empire* (New York, 1965), 113, fig. 21; Domitian's "aula regia" in the Domus Flavia, in William L. MacDonald, *The Architecture of the Roman Empire* (New Haven, Connecticut, 1965), 1:53.

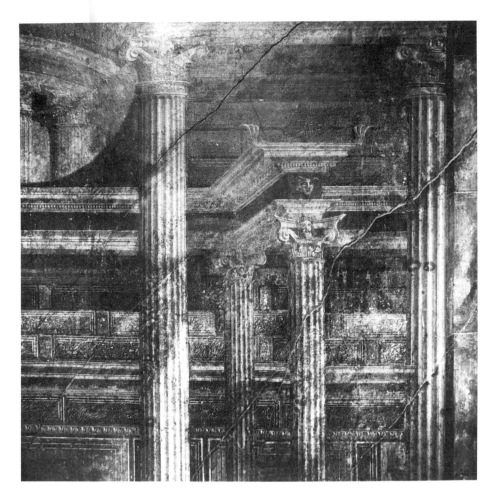

FIGURE 40. Capitals in the form of heads animate the fictive architecture.

At close range marvelous details appear: bearded heads in the composite capitals, the head of Medusa in the architrave of the ressauts, a frieze of figures in the larger architrave, and the red silhouettes dancing along the arch (Figs. 39 and 40). Such miniaturism is both rare and rarely preserved in wall painting of the Second Style; it seems to be the speciality of the workshop responsible for four wealthy commissions: the Villa of the Mysteries, the Villa of Oplontis, the Villa of Boscoreale, and the House of the Labyrinth.

We will leave the Villa of the Mysteries for a while to investigate further the mature Second Style at the Villa of Oplontis, returning, in chapter 4, to its fine Third-Style decorations of about 1 B.C.

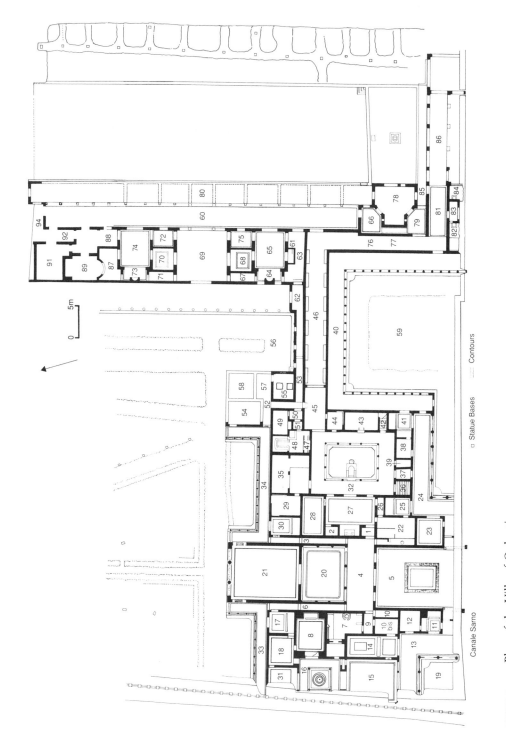

FIGURE 41. Plan of the Villa of Oplontis.

Sources and Significance Chapter 1 outlined the approach, entryway sequence, and visual axes of the Villa of Oplontis (Fig. 41). The excellent state of preservation and the high quality of decorative ensembles clarify the relationships among floor, wall, and ceiling decoration and hint at possible sources for Second-Style decoration in both actual and fictive architecture.

In chapter 2 we reviewed scholarly opinion on the origins and meanings of mature Second-Style decoration, concluding that rather than deriving strictly from either stage painting or actual architecture it embraces elements of both. The recently discovered decorative ensembles of the Villa of Oplontis provide evidence for both the contemporaneity and the cross-borrowing between the "porticus" manner described by Leach[63] and the scaenae frons fashion.

To get to the atrium from the land side of the villa, it will be remembered, the visitor had to leave the visual axis announced in the propylon hall (21) and follow along the long corridors flanking it. Once within the vast reaches of the atrium, its Second-Style painting announces its theme. On both long walls fictive colonnades in perspective frame the two large false doors, one seen frontally, the other, at the north side, foreshortened as though seen from the center of the room (Fig. 42).[64] This perspective scheme positions the viewer on axis, near the impluvium. Illusionistic steps lead up to the doors, decorated with the figures of victories and surmounted by landscape panels (Fig. 43). Shields with portrait heads (the so-called *imagines clipeatae*) and the precious marbles of the revetments and columns reveal the patron's desire to transform this already large space into a kind of royal vestibule, with doors leading to richly decorated reception halls within the palace.[65]

Painted doors occur frequently in both First- and Second-Style interiors. A fictive door completes the axial symmetry of the First-Style atrium of the House of Iulius Polybius at Pompeii. To the right of the axial entrance to the house is a real door; on the left of the entry axis the decorator painted a matching door.[66]

63. Eleanor Winsor Leach, "Patrons, Painters, and Patterns: The Anonymity of Romano-Campanian Painting and the Transition from the Second to the Third Style," in *Literary and Artistic Patronage in Ancient Rome,* ed. Barbara K. Gold (Austin, 1982), 153–159.

64. Mariette de Vos, "Tecnica e tipologia dei rivestimenti pavimentali e parietali," in *Settefinestre: Una villa schiavistica nell'Etruria romana,* ed. Andrea Carandini and Salvatore Settis (Modena, 1985), 1:85, notes painted representations of doors in the Villa of Settefinestre, the Villa of the Papyri, the Villa of Boscoreale, the Villa of the Mysteries, and in seven examples at Pompeii.

65. Leach, "Patrons, Painters, and Patterns," 147–149, interprets the fictive transverse spaces as illusionistic alae, commenting that "this atrium is intended less for practical business than for show."

66. Bek, *Towards Paradise on Earth,* 183–184, fig. 68; Bek incorrectly identifies the real door on the right as "the door leading into the house itself." Entrance is through the central opening, that of the tablinum.

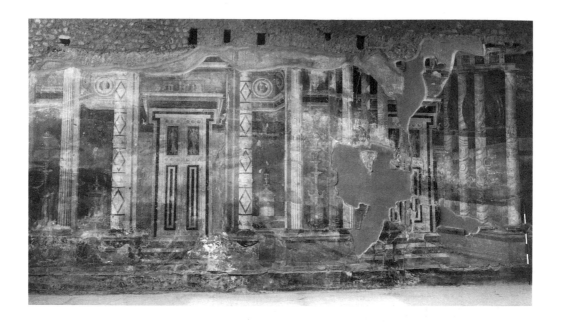

FIGURE 42. Large, ornate doors and a colonnade in perspective are regal allusions in the atrium.

The painted door both stresses the importance of architectural balance and the desire of the owner to make the modest vestibule seem grander than it was. Real doors remaining from the First-Style scheme along the sides of the atrium in the Villa of the Mysteries were left in place when the spaces to which they originally led were closed in. In this way they became false doors but kept the original symmetry and grandeur of the atrium's decoration, based on faux-marble blocks with landscape panels in the upper zone. We have already seen how the false door that forms the focus of triclinium 6's Second-Style scheme in the Villa of the Mysteries was inspired by a door leading to the atrium that was eliminated.

The grandiose tone set by the atrium is continued in the villa's enormous triclinium (14), where elaborate entrances to sanctuaries appear on the rear and side walls (Pl. 5). Tall and elaborate columns support an architrave framed at its uppermost part in stucco relief. The stucco cornice is in two parts, with a thin band below in low relief surmounted by a thick dentillated molding in high relief. This upper molding marked the actual transition from wall to ceiling. This rare survival of a stucco molding in a Second-Style room illustrates its

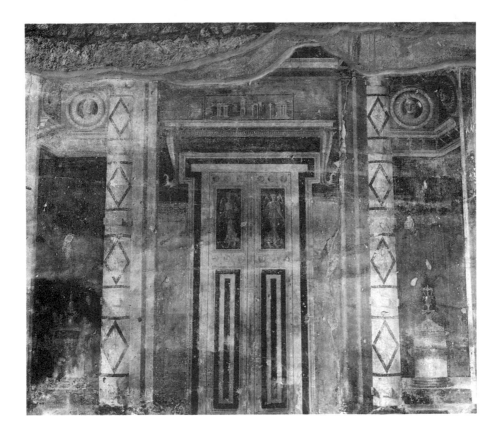

FIGURE 43. Victories adorn both battens of a door, while a landscape panel appears above the lintel.

important role in increasing the believability of the illusion that the room was a colonnaded pavilion with columns supporting the ceiling.

As in cubiculum 16 of the Villa of the Mysteries, astounding care and variety of detail invite close viewing. Golden, bejeweled tendrils wind around the golden columns framing the doors to the sanctuaries. The recent reevaluation of the gems found in the excavations of the Horti Lamiani in Rome suggests that there real columns of gilded wood and ivory were studded with precious and semiprecious gems in the manner depicted here.[67]

67. Maddalena Cima, "Il 'prezioso arredo' degli horti Lamiani," in Eugenio La Rocca and Maddalena Cima, *Le tranquille dimore degli dei: La residenza imperiale degli horti Lamiani* (Venice, 1986), 124–128, pls. 44–45; for painted representations of gems in the late Second-Style Villa

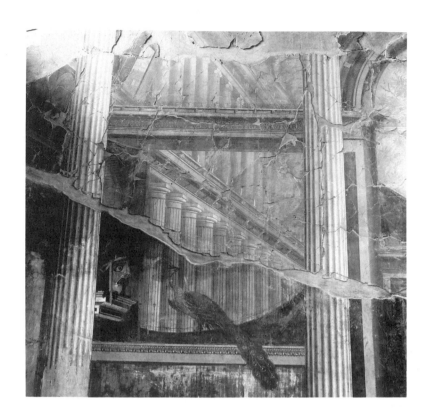

FIGURE 44. A tragic mask and a peacock on a ledge increase the strength of the illusion in oecus 15.

Although the sanctuaries pictured on the walls have been called sanctuaries of Apollo, presumably because Apolline attributes, such as the quiver and the griffin, are present, it is safer to assume that this is a hybrid of the porticus type and the stage setting for tragedy mentioned by Vitruvius.[68] As in the mysteries frieze of the Villa of the Mysteries, images are allusive but not illustrative. If one insisted on defining such Second-Style decorations strictly, for instance, the sanctuary depicted on the east wall of adjoining room 15, with its prominent peacocks, would have to be a sanctuary of Juno (Fig. 44). Incidental elements, such as the bird on the podium, the tragic masks, and the pinakes resting against columns would have to be excluded to pursue this line of reasoning.

of the Farnesina: Irene Bragantini and Mariette de Vos, *Le decorazioni della villa romana della Farnesina,* Museo Nazionale Romano, vol. 2, pt. 1: Le pitture (Rome, 1982), pls. 39, 55, 56, 153; in the Fourth-Style paintings of the House of the Menander, in Amedeo Maiuri, *La Casa del Menandro e il suo tesoro di argenteria,* 2 vols. (Rome, 1933), 2: figs. 44–46, pl. 10.
 68. Vitruvius *De architectura* 7.5.2. (Loeb, 2: 102–103).

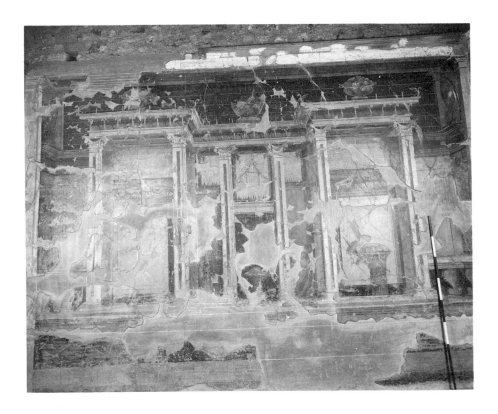

FIGURE 45. Untheatrical details, like the glass bowl with figs, adorn the five-part stage setting of oecus 23.

Room 23's Second-Style scheme is the most clearly derived from the scaenae frons of tragic theater (Fig. 45).[69] Pilasters resting on the socle divide the wall into five compartments. The two outermost compartments are pavilions pushing forward from the wall plane, and the center is clearly the stage door. But even here the incidental presence of a basket of figs resting on the podium in the right-hand compartment reveals the painter's (and the patron's) taste for anecdotal detail. Such insertion of images having nothing to do with the theater but being showy in their trompe-l'oeil illusionism weighs against any strict iconographical interpretation. If Romans like Pliny the Elder made much of Zeuxis's depiction of grapes—so realistic that birds pecked at them[70]—it seems likely

69. Leach's notion that room 23's decoration postdates the other Second-Style walls at Oplontis must be rejected; "Patrons, Painters, and Patterns," 171 note 30.
70. Pliny the Elder *Naturalis historia* 35.36.65–66. "Parrhasios is reported to have entered into a contest with Zeuxis, and when Zeuxis depicted some grapes with such success that birds flew up to the scene, Parrhasios then depicted a linen curtain with such verisimilitude that Zeuxis, puffed up with pride by the verdict of the birds, eventually requested that the curtain be removed

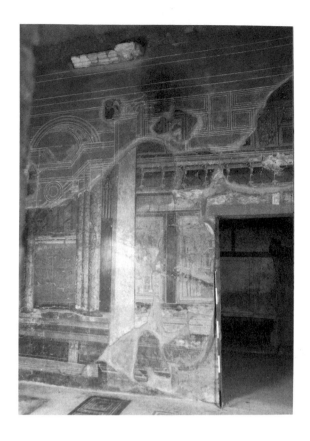

FIGURE 46. Mosaic band, painted pilaster, and projecting stucco cornice coordinate to divide the area for the seated guests from the anteroom in triclinium 14.

that they prized their frescoed Second-Style walls for their illusionistic effects as much as for the regal associations discussed in chapter 2.

Coordination of Decorative Ensembles In the end, no matter how refined the wall painting, these were rooms to be lived in, a fact underscored by the way in which painting and stucco decoration coordinate with mosaic decoration to emphasize the function of each space.

and his picture shown, and, when he understood his error, conceded defeat with sincere modesty, because he himself had only deceived birds, but Parrhasios had deceived him, an artist"; Jerome J. Pollitt, *The Art of Greece, 1400–31 B.C.: Sources and Documents* (Englewood Cliffs, N.J., 1965), 155.

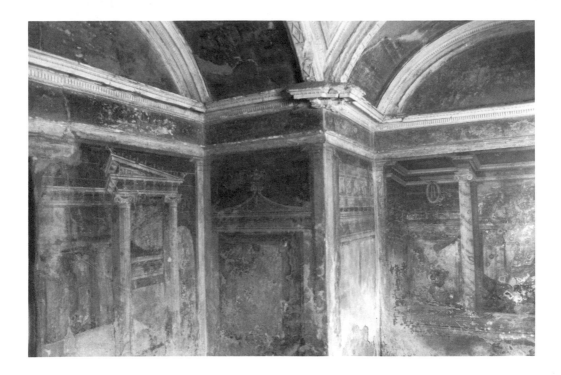

FIGURE 47. Both stucco ornament and painted perspectives differentiate the alcoves in cubiculum 11.

In triclinium 14 a mosaic band with a polychrome meander design coincides with pilasters painted on the wall (Fig. 46). Stucco molding, pilasters, and mosaic together divide the inner area where dining couches were placed from the outer area used for serving. The inner space has a central carpet with a polychrome design of diamonds in a shaded lattice pattern, with the representations of sanctuaries on the walls. In the circulation space of the outer area, walls of blocks of yellow marble with monochrome sacro-idyllic landscapes are coupled with a simple grid pattern of black tesserae on the floor. These sharp distinctions in decorative systems visually divide this single, deep, U-shaped room into two separate spaces with two different functions.

Like cubiculum 16 of the Villa of the Mysteries, cubiculum 11 at Oplontis employs carefully orchestrated ensembles of complementary but contrasting mosaic, painted, and stucco decoration to differentiate the alcoves from the antechamber (Fig. 47). Two different patterns in the mosaic scendiletti mark

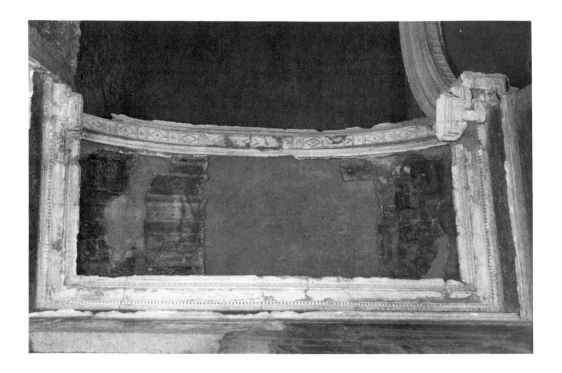

FIGURE 48. Illusionistically shaded square and rectangular lacunars decorate the ceiling of the north alcove.

the alcoves on the floor.[71] The room's well-preserved stucco moldings and painted barrel vaults over each alcove show how this differentiation of the two spaces on the floor was carried through on the walls and the ceilings. Trompe-l'oeil pilasters on the walls of each alcove correspond with the scendiletto bands on the floor. They appear to support the heavy stucco architrave and are topped on each side of the alcoves by sections of molding. Supported by consoles, these blocks of molding jut out from the upper cornice of the architrave, like those of triclinium 14. Between these jutting sections of molding run the stucco bands that frame the intrados of each barrel vault. Like the scendiletti on the floor beneath them, each carries a different design. Whereas dentil ranges and bead-and-reel moldings culminate in alternating squares and diamonds in the north alcove, they end in a band of squares with hollowed-out centers in the east alcove.

71. Clarke, "Relationships," 95 and fig. 4.

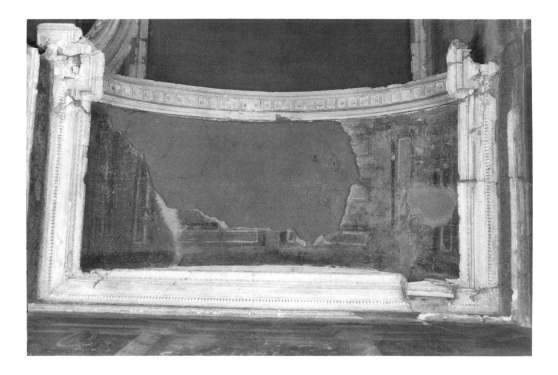

FIGURE 49. A grid of porphyry lines appears under the abraded lacunary in the east alcove's ceiling.

The scendiletti, pilasters, jutting moldings, and intrados moldings together form a three-dimensional frame defining the entrance to each alcove. As scendiletto and intrados bands differ from one alcove to the other, so do each alcove's wall and ceiling painting. The differences in the wall painting are evident from the photograph.[72]

Cubiculum 11 is unique in preserving the ceilings of both alcoves and the landscape painted in the tympanum of the north alcove. Although both ceilings employ lacunary schemes, they, too, were carefully differentiated. In the north alcove's ceiling (Fig. 48) two square lacunars appear on the lower part of each side of the vault, followed on each side by two rectangular lacunars of the same width. The illusion of the lacunars' receding planes is carried by shaded stripes

72. See also the color plates in Alfonso de Franciscis, "La villa romana di Oplontis," in *Neue Forschungen in Pompeji*, ed. Bernard Andreae and Helmut Kyrieleis (Recklinghausen, 1975), 27, fig. 14; the drawing in Alix Barbet, *La peinture murale romaine: Les styles décoratifs pompéiens* (Paris, 1985), 60, fig. 29, incorrectly reproduces the same stucco pattern for both intrados bands.

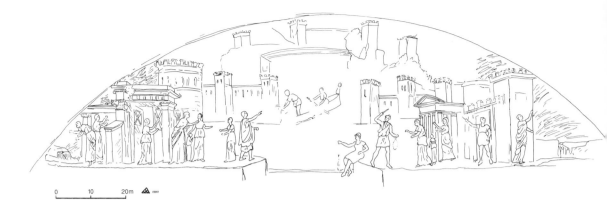

0 10 20m

FIGURE 50. A Nilotic landscape decorated the tympanum of the north alcove.

ranging in color from light cream to light red to dark red to black. Close observation reveals that these panels were ornately decorated in added gold with tongue-and-dart moldings.

The ceiling of the east alcove (Fig. 49) uses the same colors, but in place of the lacunars on the lower part of each side two long rectangular lacunary panels appear, followed by two sets of three rectangular panels set at right angles to them. The massive paint losses reveal a grid of lines painted in porphyry red that formed laying-out lines for the design.

Although much faded and abraded, the landscape in the north alcove's tympanum reveals another way in which the Second Style employed the new genre of landscape painting. Whereas similar landscapes occur in the atrium of the Villa of the Mysteries (see Fig. 29) and in the fauces of the Samnite House (see Fig. 25), before the discovery of the Villa of Oplontis they were unknown in cubicula. The drawing reconstructs the painting (Fig. 50).[73] Its details—figures standing and gesturing against colonnades and pavilions, the two men in a boat, the scenes of greeting and leave taking—serve to connect this landscape with the Nilotic tradition mentioned above; in particular the pavilion by the water compares closely with that in the Barberini mosaic.[74]

This cubiculum reveals the richness and variety of detail employed in Second-Style decorative ensembles. The complexity of their architectural illu-

73. This reconstruction is based on my own tracing of the remains of the painting done in 1988 and the drawing by Iorio done in 1968, at the time of excavation. The drawing in Barbet, *Peinture murale romaine*, 60, fig. 29, is loosely modeled after a later pencil sketch also by Iorio.

74. Gullini, *I mosaici di Palestrina*, pl. 14.

sionism and the competition of mosaic, stucco, and painted patterns, although contrary to modern canons of taste, provided a lively and engaging (but hardly restful) interior decoration.

But with Augustus this showy and aggressive decoration would come to an end, to be replaced by a more sober taste that ended in reaffirming the flatness of the decorated surfaces and explored further the miniaturism hinted at in the best Second-Style decorations.

CHAPTER FOUR

DECORATIVE ENSEMBLES OF THE THIRD STYLE, 15 B.C. – A.D. 45

Augustus (27 B.C.–A.D. 14), as the first Roman emperor and founder of the Julio-Claudian dynasty, used the visual arts to promote his regime.[1] In the development of the Third Style (outlined in chapter 2), properties owned by Augustus and his family loom large: the late Second-Style paintings of his own dwelling on the Palatine (the House of Livia and the House of Augustus, ca. 30 B.C.), the transitional paintings of the Villa under the Farnesina (ca. 20 B.C.), and the early Third-Style walls of the Villa of Agrippa Postumus at Boscotrecase. The Third Style seems to develop simultaneously in Rome and Pompeii,[2] its restraint, refinement, and miniaturism serving as expressions of Augustan neoclassicism. Some scholars see allusions to the triumph of Augustus and Agrippa over Egypt (29 B.C.) in the Third Style's ample use of Egyptian motifs.[3]

Although Pompeii had been reduced to a colony under Sulla, a thoroughgoing Romanization took place only under Augustus. Oscan, tolerated up to that point as an official language, along with Samnite weights and measures, disappears from written records. Many new families or gentes arrive on the scene; no longer are they colonist families. They are either native Campanian families or gentes from one of the inland centers of central Italy. The original owners repurchased many of the estates confiscated under Sulla.[4] Castrén has

1. For a fine modern appraisal of this much-researched area, see Paul Zanker, *The Power of Images in the Age of Augustus* (Ann Arbor, Mich., 1988).

2. Frédéric Bastet and Mariette de Vos, *Proposta per una classificazione del terzo stile pompeiano,* Archeologische Studiën van het Nederlands Instituut te Rome, no. 4 (The Hague, 1979), 44–46; Irene Bragantini and Mariette de Vos, *Le decorazioni della Villa romana della Farnesina,* Museo Nazionale Romano, vol. 2, pt. 1: Le Pitture (Rome, 1982), 50–61; Volker Michael Strocka, "Die römische Wandmalerei von Tiberius bis Nero," in *Pictores per provincias: Aventicum V,* Cahiers d'archéologie romande, no. 43 (Avenches, Switz., 1987), 29–30.

3. Bragantini and de Vos, *Farnesina,* 30.

4. Paavo Castrén, *Ordo populusque pompeianus: Polity and Society in Roman Pompeii,* Acta Instituti romani finlandiae, no. 8 (Rome, 1975), 93.

proposed that many of these new families were pro-Augustan "plants," brought there by Augustus to Romanize Pompeii. In addition to the entry of these new collaborationist families into the *ordo decurionum*—equivalent to the senatorial class in Rome—there is strong promotion of the cult of Apollo, Augustus's patron deity.[5]

If the Augustan political and ideological programs touched Pompeii's politics, society, and business, the Third Style symbolized this new order in the private sphere of the home. From the grand spaces of the Villa of Oplontis to the intimate ones of the House of Marcus Lucretius Fronto (hereafter House of Lucretius Fronto), the new manner in interior decoration announced and subtly promoted Augustan idealism. Its reserve, flatness, and attention to miniaturistic detail are decorative analogues to the cool neoclassicism promoted in official relief sculpture and portraiture. Early Third-Style painting and mosaics were based on surfaces that were once again conceived as flat, without, however, reverting to the First Style's literal imitation of marble surfaces in plaster relief. Instead of striving to involve the viewer in complex perspective games as had the Second Style, the Third Style provides a clear diagram of its design in the far view, revealing the richness of its miniature detail only at very close range. Early Third-Style schemes divide the wall into color fields, typically rectangular panels in black, cinnabar red, or ivory white. Ribbon-thin columns, pilasters, and friezes define these fields. At close range, fantastic, precise, miniaturistic details appear. A new feature, the so-called *predella*, a thin, horizontal panel inserted between socle and median zones, often receives stylized Egyptian motifs. In mosaic pavements, elegant but flat and monochrome designs replace the spatial illusionism and polychromy of the Second Style.

This chapter investigates a representative sample of Third-Style ensembles. Decorations belonging to the early Third-Style redecoration of the Villa of Oplontis reflect a range of approaches, from the ambitious schemes of the caldarium to the simple white monochrome of a passageway space. The black tablinum of the Villa of the Mysteries presents Egyptianizing motifs in an elegant tour de force, while the late Third-Style ensembles of the House of Lucretius Fronto introduce architectural and figural motifs that set the stage for the Fourth Style.

THE EARLY THIRD STYLE AT THE VILLA OF OPLONTIS

As the plan indicates (Fig. 51), although much of the early Third-Style wall painting at the Villa of Oplontis was later replaced, remaining mosaics and wall construction flesh out the picture of the remodeling of the villa in the Au-

5. Castrén, *Ordo populusque pompeianus*, 95–101.

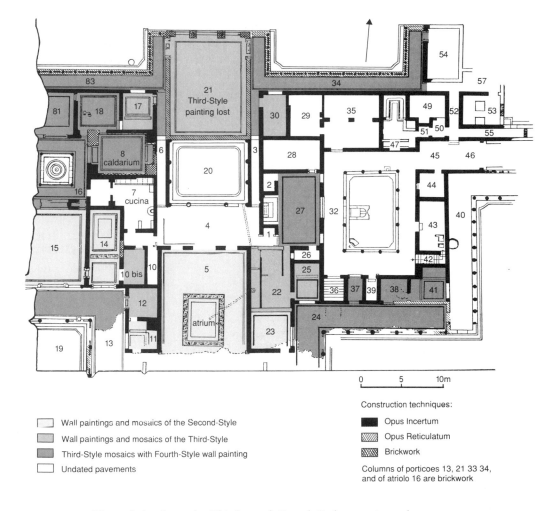

Wall paintings and mosaics of the Second-Style

Wall paintings and mosaics of the Third-Style

Third-Style mosaics with Fourth-Style wall painting

Undated pavements

Construction techniques:

Opus Incertum

Opus Reticulatum

Brickwork

Columns of porticoes 13, 21 33 34, and of atriolo 16 are brickwork

FIGURE 51. Plan of the Second-, Third-, and Fourth-Style mosaic and painting in the western part of the Villa of Oplontis.

gustan period.[6] The addition of the great oecus-propylon (21) to the north provided a monumental entrance from the land, dispensing with what must have been a fauces-peristyle sequence like that of the Villa of the Mysteries. Its mosaics repeat motifs, such as the candelabrum and the closed and open-looped palmettes, found in all of the rooms decorated in the early Third Style (25, 30, 17, and 8). The northern and southern porticoes were added at this

6. For a more detailed account, see John R. Clarke, "The Early Third Style at the Villa of Oplontis," *Römische Mitteilungen* 94 (1987): 267–294.

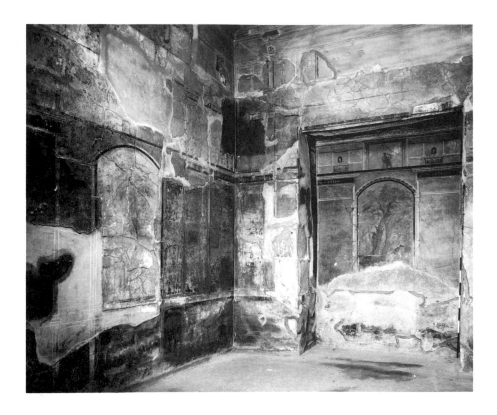

FIGURE 52. An early Third-Style scheme with central aediculae in caldarium 8.

time, providing shaded walkways on both land and sea sides. Although redecorated in part, the servants' lodgings around the second peristyle remained essentially unchanged. Rude upper rooms in wattle-and-daub construction (*opus craticium*) are preserved, along with the slaves' baths and latrine. Like the Villa of the Mysteries, the Villa of Oplontis in this period lodged slaves working the owner's lands; it even boasted a winepress.

Aediculae with Landscape Paintings in Caldarium 8 The only room attributed by the excavator to the Third Style is the elegant caldarium of the bath (Fig. 52).[7] Its wall painting, best preserved on the east and north walls, extends vertically to a great height; tiny traces of the stucco ceiling and its molding sur-

7. Alfonso de Franciscis, "La villa romana di Oplontis," in *Neue Forschungen in Pompeji,* ed. Bernard Andreae and Helmut Kyrieleis (Recklinghausen, 1975), 12: "tardo secondo stile-inizio terzo stile"; figs. 28–35.

vive. Socle and median zones employ a scheme remarkably similar to that of red cubiculum 16 of the Villa of Agrippa Postumus at Boscotrecase, discussed in chapter 2 (see Fig. 18). Comparison of the two rooms reveals the same divisions of the wall and the same large aediculae framing pictures in the center of each wall, with one significant difference: at Oplontis the aediculae are round-headed, whereas the columns of Boscotrecase 16 carry straight architraves. This difference in aedicula type results in proportionally taller pictures within Oplontis's aediculae.[8]

There is a further complication. Although the caldarium was originally decorated in the early Third Style around 10–1 B.C., when much of the villa was redecorated in the early Fourth Style of ca. A.D. 45–55, the owner instructed the painters to save the original decoration of the caldarium. On the north wall they seem to have kept the original painting, but on the east wall, particularly in the niche, they imitated the Third-Style scheme only in the socle and median zones. They painted the upper zone in the style of the time.[9]

Although much damaged, the main features of the landscape in the north aedicula of the caldarium can be discerned (Fig. 53). It represents a sacred grove with a huge tree growing around a column decorated with a yellow fillet. In the bottom foreground is a low cylindrical fence. The best parallels with the picture are found in the House of Livia in Rome, dated at least twenty years earlier,[10] indicating that the original paintings were consciously retardataire, harking back to an earlier Augustan manner. The painting in the east niche is of a very different nature and relates to the bold mythological landscapes with large figures that appear in the period of the Fourth Style. It may depict Hercules in the Garden of the Hesperides (Fig. 54). Both pictures contrast sharply with the landscapes of Boscotrecase, where vaguer events occur in a setting that floats like a triangular Camelot against a creamy white background. Boscotrecase's landscape topoi fade into the atmospheric white, while tiny figures go about their human activities.

Since the caldarium's only source of light is its large western opening onto the little peristyle garden,[11] the architect chose a white mosaic floor to reflect

8. Height (H), width (W). Boscotrecase 16: North wall, aedicula H 1.88 m, W 1.10 m, picture H 1.45 m, W 0.93 m. East wall, aedicula H 1.80 m, W 1.22 m, picture H 1.41 m, W 1.00 m. West wall, aedicula W 1.21 m, picture W 1.01 m. Oplontis 8: North wall, aedicula H 2.03 m, W 1.37 m, picture H 1.80 m, W 1.20 m. East wall, aedicula W 1.12 m, picture W 0.91 m.

9. Clarke, "Oplontis," 293–294; Wolfgang Ehrhardt, *Stilgeschichtliche Untersuchungen an römischen Wandmalereien von der späten Republik bis zur Zeit Neros* (Mainz, 1987), 34 note 360.

10. Giulio Emanuele Rizzo, *Le pitture della 'Casa di Livia,'* Monumenti della pittura antica scoperti in Italia, sec. 3, Roma fasc. 3 (Rome, 1936), 57–58, figs. 37–38, 59–60, fig. 42; the two paintings, now ruined, were in room IV.

11. Sutures in the present mosaic of this doorway indicate that it was enlarged, probably at the time of the Fourth-Style remodeling of the bath complex.

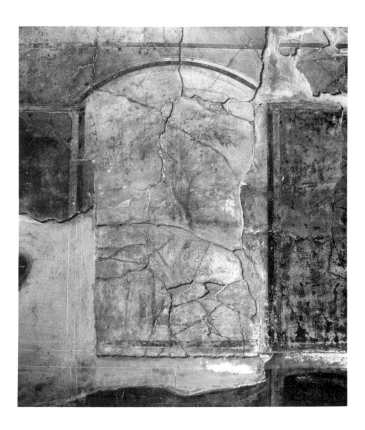

FIGURE 53. The ruined landscape painting of a tree-entwined column in the north aedicula.

the maximum amount of light. The pavement is an unaccented allover pattern of white tesserae laid on the bias and framed by two bands of black tesserae. A decorative band of two rows of step triangles marks the entrance to the eastern niche; this motif occurs in a mosaic from the Farnesina.[12] In its original form—without its somewhat disharmonious and strident Fourth-Style upper zone—the caldarium at Oplontis must have been a source of pride for the owner, both for its great size and for the refinement and restraint of its decoration. Executed perhaps by the same artist and workshop as the nearby Villa of Agrippa Postumus, it was a space that successfully conveyed, on a grand scale, the elegance of the current fashions in Augustan Rome.

12. Bragantini and de Vos, *Farnesina*, inv. 125548, 9, pl. 1. Two decades earlier the same motif appears at Settefinestre: Andrea Carandini and Salvatore Settis, *Schiavi e padrone nell'Etruria romana* (Venice, 1979), pl. 28.

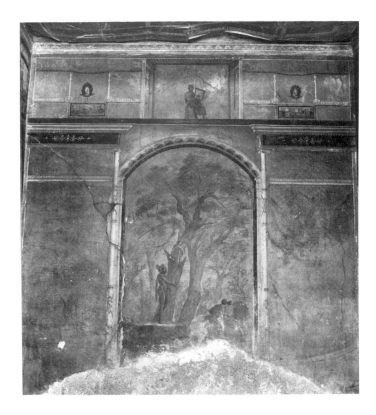

FIGURE 54. Hercules in the Garden of the Hesperides in the eastern aedicula.

Monochromy, Miniaturism, and Novel Motifs in Oplontis 25 and 12 Oplontis 25, a predominantly white cubiculum, faces south on the seaside portico near two entrances to the slaves' quarters. It takes its light from a single, wide opening onto the portico. Its white mosaic floor, together with its white walls, would have made it a relatively bright room with delicate decorations, occupying the opposite pole of the decorative spectrum from the complexities and bright colors of the villa's Second-Style rooms (Fig. 55). Although its walls are badly damaged, the cubiculum's flattened painted architecture, consisting of gold and light blue pilasters supporting cinnabar red and purple-pink friezes, contrasts strikingly with the boldly illusionistic perspectives of the mature Second-Style rooms. In the mosaic floor, a scendiletto design marks the transition from anteroom to the alcove, but without a hint of polychrome shading or illusionism. In fact, the very motif employed in the scendiletto—squares with

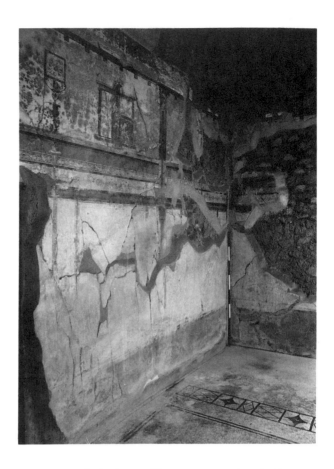

FIGURE 55. A single scendiletto meets a painted pilaster to define the single alcove of cubiculum 25.

concave sides and an L in their center—represents the last vestige of a device worked out in polychrome mosaics: the shaded lacunar.[13]

The drawing reveals the reduced architectural scheme of the wall decoration (Fig. 56). Gone are the dynamics of weight and support, achieved through a regular repetition of supporting columns or pilasters in the Second Style. Although the architrave is supported by pilasters folded into the north and south

13. Although Erich Pernice, *Die hellenistische Kunst in Pompeji: Pavimente und figürliche Mosaiken* (Berlin, 1938), 143, and Maria Luisa Morricone Matini, "Mosaico," in *Enciclopedia dell'arte antica, Supplemento* (1970), s.v., consider the so-called "L design" to be a novelty introduced in the period of the Third Style, Mariette de Vos has demonstrated its appearance in the period of the Second Style: see Bastet and de Vos, *Terzo stile,* 109–110 note 16.

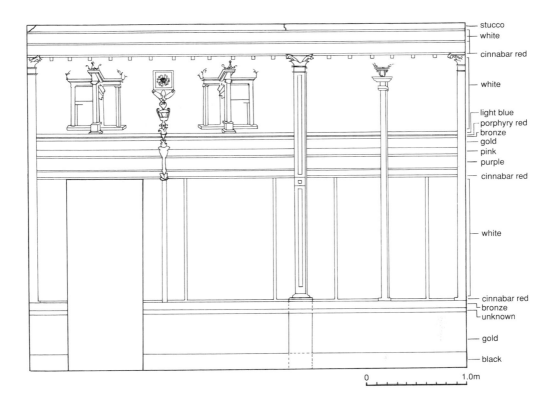

stucco
white
cinnabar red
white
light blue
porphyry red
bronze
gold
pink
purple
cinnabar red
white
cinnabar red
bronze
unknown
gold
black

0 1.0m

FIGURE 56. Reconstruction of cubiculum 25's early Third-Style wall painting.

corners, with another appearing at the scendiletto position, two candelabra occupy the intervals where the other two pilasters should be. Rather than supporting the architrave, they carry fanciful decorations: a floral plaque and an impost block flanked by volutes.

The two whimsical architectural constructions in the upper zone that flank the candelabrum holding the floral plaque could serve as emblems of the new style: they depict architecture as decoration rather than pretending to be architecture. Although examples of late Second- and early Third-Style paintings with rudimentary architecture in the corners of the upper zone abound,[14] the closest comparison is with the representations of rustic shrines in the sacro-

14. Aula Isiaca: Giulio Emanuele Rizzo, *Le pitture dell'Aula Isiaca di Caligola*, Monumenti della pittura antica scoperti in Italia, sec. 3, Roma fasc. 2 (Rome, 1936), fig. 4, pl. II, 1 and 2; Farnesina cubiculum D, right (northeast) wall, illustrated in August Mau, *Monumenti dell'instituto* 12 (1884), pl. Va; Pompei, Casa V, I, 14–15, illustrated in August Mau, *Die Geschichte der dekorativen Wandmalerei in Pompeji* (Leipzig, 1882), pl. VIII.

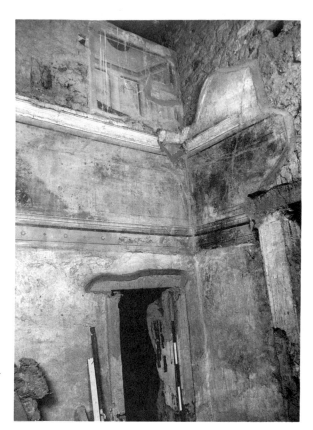

FIGURE 57. Above the early
Third-Style cornice appears
the original mature Second-
Style painting of oecus 12.

idyllic stuccoes of the Farnesina, where pavilions like these two appear, self-
contained, with no attempt made to connect them with the other fictive archi-
tecture on the wall. These pavilions in the sacro-idyllic stuccoes have similar
partition walls, isolated columns on podia, and silhouetted architraves.[15]

As in much of early Third-Style painting, the painters had to add many de-
tails after the plaster had partially dried, because the delicate light blues, pinks,
lavenders, and light greens would be spoiled if applied in true fresco technique.
As a result, many details of the friezes have disappeared, including fanciful ver-
tical and horizontal palmettes, gems framed by heart-shaped volutes, lotuses,
and rosettes.

If cubiculum 25 paves the way for the elimination of fictive architecture,
room 12, whose preserved upper zone consists of only black rectangles, has
already passed the point of no return (Fig. 57). This room's relationship with
cubiculum 11 was that of an oecus adjoining a cubiculum, much like the con-

15. Bragantini and de Vos, *Farnesina*, inv. 1037, 193, pl. 111.

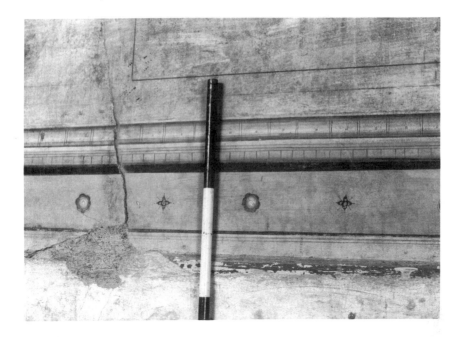

FIGURE 58. Miniature craters appear in the lowest band of the frieze; two types of flowers alternate in the upper band.

figuration of Villa of the Mysteries rooms 4 and 5. Remnants of plaster in the jambs of the door that pierces the north alcove of 11 prove that this relationship was planned from the beginning. Originally the oecus was decorated in the same manner as the cubiculum, since above its cornice in the southwestern corner are the remnants of its original Second-Style scheme, which remained in place when around 10 B.C. the ceiling was lowered and the room decorated in the new style.[16] The patron must have wanted the resulting contrast of styles, since the rooms were interdependent.

What remains of the oecus's scheme must have seemed positively revolutionary in comparison with the villa's powerful Second-Style decorations. In addition to its lack of any illusionistic perspectives, its preserved frieze and upper zone employ colors, decorative motifs, and miniaturistic details completely foreign to those of the cubiculum. This was a new aesthetic, applied willfully.

The widest band of the frieze is pink (Fig. 58), framed below by a porphyry red band containing tiny craters with loop handles, and a light green molding;

16. The same succession of the same styles occurred in the redecoration of rooms 11–14 of the Villa of the Mysteries. Amedeo Maiuri, *La Villa dei Misteri* (Rome, 1931), plan of room, 1:59–60, fig. 20; illustrations 187–191, figs. 75–78.

above it are a porphyry red band, a light blue molding, and a shaded, white half-round molding.[17] The flowers in the pink zone alternate between two types familiar to the repertory of late Second- and early Third-Style painting.[18]

Given the relative darkness of the oecus, it is surprising to find a black upper zone. Although much faded, like the south wall of the black tablinum (2) of the Villa of the Mysteries,[19] the white lines that define the rectangular blocks making up this zone prove that its original color was black. The decorative motifs in the centers alternated between bunches of flowers and sprigs of ivy (Fig. 59). Above the blocks, running around the room's perimeter, was a frieze of flowers hanging on long stems from the meeting of volutes. Above this floral frieze runs a porphyry red stripe defining the lower edge of a wider pink band that meets the stucco cornice.

This kind of miniature detail made unusual demands on the viewer. Whereas a person could take in the bright, bold perspectives of the adjoining cubiculum in a moment, it takes time, and a bit of patience, to pick out the details in this little oecus. Although at first glance the geometrical division of the wall surfaces into simple horizontal bands is obvious, a person would have to examine the walls at fairly close range to be rewarded with the discovery of a finely executed ivy sprig or miniature floral frieze. This taste is not for everybody; it speaks to the connoisseur, the person aware of the new Augustan fashions in decoration.

The Candelabrum Style in Room 30 The nearly twin rooms (30 and 17 on the plan) flanking the great oecus-propylon have the same spatial configuration as cubiculum 25, divided into antechamber and alcove by simple scendiletti and by corresponding changes in their wall systems. Their principal source of light is from the north, or landside peristyle, although for room 30 the opening is a door and for 17 a broad window. At a later moment cubiculum 17 became an anteroom to the bath complex. Given their strategic positions on either side of the principal entrance from the land and the two corridors leading into the atrium, one wonders if they may have functioned originally as custodian's rooms.

Cubiculum 30 (Fig. 60) is painted in the "candelabrum style," another variant of the early Third Style.[20] These candelabra are merely decorative, incapa-

17. René Ginouvès and Roland Martin, *Dictionnaire méthodique de l'architecture grecque et romaine* (Rome, 1985), 1 : pl. 48, 1 and pp. 159–160.

18. Clarke, "Oplontis," 282 notes 38–41.

19. Maiuri, *Villa dei Misteri*, 201–204.

20. Mau, *Geschichte der dekorativen Wandmalerei*, 374–394, places the "candelabrum style" in the period of transition between the Second and Third Styles; his lists of candelabrum-style deco-

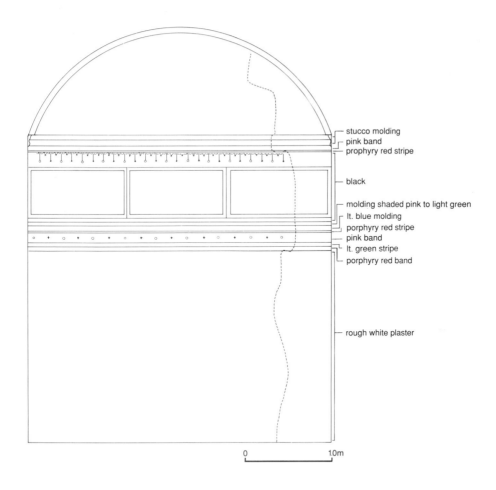

स्टुको molding items are labeled as follows:

- stucco molding
- pink band
- prophyry red stripe
- black
- molding shaded pink to light green
- lt. blue molding
- porphyry red stripe
- pink band
- lt. green stripe
- porphyry red band
- rough white plaster

0 1.0m

FIGURE 59. Reconstruction of oecus 12's east wall.

ble of supporting weight, unlike the relatively hearty pilaster(s) that divided cu-
biculum 25 into antechamber and alcove at the scendiletto's position. They
change color as they extend upward, from black in the socle and median zones
to pink in the upper zone. Thin columns resting on the black socle divide the
room's perimeter at regular intervals, substituted with candelabra at the back
wall of the alcove. These continue above the cornice into the upper zone, and

rations updated in Mariette de Vos and Arnold de Vos, "Scavi nuovi sconosciuti (I 11, 14; I 11,
12): Pitture memorande di Pompei, con una tipologia provvisoria dello stile a candelabri,"
Mededelingen van het Nederlands Instituut te Rome 37 (1975): 74–75, 78–79.

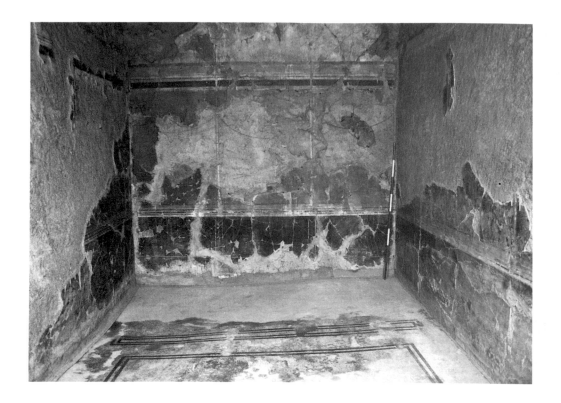

FIGURE 60. Thin candelabra substitute for columns on the rear wall of cubiculum 30.

may have held figures supporting a pseudo-architectural element—a porphyry red band.[21]

Finely executed decorative motifs in white appear in the black socle. Under the candelabra of the rear wall there are vertical rows of facing heart-shaped volutes and loop palmettes just like those arranged horizontally on the porphyry red architrave above (Fig. 61). These alternate with dart and palmette motifs suspended from the socle's top edges.

Thin columns, shaded from gold to light blue added in secco over the median zone's cinnabar ground, divide the wall into regular panels. This shading has no relation to the actual light sources in the room. In fact, in the upper zone, these columns turn into a medium blue-green color. One gets a notion of

21. Here the closest analogy is the rear wall (north) of cubiculum *h* of Pompeii Casa I 11, 12; see de Vos and de Vos, "Stile a candelabri," pl. 20, fig. 23 (drawing) and pl. 22, fig. 24; description, 68–69.

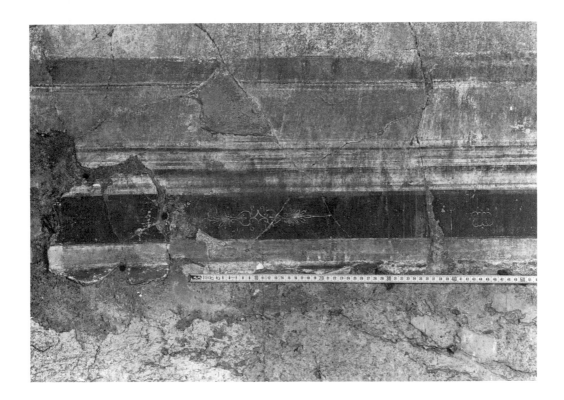

FIGURE 61. Tiny palmettes and volutes decorate the architrave.

the care lavished on the decoration of these columns from fragmentary remains of an elaborate fish-scale motif painted on the base and lower shaft of the north column of the west wall (Fig. 62). The base itself, as well as the network of appliqué, is outlined in black with white highlights.[22]

This room shares with cubiculum 25 decorative motifs such as the candelabrum, opposed closed palmettes, and symmetrical volutes enclosing both gems and squares with concave sides. Yet here these motifs—shaded and residually substantial in cubiculum 25—become entirely decorative, painted in fine lines and on a miniature scale. Because of the contemporaneity of the two room's mosaic floors, it is unlikely that they differ much in date; a different

22. This is a rare early example of this motif, found in the late-second-century painting of the House of Jupiter and Ganymede at Ostia Antica (I, 4, 2), tablinum 4, east wall, south part (see Fig. 203). Guido Calza, "Gli scavi recenti nell'abitato di Ostia," *Monumenti antichi* 26 (1920): 389—396.

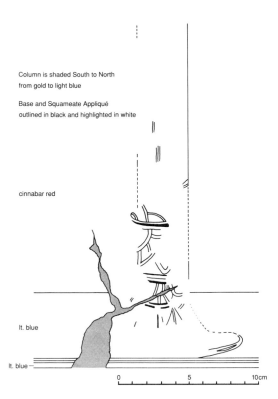

Column is shaded South to North
from gold to light blue

Base and Squameate Appliqué
outlined in black and highlighted in white

cinnabar red

lt. blue

lt. blue

0　　　　　5　　　　　10cm

FIGURE 62. This tracing
reveals the netlike ornament
on the shaft of a column in
cubiculum 30.

hand, perhaps more attuned to the miniaturism of the new style, may have carried out this decoration and that of rooms 17 and 8.

It is clear that subsequent owners of the Villa of Oplontis prized these delicate early Third-Style ensembles, since they preserved the existing painting in the caldarium when it would have been easier to redo the whole room in the current early Fourth Style. Like the magnificent, and initially more impressive, Second-Style rooms, they became "period rooms," reminders of an age that prized clear constructions, delicate colors, and minute details (see Fig. 51). This same taste transformed important rooms in the Villa of the Mysteries.

THE EARLY THIRD STYLE IN THE VILLA OF THE MYSTERIES

The Villa of the Mysteries was being remodeled and redecorated in the early Third Style at about the same time as the Villa of Oplontis. As at Oplontis, these changes, carried out in tufa reticulate with brickwork quoins and columns, focused on the private, or view side of the villa (Fig. 63). At this point, it

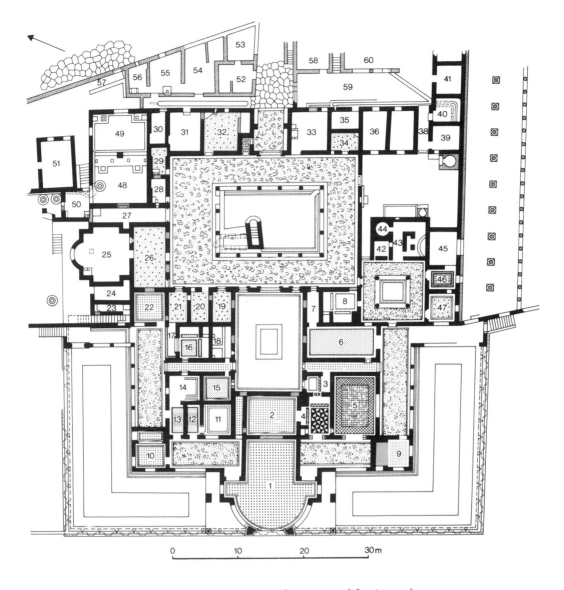

FIGURE 63. Plan of the Villa of the Mysteries showing modifications of
ca. 15 B.C.–A.D. 15.

FIGURE 64. Diaeta 9's early Third-Style mosaic employs tiny tesserae in black and white.

will be remembered, a kind of viewing pavilion (room 1) of semicircular plan was added on the tablinum's axis, and the northwest and southwest corners of the peristyle were enclosed to create cubicula diurna. A group of small rooms (11–14) inserted into the northwestern suite abolished its Second-Style decoration. It seems clear that a desire for more sleeping rooms and a more novel command of the view than was provided by the rather small and conventional tablinum motivated these changes.

Although the wall painting of the two cubicula diurna and the apsidal pavilion is gone, their pavements transmit the taste of the early Third Style. Comparison of room 9's mosaic (Fig. 64) with that of the adjoining portico (Fig. 65) clarifies the differences between pavements of the mature Second Style and the Third. The earlier pavement is bold in design, consisting of roughly rectangular white marble chips set in pairs to form a loose basketweave pattern and decorated with insets of orange, red, purple-red, and blue-green marble.[23] Regular

23. See Katherine M. D. Dunbabin, "Technique and Materials of Hellenistic Mosaics," *American Journal of Archaeology* 83, no. 3 (1979): 265–277, for the history of the chip technique.

FIGURE 65. The Second-Style pavement of the portico uses rectangular white tesserae to form a basketweave pattern enlivened by colored marble insets.

cubic tesserae in white and black appear only in the single black frame. This kind of pavement, perhaps called *opus scutulatum*,[24] occurs throughout Italy in the first century B.C. and corresponds to the taste for showy, colorful illusionism in wall painting. Much smaller tesserae, in black and white only, pave room 9. Flat, vegetal forms in silhouette decorate both the threshold and the scendiletto. Thin rows of black and white tesserae define the room's edges with a double frame. This is the same sober black-and-white decoration found in the early Third-Style pavements at Oplontis.

Egyptianizing Motifs and Miniaturism in the Black Tablinum The black tablinum, room 2, must have been a tour de force when new.[25] Even today the room's shiny black walls and undecorated white mosaic floor amaze the visitor with their seeming simplicity. Light reflected from the floor, and originally from the white upper zone high above, aids in deciphering the decorative

24. Maria Luisa Morricone Matini, *Scutulata pavimenta* (Rome, 1980).
25. Because of its unusually small entryway, room 2 is hardly a conventional tablinum; because it is in the tablinum position on the plan the name has been retained here for convenience.

FIGURE 66. Egyptian-inspired scenes of zoolatry enliven the predella in the Third-Style tablinum.

scheme. Only the north wall is well preserved (Pl. 6): above a black socle decorated with stylized plants is a predella with scenes depicting Egyptian deities. Two scenes of animal worship flank the central image of a winged serpent (Fig. 66). Recent, thorough investigation of "Egyptomania" in painting of the Third Style demonstrates that the Roman decorators used these forms approximately, for effect, rather than with any knowledge of the meaning of the appropriated imagery.[26] Because the viewer must get quite close to see these tiny tableaux, the painter took great pains to include precise detail. The figures fairly glow with enamellike colors against their black background.

Fantastically ornate, ribbon-thin columns ending in lotus buds support—or, more accurately, extend to—a white band delimiting the lower edge of the upper zone (Fig. 67). In line with this tangent tendril on the other side of the band a delicate upside-down lotus supports a square plaque flanked by ovals

26. Mariette de Vos, *L'egittomania in pitture e mosaici romano-campani della prima età imperiale,* Etudes préliminaires aux religions orientales dans l'empire romain, no. 84 (Leiden, 1980).

FIGURE 67. Miniature columns define the upper edge of the median zone.

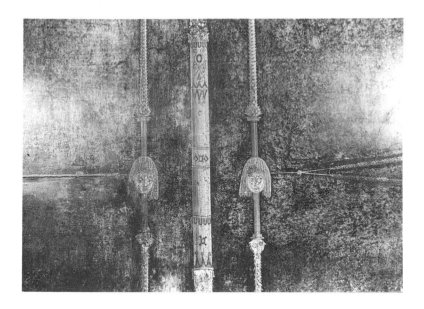

FIGURE 68. Exotic heads mark the midpoint of the median zone.

containing felines. These columns' ornamentation shifts several times, from delicate linear patterns, like those used in the early Third-Style schemes at Oplontis, to green vegetation filled with flowers. Even thinner vegetal wands extend upward and downward from the centerline of the three median zone panels, marked with mop-haired heads (Fig. 68). Vegetal garlands stretched like wires connect these heads with the squares decorating the centers of each panel.

In place of the clear, grandiose, and relatively unsubtle illusionistic perspectives that opened up the walls of Second-Style rooms, this decoration invites and rewards close viewing. Because its illusionism occurs upon the wall's reflective, black surface in taut linear designs, the viewer must be willing to pursue its detail. The fantastic creatures and structures one meets in this pursuit reveal the genius and imagination of a consummate miniaturist.

THE LATE THIRD STYLE IN THE HOUSE
OF LUCRETIUS FRONTO, A.D. 25–45

Despite its small size (ca. 460 m²) and location far from Pompeii's fashionable center, the House of Lucretius Fronto's late Third-Style decoration is of incomparable refinement and beauty. From the fauces to the garden, a finely tuned decorative program articulates spatial hierarchies from the public to the private (Fig. 69). After entering the atrium from the off-center fauces, the visitor's gaze can penetrate the house's axis, past the marble table, or *cartibulum*, through the tablinum to a row of columns along the south side of the garden that culminates in a (now lost) sacro-idyllic painting (Fig. 70).[27] This single row of columns, ending in an engaged column against the wall with the terminal landscape, would fool the casual viewer into thinking that the house was larger, with a complete peristyle. Although space-saving compromises abound in the garden area (decorated after the earthquake of A.D. 62 in the Fourth Style) the front of the house is a veritable jewel box. Along this visual axis the decorators orchestrated ensembles that increase in complexity, from the simple schemes of the fauces, to the elegant all-black atrium, to the coloristically and iconographically complex tablinum.

The fauces' linear ornament emphasizes its role as a passageway space: there are no pictures or complex figural themes to ponder.[28] Its black socle, red middle zone, and cream white upper zone provide a color key to the house's

27. Wilhelmina Jashemski, *The Gardens of Pompeii, Herculaneum, and the Villas Destroyed by Vesuvius* (New Rochelle, N.Y., 1979), 79. W. J. T. Peters, with members of the Dutch Institute in Rome, is preparing the full publication of the House of Lucretius Fronto.
28. Illustrated in Bastet and de Vos, *Terzo stile*, fig. 190 and pl. 27, 51.

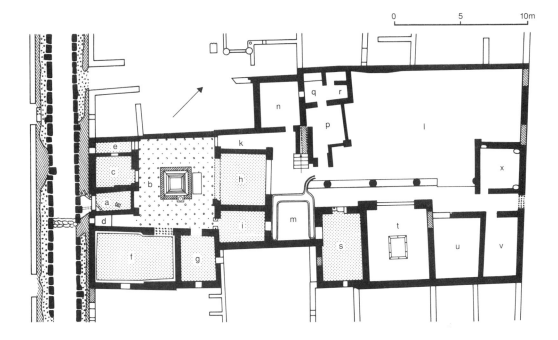

FIGURE 69. Plan of the House of M. Lucretius Fronto.

Third-Style decorations. In the upper zone thin architectural members support the Dionysian thyrsus and tambourine.

Like the black tablinum of the Villa of the Mysteries, the atrium of the House of Lucretius Fronto astonishes the viewer with its severity and elegance. The black lavapesta floor, decorated with a grid of chips of colored marble and little crosses made of white tesserae, frames the white marble impluvium, set off from the black floor by a tessellated braid in black and white. The atrium's black walls (the red socle is a later restoration) mirror its floors. Was this elegant black interior a play on the word "atrium"? Two ancient authors contend that the word "atrium" comes from *ater,* meaning black, because originally smoke from cooking filled the atrium.[29] In a recent survey of 115 atrium floors in Pompeii, 68 had black pavements.[30]

On the preserved north wall, three broad gold bands divide the median zone

29. Servius *On the Aeneid* 1: 726; Isiadorus Hispalensis *Libri originum* 15.3.4.
30. Mariette de Vos, "Tecnica e tipologia dei rivestimenti pavimentali e parietali," in *Settefinestre: Una villa schiavistica nell'Etruria romana,* ed. Andrea Carandini and Salvatore Settis (Modena, 1985), 1:84; at Pompeii forty-three were lavapesta and twenty-five were black mosaic; two black atrium floors were preserved in both Ostia Antica and Rome.

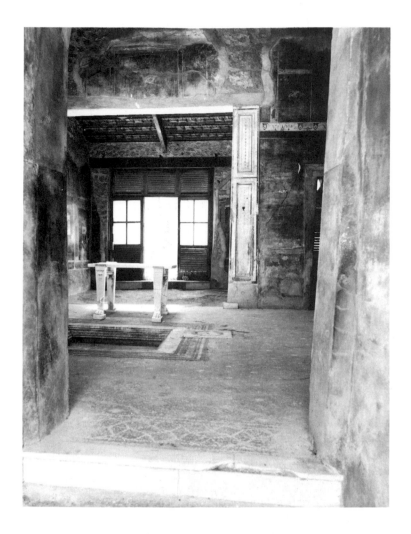

FIGURE 70. View into the atrium and tablinum from the off-center fauces.

vertically; a cream-colored horizontal band tops this zone and forms the base for attenuated architectural fantasies in the upper zone (Pl. 7). Porphyry red squares containing masks and panthers' heads alternate with ovals to form a continuous chain of miniature ornament running down the centers of the yellow bands. Added in secco over the golden ground color, these delicately painted motifs refer to the realm of Dionysus (Fig. 71). Tendril columns preserved on the west wall contain surprises for the careful observer, for a snail and a titmouse inhabit the metallic leaves (Fig. 72). In the centers of the panels

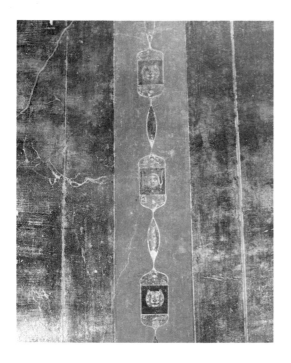

FIGURE 71. Masks and panthers' heads decorate the golden dividing band in the atrium's mature Third-Style scheme.

FIGURE 72. A tiny snail and a titmouse inhabit a metallic stalk.

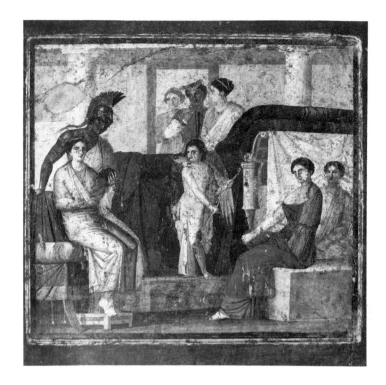

FIGURE 73. The central picture on the north wall of the tab-
linum: Mars and Venus in a crowded bedchamber.

hunting dogs race after their prey. Although painted, like the snail and tit-
mouse, in naturalistic colors, they take on a surreal air against their anti-
illusionistic black background.

The relatively sober decoration of fauces and atrium follows the principle
that spaces with a dynamic function receive decoration meant for immediate
perception rather than prolonged examination. Equivalent vertical and hori-
zontal members divide the spaces simply; there is no single axial focus in the
center of any wall.[31] Just the opposite is true in the tablinum, where axial foci,
central pictures, and color schemes encourage study and contemplation.

In the static space of the tablinum, north (Pl. 8) and south (Pl. 9) walls are
organized around a central aedicula framing a picture and surmounted by the
stage building whose central focus is a tripod. These schemes form an axial

31. Daniela Corlàita Scagliarini, "Spazio e decorazione nella pittura pompeiana, *Palladio*
23–25 (1974–1976): 19–20.

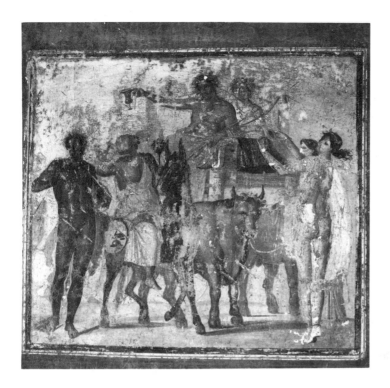

FIGURE 74. The central picture on the south wall of the tablinum: Dionysus and Ariadne in a joyous procession.

focus for each wall, yet the device of mirroring the same architectural schemes on the two walls invites the viewer to figure out the differences between them. Immediately apparent are the different subjects of the pictures: *Mars and Venus* on the north wall (Fig. 73), and *Dionysus and Ariadne in Procession* on the south wall (Fig. 74), two variations of fish still lifes beneath the tripods of the upper zone (probably representing *xenia*, or gifts of fresh produce traditionally given to houseguests), and four different landscapes with seaside villas (Fig. 75). Less apparent is the fact that the enclosed garden (*hortus conclusus*) in the north wall's socle encloses a fountain but in the south wall a crater. And the heraldic panthers, silver vessels, lyres, and swans pulling carts appear in the predellas of both walls, but their order reverses from north to south wall. This game of comparing mirrored schemes fixes the viewer in rapt amazement no less than does the refinement and exuberance of the room's miniaturistic ornament (Fig. 76).

If the color schemes of fauces and tablinum exhibit unity and restraint, the

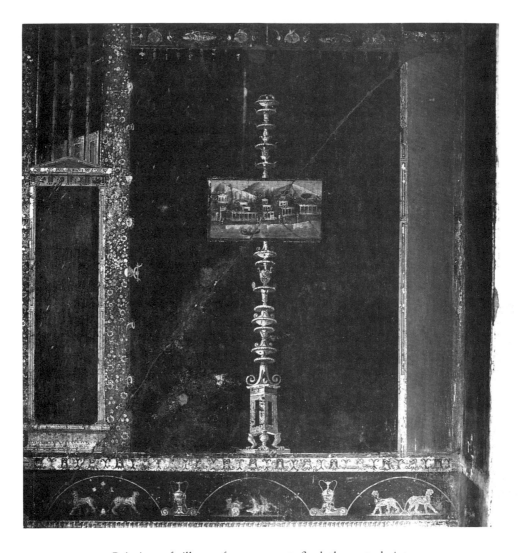

FIGURE 75. Paintings of villas on fancy supports flank the central pictures.

tablinum's black socle, porphyry red predella, red and black median zone, and
gold, red, and black upper zone jostle each other for attention; they are compet-
ing planes of projecting and receding color rather than monochrome grounds
identical with the flat wall. This late Third-Style decoration exhibits its ba-
roque tendencies in perspective constructions as well. Curved colonnades hol-

FIGURE 76. Miniature garlands in the tablinum filled with
attributes of both Apollo and Dionysus.

low out space behind the aediculae (albeit with thin, closely spaced columns),
and the complex perspectives of a scaenae frons enliven the upper zone.[32]

Cubiculum *g*'s decoration is as refined and elegant as that of the tablinum.[33]
It shares with the atrium its essentially black decoration. The floor here, like
that of the atrium, is of black lavapesta (Fig. 77). A design of crosses made of

32. Alan M. G. Little, *Roman Perspective Painting and the Ancient Stage* (Kennebunk, Me.,
1971), 10, pl. 11, reconstructs this architecture as a scaenae frons. R. C. Carrington, *Pompeii*
(London, 1974), 143, identifies three forms: a basilica with three naves flanked on each side by a
pavilion.

33. For a graphic reconstruction, see Bastet and de Vos, *Terzo stile,* 56, pl. 30.

FIGURE 77. Cubiculum *g*'s black cement floor with decorative motifs defined by rows of white tesserae.

trompe-l'oeil cubes encloses squares decorated with crosslets. Two gold panels in the median and upper zones divide its black walls into five parts. Cinnabar red both frames the central aediculae in these zones and unites them in vertical bands that form the background for silver candelabra topped with sphinxes. Unlike Second-Style schemes with columns folded into the corners to join all four walls in one illusion, here the corner panels of adjoining walls are painted in contrasting colors, further divided by a painted corner stripe.[34]

34. Scagliarini, "Spazio e decorazione," 20, fig. 15.

FIGURE 78. Tiny sphinxes and masks ornament the upper part of an aedicula in cubiculum *g*.

Precious ornament delights the lingering viewer: in the predellas birds, masks, and herons attacking frogs fill the compartments flanking the enclosed garden depicted under the central panels. Rainbow-colored sphinxes alternate with expressive masks in the white band above the central pictures, and above this is a black compartment where tiny masks hang from strings (Fig. 78). Crouching at the edges of tenuous pavilions at the sides of the upper zone are winged creatures resembling those of Hieronymus Bosch. Three of the room's four central pictures remain: *Ariadne Giving Theseus a Ball of String to Lead Him out of the Labyrinth* (west wall); *Venus Dressing Her Hair* (east wall); and *The Battle of Troy* (over the north doorway).

Meanings of the Figural Decoration in Tablinum h *and Cubiculum* g To what extent can the figural representations—both in the pictures and in the decorative framing—convey meanings? The central paintings are all by the same hand. Seams around them and the four villa landscapes prove that they

were executed after the rest of the decoration of the walls, suggesting that a specialist, a picture painter or pictor imaginarius, painted them to order. This same pictor imaginarius may have painted the pictures in another Third-Style house, that of the banker L. Caecilius Iucundus (V, 1, 26).[35] It is likely , though not provable, that the patron could choose from a large repertory of possible subjects presented in a model or pattern book. If there was a choice, why did Marcus Lucretius Fronto, if he was the owner of this house when it received its Third-Style decoration, choose these pictures?

Mars and Venus is the most enigmatic iconographically. Both deities were popular in the period of the late Third Style. Augustus's successors built on his religious and dynastic propaganda: Vergil's *Aeneid* popularized Julius Caesar's descent from Venus through Aeneas, and Mars (particularly as Ultor, or avenger of Caesar's murder) became the Roman's model war god. For example, Augustus's temple of Mars Ultor in his form in Rome iconographically completed Caesar's temple of Venus Genetrix (Venus as mother of the gens Iulia, and therefore of the dynasty of Julio-Claudian emperors).[36] Furthermore, Venus Pompeiana was the tutelary deity of the colony founded in 80 B.C. and appears throughout the city as its protectress.[37] But the usual scenes of Mars and Venus represent them in an intimate moment, nearly nude, with only cupids present.[38] In the House of Lucretius Fronto their bedroom is crowded with five onlookers in addition to Cupid, whose quiver hangs from the bed while he unstrings his bow. Maiuri has called this a charming *scène galante* of antiquity in the spirit of a fashionable eighteenth-century Parisian boudoir;[39] Curtius has proposed that this interior scene takes place in the house of Hephaestus, and that the figure with wings on his forehead is Hermes, one of the Olympians who came to see the couple. In this interpretation the luxurious bed will trap the lovers.[40] Difficulties remain, however, since Hermes should have wings on his feet, not his head, and the couple is not yet caught in Hephaestus's nets. Discovery of a second, almost identical version of the same composition in the Third-Style tablinum of Pompeii I, 7, 19 has led to another

35. Mariette de Vos, "Funzione e decorazione dell'Auditorium di Mecenate," in *Roma capitale, 1870–1911: L'archeologia in Roma capitale tra sterro e scavo* (Venice, 1983), 231–247. See the following illustrations in Carlo Ragghianti, *I pittori di Pompei* (Milan, 1963): pls. on 69, 87, 91, 93 and figs. 141–143. However, Caroline E. Dexter, "The Casa di L. Cecilio Giocondo in Pompeii" (Ph.D. diss., Duke University, 1974), 135–140, dates the Third-Style wall decoration of the triclinium to the Augustan period.

36. On the complexities of this relationship, see Zanker, *The Power of Images*, 192–201.

37. August Mau, *Pompeii: Its Life and Art*, trans. Francis W. Kelsey, rev. ed. (1902: reprint, New Rochelle, N.Y., 1982), 12.

38. For instance, in the painting from the House of Mars and Venus, Museo Archeologico Nazionale, Naples, illustrated in Ludwig Curtius, *Die Wandmalerei Pompejis* (Hildesheim, 1960), pl. 1.

39. Amedeo Maiuri, *Roman Painting* (Geneva, 1953), 78.

40. Curtius, *Wandmalerei Pompejis*, 250–251; Homer *Odyssey* 8.333–342.

interpretation, in which the god with wings on his head is Hymen, god of marriage; the scene would then allude to the wedding of Mars and Venus.[41] Perhaps it was enough for the patron that the painting include allusions to the love between these handsome and popular deities without specifying the details of the story in which they were entrapped by the lame, jealous husband, Hephaestus.

The picture opposite, *Dionysus and Ariadne in Procession,* lends itself to clearer interpretation. This is a joyous moment, when Ariadne, rescued from her abandonment, rides in triumph with her savior, Dionysus. Curtius supports his contention that this picture was a pastiche by pointing to motifs in the painting found elsewhere in Pompeii: the *Triumph of the Young Dionysus* from the House of Marcus Lucretius,[42] and the nude dancing female from the south wall of the Villa of the Mysteries, room 5 (see Pl. 2).[43] It is unlikely that our painter would have had to roam the houses and villas of Pompeii to find these motifs, since they were current ones found in more than one pattern book. And knowing that the paintings of the tablinum are a pastiche still leaves unanswered the question of their meaning for the patron. Perhaps the subject matter of the central pictures in cubiculum *g* will offer further clues.

Cubiculum *g*'s identification as a woman's room rests on the feminine subject matter of the central pictures: *Venus Dressing Her Hair, Ariadne Giving Theseus a Ball of String to Lead Him Out of the Labyrinth,* and *The Battle of Troy* (launched by the beautiful Helen). Without the fourth central picture, and the tenuous link between the battle and the beauty, this identification is shaky at best. Seen in the context of the three deities celebrated in the tablinum, however, connections appear. Venus, dressing her hair with the help of Cupid, could be preparing for her amorous adventure with Mars. The Ariadne whom we see helping Theseus out of love for him will eventually be abandoned by him on Naxos, only to return in triumph in Dionysus's carriage. And the battle of Troy is the end of one civilization and, through Aeneas, son of Venus, the beginning of another, that of the Romans.

A further theme runs through the late Third-Style decorations of the House of Lucretius Fronto: the balance between Apollo and Dionysus. Throughout the dense miniature garlands surrounding the aediculae in the tablinum appear

41. Amedeo Maiuri, *Notizie degli scavi* (1929): 362–364, pl. 19; Maiuri also suggests that the figure with the winged head is Hypnos; Matteo Della Corte, *Römische Mitteilungen* 54 (1942): 34, concurs. Against this interpretation see Karl Schefold, *Die Wände Pompejis: Topographisches Verzeichnis der Bildmotive* (Berlin, 1957), 36: Mars and Venus surprised by the gods; Pompeii VII, 2, 23 (House of the Punished Cupid) had a painting in tablinum *f,* now in Naples, in which Mars and Venus appear in the same pose, but without the additional figures: Karl Schefold, *Pompejanische Malerei* (Berlin, 1972), pl. 21.

42. Curtius, *Wandmalerei Pompejis,* 299, fig. 177, Museo Archeologico Nazionale, Naples.

43. Curtius, *Wandmalerei Pompejis,* 298, fig. 188.

Dionysus's tambourine, castanets, and drinking horn, along with Apollo's lyre (see Fig. 76); in the predella Apollo's swans draw a cart in one compartment while Dionysus's silver drinking cups appear in another. Apollo's tripod marks the center of the upper zone, yet the building that houses it is Dionysus's theater, hung with masks and panthers' heads. One could multiply examples, but the point is clear: in the minds of the Romans, as in those of the Greeks, Dionysus and Apollo are two sides of the same divine impulse.[44] It is true that this balance, expressed by alternating the two gods' symbols, occurs at a secondary level: in the miniature decoration inserted into the architectural and color divisions of the walls. But the precision and perfection of these miniatures invite the viewer's scrutiny as much as the figural pictures. By comparison, the blatantly Dionysian iconography of rooms 4 and 5 of the Villa of the Mysteries seems heavy-handed. If Augustan art had an iconographical message, it was that Augustus was the new Apollo; Augustus revived styles both archaistic and neoclassic to give artistic form to the new Golden Age he proclaimed in official propaganda. If early Third-Style art had an iconographic legacy, it was in this introduction of Apolline symbolism into the balance of late Third-Style decorative systems.

Marcus Lucretius Fronto and the Fourth-Style Program The Lucretii were a prominent, almost certainly collaborationist, family who came to power in the period of Augustus,[45] at the time of the diffusion of the Third Style from Rome to Campania. When the House of Lucretius Fronto received its Third-Style decoration, around A.D. 40, several branches of the family had established themselves in Pompeii to such an extent that one scholar claims that they were "perhaps the most important gens in Pompeii."[46]

The identification of Marcus Lucretius Fronto as the owner of this house is based on four electoral slogans painted on the street that announce three candidacies, for *aedile, duovir,* and *quinquennial duovir.* Of these offices, that of aedile was relatively unimportant, whereas it was difficult to become a duovir and even more difficult to become a quinquennial. To run for the office of quinquennial, as he did in 73–79, M. Lucretius Fronto had to have been duovir (the duoviri presided over the popular assembly), and he had to have won over

44. This reciprocity between Dionysus and Apollo has been discussed thoroughly; its most forceful formulation is perhaps that of Friedrich Nietzsche, *The Birth of Tragedy,* trans. Clifton P. Fadiman, in *The Philosophy of Nietzsche* (New York, 1977), 187–207.

45. Castrén, *Ordo populusque pompeianus,* 185–186.

46. James L. Franklin, Jr., *Pompeii: The Electoral Programmata: Campaigns and Politics, A.D. 71–79,* Papers and Monographs of the American Academy in Rome, no. 28 (Rome, 1980): 99–100.

the municipality and its citizens through acts of public munificence.[47] If the graffito with his name, found in the garden of the house, proves that it belonged to this busy and prosperous public figure,[48] the Fourth-Style decoration in progress at the time of the eruption ought to inform us about his tastes and ideology.

The earthquake of 62 had not damaged the by now venerable thirty-year-old rooms of the late Third Style discussed above, but the winter triclinium *f*, cubiculum *i*, and all the rooms of the garden area (*s*, *t*, and *u*) received new decoration. Exedra *t* was still incomplete when Vesuvius covered the house.[49]

Expectations to the contrary, the only room of this late Fourth-Style campaign with a clear message is yellow cubiculum *i*. The room contains a series of moral lessons for the child or children who slept there. On the north wall a large painting of Narcissus, who fell in love with his own image and was punished by Nemesis for ignoring the nymph Echo, warns against vanity and self-absorption (Fig. 79).[50] Opposite it, Pero overcomes her modesty in the ultimate act of filial piety, giving her imprisoned father Micon milk from her breast so that he will not starve to death. The accompanying epigram, "in sadness is the meeting of modesty and piety," underscores the picture's message (Fig. 80). Twin medallions at either side of the doorway depict a girl and a boy (Fig. 81 and Fig. 82). The boy is shown as Mercury, perhaps to encourage the child's interest in the financial gain guaranteed by this god. High on the west wall is the graffito *Marcus*,[51] perhaps identifying this as the young son of the patron Marcus Lucretius Fronto.

Unfortunately, the other Fourth-Style rooms of the House of Lucretius Fronto lack the unity and tendentiousness of the child's bedroom. Their central pictures fall into two categories, theatrical stories and standard representations of gods and goddesses. In the winter triclinium *f*, the dramatic depiction of Orestes killing Neoptolemos on the altar of Apollo at Delphi (Fig. 83) was balanced by a painting (now lost) of Mars and Venus. The pyramid of struggling forms, pushed to the foreground, is reminiscent of other crowded Fourth-Style scenes, such as the *Punishment of Dirce* in the House of the Vettii (see Pl. 16).

47. Castrén, *Ordo populusque pompeianus*, 66.

48. Arnold de Vos and Mariette de Vos, *Pompei Ercolano Stabia*, Guida archaeologica Laterza, no. 11 (Rome, 1982), 214.

49. de Vos and de Vos, *Pompei Ercolano Stabia*, 214; the house's excavator, A. Sogliano, "Relazione degli scavi fatti durante il mese di febbraio 1901," *Notizie degli scavi* (1901): 168, did not realize that the decoration of exedra *t* was incomplete.

50. Lawrence Richardson, Jr., "Pompeii: The Casa dei Dioscuri and Its Painters," *Memoirs of the American Academy in Rome* 23 (1955): 152 note 151, attributes the painting of Narcissus to the painter of three scenes in the House of the Menander: the Rape of Cassandra, the Trojan Horse, and Perseus and Andromeda.

51. Sogliano, "Scavi 1901," 161.

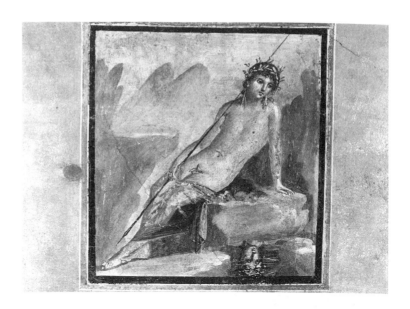

FIGURE 79. The central picture in the north wall of Fourth-Style
cubiculum *i:* Narcissus falls in love with his reflection.

FIGURE 80. The central picture on the south wall of cubiculum *i:*
Pero suckles her imprisoned father Micon.

FIGURE 81. A tondo of a girl
on the south wall of the
doorway.

FIGURE 82. A tondo of a boy
Mercury on the north wall of
the doorway.

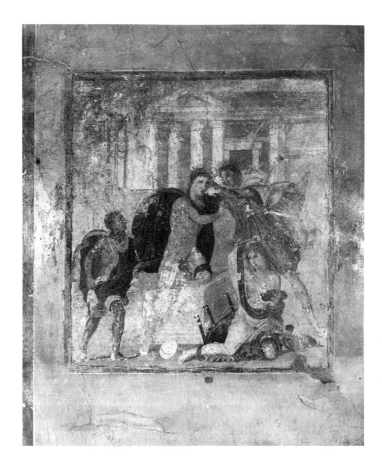

FIGURE 83. The central picture on the east wall of the Fourth-Style winter triclinium: Orestes slays Neoptolemos on the altar of Apollo at Delphi.

In the summer triclinium *s,* the tragic love story of Pyramus and Thisbe (also adorning the outdoor biclinium of the House of Octavius Quartio) opposed a picture of Dionysus with Silenus.[52] Even the representations of wild beasts stalking each other painted on the walls of garden *l* (Fig. 84) reveal little about the character and ideology of Marcus Lucretius Fronto, since in the period of the late Fourth Style this theme appears in several garden settings with only the

52. Sogliano, "Scavi 1901," 168–170, illustrates the now-vanished paintings of garden cubiculum *u:* Europa and the bull on the north wall (fig. 19), Danae on Seriphus on the west wall (fig. 21), and Poseidon on the south wall (fig. 20).

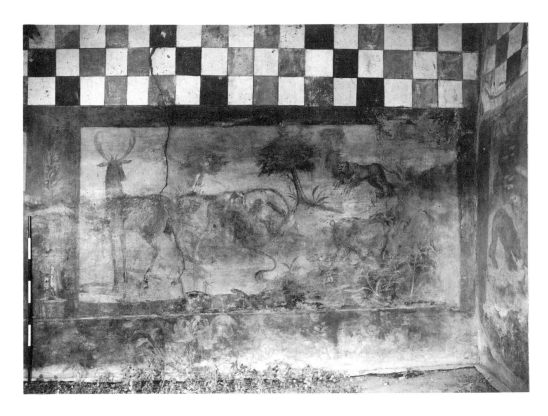

FIGURE 84. A paradeisos painting adds regal associations to the garden.

general connotations of the game preserves, or paradeisoi, of Hellenistic rulers.[53] In the end, the late paintings of the House of Lucretius Fronto tell us less about the man and more about the new taste for theatrical central pictures and showy, often banal effects in wall painting at the time. In the hands of more capable artists than the Fourth-Style painters in this house, the theater is eloquent and the effects impressive.

53. Examples at Pompeii include the viridarium of the House of the Ceii (I, 6, 15), the peristyle of the House of Romulus and Remus (VII, 7, 10) (illustrated in Karl Schefold, *Vergessenes Pompeji* [Bern, 1962], 1–2, fig. 15), and the south walls of the House of Octavius Quartio. Eugenio La Rocca, Mariette de Vos, and Arnold de Vos, *Guida archeologica di Pompei*, ed. Filippo Coarelli (Milan, 1976), 66, believe that the painter of the exterior walls in the House of Octavius Quartio, who signed his work "Lucius," may have been the author of the paradeisos of the House of Lucretius Fronto. For the meaning of paradeisoi in Pompeian houses, see La Rocca, de Vos and de Vos, *Pompei*, 59; for the range of meanings, see K. Galling, "Paradeisos," *Pauly-Wissowa*, s.v.

CHAPTER FIVE

FOURTH-STYLE ENSEMBLES, A.D. 45–79

Pompeii's Romanization during the Augustan period improved trade and commerce, giving its export industries regular access to ports throughout the Mediterranean. The town was relatively prosperous and untroubled until the period between 41 and 52, when because of an undetermined political crisis no magistrates appear in the records. The riot in Pompeii's amphitheater in 59 caused the emperor to close it for a period of ten years, and the crisis may have deterred Nero from helping Pompeii after the great disaster that followed three years later, when a violent earthquake devastated the city.[1] Although no one knew it at the time, the earthquake of February 5, 62, was the prelude to the eruption of Vesuvius on August 24, 79.

The immediate consequences of the earthquake were grave enough. Pompeii's economy collapsed.[2] The wealthy left the ruined city; those who remained began the long task of rebuilding houses and public monuments. Seventeen years later, when Pompeii was buried by the eruption of Vesuvius, the work was still not completed. The only public monument that had been restored was the Temple of Isis. Many wealthy houses and villas were vacant, with workmen slowly repairing the earthquake damage; others were subdivided into rude housing for the construction workers. Agrippa's aqueduct, which had supplied the city with water since 30 B.C., had still not been repaired.

Political changes accompanied the economic ones. Because of the economic crisis, entry into the senatorial class, that is, the ordo decurionum, became easier for newcomers. Members of modest families and even descendants of freedmen appear in the written sources.[3] As in the Augustan period, the Flavian emperors sought to secure their power by introducing their own men into the

1. Paavo Castrén, *Ordo populusque pompeianus: Polity and Society in Roman Pompeii*, Acta Instituti romani finlandiae, no. 8 (Rome, 1975), 105–109.

2. Jean P. Andreau, "Histoire des séismes et histoire économique. Le tremblement de terre de Pompéi (62 ap. J.-C.)," *Annales: Economies, sociétés, civilisations* 28 (1973): 369–395.

3. Castrén, *Ordo populusque pompeianus*, 124.

ordo decurionum. These changes made it attractive for enterprising freedmen and ambitious middle-class citizens to jostle for position and power in Pompeii's last days. An important aspect of the new upward mobility for these newcomers, or *homines novi,* was the decoration of their homes. As we have seen in chapter 1, this last period at both Pompeii and Herculaneum sees a filtering down of the concept of the luxury villa to the town houses, causing owners to convert their properties into miniature villas. Many turned the consequences of the earthquake to their advantage by buying adjacent houses at low prices; in this way they could expand their domains, adding upper-class features like second atriums, peristyles, and extensive gardens.

Because of Vesuvius's eruption, the greatest quantity of wall, ceiling, and floor decoration surviving in Roman Italy belongs to the period of the Fourth Style. It is obvious that more examples of the style in vogue during the final thirty years of Pompeii and Herculaneum would be preserved in the volcanic ash than ensembles of styles as much as 180 years old at the time of the eruption (such as those of the First Style). The earthquake of 62 also increased the number of Fourth-Style ensembles, since owners had to redecorate ruined walls and pavements after they were made structurally sound again. Given the abundance of preserved decorative ensembles and the possibility in many cases of knowing who the owners were, this chapter ventures deeper into questions of patronage than did the previous chapters. In addition to exploring both the aesthetics and viewing patterns of a range of typical Fourth-Style manners, this chapter will investigate the possible meanings these ensembles had for their patrons and their guests.

THE FOURTH-STYLE TAPESTRY MANNER AT THE VILLA OF OPLONTIS, A.D. 45–55

The third decorative phase at the Villa of Oplontis took place following substantial additions and modifications, which included extending the villa to the east and adding a large, sixty-meter swimming pool. As the plan indicates, although their floors remained, most early Third-Style walls and ceilings were repainted at this time (see Fig. 51). Rooms 8, 37, 38, and 46 (and 60, 76, 77, and 79 in the eastern part of the villa, see Fig. 41) preserve considerable portions of their Tapestry-Manner walls, stucco moldings, and ceilings, providing high-quality examples of the new taste in decoration.

As mentioned above, when wall painters renewed the decoration of caldarium 8, the patron instructed them to retain the early Third-Style scheme. Because the eastern wall received a niche, here the painters had to imitate the early Third-Style scheme. Comparison of the unaltered north wall with the imi-

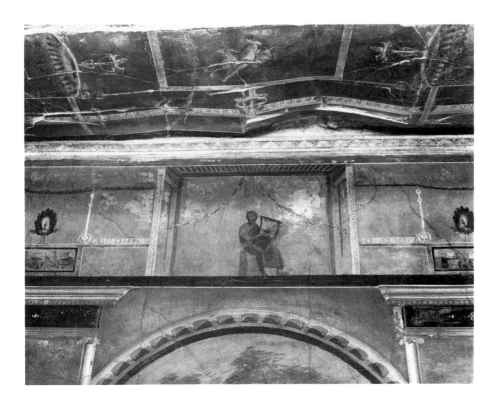

FIGURE 85. A poet flanked by twin landscapes occupies the early Fourth-
Style upper zone in caldarium 8 at Oplontis.

tation early Third-Style scheme of the east wall indicates that the painters fol-
lowed the schemes of the socle and median zone faithfully. However, the upper
zone of the niche, the area above the upper zone, and the room's ceiling have
nothing to do with the Third Style.[4] In the niche, carpet borders executed in
white added over the yellow-gold ground replace the tiny decorated columns
and pilasters of the Third Style (Fig. 85). Above the aedicula with a painting of
Hercules in the Garden of the Hesperides sits a minuscule poet, sitting with his
lyre in a shallow square niche constructed in part from airy carpet borders.
Similar carpet borders connect his niche with the tiny twin landscapes sur-
mounted by strutting frontal peacocks that flank him on either side.

4. Wolfgang Ehrhardt, *Stilgeschichtliche Untersuchungen an römischen Wandmalereien von
der späten Republik bis zur Zeit Neros* (Mainz, 1987), 34 note 360, concurs, noting that the cen-
tral picture of the north wall is earlier than the picture in the niche, restored in the period of the
Fourth Style.

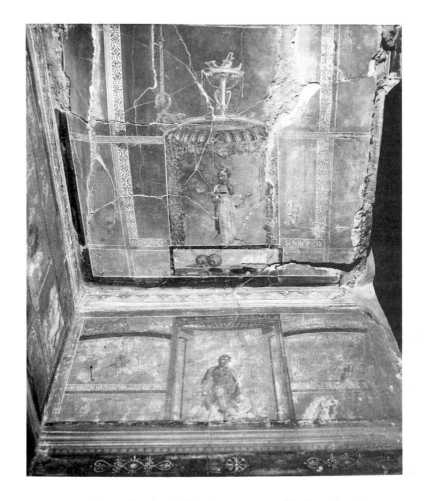

FIGURE 86. Carpet borders define the geometry of both wall and ceiling painting.

This niche's ceiling and stucco molding demonstrate how the vertical divisions of the aediculae on the wall dictated the position and dimensions of the answering aediculae on the ceiling (Fig. 86). On a podium formed by a fruit still life a bearded male with an offering tray stands in an aedicula formed by carpet borders on the sides and a shell overhead, topped by a rhyton on a fanciful stand. Taut wirelike garlands attach to the upper corners of this aedicula to connect with a carpet band framing the figure of a nereid riding a marine bull. Another carpet border frames the outer edges of the ceiling, and a thin stucco molding, with a pattern of double-framed semicircles framing trefoils, separates walls from ceiling.

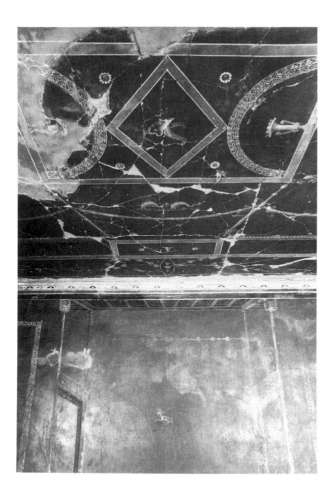

FIGURE 87. Columns and carpet borders align in both
wall and ceiling of room 38.

In place of the illusionistic architectural members of the Second Style, and
their attenuation and stylization in the Third, in this Tapestry Manner of the
early Fourth Style, carpet borders divide monochrome walls and ceilings into
geometric shapes with only residual architectural features. Not only has the
wall returned to its status as a flat field for decoration, but the center of interest
has shifted from the illusionistic architecture itself to individual figural and
decorative motifs rendered illusionistically yet floating against monochrome
backgrounds.

Room 38, a low-ceilinged anteroom to cubiculum 41, is a monochrome red
room painted by the workshop of caldarium 8 (Fig. 87). Wall and ceiling, seen

together, reveal their interdependent, linear, geometric organization. Thin columns with a shallow coffered ceiling align with the rectangle in the center of the ceiling, itself divided into two lunettes and a diamond by carpet borders. Aligned with the place where the orthogonals of the central niche converge in a trapezoidal shape is an ellipse on the ceiling. On this same line in the center of the ceiling are painted a bull's skull (*bucranium*), twin dolphins, and the diamond framing a swan. The motifs, by now entirely decorative, come from the realm of Dionysus (rhyta, craters, thyrsi), Apollo (swans), and Venus (dolphins). At the junction between wall and ceiling, the stucco molding, impressed with the same design seen in caldarium 8 but painted in alternating red and blue, has the effect of a carpet border in relief.

In this simple adornment of a modest space, the Tapestry Manner creates a unified flat decoration enlivened by the linear details of carpet borders, garlands, and thin metallic candelabra framing isolated and miniature decorative motifs. This manner, in the important spaces of the House of the Menander, aspires to much weightier effects.

HIGH DRAMA, LOW HUMOR, AND INTELLECTUAL PRETENSIONS
IN THE HOUSE OF THE MENANDER

In chapter 1 we examined the plan and visual axes of the House of the Menander (see Fig. 2). It is a very large house for Pompeii (1,800 m²); because it occupies a site that slopes southward it has two ground levels (see Fig. 6). Farm quarters, servants' lodgings, and the kitchen are on the lower level, while the peristyle and its rooms occupy a platform of earth fill. A seal belonging to the freedman *procurator*, or administrator, of Quintus Poppaeus, found in room 43, indicates that at the time of the eruption the house belonged to the Poppaei. Other properties at Pompeii, and possibly the Villa of Oplontis, belonged to branches of this wealthy local family.[5]

Beginning in the third century B.C. as an atrium house, made grander in the following century with the addition of tufa pilasters at the entry and engaged columns at the tablinum's entrance, the House of the Menander spread in massive renovations of about 30 B.C. into the area formerly occupied by similar atrium houses. By buying these houses and filling in the center of the insula, the owner created a huge peristyle surrounded by luxurious spaces in the

5. Carlo Giordano, "Poppea e Nerone tra Oplontis e Pompei," *Sylva Mala* 3, nos. 1–6 (1982): 2–8, notes that the House of the Menander and the House of the Amorini Dorati belonged to the gens Poppaea and collects the evidence and bibliography for the attribution of the Villa of Oplontis to this same family. His contention that Nero visited the temple of Venus at Pompeii and stayed at Oplontis is highly debatable.

Hellenistic fashion: oeci, a private bath complex, exedrae, and the largest entertainment space found at Pompeii—a room too large for the traditional placement of the triclinium couches. Because the existing House of the Lovers remained, the architect built a series of exedrae, rather than further rooms, at the south end of the peristyle. Later land acquisitions added a stable and farm quarters to the southeast corner of the house. The family may have operated vineyards and market gardens just south of the house on unoccupied land inside the walls.[6] At the time of the eruption little remained from this late first-century B.C. phase: a number of Second-Style pavements[7] and the wall painting of exedra 25.[8] The house was entirely redecorated between 45 and 55 in the Fourth Style. These decorations demonstrate the aesthetics, viewing patterns, and iconographic programs of the Fourth-Style Tapestry Manner.

Design, Color, and Function of Spaces The decoration of the atrium, ala, and tablinum reveal the designer's desire to integrate the mutually dependent reception rooms (Fig. 88). All three spaces have white cement pavements with a random pattern of black, red, and yellow limestone fragments, and all have black socles decorated with plants. The tablinum's socle is the most elaborate, with the addition of birds, panthers, and a dolphin. In the median zones reciprocal color relationships occur. The atrium has red tapestry panels on a gold ground, whereas both the ala and the tablinum have gold panels on a red ground.[9] The ala's antae are gold, whereas the engaged columns framing the tablinum are white with gold bases. Upper zones in the tablinum and ala have white grounds with architectural elements and garlands. In this way the artist differentiated the spaces within his integrated scheme, visually separating ala and tablinum through the use of a color scheme opposite from that of the atrium, so that even when the rooms were not closed off from the atrium by folding wooden screens or drapery, their status as functionally separate rooms was clear from their subtly different uses of the geometry and color.

The tradition of placing landscapes high up on the atrium walls, begun in the mature Second-Style atrium of the Villa of the Mysteries, continues here

6. John Ward-Perkins and Amanda Claridge, *Pompeii, A.D. 79*, 2 vols. (Boston, 1978), 2:153.
7. In all rooms of the bath, and rooms 11, 15, and 21–25.
8. The date of the wall painting of exedra 25 has been the focus of much debate. Amedeo Maiuri, *La Casa del Menandro e il suo tesoro di argenteria* (Rome, 1933), 1:96, believed it to be of the mature Second Style, noting that the altar and niches were added in the house's last years (98–99); Karl Schefold, *Die Wände Pompejis: Topographisches Verzeichnis der Bildmotive* (Berlin, 1957), 44, calls it "imitation Second Style"; and Hendrick G. Beyen, *Pompejanische Wanddekoration vom zweiten bis zum vierten Stil* (The Hague, 1960), 2:162–172, considers it to be Second Style; Arnold de Vos and Mariette de Vos, *Pompei Ercolano Stabia*, Guida archeologica Laterza, no. 11 (Rome, 1982), 93, Second Style. The red socle was painted over the individual socles supporting columns, added at the same time as the red ceiling.
9. The heat of the volcanic ash changed the gold panels of both the south wall of the ala and its south anta to red. This same effect occurred on the east wall of Villa of Oplontis, 8.

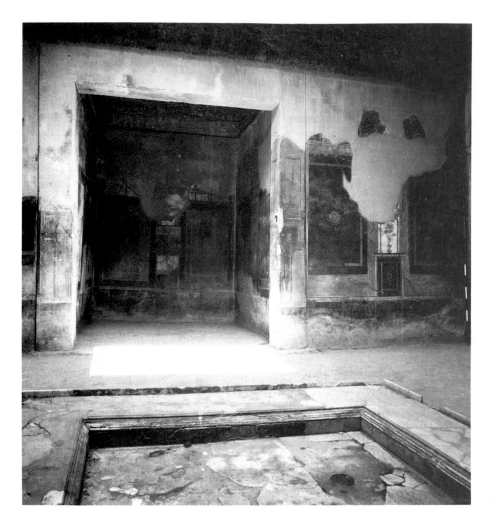

FIGURE 88. The ala in the House of the Menander coordinates with the schemes of atrium and tablinum.

(Fig. 89). The elegant seaside villa preserved on the west wall boasts palatial porticoes overlooking a long pier and fringed with forests on the land side. Another, on the north wall, is a Nilotic scene. Although the position of these landscapes high up on the atrium's wall requires prolonged viewing for them to be appreciated, there are no central pictures in the median zone, apparently because they were deemed inappropriate for dynamic spaces like the atrium and

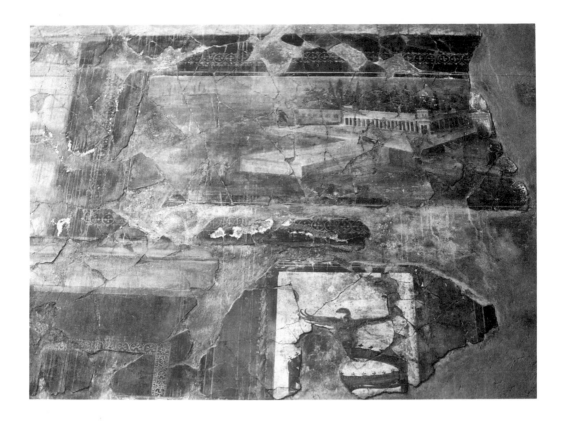

FIGURE 89. A picture of a seaside villa for the upper zone of the atrium continues a tradition of a hundred years before (compare Fig. 29).

fauces.[10] Instead, the median zone has small scenes in its red panels, including a motif that survives into second- and third-century painting at Ostia, that of birds pecking cherries.[11] In roundels appear the head of Zeus-Ammon[12] and tragic masks in little rectangular frames.

This same system of carpet-bordered panels in red, gold, and black with

10. See Daniela Corlàita Scagliarini, "Spazio e decorazione nella pittura pompeiana," *Palladio* 23–25 (1974–1976): 19–20, for a discussion of the usual decoration for dynamic spaces, to which the landscape panels form a kind of exception. See also John R. Clarke, *Roman Black-and-White Figural Mosaics* (New York, 1979), 7–8, on the lack of figuration on atrium floors.

11. Ostia Antica III, x, 1, Insula of the Charioteers, 30, 8, south wall (Antonine phase), photograph in the archives of the Istituto centrale per il catalogo e la documentazione, Rome, ICCD E 40746.

12. The head of Zeus-Ammon appears in the early Antonine decoration of room 11 in the House of the Painted Vaults.

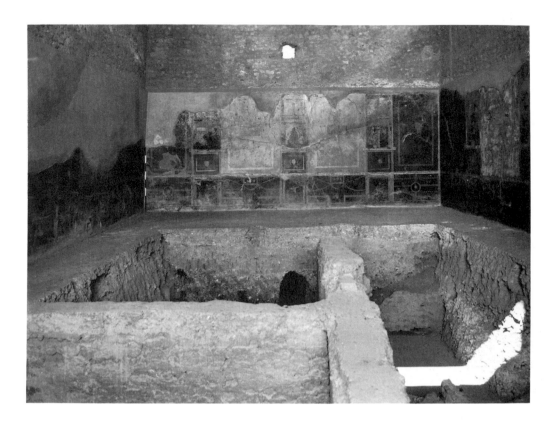

FIGURE 90. A Tapestry Manner decoration without central foci adorns the great triclinium (see Fig. 20).

tiny figures in their centers decorates triclinium 18 (Fig. 90). Its red signinum floor meets the black socle, decorated with lily and oleander bushes, birds, vases, gorgon heads, pegasi, and dolphins. The alternation of red and porphyry red panels, like the system in the atrium, is interrupted by slots on top of black square panels containing heads of gorgons, Zeus-Ammon, and panthers. These slots, white in the atrium and framing tripods, here are black and frame architectural motifs. Like the atrium, this triclinium employs tapestry panels and slots without any single focal center in the middle of the wall. Scagliarini has shown how the designer deliberately interrupted panels at the room's corners, further deemphasizing any focus on the walls' center points (see Fig. 20).[13]

13. Scagliarini, "Spazio e decorazione," 14, fig. 22.

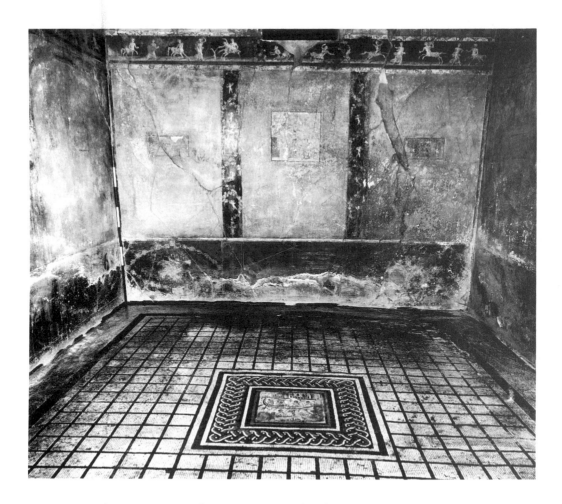

FIGURE 91. The patron retained oecus 11's Second-Style mosaic system when the walls were redecorated in the early Fourth Style.

A different decorative strategy from these tapestry panel systems appears in the House of the Menander's three monochrome rooms. These are all oeci, relatively intimate spaces facing the peristyle and meant for conversation, reading, and perhaps small dinners. Oecus 11 has sea-green median and upper zones resting on a porphyry red socle, with a frieze in shades of porphyry red (Fig. 91). Oecus 15 is a nearly square room with a black socle topped by red median and upper zones, and a red ceiling. Unlike oecus 11, which was somewhat dark and protected from the sun by its position in the peristyle's corners,

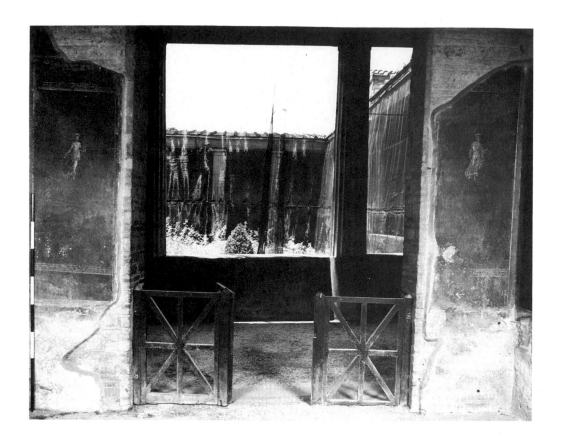

FIGURE 92. Floating Muses frame the view out of oecus 15.

oecus 15 received the full afternoon sun from the west (Fig. 92). Its Second-Style floor is a design of white tesserae patterned into a network of diamonds with black slate strips. Like 15, oecus 19 faced west, but with a view along the south wing of the peristyle. Two zones of gold-ground decoration surmount its porphyry-red socle. Monochrome decorations, already seen at the Villa of Oplontis and the House of Lucretius Fronto, become quite fashionable in this period, especially for static spaces such as sitting rooms or bedrooms. They, too, become a tradition in Roman interior ensembles that survives and develops in the second century.

Dramatic Themes in a Popular Style Combinations of paintings in several rooms of the House of the Menander reveal the patron's taste for highly dramatic pictorial cycles or individual paintings illustrating climactic moments in

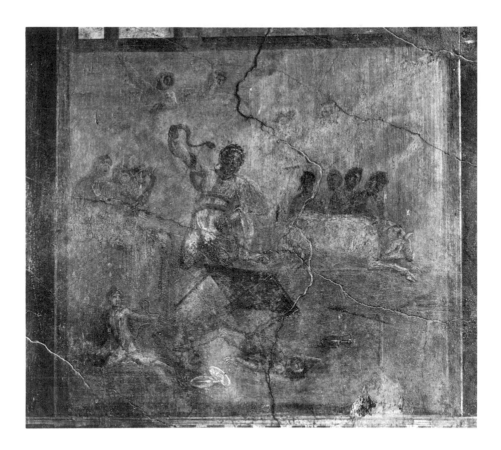

FIGURE 93. A Trojan cycle in ala 4: Laocoon and his sons strangled by serpents.

myths. In this regard he or she exhibits interests found in many houses decorated at this time in Pompeii and Herculaneum.

Three dramatic events, all directly related to the fall of Troy and described in the *Aeneid*, decorate the ala: on the south wall, *Laocoon and His Sons Strangled by Serpents* (Fig. 93); on the east wall, *Cassandra Opposes the Entry of the Wooden Horse into Troy* (Fig. 94); and, on the north wall, *Cassandra Resisting Abduction by Ajax* (son of Oileus) (Fig. 95). All three pictures relate in theme and in style.[14] The Laocoon picture, although much damaged, presents the moment of doom for the ill-fated priest; one son has already succumbed, the other is about to expire, and Laocoon realizes that not only he,

14. Georg Lippold, *Antike Gemäldekopien* (Munich, 1951), 83–84.

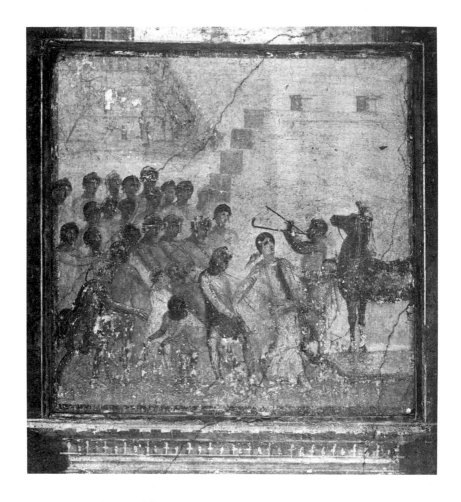

FIGURE 94. The Greek horse enters Troy.

but Troy itself, is doomed. The entry of the wooden horse filled with Greeks into Troy represents the cause of its final defeat. For the Romans, of course, there is a happy ending in the sense that it was Aeneas, a Trojan who escaped, who survived to found Rome. The painting on the north wall combines two different moments in the saga to underscore Priam's conflicting paternal emotions. Priam helplessly watches Cassandra's vain resistance to Ajax's grasp as she clutches the ancient image of Athena, while on his right Menelaos confronts Priam's daughter-in-law, the faithless Helen. As Maiuri notes, this painting abandons the literary and poetic traditions to follow a currently popular

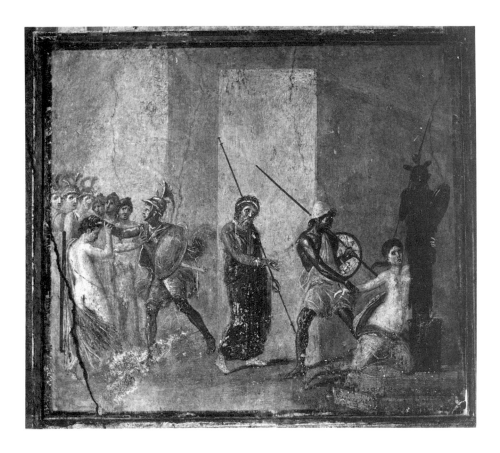

FIGURE 95. Cassandra, on the right, resists abduction by Ajax (son of Oileus) while Priam watches; Menelaos confronts Helen on the left.

story of portraying the old king's plea for the safety of his prettiest daughter and respect for his most wayward daughter-in-law.[15] Schefold has proposed that the three scenes in ala 4 connected with the Emperor Nero's poem on the Fall of Troy, which he recited while Rome burned in A.D. 64. Nero, too, may have had the sculptural group of the Laocoon installed in his Domus Aurea,[16] and the owner of the House of the Menander, Quintus Poppaeus, belonged to the same gens as Nero's second wife.[17] Even without the Neronian connections,

15. Maiuri, *Casa del Menandro*, 51.
16. C. C. van Essen, "La découverte de la Domus Aurea," *Mededelingen van het Nederlands Instituut te Rome* 18 (1955): 291–308.
17. Karl Schefold, "Die Troiasage in Pompeji," *Nederlands kunsthistorisch Jahrboek* 5 (1954): 222–223.

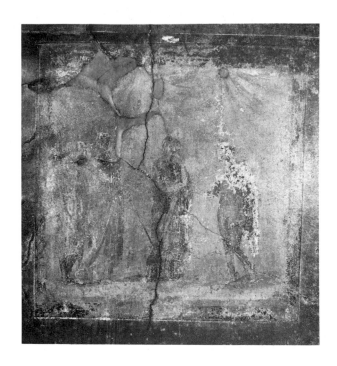

FIGURE 96. Mythological pictures in oecus 15:
Perseus in Cephas's palace.

this ala presents well-known dramatic turning points in a saga familiar to all, depicted in a popular narrative style. In this sense the pictorial ensemble was a safe choice, since even persons of ordinary learning would capture its meaning.

So, too, with the three mythological pictures in oecus 15. Two of them, *Perseus in Cephas's Palace* (Fig. 96) and *Perseus Saving Andromeda* (Fig. 97), illustrate successive moments in the same story. A synoptic version of this story in the House of the Priest Amandus condenses these two scenes into one picture.[18] What little remains suggests authorship by a painter of greater talent than the rather banal artist of ala 4.[19] Whereas these two pictures tell a romantic love story complete with damsel in distress and virile hero, the third picture, *The Punishment of Dirce* (Fig. 98), is a tale of two sons' vengeance against

18. Karl Schefold, *Vergessenes Pompeji* (Bern, 1962), pl. 6; Amedeo Maiuri, *Le pitture delle case di "M. Fabius Amandio" del "Sacerdos Amandus" e di "P. Cornelius Teges,"* Monumenti della pittura antica scoperti in Italia, sec. 3, Pompei fasc. 2 (Rome, 1938), pl. B.

19. Carlo Ragghianti, "Personalità di pittori a Pompei," *Critica dell'arte* 1 (1954): 214–216, identified the Iphigenia Painter, attributing to him the Rape of Cassandra and the Trojan Horse of ala 4 and the Perseus Saving Andromeda of oecus 15; Lawrence Richardson, Jr., "Pompeii: The

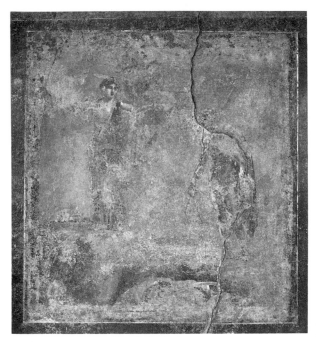

FIGURE 97.
Perseus saving Andromeda.

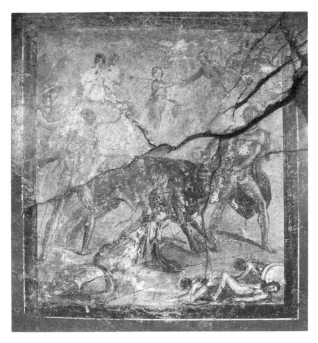

FIGURE 98. The punishment of Dirce
(compare Pl. 16).

Dirce, who had mistreated their mother and was about to have her tied to a bull. At the last moment, Dirce's evil is discovered, and she receives the punishment intended for the mother.[20] This representation is synoptic, unlike the successive moments represented in the Perseus myth: in the lower right lie dead soldiers who tried unsuccessfully to carry out Dirce's plans; Dirce, tied to the bull, is already dead; and Amphion, in the upper left, has begun to build the walls of Thebes with his magical lyre. Unlike ala 4, whose paintings clearly related to a single, unified theme, these images bear quite different messages: one a heroic story of love and rescue, the other a story of sons avenging a mother's cruel treatment at the hands of an evil woman.

Since it is unlikely that these three paintings were meant to be considered together, their role in the room's decoration may have been that of recalling well-known paintings by Greek masters. The Muses floating between the paintings suggests that this was a Room of the Muses, or *museion*, where discussion of masterpieces of Greek art and literature would be entirely appropriate. The Muses' attributes identify some of them (there were originally only eight). One, with a lyre in her left hand and a plectrum in the other, must be Erato, the Muse of love poetry (Fig. 99). Not all of them were present, nor have all survived, but the evocation of the Muses sets the tone for the patron's literary interests—or at least his literary pretensions, for rooms dedicated to the Muses in private houses were meant for discussion, if not performance, of the literary and the lively arts. Every cultivated person needed a private *museion*.[21] We will see that this type of room also survives long after the destruction of Pompeii at Ostia Antica—another thread in the skein of lasting decorative traditions.

Even more popular than the drama of Dirce's punishment was that of Actaeon, pictured twenty-one times on walls at Pompeii and Herculaneum.[22] Perhaps its popularity was due in part to the fact that the subject fit so well into landscape paintings and the setting of gardens and peristyles. In the House of the Menander, Diana, fully clothed and iconic, stands on the axis of apsidal

Casa dei Dioscuri and Its Painters," *Memoirs of the American Academy in Rome* 23 (1955): 149–152, attributes the following paintings in the House of the Menander to this artist: oecus 19, north wall, Cupid Frightened by Mask; south wall, Satyr Playing Syrinx to Nymph; exedra 23, megalographic figure of Menander and masks. Richardson, 152 note 15, removes the paintings of ala 4, oecus 15 from the Iphigenia Painter and gives them to his pupil, who would have worked side by side with his master in the House of the Menander.

20. The seven representations of this myth found to date at Pompeii are discussed in Eleanor Winsor Leach, "The Punishment of Dirce: A Newly Discovered Painting in the Casa di Giulio Polibio and Its Significance within the Visual Tradition," *Römische Mitteilungen* 93 (1986): 157–182.

21. Müller-Graupa, "Museion," *Pauly-Wissowa*, s.v.; Karl Schefold, *La peinture pompéienne: Essai sur l'évolution de sa signification* (Brussels, 1972), 69–78, "La maison comme *museion*."

22. Eleanor Winsor Leach, "Metamorphoses of the Acteon Myth in Campanian Painting," *Römische Mitteilungen* 88 (1981): 307–327, with a list of representations of the Actaeon myth on 312–313 note 26.

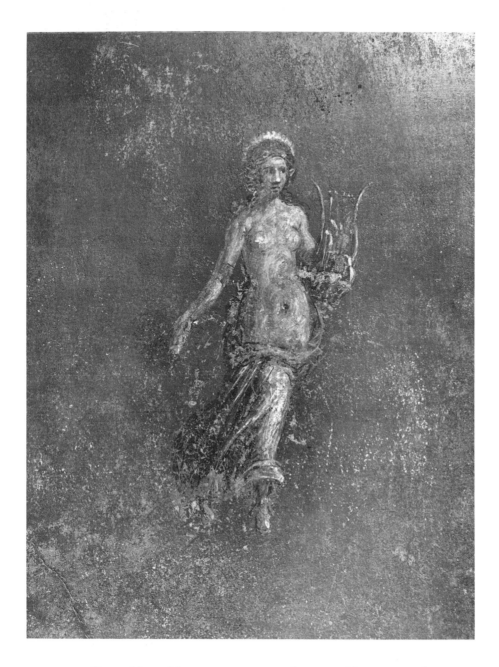

FIGURE 99. Erato, Muse of love poetry, suggests that oecus 15 was a museion.

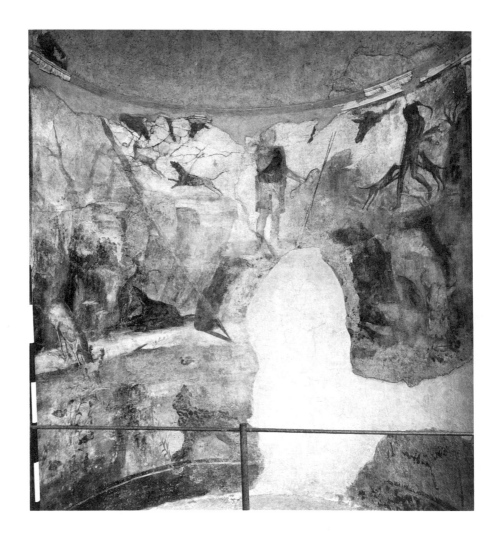

FIGURE 100. Actaeon's punishment appears to the upper right of Diana's image in exedra 22.

exedra 22, while Actaeon appears in the upper right (Fig. 100). Its axial composition and preponderance of landscape detail make this depiction of the Actaeon myth correspond with the representation of Venus in a wooded setting in twin exedra 24 (Fig. 101). With this painting of Venus and Cupid in their small rustic temple we leave the high drama of saga and myth for more usual representations of gods, goddesses, and demigods. Like the two paintings of nymphs

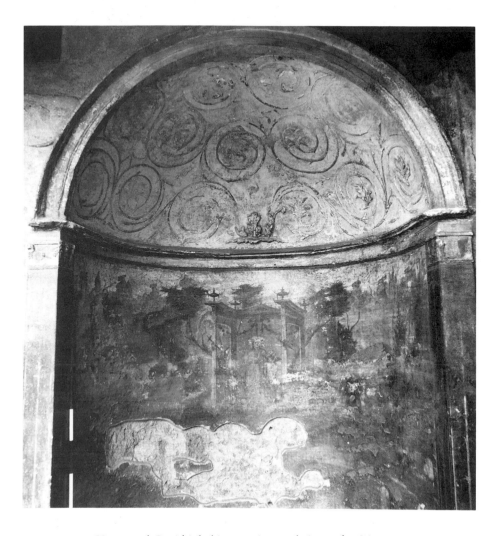

FIGURE 101. Venus and Cupid inhabit a rustic temple in exedra 24.

and satyrs in room 19, or the pictures of maenads, cupids, and satyrs in room 11, exedra 24's Venus is simply presentational. We see these deities in their environments rather than as protagonists in a narrative.

Humor in the Bath and the Green Oecus Two generations of patrons who liked humor must have lived in the House of the Menander, for the comical frieze of drunken centaurs trying to abduct Lapith women in oecus 11

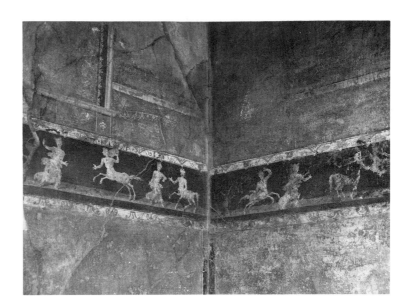

FIGURE 102. A farcical frieze of centaurs abducting Lapith women in oecus 11.

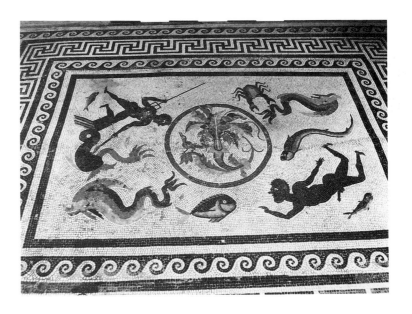

FIGURE 103. An eclectic mixture of motifs collected in the caldarium's Second-Style mosaic.

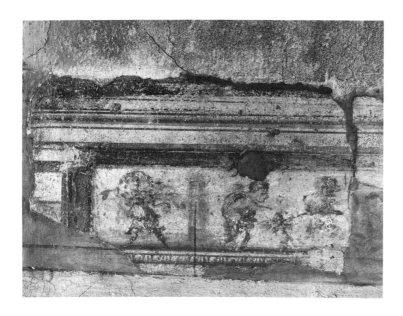

FIGURE 104. A Second-Style caricature in the atriolo of the bath:
Venus incites Cupid to shoot an arrow.

(Fig. 102) was painted at least sixty years after the caricatures of the gods sur-
rounding the little atrium (*atriolo*) of the bath. The owner who commissioned
the entire late Second-Style bath complex must have also enjoyed the slightly
risqué mosaics of the caldarium. An enormous semierect penis with a red glans
sticks out of the black bathboy's loincloth in the entryway, and the black swim-
mer inside sports a healthy erection (Fig. 103).[23] Similar figures of black macro-
phallic bath servants and ithyphallic swimmers with negroid features appear in
other private baths. Both the ancient literature and modern studies indicate
that upper-class Romans hypersexualized black males and regarded the black
African (the *Aethiops*) as exotic.[24]

The atriolo's Second-Style decoration was in the process of being replaced
when the disaster struck. Enough remains of the frieze to see that it too was
conceived in a light vein. Caricatures of gods and goddesses, with tiny bodies
and big heads, undertake their lofty duties. On the fragment remaining on the
north wall, Theseus battles the Minotaur. Venus encourages Cupid to shoot
one of his arrows in a fragment on the east wall (Fig. 104).

23. Clarke, *Mosaics*, 13–14, 59–61, figs. 13–14.
24. Lloyd A. Thompson, *Romans and Blacks* (Norman, Oklahoma, 1989), 107–109.

The little emblema with scenes of pygmies in their boats on the Nile belongs with the original Second-Style decoration of oecus 11 (Pl. 10). Its retention as the centerpiece of the floor when the room was repainted is not unusual, especially considering its relative refinement and good state of preservation. It is probably no coincidence that its subject matter complements the original paintings and mosaics of the bath complex. The Fourth-Style painter of this room maintained the light, exotic tone of the emblema when he redecorated the room. The sexual passions of the centaurs who pursue dismayed Lapith women in oecus 11 must have provided amusement for those who sat there. This farcical representation of the eternal battle between the sexes would have delighted both men and women. The delicate decoration of the vertical bands beneath, some woven with miniature tendrils filled with flowers, others with tiny heads in medallions, has led to speculation about its date.[25] All indications are that it belongs with the early Fourth-Style decorations of the rest of the house.

Menander's Mate—and Dionysus The visual and iconographical focus of the House of the Menander is the square exedra, the terminus of the 141-foot-long axial view that begins in the fauces (see Fig. 2).[26] As discussed in chapter 1, it is clear from the plan that the patron wanted this dramatic focus and that the architect took great pains to realize it (see Fig. 6).[27] It is logical, then, that the imagery of this exedra announce both to his clientela (who could only glimpse this gold shrine from afar and guess at its contents) and to intimates (whose tour of the house would stop here, possibly to sit and gaze back along the axis to the entryway) the patron's intellectual and cultural aspirations. Here, on the west wall, appears the playwright Menander (Fig. 105), seated, his knees parted in a relaxed pose as he reads "The Twins" (*Didumai*). A label in Latin (in rustic capitals) beneath his chair and lines of writing at the top of the scroll identify him as Menander, adding that he was the first author of this comedy.[28]

25. Hendrick G. Beyen, "Die grüne Dekoration des Oecus am Peristyl der Casa del Menandro," *Nederlands kunsthistorisch Jaarboek* 5 (1954): 199–210, argues that it is transitional between the Third and the Fourth Style. Schefold, *Die Wände Pompejis*, 40, identifies it as the Vespasianic Fourth Style imitating the Third Style, and the mosaic emblema as an imitation of the Second Style. Maiuri, *Casa del Menandro*, 57, places it in the Fourth Style.

26. Approximately 43.5 m from the threshold of the vestibule to the rear wall of 23.

27. Heinrich Drerup, "Bildraum und Realraum in der römischen Architektur," *Römische Mitteilungen* 66 (1959): 155–161, discusses the "view through," or *Durchblick*, in the House of the Menander.

28. Maiuri, *Casa del Menandro*, 112:

Menander
Hic primu[s]
[novam?] com-
[o]ediam scripsit

.

.

Lib[ri] IIII

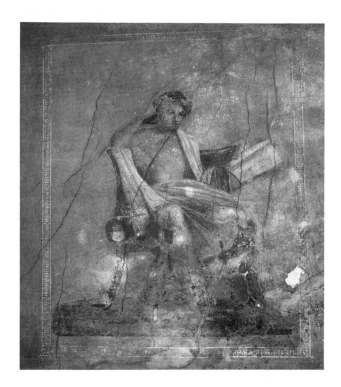

FIGURE 105. Menander, on the right-hand wall of focal exedra 23.

Crowned with laurel and supporting his head with his right arm, Menander is absorbed in his reading, unaware of the viewer. His himation has fallen to his lap, exposing his nude torso. Comic masks on a table at the right on the back of the niche, visible in the axial view, constitute the symbolic counterpart of Menander's portrait. Balancing them, on the left side of the niche, is a table with tragic masks, suggesting that opposite Menander on the east wall there appeared the image of a tragic poet. But the surviving image is badly damaged: almost all of the added secco paint that delineated its features, intact in Menander's image, has fallen off. The few fragments that remain, around the head, chair back, and scattered through the drapery and at the lower left, are badly encrusted and nearly illegible. For this reason the identity of Menander's mate has remained a mystery.

Close inspection in raking light, however, reveals lines incised by the painter into the still-damp gold fresco ground.[29] As the tracing reveals, the figure of Menander's mate can be recovered from these roughly sketched guidelines

29. Richardson, "Casa dei Dioscuri," 145, notes that the Iphigenia Painter used incised lines rather than painted guidelines in the House of the Dioscuri.

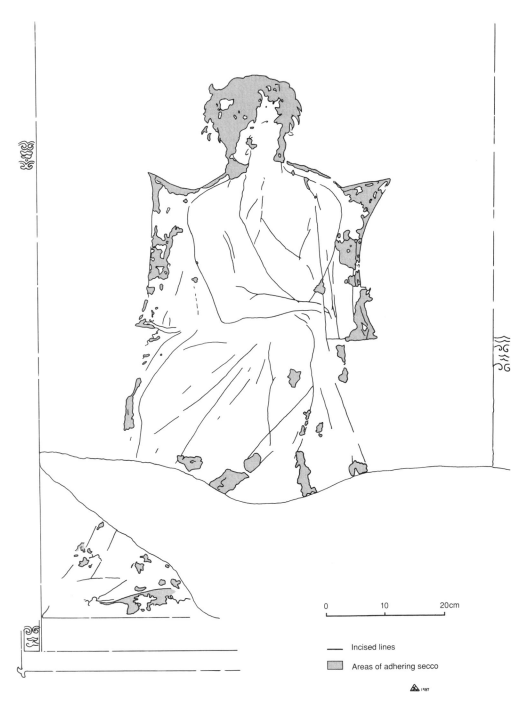

0 10 20cm

—— Incised lines

Areas of adhering secco

FIGURE 106. Tracing of guidelines incised on the left-hand wall of 23: Euripides?

(Fig. 106).[30] He sits, like Menander, on a high-backed chair, but in a different attitude. He is not reading; rather, his gesture is contemplative, as he supports his head with his left hand raised to his chin, left elbow on his knee. His pose is nearly frontal, legs spread apart. A stool must have occupied the lower right, since the playwright's left leg is raised up to support his left elbow and right hand. Incised lines at lower left, and fragments of a ground line like that in the image of Menander, indicate that this figure's right foot rested here.

Who is this engaging yet contemplative man? Euripides has received the most votes from scholars, since a tragedian should balance the writer of comedy, and tragic masks rest on the adjacent table.[31] The many representations of scenes from Euripides on Pompeian walls underscore local interest in this Greek tragedian in the first century A.D. Comparisons with known portraits of Euripides neither confirm nor negate the likelihood of this identification; one feature that known portraits in sculpture seem to have shared with this painted representation is the depiction of Euripides as bearded.[32]

Even greater than the problem of determining the identity of the poet opposite Menander is that of the large figure in the center of the niche's south wall. Although there are no traces left today, Maiuri reported that at the time of excavation outlines in the plaster indicated a seated figure, larger than Menander, his nude right leg exposed outside of a mantle. Below, on the right, was the outline of a small crouching or prone figure at the feet of the chair. Maiuri supposed that this could have been either Aeschylus, father of tragedy, or Aristophanes, father of comedy.[33] Schefold's suggestion, that the figure represented Dionysus,[34] is much more convincing because it takes into consideration the iconography of the whole series of exedrae. Dionysus, god of the theater par excellence, rules in the most privileged position in the House of the Menander, the focus of all eyes. Flanking him to the east is the virgin goddess Diana and to the west Venus, in a landscape setting that emphasizes her ties with the realm of Bacchic revelry.[35]

30. Roger Ling has generously permitted me to compare his drawing made from these incised lines with my own, although I have not incorporated any of his drawing's features into my drawing.

31. Maiuri, *Casa del Menandro*, 107, cautions, after presenting the case for Euripides, that it could be someone minor, citing the cups with figures of skeletons from the Boscoreale treasure, where the little-known cynic philosopher Monimos appears next to important poets and philosophers.

32. Gisela M. A. Richter, *The Portraits of the Greeks* (London, 1965), 2: figs. 717–779, especially the seated figure in the relief in the Istanbul Archaeological Museum, inv. 1242, fig. 767, showing Euripides seated on a klismos.

33. Maiuri, *Casa del Menandro*, 107.

34. Schefold, *Die Wände Pompejis*, 42.

35. Maiuri's conjecture that the double-alcoved cubiculum 21 was fitted for shelves to convert it into a library would make the exedrae (except for 25) reading spaces; Maiuri, *Casa del Menandro*, 88–89.

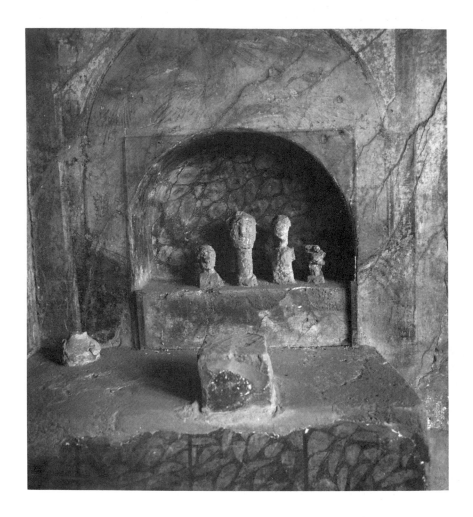

FIGURE 107. The ancestral shrine with ancestors' portraits and lares in exedra 25 announced the patrician pretensions of the owner.

An Ancestral Shrine Only slightly less conspicuous than the playwrights' exedra is the nearly square space terminating the axis of the peristyle's west wing (Fig. 107). Here a showy domestic altar held the ancestral images (*imagines maiorum*) so important to patrician families, for their presence established a family's status through the great deeds (real or fictive) of those represented. Polybius, writing about 130 B.C., described the use of wax death masks in Roman funeral rituals.[36] Each time a family grew through marriage, these images

36. Polybius *The Histories* 6.53.4–6.

had to be copied, most likely through casting, thus becoming smaller and smaller the older and more extensive the gens became. Until the discovery of this ancestral shrine in the House of the Menander none of these images had come to light, since they were made of perishable wax or wood. Maiuri was able to pour plaster into the cavities left in the volcanic ash and thus retrieve four featureless heads and the statue of a household lar.[37]

Exedra 25 reveals yet another aspect of the patron's intentions as he conceived this early Fourth-Style decorative program. In addition to the new decorations that presented him as a man of high culture, proud of his knowledge of Greek theater and Hellenistic caricature, he had an important ancestry. In this context, this conspicuous shrine had to retain its venerable Second-Style wall painting, even if the socle and ceiling needed to be repainted in the current fashion.[38]

Aside from this ancestral shrine and the touch of naughty humor in the bath complex, the House of the Menander was unusual more for its size and relative luxury than for the originality of its decoration. In the period of the late Fourth Style, two houses decorated in the Theatrical Manner, the House of Octavius Quartio and the House of the Vettii, reveal social, cultural, and religious pretensions far overstepping the boundaries of bourgeois conventionality observed in the House of the Menander.

THE CULT OF ISIS AND MYTHICAL CYCLES IN THE HOUSE OF OCTAVIUS QUARTIO

In chapter 1 we examined the House of Octavius Quartio as an example of the late Pompeian vogue that transformed ordinary domus into tasteless miniature villas. There, consideration of the house's plan, its visual axes, and its exterior painting and sculpture suggested that the owner desired above all to pack the greatest possible number of villa features into his domain. Here, consideration of the imagery adorning the walls of the two most important interior spaces of the house reveals that the owner's ambitious evocations of high culture did not stop out-of-doors.

Who was the owner? Discovery of a bronze seal with the name of the last owner of this house has swayed scholarly opinion away from its former attribution to Loreius Tiburtinus.[39] The Fourth-Style decorations of the House of Oc-

37. Maiuri, *Casa del Menandro*, 100–106.
38. Exedra 25's monochrome red ceiling closely resembles those of Villa of Oplontis 8 (fig. 86), 37, and 38 (fig. 87).
39. Vittorio Spinazzola, *Pompei alla luce degli scavi nuovi di via dell'Abbondanza* (Rome, 1953), 1:369, fig. 414. Unfortunately, the bronze seal was found in the eastern shop rather than in the house proper, indicating that it could have belonged to a client of the proprietor rather than the owner himself. See Matteo Della Corte, "I MM. Lorei Tiburtini di Pompei." *Atti e memorie della*

tavius Quartio belong to a thorough remodeling following the earthquake of 62. From the core of the third-century B.C. atrium house, its area was extended to about 1,800 square meters by the addition of a garden plot that extended to the south extremity of the city block (Fig. 108). This garden sloped southward, but instead of building a platform for a peristyle like that of the House of the Menander, the owner of the House of Octavius Quartio created a garden with fanciful waterworks (Fig. 109). As we saw above, these included two canals. The shorter one, framed by room *f* on the west and a summer biclinium on the east, formed the source for the longer canal, which extended the full length of the lower garden to the postern gate. Unlike the House of the Menander, where the additions involved the considerable expense of building and decorating the peristyle and its dependencies, the new areas of the House of Octavius Quartio consisted of the elaboration of a walled garden area with only four new rooms and the new waterworks. The garden may even have been used for commercial purposes, like that of its neighbor two blocks to the east, the Praedia of Julia Felix.[40]

A Domestic Shrine to the Cult of Isis? The house's unusual layout, several of the images included in the wall decoration, and the presence of images associated with Egypt have caused scholars to speculate that the canals were flooded to simulate the flooding of the Nile in ceremonies related to the cult of Isis.[41]

Although the Fourth-Style figural imagery and preserved central pictures of rooms *a,c,d,* and *e* are as ordinary as the wall decoration itself, room *f* (most resembling a diaeta in size and prospect) is of exceptional quality and contains several possible references to the cult of Isis.

The west wall is the best preserved (Pl. 11). On a black socle rest white panels bordered by bright red and separated from each other by tall aediculae in gold and black. The room's most unusual feature is a rectangular niche in the west wall, found empty at the time of discovery: some scholars have speculated that it held cult objects carried away during the eruption.[42] It is more likely that it held a wood-framed panel painting. Above this niche a female figure seated

Società tiburtina di storia e d'arte 11–12 (1931–1932): 182–216, where he bases his attribution on the shaky evidence of electoral programmata. The strongest evidence against Della Corte's attribution to "Loreius Tiburtinus" is that of Castrén, *Ordo populusque pompeianus,* 184.

40. Wilhelmina Jashemski, *The Gardens of Pompeii, Herculaneum, and the Villas Destroyed by Vesuvius* (New Rochelle, N.Y., 1979), 48.

41. Della Corte, "I MM. Lorei Tiburtini," 196–200; Victor Tran-Tam-Tinh, *Essai sur la culte d'Isis à Pompéi* (Paris, 1964); de Vos and de Vos, *Pompei Ercolano Stabia,* 138. Robert Wild, *Water in the Cultic Worship of Isis and Sarapis,* Etudes préliminaires aux religions orientales dans l'empire romain, no. 87 (Leiden, 1981), 221, supports the theory of the artificial inundation of the House of Octavius Quartio, which he believes to have belonged to Loreius Tiburtinus, "priest of Isis."

42. Spinazzola, *Scavi nuovi,* 1:386, refers to the little statuette of the goddess taken away; de Vos and de Vos, *Pompei Ercolano Stabia,* 138–139, to cult objects.

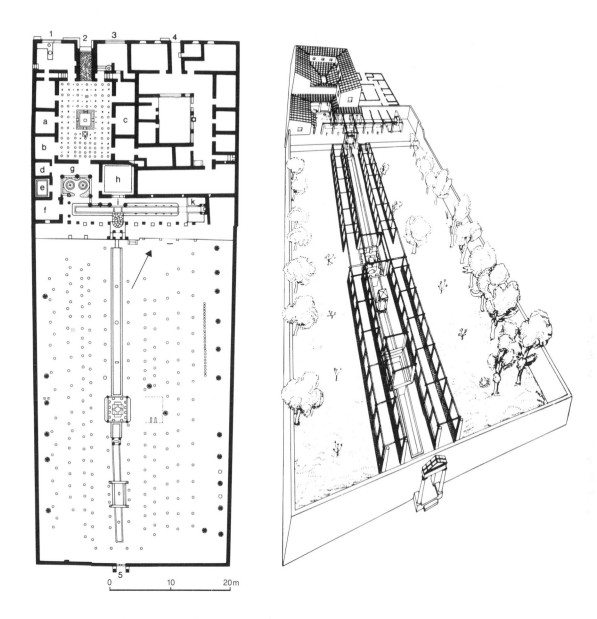

FIGURES 108 and 109. Plan of the House of Octavius Quartio. The ax-
onometric drawing illustrates the relationships among house, gardens, and
canals.

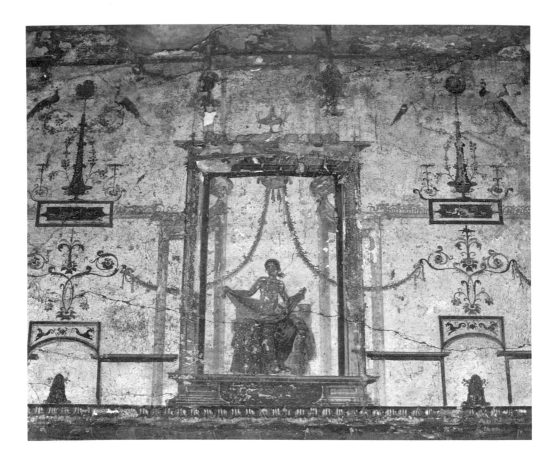

FIGURE 110. Delicate ornament frames a female figure in the upper zone of
diaeta *f*.

in an airy aedicula reveals her torso (Fig. 110). This all-white upper zone, filled
with refined ornament, includes stock motifs such as heraldic peacocks flank-
ing a globe and tragic masks resting on the painted cornice. Whereas heads in
medallions flank the central niche on the west wall (and the diaphragm walls
framing the eastern doorway, where a nymph and satyr appear, Fig. 111),
north and south walls employ standing figures. The personification of summer,
floating on the north wall, is fairly standard (Fig. 112), but the appearance of a
priest of Isis opposite her on the south wall (Fig. 113) forms the basis for Della
Corte's hypothesis that the grandfather of the owner of the house is pictured
here.[43] Beneath the image the nearly illegible letters have been read as *Amulius*

43. Della Corte, "I MM. Lorei Tiburtini," 192.

FIGURE III. Heads of a nymph and a satyr fill a tondo on the eastern spur wall.

Faventinus Tiburs or *Amplus Alumnus Tiburs*. The first reading would give us the name of someone of the gens Faventinus who came from Tibur, modern-day Tivoli. The second would give us "illustrious disciple Tiburs"—disciple of Isis.

His shaved head, white robe, bare chest, and the sistrum held in his right hand identify him as a devotee, if not a priest, of Isis. Two representations of Isiac ceremonies from Herculaneum include figures of priests and attendants with the same attire and attributes.[44] A further possible connection with Isis could be the personifications of summer, mentioned above, and another of autumn (Della Corte identifies her as spring),[45] two seasons when ceremonies honoring the Egyptian deity took place.

44. Illustrated in Tran-Tam-Tinh, *Culte d'Isis à Pompéi*, pls. 23 and 24.
45. Della Corte, "I MM. Lorei Tiburtini," pl. 28, fig. 10.

FIGURE 112. A personification of summer on the north wall.

A marble ibis, the sacred bird of Isis, was found in viridarium *g*, along with glazed terra-cotta statues of Egyptian deities, including Bes, whose head is a frequent decorative motif in early Third-Style painting.[46] And among the ten statues lining the two sides of the transverse canal was a marble sphinx with a bronze satyr's head between its paws.[47]

This Egyptian theme, as we have already seen, does not extend exclusively to the remaining painted and sculpted decoration along the canals or to the ex-

46. Spinazzola, *Scavi nuovi*, 1: figs. 450–451.
47. Spinazzola, *Scavi nuovi*, 1: fig. 454.

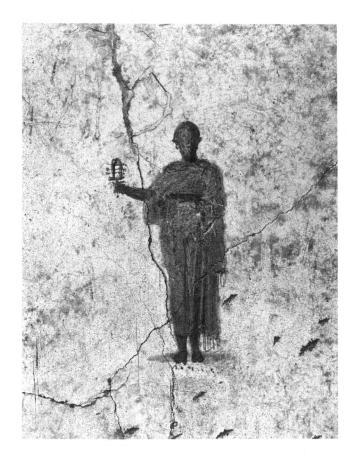

FIGURE 113. This depiction of a priest of Isis caused scholars to attribute ownership of the House of Octavius Quartio to a follower of Isis.

terior walls of the house (see chart, Fig. 114). The deity most evoked in the painted decoration is Diana, virgin goddess of the hunt. Studies of the cult of Isis have shown that she was conflated with Diana,[48] if more rarely, it is true, than with Venus. A fine bronze head of Isis-Diana was found at Boscoreale.[49] But clearly the back part of this relatively modest house did not take the place of the venerable sanctuary of Isis in the zone of the Triangular Forum at Pompeii.[50] When one considers that room *f* was a small room in a big garden area that included *h*, a large dining oecus, *k*, a summer biclinium facing *f*, and long vine-covered paths along the lower canal, its function seems to be like that of the ancestral shrine in the peristyle of the House of the Menander. It is a theme

48. Sharon Kelly Heyob, *The Cult of Isis among Women in the Graeco-Roman World* (Leiden, 1975), 67.

49. Illustrated in R. E. Witt, *Isis in the Graeco-Roman World* (Ithaca, N.Y., 1971), fig. 26.

50. Olga Elia, *Le pitture del Tempio di Iside,* Monumenti della pittura antica scoperti in Italia, sec. 3, Pompei fasc. 3–4 (Rome, 1941).

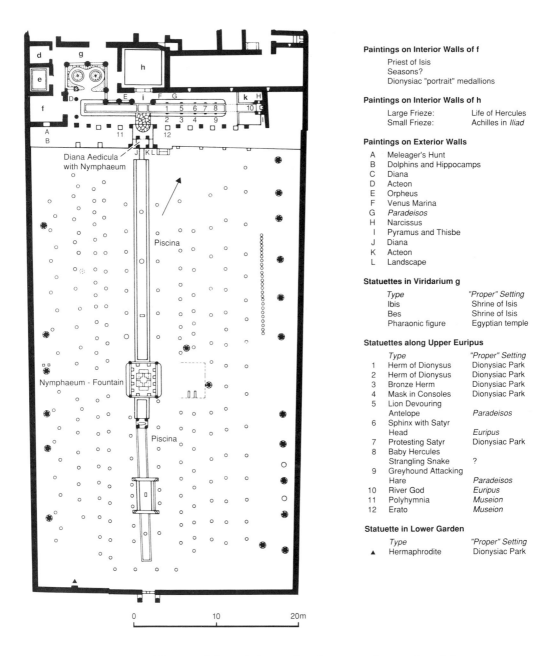

Paintings on Interior Walls of f

Priest of Isis
Seasons?
Dionysiac "portrait" medallions

Paintings on Interior Walls of h

Large Frieze:	Life of Hercules
Small Frieze:	Achilles in *Iliad*

Paintings on Exterior Walls

A	Meleager's Hunt
B	Dolphins and Hippocamps
C	Diana
D	Acteon
E	Orpheus
F	Venus Marina
G	*Paradeisos*
H	Narcissus
I	Pyramus and Thisbe
J	Diana
K	Acteon
L	Landscape

Statuettes in Viridarium g

Type	*"Proper" Setting*
Ibis	Shrine of Isis
Bes	Shrine of Isis
Pharaonic figure	Egyptian temple

Statuettes along Upper Euripus

	Type	*"Proper" Setting*
1	Herm of Dionysus	Dionysiac Park
2	Herm of Dionysus	Dionysiac Park
3	Bronze Herm	Dionysiac Park
4	Mask in Consoles	Dionysiac Park
5	Lion Devouring Antelope	*Paradeisos*
6	Sphinx with Satyr Head	*Euripus*
7	Protesting Satyr	Dionysiac Park
8	Baby Hercules Strangling Snake	?
9	Greyhound Attacking Hare	*Paradeisos*
10	River God	*Euripus*
11	Polyhymnia	*Museion*
12	Erato	*Museion*

Statuette in Lower Garden

	Type	*"Proper" Setting*
▲	Hermaphrodite	Dionysiac Park

FIGURE 114. Themes of the painting and sculpture on the exterior of the House of Octavius Quartio.

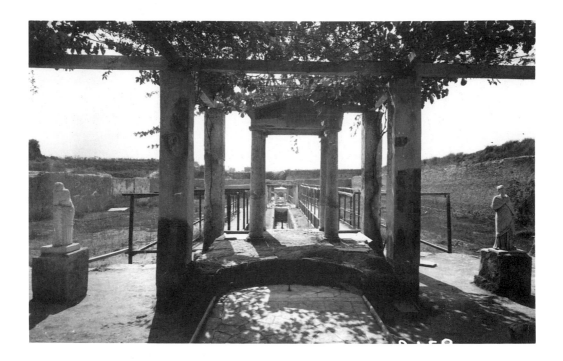

FIGURE 115. From the doorway of oecus *h* a series of framing devices defines the long axis of the canal.

woven in among others of special interest to the patron—or in this case the patroness. Heyob has demonstrated the popularity of the cult of Isis among Roman women. Although statistics indicate fewer devotees than implied by the literature, their participation is significant, since Greek and Roman religion narrowly limited females' roles.[51] Although the representation in room *f* is of a priest and not a priestess of Isis, it is possible that this part of the house's decorative ensemble celebrated the domina's religious choice. It is balanced by a hearty dose of heroic epic battling in the more prominent room *h*.

Heroic Literary Sagas in the Dining Room The size and position of oecus *h* make it the most important room in the House of Octavius Quartio. Someone standing in its southern doorway could view the whole of the canal's long axis (Fig. 115) framed above by a pergola housing a fountain and flanked by the Muses Polyhymnia and Erato.[52] The lower-level canal, with vine-shaded walk-

51. Heyob, *Isis among Women*, 110.
52. Identified as Mnemosyne by Jashemski, *Gardens of Pompeii*, 45–46.

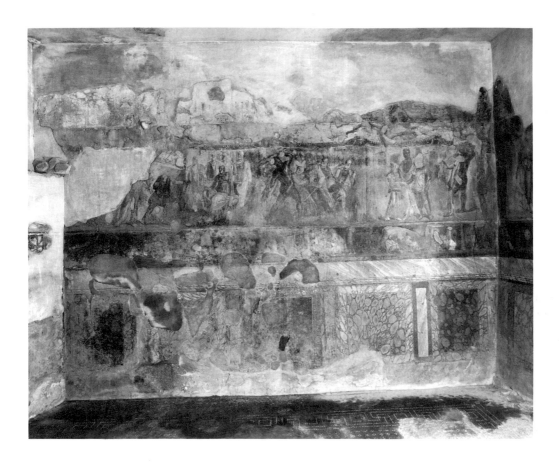

FIGURE 116. The double frieze in its architectural setting.

ways on either side, was punctuated by other fountain houses. Room *h*'s
smaller western entryway, aligned with the axis of room *e*, adjoined a carefully
planned viridarium or sculpture garden, *g*. Little wonder that the patron hired
an artist able to paint not one, but two, narrative friezes on the walls of this
important room.

The room's elegant red cement floor, framed with a meander picked out in
white tesserae, held a marble roundel in its center. Part of the ceiling's design, a
low segmental vault with stucco moldings, remains over the eastern third,
aligning with the western doorway. High faux-marble wainscoting lines the
walls beneath the friezes (Figs. 116 and 117). The smaller frieze, with a pre-
dominantly black background, lies beneath the larger frieze. Red and gold

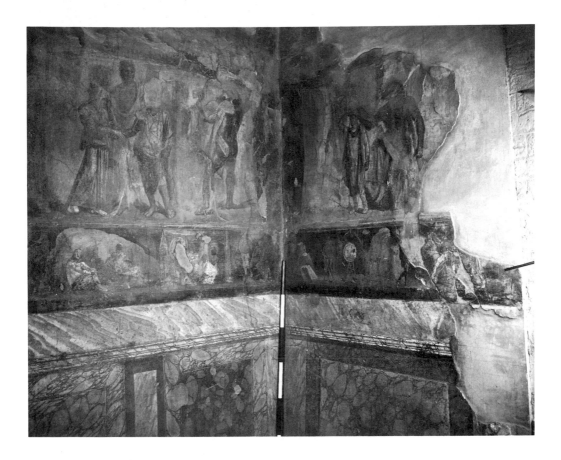

FIGURE 117. The *Iliad* frieze begins at the left of the main doorway and continues to the midpoint of the east wall.

drapery, swagged along the larger frieze's upper edge, reveal its scenes. This high wainscoting and overhanging drape give the illusion that one is looking at costly originals.[53]

Analysis of the content and composition of the friezes proves that, like the Dionysiac frieze of the Villa of the Mysteries, they were tailor-made for this room. The design cues the viewer repeatedly as he or she moves through the space to follow the narrative thread.

Two temporally distinct sagas of Troy—a theme dear to the Romans, as dis-

53. Paul Zanker, "Die Villa als Vorbild des späten pompejanischen Wohngeschmacks," *Jahrbuch des deutschen archäologischen Instituts* 94 (1979): 475.

Hercules scenes in Large Frieze

1 Hercules kills the monster and frees Hesione
2 Telamon asks Laomedon for the horses promised for freeing Hesione
3 Hercules murders Laomedon, defended in vain by Hesione
4 Wedding of Telamon and Hesione in Hercules's presence
5 Hercules invests the child Priam with the kingdom of Troy
6 Hercules and Deianira after the battle with Nessus
7 Deianira and Nessus's gift
8 Hercules on the pyre
9 Glorification of Hercules?

Scenes from the *Iliad* in Small Frieze

1 Apollo shoots arrows into the Greek camp, causing plague
2 Horses watering
3 Ulysses, Ajax (son of Telamon), and Phoenix going to negotiate with Achilles
4 Achilles in front of his tent
5 Phoenix at Achilles's feet
6 Combat below the wall of the Greek camp
7 Combat near the ships; Ajax wounds Hector
8 Trojans try to recover the body of a casualty (?)
9 Patroclus, dressed in Achilles's armor and riding chariot drawn by Xanthos and Balios, fights the Trojans
10 Achilles arms himself in the presence of Thetis
11 Achilles drags Hector's body in the dust
12 Games in honor of Patroclus
13 Priam at Achilles's feet to ransom Hector's body
14 Priam and the chariot-driver Idaeos guard Hector's body

*Identification of scenes after Spinazzola, *Scavi Nuovi*, vol. 2: 975-1006.

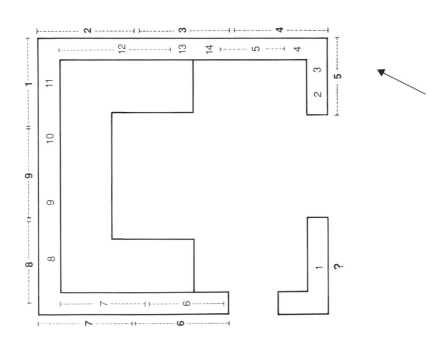

FIGURE 118. Epitomized scenes in the Hercules saga and the *Iliad* cycle require two different reading sequences.

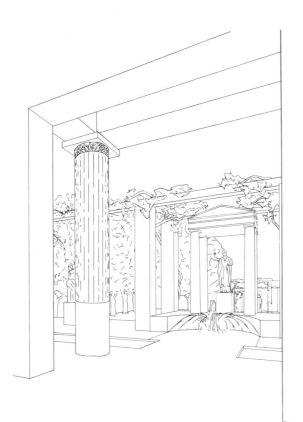

FIGURE 119. Reconstruction of the guest of honor's view from his place on the triclinium couch.

cussed above—form the subject matter of the friezes (Fig. 118). The large frieze narrates episodes from the life of Hercules, edited to emphasize his deeds in Troy. In the first five episodes Hercules establishes the child Priam as king of Troy; the next four belong to his final days, culminating at the pyre, where his mortal coil burns away. The missing final scene, in the center of the north wall, would certainly have been his apotheosis. Anyone entering the room along its privileged long axis would see Hercules in glory. Furthermore, when the triclinium couches were set up as indicated on the plan, the apotheosis scene would be most easily seen by the guest of honor, who would have occupied the northwest corner of the dining couch, his feet in the corner so that he could have easily turned his head to see the image of Hercules.[54] The guest of honor and Hercules would have surveyed the framed vista to the south (Fig. 119).

54. The most distinguished guest was *imus* on the *lectus medius*, the so-called *locus consularis*. See discussion of seating arrangements in triclinia, chapter 1, 16–17.

Hercules' massive body, his back toward the viewer, also confronts someone entering from the western doorway. This, too, is a key moment in the saga: Hercules is killing Laomedon, leaving the throne to the boy Priam.

These episodes from Hercules' mission against Troy foreshadow the Trojan War (as mentioned three times in the *Iliad*),[55] thus establishing a relationship with the small frieze. It depicts scenes from the *Iliad,* beginning with Apollo shooting arrows into the plague-stricken Greek camp and ending with the dual plight of Priam: pleading for Hector's body at Achilles' feet and then guarding Hector's body at night. Both cycles telescope events in the literary sources to create what Weitzmann has termed an "epitomized narrative";[56] the viewer must supply links between one picture and another, drawing on his or her knowledge of the tale and aided only by the figures' name tags. Spinazzola has shown that although Latin characters label the figures, and the *Iliad* frieze does not follow Homer in all details, it does follow Greek literary and artistic sources.[57] In order to relate to the Hercules saga, the small frieze underscores the role of Achilles in the *Iliad* and also emphasizes the deeds of the sons of characters in the Hercules saga: Hector, son of Priam (whom Hercules installs as king of Troy), and Ajax, son of Telamon. Peleus, who figures in Ovid's version of the story, is both Telamon's brother and father of Achilles.[58]

If the Hercules frieze provides strong cues to its reading, the *Iliad* cycle requires much more patience and erudition from the viewer. Its fourteen scenes have a different reading sequence, beginning on the western part of the south wall and continuing to the eastern part, where they turn the corner and progress to the midpoint of the east wall (see Fig. 118). Up to this point, compositional cues and the figures' movements have been from right to left. Now the sequence shifts to the opposite wall and the composition reads from left to right, turning the corner to continue along the north wall and terminating in the center of the east wall. Why this order?

With the triclinium couches in place, the change from counterclockwise to clockwise reading order makes sense. Walking from right to left in the unencumbered area of the room, the viewer could follow the narrative to the point where it abuts the latest event depicted, easily recognizable as near to the end of the tale. The rest of the story could be read from one's dining couch—with a bit of neck craning—and would form ready topics for literary conversation. Rising from a meal, the guests could contemplate the parallels between upper and lower frieze: Hercules in glory in the center of the north wall with the turn-

55. Homer *The Iliad* 5.632–658; 14.250–266; 15.15–40; see Richmond Lattimore, trans. (Chicago, 1951), 145, 300–301, 309–310.

56. Kurt Weitzmann, *Illustrations in Roll and Codex* (Princeton, N.J., 1947), 12–46.

57. Spinazzola, *Scavi nuovi*, 2:977–1002.

58. Ovid *Metamorphoses* 11:221–265.

ing point of the *Iliad* beneath in the scenes (9 and 10 in Fig. 118) showing Patroclos riding into battle wearing Achilles' armor, and Achilles arming himself with the weapons brought to him by Thetis.

Orchestrating the cycles and executing them for this room made great demands on the artist. Working from pattern books in circulation, he pulled together scenes that would both draw the eye and tease the literary mind. The ploy of right-to-left reading in the first part of the *Iliad* frieze was an inspired one, probably accomplished by reversing the images in his model. More impressive still is the double emphasis of the view from the western doorway in the east wall's composition, marked by both Hercules' massive body and the break in the reading pattern of the *Iliad* frieze. Trojan cycles, specifically mentioned by Vitruvius as one of the themes appropriate for continuous painted friezes,[59] disappear after the period of the Second Style, replaced by schemes with central pictures. Their reappearance here, like the renewed interest in illusionistic architectural perspectives, was part of a Second-Style revival that took place in the period of the Fourth.[60]

Two other artists (or perhaps workshops) with different specializations were responsible for the rest of the Fourth-Style decoration in the House of Octavius Quartio. An artist able to compete with the finest Neronian decorations in Rome produced the exceptionally high-quality paintings of room *f*. Another artist, with humbler skills but with enough pride to sign his work, produced the outdoor paintings.[61] His signature, *Lucius pinxit,* appears on the southern couch of the outdoor biclinium, featuring two rather hackneyed themes in Fourth-Style painting, *Narcissus* and *Pyramus and Thisbe.*

This ensemble of three radically different kinds of Fourth-Style painting, just completed at the time of the eruption,[62] must have impressed the ancient visitor with its imaginative (if somewhat perplexing) combinations of visual and intellectual messages. With the novelties of Isiac shrine, epic oecus, canals, fountains, and garden sculptures, it must have been a somewhat idiosyncratic and ultimately delightful petit bourgeois Disneyland,[63] completely foreign to the traditional plan, unity, and conventional decoration of the House of the Menander. This all-inclusive passion reaches a fever pitch in the House of the Vettii.

59. Vitruvius *De architectura* 7.5.2.
60. Schefold, "Troiasage," 211, 217.
61. These include two scenes of Diana and Actaeon, one on the exterior of the east wall of *f* and the other on the north wall of the northernmost lower-level fountain; Meleager on the south exterior wall of *f;* Orpheus charming the animals and Venus floating in her shell on the south exterior wall of *h;* Narcissus and Pyramus and Thisbe on the east wall of the biclinium.
62. If the oven found in the first cubiculum on the atrium's west wall was meant for preparing pigments for painting in progress: de Vos and de Vos, *Pompei Ercolano Stabia*, 138; Spinazzola, *Scavi nuovi*, 1:419–421, believed it to be a kiln for firing small terra-cottas.
63. Zanker, "Villa als Vorbild," 480.

A. Vettius Restitutus and A. Vettius Conviva, the two freedmen brothers who owned the House of the Vettii, had done very well for themselves indeed. A. Vettius Conviva was an *augustalis,* the highest civic office open to a freedman; to become a *servus augusti* the freedman had to donate a great sum of money for public works. In return, the emperor appointed him augustalis, so that the freedman bought with money an equivalent of the upper-class status open only to freeborn aristocrats.[64] Through commercial success the Vettii had "arrived" in their difficult climb from former servitude. Their house, not the largest at Pompeii but perhaps the finest in the quality of its Fourth-Style decoration, expresses in several fashions their nouveau-riche mentality.

The House of the Vettii is a remodeling of a much older house with two atria, *c* and *v* (Fig. 120), and a large peristyle in back that accounted for 40 percent of its area. There are two unusual features in the plan: there is no tablinum, and the peristyle's axis crosses that of the fauces and atrium at right angles. In place of the tablinum there was a large opening in the rear wall of the atrium defined by two widely spaced piers framing the visual axis from the fauces (marked with an arrow on the plan). Two pairs of peristyle columns continue this axis framing. Bek has noticed that the space between the two pairs of peristyle columns is so much shorter than the space between the atrium piers that from the fauces the viewer thinks the house is much larger than it actually is.[65] A similar exaggeration of perspective lengthens the perceived visual axis in the House of the Menander. Once the visitor has arrived in the peristyle, the strong cross axis of the largest oecus (*q*, vertical hatching on the plan), encourages movement to the right. Two other oeci (*p* and *n*, horizontal hatching on the plan), face the peristyle as twin elements on either side of the entrance axis. The entrance to a private area flanks the great oecus, including rooms *t* and *u*, arranged around peristyle *s*. This isolated area might be a *gynaeceum,* or women's quarters. Servants' quarters were located around the second, minor atrium (*v*, diagonal hatching on the plan). The kitchen, *w*, is tucked behind the servants' atrium. Stairs lead to now-destroyed upstairs rooms.

The exquisitely executed Fourth-Style decoration, carried out by a single workshop after the earthquake of 62, exploits the house's entry sequence, visual axis, and symmetrical arrangements of rooms along the axis to impress the

64. Steven E. Ostrow, "*Augustales* along the Bay of Naples: A Case for Their Early Growth," *Historia* 34 (1985): 64–101, argues that only rarely was the freedman's appointment directly instituted from Rome.

65. Lise Bek, *Towards Paradise on Earth: Modern Space Conception in Architecture: A Creation of Renaissance Humanism. Analecta romana Instituti danici,* supplement 9 (Rome, 1980), 185, fig. 40, pl. 69.

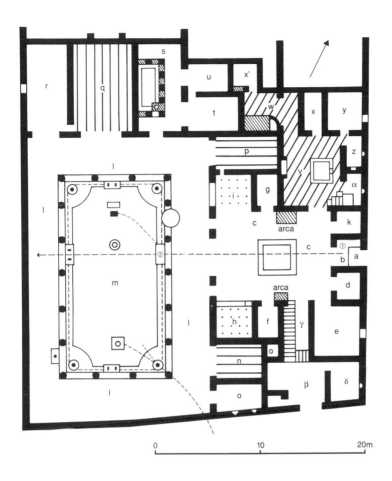

FIGURE 120. Plan of the House of the Vettii.

visitor. This careful planning goes beyond the choice of central pictures in the static rooms (*d, e, p, n, q,* and *t*—subject of a recent dissertation by William Archer)[66] to include the decorative motifs, garden, fountains, and sculpture,[67] in an overburdened display with multiple religious and mythological themes. As in the House of Octavius Quartio and many others at Pompeii from this

66. William Carthon Archer, "The Paintings of the Casa dei Vettii in Pompeii," 2 vols. (Ph.D. diss., University of Virginia, 1981).
67. See the excavation reports of August Mau, "Scavi di Pompei, 1894–95, Reg. VI, Isola ad E della 11," *Römische Mitteilungen* 11 (1896): 3–97 and of A. Sogliano, "La Casa dei Vettii in Pompei," *Monumenti antichi dell'Accademia dei Lincei* 8 (1898): cols. 233–416, with careful descriptions of decoration and sculpture.

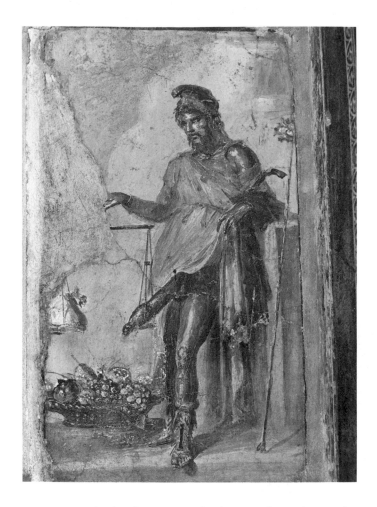

FIGURE 121. As the viewer enters the doorway, he or she sees the image of Priapus weighing his manhood against a bag of money.

period,[68] the decorative ensembles of the House of the Vettii attempted to pack as many allusions to the world of aristocratic culture as would fit within its modest area. Our investigation seeks to discover the various rationales behind the patrons' choice of imagery in light of their presumed social status and the functions of their house.

68. Discussed in Zanker, "Villa als Vorbild," including: the House of Apollo (VI, 7, 23), 481–484; the House of the Anchor (VI, 10, 7), 484–488; House of the Moralist (III, 4, 3), 488–490; House of Sallustius (VI, 2, 4), 490, 498–500; House of the Gilded Cupids (VI, 16, 7), 493–494; House of M. Lucretius (IX, 3, 5), 496–498; House of the Ephebe (I, 7, 10), 500–502; House of the Large Fountain (VI, 8, 22), 504–505; House of the Small Fountain (VI, 8, 23), 504–505; House of the Amazons (VI, 2, 14), 508; House of the Vettii, 512–513.

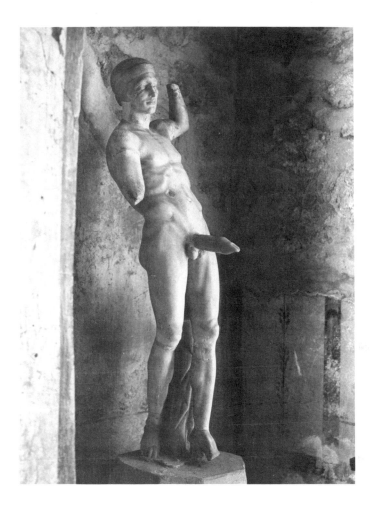

FIGURE 122. This second Priapus, a fountain figure, visually rhymed with the painted Priapus in the fauces and marked the visual axis from fauces to peristyle.

Priapus, Mercury, and Dionysus: Protection, Money, and Revelry No visitor to the House of the Vettii fails to remember the image of Priapus weighing his enormous penis, on the west wall of the fauces *b* (Fig. 121). He holds a scale in which his massive member on one side comes out even in weight—and importance—with the sack of money on the other. Found disassembled within the house was a half–life-size marble statue with a gigantic phallus, drilled so that it could spurt water into the basin of a fountain (Fig. 122). In its original location on either of two bases flanking a marble basin (at number 2 on plan), it

marked the visual axis from the fauces to the back wall of the peristyle. The statue lacks a beard and other elements of the standard iconography of Priapus.[69] Scholars have been content to note that both images are apotropaic, that is, they warded off the evil eye, thereby protecting the house. No one has asked why they are so large and so prominently displayed, the two images forming, as it were, a "Priapus" axis clearly visible to anyone entering the house. These two unusually bold images alluding to the deity who protected the occupants from evil and ensured fertility could not have escaped notice and comment in antiquity.

By the time of its double installation in the House of the Vettii, the cult of Priapus, brought in from the Near East, had had a long Roman history. Originally associated with either the phallic cult of Mutunus Tutunus and the genii who protected agriculture,[70] or with Liber Pater, a rustic fertility deity, Priapus's role as protector of the household and guarantor of (particularly male) fertility became firmly established by the first century B.C.

Mercury's role as phallic deity also has a long history. In his Greek form as Hermes his phallic nature is clear. Worshiped first as the centerpost that held up the Greek house, his image, in the form of a post or pier, began to be venerated at crossroads.[71] These herms were frankly phallic in nature, with erect penises, and regarded as sacred, as the famous story of charges against Alcibiades for mutilating Athenian herms attests.[72] By association with traveling merchants, Mercury became the protector of commerce, bringing success and money to traders. Representations of the phallus alone appear throughout Pompeii, in bakeries to ward away evil and at crossroads.

Given both deities' phallic roles, it is little wonder that Priapus is associated with Mercury in the House of the Vettii. In the fauces' painting two hints at this relation appear: Priapus is weighing his manhood against a sack of money, an attribute of Mercury; and Mercury's attributes appear in the picture on the adjacent north wall of the fauces. The Vettii took pains to display their new wealth in the atrium, where in plain view two great chests (labeled *arca* on plan), designed to hold money and treasures, announced in concrete terms the success Mercury had brought them. Furthermore, painted on the pilaster between rooms *g* and *i* is a cart carrying the attributes of Mercury. What of the other "Priapus" in the garden?

69. Priapus figures were originally scarecrows that protected gardens; see the collection of *Priapea* and Horace *Satires* 1.7.
70. Pierre Grimal, *Les jardins romains à la fin de la république et aux deux premiers siècles de l'empire* (Paris, 1943), 46, 50; Katherine M. D. Dunbabin, *The Mosaics of Roman North Africa: Studies in Iconography and Patronage* (Oxford, 1978), 176.
71. Guido Kaschnitz von Weinberg, *Die mittelmeerischen Grundlagen der antiken Kunst* (Frankfurt, 1944), 21, notes on 73.
72. Thucydides *The History of the Peloponnesian War* 6.27–28.

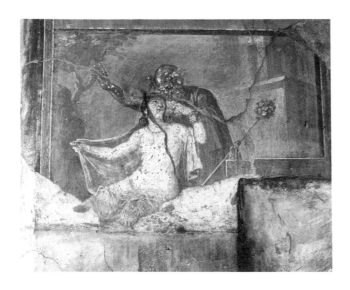

FIGURE 123. Pan surprising Hermaphrodite, to the right of
someone exiting oecus *q*.

Whether located to the right or left of the basin (number 2 on the plan) that
caught the water it spurted, the statue would have been conspicuous and atten-
tion grabbing. It turns out that Priapus belonged in the garden as much as at
the doorway. For in addition to his association with Mercury, Priapus was as-
sociated with Dionysus, to the point that he was considered to be one of Dio-
nysus's incarnations, son of Dionysus and Ariadne.[73] The garden of the House
of the Vettii was filled with statues of Dionysus and his companions: there is
a double herm of Dionysus and Ariadne, another of a maenad and Silenus, a
statue of the young Dionysus, a nude satyr, and a seated satyr with hare. The
paintings surrounding the peristyle extended this concept of the Dionysiac gar-
den: a young satyr with pan pipes and a maenad take the central position on
the west wall.[74]

The Dionysian Priapus conflates his imagery with that of Hermaphrodite.[75]
On the south wall of the House of the Vettii's principal oecus (*q*, vertical hatch-
ing on plan), to the right of someone looking out to the garden, appears a
painting of Hermaphrodite, with an erection, being approached by Silenus
(Fig. 123). Another image of Hermaphrodite appears over the southern door-

73. Enrico Paribeni, "Priapo," *Enciclopedia dell'arte antica*, s.v.
74. Robert Etienne, *La vie quotidienne à Pompéi* (Paris, 1962), 239; Eugene Dwyer, *Pompeian
Domestic Sculpture: A Study of Five Pompeian Houses and Their Contents* (Rome, 1982), 137.
75. Paribeni, "Priapo."

way of oecus *p*. If Priapus in the fauces is the apotropaic guardian of the Vettii's riches, in his Dionysian aspect in the garden and in the two oeci he is a god of fertility. In the House of the Vettii images of Priapus and Dionysus seem to have celebrated not only fecundity but also the pleasures of revelry and love.

Four cupids carry the theme of love into the garden itself. In fact, its best statues are two bronze cupids each holding grapes (attributes of Dionysus) and a goose (Venus's emblem). Two more cupids in marble occupy the square basin on the western side, and there is a marble statue of tragically love-struck Paris. In the house as a whole, there are more representations of cupids than of any other subject. The painting of cupids and their female counterparts, psychai, seems to have been a speciality of the accomplished artist who decorated the atrium and largest oecus. This room, with the peristyle, may have carried a dual message for the owners and their clients and guests.

Work and Play in Atrium, Peristyle, and Oecus q If the Vettii received clients, where did they receive them? Since the house lacks a tablinum, some other room or rooms must have been used. The house's layout, pavements, graffiti found in the peristyle, and the preserved imagery of the largest oecus (*q*, vertical hatching on plan) suggest that this room had a dual use: receiving the clientela and entertaining guests.

Much has been made of the axial division of the House of the Vettii, and for good reason. Not only are there four sets of twin rooms along the axis established by the fauces and impluvium (*k* and *d*, *g* and *f*, *l* and *h*, *p* and *n*), but the identical decoration of alae *l* and *h* (dotted shading on plan) and the iconographical parallels between *p* and *n* (horizontal hatching) reinforce this axial division. This axis divides the peristyle and garden unequally, the shorter end to the north. The same design of a grid of white tesserae decorates and unites the dynamic spaces of atrium and peristyle. The largest oecus, the most important static space, also has the finest pavement of the house, the only one executed in opus tessellatum. A meander pattern in black and white forms the threshold of the room, which is otherwise simply paved with white mosaic bordered by a thin black stripe. The same meander pattern, traced in white tesserae, appears between the columns of the peristyle where the black cement floor changes to red. Along the path to room *q* were found most of the graffiti in the peristyle, probably recording the names of clients who waited there.[76]

Aside from its size and prominent position in the plan, the strongest evi-

76. Sogliano, "Casa dei Vettii," cols. 270–271: *north portico:* second column from northeast corner column: CHRYSEROS, IOSIMUS, OC CIILIIR FIICITII; second column from northwest corner column: AMITIIS; northwest corner column: SALV, SAL; *west portico*, middle column: VITALIO VA; ACTIVS COSSINIAII; MAMMII SVAII; PLURIMA SALVT.

dence that these men of commerce used their impressive dining room for business is in the famous frieze of cupids and psychai that circles oecus *q*. Excavators found a rectangular cavity with the remains of iron pins where the central picture on the rear wall had been inserted. Presumably it was saved from a previous decoration. But the images in the famous miniature frieze were tailor-made for this room. They both romanticize and document industries at Pompeii that bought men and women like the Vettii their freedom, luxury, and status.

The first scene on the right wall as one enters is one of flower sellers and garland makers hauling roses on a goat, manufacturing floral crowns, and selling them (Fig. 124). In the following scene (Fig. 125) two cupids hammer wedges into a flower press to extract the oil that falls into a container; a psyche mixes it in a cauldron. Near the counter a client tests some of the perfume on her hand. A scene of cupids at play follows, depicting a race in a circus of four chariots, each drawn by two antelopes. Next comes a scene of goldworking (Pl. 12): seated by a forge decorated with the head of Vulcan a cupid with a chisel works on a gold bowl while a psyche stirs up the fire to solder a metal object which she holds with tongs. A seated cupid hammers at an anvil. In the middle of the scene is a stepped counter for the merchandise, with a client watching an object being weighed. Nearby two cupids work with tongs. The last compartment on this wall illustrates the activities of fullers (*fullones*) (Fig. 126). The fulling process shrinks and thickens wool by the application of moisture, heat, friction, and pressure. On the right cupids and psychai check and fold the fabric, in the center they card it, and on the left two cupids are treading on it in a tub next to an amphora filled with urine or fuller's earth.

The following panel on the north wall (badly abraded) featured bakers celebrating the feast of their patron divinity Vesta. Four reclining diners surround a platter with metal cups on it; the figure of an ass in the background refers to its role in turning the flour mills. In the center panel cupids make wine; two in the center work a press like the ones found in the Villa of the Mysteries and the Villa of Oplontis. Wine drinking in a Dionysiac procession, or *thiasos*, follows (Fig. 127). Dionysus rides a cart pulled by goats, accompanied by cupids. An ithyphallic Pan playing the double flute follows; behind him is a cupid dancing with a crater on his shoulders. These last two scenes have led to speculation that the Vettii made their fortune in the wine business.[77] Given the variety of other activities pictured on these walls, it seems risky to speculate.

77. Mikhail Rostovtzeff, *The Social and Economic History of the Roman Empire,* 2d ed. (Oxford, 1957), 92, followed by Etienne, *Vie quotidienne,* 151; against this interpretation, see Matteo Della Corte, *Case ed abitanti di Pompei,* 3rd ed. (Naples, 1965), 70 note 2, and Jean P. Andreau, *Les affaires de Monsieur Jucundus* (Rome, 1974), 229.

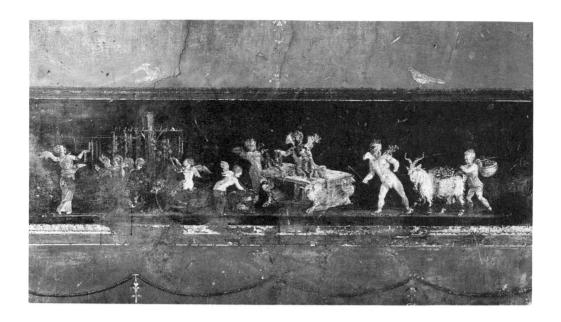

FIGURE 124. Mythologized scenes of Pompeian industries in the oecus *q:*
cupids and psychai making and selling floral crowns and garlands.

FIGURE 125. Perfume makers extract oil from flowers and reduce it in a
cauldron while a client tests the result.

FIGURE 126. Cupids and psychai as fullers treat woolen cloth.

FIGURE 127. Dionysus and his companions in a *thiasos*.

FIGURE 128. Psychai play darts.

The point remains, however, that these scenes of industry, graceful and romantic as they are, would seem particularly appropriate and interesting to clients during the business hours. Leaving the room, the visitor could inspect two scenes in a playful vein. On the eastern part of the south entry wall psychai play darts (Fig. 128), and on the west side, in the upper level, a Silenus leans over an ithyphallic hermaphrodite discussed above (see Fig. 123). Along with this evocation of industry and the revelry of Dionysus and his companions (there are also maenads and satyrs in the upper zones), Apollo and the Muses appear—a balance noted in the House of Lucretius Fronto and the House of the Menander. The wonderfully painted scene of Apollo and the serpent Pythia under his tripod at Delphi decorates the base of an ornate gold column on the east wall (Pl. 13). As if to continue this balance (however heavily weighted in this house

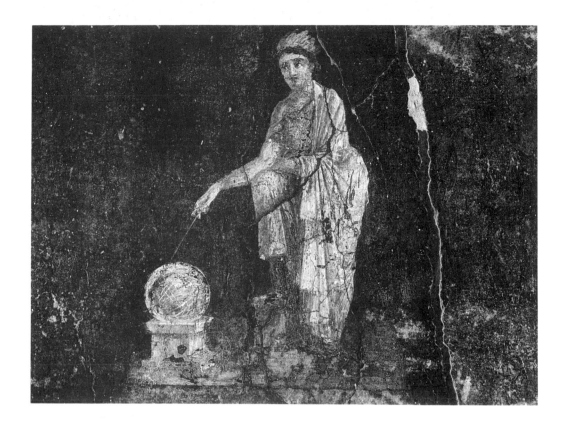

FIGURE 129. Urania, the Muse of astronomy, with her pointer and globe, painted in a conspicuous place in the peristyle.

in favor of Priapus and Dionysus), the Muse Urania appears on the eastern wall of the peristyle, in full view of clients making their way to room *q* (Fig. 129). Standing, she indicates her globe with a *radius*, or pointer. And at the opposite end of the peristyle, on axis with oecus *q,* appears the figure of a poet or philosopher. Although he does not occupy an exedra like the one in the House of the Menander, his image gains importance from its central position: the poet marks the principal axis and is the focus of the axial view from oecus *q*.[78] Although the image has deteriorated greatly, the excavator left a detailed description. The poet is at a writing stand with two scrolls. It is likely that this was the

78. Bek, *Towards Paradise on Earth*, 192, fig. 40, pl. 82, unconvincingly argues for an extremely oblique view from oecus *q*.

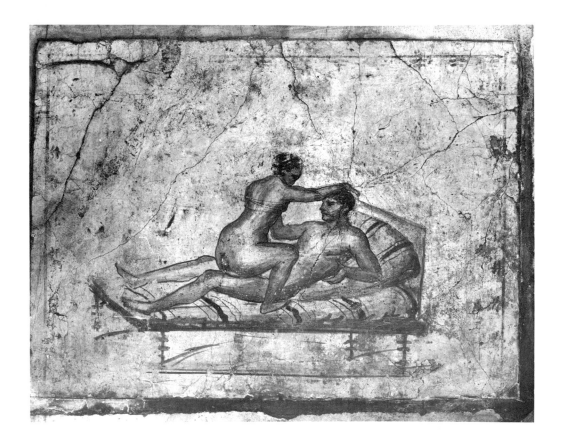

FIGURE 130. A simply painted scene of lovemaking in the cook's bedroom.

owners' favorite poet,[79] a reminder of the entertainments following a banquet. Sometimes, if the guests were unlucky, the host recited his own poetry, like the wealthy up-from-under freedman Trimalchio in the famous banquet recounted in Petronius's *Satyricon*.[80] For rich freedmen like the Vettii, Trimalchio's feast may have taken place more than once in this oecus and peristyle.

Two Kinds of Women The fact that room *x*[1] faced the kitchen in the servants' atrium makes it likely that it was reserved for the cook. The Vettii, like Trimalchio, seem to have held the cook in particularly high esteem, since his room received a special kind of decoration. There, painted in the same rapid

79. de Vos and de Vos, *Pompei Ercolano Stabia*, 173, suggest that it could be the owner himself pictured as a literary man.
80. Petronius *Satyricon* 25.34.55.

but explicit manner found in the whorehouse, or *lupanar,* not far away, are three scenes of lovemaking (Fig. 130). An owl is even painted on the south wall as a token of good luck in the cook's romantic exploits. The masters of the house never frequented bordellos, since they would simply purchase slaves to fulfill their desires. Room *x*¹'s painted decoration could have been a gift to the occupant, if it *was* the cook, reminding him of the pleasures of the lupanar, much like the inevitable pinups one sees in car-repair shops today. The many sexual graffiti found in Pompeii attest to prostitution as a social institution; even in the doorway of the House of the Vettii one reads: EUTYCHIS VGRAECA II A MORIBUS BELLIS (Eutychis, born in the house of her master [later corrected to "from Greece"], has beautiful skills and costs two asses).[81] The price was very low, since the *as* was one of the smallest coins in circulation.

This room and the graffiti underscore the exploitation of the women of the underclasses in Roman society. Even if the conclave around the little hidden peristyle *s* was not a *gynaeceum,* the remaining paintings of its triclinium illustrate "typical" roles of females in mythological settings.[82] Secluded from the rest of the house, with its own little peristyle, the suite included triclinium *t* and adjoining cubiculum *u*. The two remaining central pictures of *t* have as their theme sudden recognition and surprise: Achilles on Skyros, discovered as a man in women's dress; and the drunken Hercules surprising Auge, who will become mother of Telephos. Both pictures seem to be chosen for their focus on the male as sex object: the handsome Achilles' virile nature cannot be hidden under women's clothes; he must fulfill his heroic destiny. And Auge, although priestess of the virgin Athena, must yield to Hercules' handsome strength, his act of rape excused by his drunkenness.

It is worth commenting that the representation of women both in the cook's room and in the intimate reception area reveals a male bias. For the male servant, the woman is a sex object and pleasure machine for hire; for guests entertained in the most intimate quarters in the house, she yields in the highbrow context of male aggression against women in mythology. The decoration of these two areas of the House of the Vettii expresses a double sexual standard— one for the men and another for the women—that gave both female slaves and freedwomen, seen as sex objects, little choice but to yield to their male masters, whether slaves or freedmen.[83]

81. Mau, "Reg. VI, Isola ad E della 11," 93; Sogliano, "Casa dei Vettii," col. 235.

82. Amedeo Maiuri, "Ginecèo e 'hospitium' nella casa pompeiana," *Memorie: Atti della Accademia nazionale dei Lincei,* ser. 8, vol. 5 (1954): 451–461, proposes various secluded areas of houses, including suite *s-t-u* of the House of the Vettii, as gynaecea. Andrew Wallace-Hadrill, "The Social Structure of the Roman House," *Papers of the British School at Rome* 56 (1988): 52 note 32; on 94 he convincingly argues that this area would be appropriate for reception of intimates of either the master or the mistress of the house.

83. For profiles of women who escaped this dual trap, see Michele d'Avino, *The Women of Pompeii,* trans. Monica Hope Jones and Luigi Nusco (Naples, 1967), and Sarah B. Pomeroy, *God-*

	IXION ROOM P			PENTHEUS ROOM N		
	Pasiphae (left = p 1)	Ixion (back wall = p 2)	Dionysos (right = p 3)	Herakles (left = n 3)	Pentheus (back wall = n 2)	Dirke (right = p 3)
General thematic relationship	Punishment inflicted by a God (Poseidon or Zeus)	Punishment inflicted by a God (Zeus)	Love of a God (Dionysos, Zeus's Son) for a Mortal Woman / Happy Outcome	Care of a God (Zeus as an Eagle) for his Mortal Son / Happy Outcome	Punishment inflicted by a God (Dionysos, Zeus's Son)	Punishment inflicted and carried out by Men (Zeus's Sons)
details	(Wooden) Cow / Human actors only	6 figures			6 figures	Bull / Human actors only
Intellectual relationship	A Woman is Guilty / Pasiphae as transgressor, who because of her perverse passion acts against divine laws and indirectly against the gods	A Man is Guilty / Ixion as transgressor, who wanted to violate Hera and thereby directly and consciously acted against a divinity: Development of p 1, Hybris	A god appears on earth and rescues: a woman; this woman is loved by a god, is admitted to the gods, achieves immortality, marries a god. The same god punishes (indirectly) in n 2	A god appears on earth and rescues: a boy; this boy is loved by a god, is admitted to the gods, attains immortality, marries a goddess (Hebe). The same god punishes (indirectly) in 2	A Man is Guilty / Pentheus as transgressor, who assaulted Dionysos and thereby directly and consciously acted against a divinity: Intensification of n 1, Hybris	A Woman is Guilty / Dirke as transgressor, who because of her inhumanity to Antiope acts against divine laws and indirectly against the gods
Each room in itself as a closed unity	Unified thematic message: The relationship between the sexes / Love as a pleasant and as a disaster-bringing power / The themes of two pictures (p 1 and p 3) come from the Cretan legendary cycle / The events in each picture go on quietly			Unified thematic message: The relationship between parents and children / Pietas as solicitude (of father for son) and as vengeance (sons for mother) and as lethal inversion / The themes of all pictures come from the Theban legendary cycle / The events in each picture go on dramatically		
The general theme of both rooms	The power of the gods, especially Zeus and his sons, as guarantors of world order: blessing the innocent and god-fearing but punishing the transgressors and those odious to the gods					

FIGURE 131. Chart of possible relationships among central pictures in the "twin" oeci p and n.

Doubling Their Luck: Fortuna As if the representations of Priapus and Mercury did not adequately show off their good fortune and their desire that it continue, the Vettii also included Fortuna in their decorative program. Her place in the atrium announces her function unequivocally. She is located to the right of the strongbox on the north wall (indicated by the hatched rectangle labeled *arca* on the plan). Fortuna sits with rudder and globe while cupids sacrifice to her. Fortuna, the Greek goddess *Tyche,* rose to great popularity in the Hellenistic period.[84] In her lofty role as she who governed people's fate, Fortuna was a favored deity of the Hellenistic rulers. Her more concrete role was protecting navigation and, by extension, commerce.

Fortuna appears in the upper zone of the east wall of oecus *p.* Battleships pictured in the decorative panels of the median zone may allude to her rule over navigation. Her dominant position underscores the role of capricious fate in determining the dramatic events in the central pictures in this room and, by extension, in the decoration of oecus *n,* conceived as a pendant to *p.*

Conflict and Reconciliation of Gods and Mortals in Pendant Display As we saw in chapter 2, picture galleries, or pinacothecae, filled, like our museums, with paintings by the old masters, signaled the high culture and wealth of their owners. Leach identifies the earliest imitations of these public buildings in domestic wall painting in the period of transition from the late Second to the early Third Style.[85] Philostratus's rhetorical exercise, based on the pictures that decorated the rooms of a friend's villa in Naples, demonstrates that iconographical and stylistic considerations often governed the hanging of such galleries.[86] One of the clearest reflections of such ancient pinacothecae is in the iconographical program of the central pictures in oeci *p* and *n* of the House of the Vettii (horizontal hatching on plan).[87] Mary Lee Thompson first analyzed the programmatic possibilities of these room's pictures in 1960, and Richard Brilliant has recently recast her arguments in the context of his broader discussion of painted narratives in pendant display.[88] The chart in Fig. 131 follows for the most part

desses, *Whores, Wives, and Slaves* (New York, 1975), but note Pomeroy, 191–192, on the sexual exploitation of slaves.

84. Jerome J. Pollitt, *Art of the Hellenistic Age* (Cambridge, 1986), 1–4.

85. Eleanor Winsor Leach, "Patrons, Painters, and Patterns: The Anonymity of Romano-Campanian Painting and the Transition from the Second to the Third Style," in *Literary and Artistic Patronage in Ancient Rome,* ed. Barbara K. Gold (Austin, 1982), 158–167.

86. Karl Lehmann, "The *Imagines* of Philostratus the Elder," *Art Bulletin* 23, no. 1 (1941): 16–44; Mary Lee Thompson, "Programmatic Painting in Pompeii" (Ph.D. diss., New York University, 1960); Mary Lee Thompson, "The Monumental and Literary Evidence for Programmatic Painting in Antiquity," *Marsyas* 9 (1960–1961): 36–77.

87. See also Zanker, "Villa als Vorbild," 512–513.

88. Richard Brilliant, *Visual Narratives: Storytelling in Etruscan and Roman Art* (Ithaca, N.Y., 1984), 71–73.

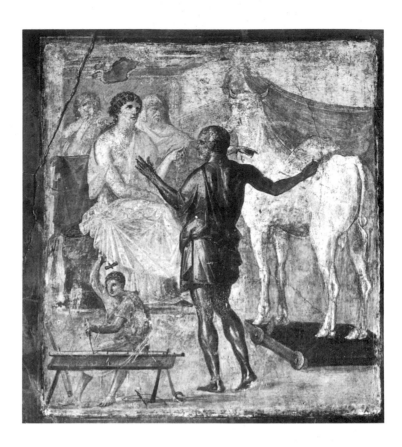

FIGURE 132. Union of gods and mortals in oecus *p:* Daedalus making a wooden cow for Pasiphae.

Theo Wirth's analysis of the iconographical relationships of these pictures. Wirth shows how their subject matter can be conceived in paired terms.[89] All three authors' systems stress the importance of the House of the Vettii's east-west axis, since the symmetry of the proposed iconographically linked pairs depends on seeing the imagery of rooms *p* and *n* in mirror reversal.

Two scenes in oecus *p* refer to an illicit union between gods and mortals with a disastrous outcome. On the north wall Daedalus constructs a wooden cow so that Pasiphae can fulfill her lust for the white sacrificial bull of Jupiter (Fig. 132). From this union comes the Minotaur, scourge of Athens.[90] Ixion re-

89. Theo Wirth, "Zum Bildprogramm in der Casa dei Vettii," *Römische Mitteilungen* 90 (1983): 449–455.

90. Archer, "Casa dei Vettii," 1:413–433.

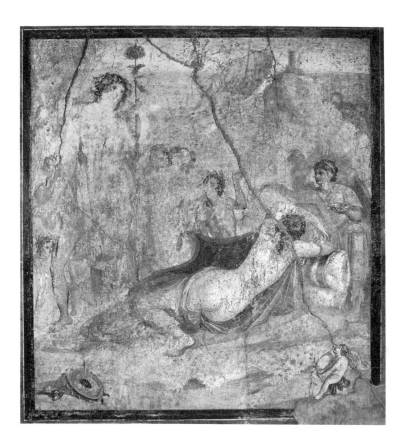

FIGURE 133. Dionysus discovers Ariadne on Naxos.

ceives his punishment for lusting after Hera on the east wall, where Hephaestus ties him to a wheel with serpents (Pl. 14). The object of his desire looks on, unmoved, for at the last moment Zeus substituted a cloud for Hera. From this union will be born the centaurs. Hermes oversees the punishment; beneath Hera a female figure looks imploringly at Hermes. She is most probably Nephele, or the cloud.[91] A goddess with a halo, possibly Iris, points to the scene.[92] The third picture, on the south wall, has a happy outcome. Here Dionysus finds Ariadne, whom Theseus had abandoned on Naxos (Fig. 133).[93]

The infant Hercules overcoming serpents sent by the jealous Hera to destroy

91. Archer, "Casa dei Vettii," 1:403.
92. Lippold, *Antike Gemäldekopien*, 88–89.
93. An earlier, sad moment in the tale, representing Theseus abandoning Ariadne, is pictured in room *d* of the House of the Vettii.

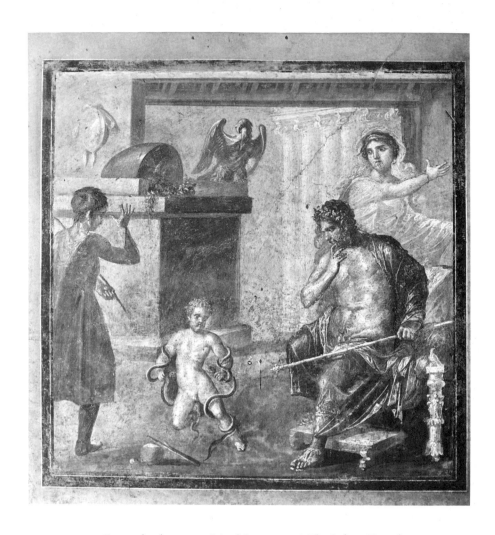

FIGURE 134. Copy of a famous original in oecus *n*? The infant Hercules strangles serpents before his mortal parents, Alcmene and Amphitrion.

him, on the north wall of oecus *n* (Fig. 134), is paired, if across a distance, with this happy ending to Ariadne's woes. Son of Zeus and the mortal woman Alcmene, Hercules at the age of eight months successfully dispatches the serpents, as his terrified mother rushes to her husband Amphitrion, about to pick up the infant. This episode receives brief mention by Pliny the Elder.[94] Some scholars believe the panel in the House of the Vettii reproduces a famous work by the

94. Pliny the Elder *Naturalis historia* 35.36.63: "Hercules infans dracones strangulans Alcmena matre coram pavente et Amphitryone."

fifth-century B.C. painter Zeuxis.[95] On the room's east wall appears the terrible outcome of Pentheus's refusal to accept Dionysus (Pl. 15): maenads in wild Dionysiac frenzy, or ecstasy (literally "standing outside of oneself"), tear Pentheus limb from limb. In the final scene in Euripides' play, one of the maenads, Pentheus's own mother, Agave, comes to her senses to realize that she is holding her son's severed head in her hands. The punishment of Dirce, in the center of the south wall (Pl. 16), has a different pictorial source from the painting already encountered in the House of the Menander.[96] The outcome, however, is the same, as Zethus and Amphion, Zeus's sons by Antiope, avenge the years of slavery inflicted upon their mother by Dirce. Although the story has a violent and fatal ending for Dirce, it has a positive outcome as well: justice has been served, and mother and sons are reunited.

The Theatrical Manner in Room e Scholars have repeatedly cited room *p,* the "Ixion Room," as the prime example of the baroque aspects of what I have called the Theatrical Manner of the Fourth Style, and with excellent reason (Fig. 135). Its decoration synthesizes aspects of all the previous styles and manners. The faux-marble revetment of the socle recalls both the First and Second Style; Second-Style, too, is the reappearance of fictive architectural members. Though more substantial than the attenuated columns and architraves of the Third Style, these architectural perspectives appear in slots lit from behind with dissolving white light.[97] Aediculae with central pictures, begun in the late Second Style and developed during the Third, dominate the scheme of each wall. White panels decorated with flying figures of male and female bacchants alternate with panels in bright blue and bright red. Monochrome paintings appear on some of these panels, others have miniature seascapes with ships. Dionysiac symbols, like the phallus in a basket, appear on ledges, and the god's panthers walk across garlands (see Fig. 132). Figures of struggling men in high relief adorn gold aedicular columns, and a trio of hippocamps rides beneath each central picture. This decoration is a feast for the eyes of the viewer who tarries here and a compendium of the possibilities in wall painting during the late Neronian and early Flavian period.

Room *e*'s more restrained decoration, carried out on a white ground,

95. Heide Lauter-Bufe, "Zur Stilgeschichte der figürlichen pompejanischen Fresken" (Ph.D. diss., Cologne, 1967), 47–53, considers the Herakliskos from the so-called Basilica at Herculaneum to be the closest to Zeuxis's fifth-century original, whereas many other scholars consider the picture in Pompeii VII, 3, 10, room *i* to be the closest. Otto Brendel, "Der schlangenwürgenden Herakliskos," *Jahrbuch des deutschen archäologisches Instituts* 47 (1932): 200, sees the painting of the House of the Vettii as a Hellenistic adaptation of Zeuxis's picture. Archer, "Casa dei Vettii," 1:489–493, denies connections with Zeuxis's painting because Hercules is incorrectly depicted.
96. Leach, "Punishment of Dirce," 166–168.
97. Sheldon Nodelman, "Roman Illusionism: Thoughts on the Birth of Western Spatiality," *Art News Annual* 37 (1971): 36–38, points out that because architectural illusionism is local rather than comprehensive, the Fourth Style does not constitute a return to the Second Style.

FIGURE 135. The "Ixion Room" (oecus p), a baroque version of the Fourth Style, incorporating elements of the previous styles: faux-marble socle (First and Second), architectural perspectives (Second), and aediculae with central pictures (Third).

FIGURE 136. A deeply projecting stucco molding separates median from upper zone in winter triclinium *e*.

presents a more selective picture of the Theatrical Manner (Pl. 17). This room probably served as a winter triclinium. The median zone rests on a gold socle ornamented with carpet borders and panels with hanging tragic masks. Two central pictures remain. On the south wall, opposite the entryway, Eros fights Pan under the eyes of Dionysus and Ariadne, while Silenus encourages Pan.[98] For the Romans, this battle symbolized the struggle between unbridled animal passion and courtly love. Opposite this morality picture Cyparissus sits languidly contemplating his beloved deer, sacred to the nymphs, which he has unwittingly killed. Cyparissus is dying of grief, but Apollo will make him immortal by turning him into the tree that bears his name.[99] Apollo's tripod denotes his role in the metamorphosis. The bust of a female spectator (a nymph?) appears in the upper left corner behind a rocky ledge; she watches as a cypress cone sprouts from Cyparissus's head.

An ornate stucco molding separates median from upper zone. Its figural frieze is framed by two different patterns, a tongue molding beneath it and a palmette frieze on top. Heraldic figures of victories facing swans symmetrically frame two alternating central motifs: a kantharos and a Medusa's head (Fig. 136). This wide and elaborate molding, painted in red, blue, and white,

98. Lippold, *Antike Gemäldekopien*, 90–91.
99. Ovid *Metamorphoses* 10.106–142.

FIGURE 137. A figure descending stairs in room *e*'s scaenae frons.

forms a kind of platform for the scaenae frons of the upper zone, divided into aediculae that frame Dionysiac figures descending stairways (Fig. 137). The motif of figures descending staircases, already seen in the bottom of the median zone in diaeta *f* of the House of Octavius Quartio (Fig. 138), is one of the distinguishing features of the Theatrical Manner.

But the main actors are the seated figures of Zeus and two of his mortal lovers, Leda and Danae. From his throne in the center of the west wall, a beardless Zeus, his head resembling that of Alexander the Great, sits enthroned with his scepter in his right hand and his thunderbolt in his left (Fig. 139). Scholars have proposed that this image is the only replica of Apelles' famous

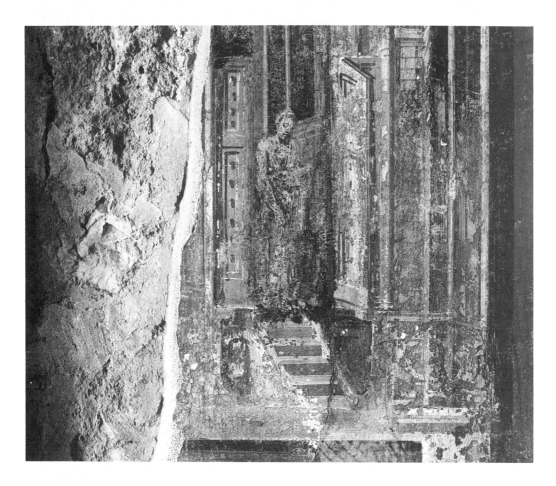

FIGURE 138. A similar figure in diaeta *f* of the House of Octavius Quartio.

painting commissioned for the Temple of Diana at Ephesus.[100] Leda, in the center of the south wall (Fig. 140), reproduces a sculptural type of the early fourth century B.C.,[101] illustrating a version of the myth in which Zeus exhorts Aphrodite to help him have his way with Leda. Taking the form of an eagle, Aphro-

100. Paolino Mingazzini, "Una copia dell'Alexandros Keraunophoros di Apelle," *Jahrbuch der Berliner Museen* 3 (1961): 7–17, argues that this image of a beardless Zeus is a close replica of the painting of Alexander holding a thunderbolt described by Pliny the Elder *Naturalis historia* 35.36.92.
101. This sculptural type has been attributed, without foundation, to Timotheos. Mingazzini, "Alexandros Keraunophoros," 17, proposes that this Leda and the Danae reproduce original paintings by Apelles or, less likely, by Nikias.

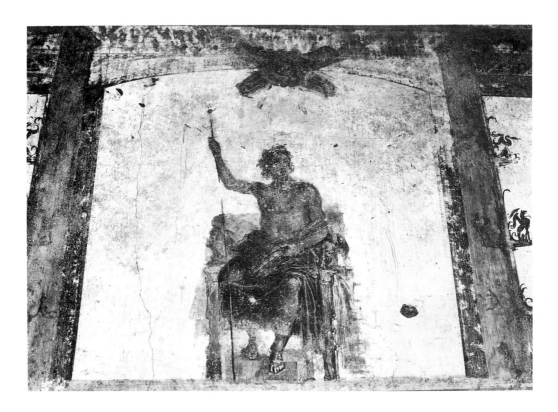

FIGURE 139. A beardless Jupiter modeled on a painting by Apelles surveys his mortal lovers, Leda and Danae.

dite pretends to menace Zeus, who has become a swan. In the painting we see the compassionate Leda raising her arm to protect the swan while she presses him into her lap. Opposite her Danae raises her garment to accept Zeus in the form of a shower of gold. These small yet accurate renderings illustrate the strength of a typological tradition that translated famous works of art into prototypes for interior decoration. Conceptually, they tie together the room's Olympian system: Jupiter with his mortal loves above, and Apollo and Dionysus with their mortal loves in the central pictures below.

The Patrons and the Decorative Program Two observations on the programmatic painting of rooms *p, n,* and *e* have relevance here. First, the quality of the central pictures is poorer than that of the elegant Fourth-Style decorative framework that surrounds them. Comparison of a central picture, like the rep-

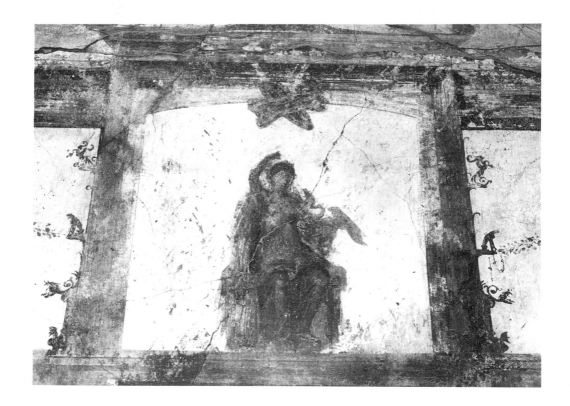

FIGURE 140. The Leda recalls a fourth-century sculptural type.

resentation of Daedalus's workshop, with its surrounding decoration, reveals mistakes in drawing and perspective in the picture that are absent from the decoration (see Fig. 132). This dichotomy in quality between highly refined decoration and mediocre central pictures seems best explained by the fact that the preeminent picture painters would never have stooped to making replicas of their paintings fixed into the frescoed walls of a house. Fine paintings that rivaled those of our own old masters certainly existed, painted on wooden panels or canvas, and they have just as certainly all disappeared. A truly wealthy patron would have owned real paintings rather than depictions of them "hanging" against a fictive background imitating the precious marble revetments and costly aediculae that he could afford to have constructed.

Second, the governing assumption that the Vettii chose the decorative program by themselves must remain hypothetical. We might ask ourselves: Could

a professional iconographer have set the decorative program? Sources like the letter of Annibale Caro to the painter Taddeo Zuccaro laying out the iconographic program of the Villa at Caprarola document the practice in the Renaissance, when wealthy individuals often hired a professional to make sure that a correct program would be worked out.[102] The same must have been true in antiquity. In the case of the paintings preserved in houses like that of the Vettii, it is entirely possible that the patron entrusted some or all the details of the decorative program to the architect or head of the wall-painting workshop.

And although we find signs of greater unity in the House of the Vettii than in the House of Octavius Quartio, no amount of casuistry or iconographical juggling can unify such a combination of imagery. No single system explains the entire program. Instead we find a number of more or less independent subsystems, like the thematic correspondences between the Ixion room and the Pentheus room, the relationship of cupids in the great oecus, garden, and atrium, or the Priapus axis from fauces to peristyle. Other imagery appears in less sytematic ways, like the two images of Fortuna and of Hermaphrodite, or even the erotic pictures in the cook's room. Knowing that the Vettii were freedmen with lots of money and perhaps not such developed tastes as the owners of large villas and town houses they seem to be emulating, we can propose two explanations for the overburdened display of disparate imagery in their house.

We can use as a model the character Trimalchio in Petronius's *Satyricon,* who clearly broke the codes of tasteful decoration in his effort both to display his wealth conspicuously and to celebrate his favorite myths and anecdotes from his life.[103] This would characterize the Vettii as entrepreneurs with a strong, perhaps superstitious, interest in gods of fertility, industry, and the mythological representation of the strife between mortals and the gods. But perhaps this is crediting them with more control over the particulars of their house's decoration than they actually had or wanted to have. If the Vettii hired a professional iconographer (or left the choice of imagery to the head of the wall-painting workshop), they were content if he succeeded in giving their house the luster of intellectual sophistication to duly impress their clients and guests. If the overdone display that resulted bewilders and amuses us today, we are receiving messages that these up-from-under freedmen wished their guests to receive. And if their tastes seem strange, it is because the Vettii as patrons chose decorative ensembles with talking walls, filled with images whose details and interpretation were meant to stimulate and impress the viewer.

102. Ernst H. Gombrich, *Symbolic Images: Studies in the Art of the Renaissance* (London, 1972), 23–25, presents the original text of Caro's letter, after Giovanni Gaetano Bottari, *Raccolta di lettere sulla pittura, scultura ed architettura scritte da' più celebri personaggi dei secoli xv, xvi, e xvii* (Milan, 1822), 3:249–256.

103. Trimalchio, however, was not a typical freedman. Unlike most *liberti*, he had inherited his dead *patronus*'s estate. See John H. D'Arms, *Commerce and Social Standing in Ancient Rome* (Cambridge, Mass., 1981), 97–120; Jean Andreau, "Il liberto," in *L'uomo romano,* ed. Andrea Giardina (Rome, 1989), 186–213, defines the social status of the libertus from texts.

It is interesting that in their choice of decoration the Vettii emphasized wall painting over pavimentation; the cement floors of the House of the Vettii are so simple that one wonders whether they were adorned with elaborate textiles. We will never know, but the House of the Mosaic Atrium and the House of the Stags represent another approach to interior decoration in this period that reduces the importance of the wall painting while increasing both the variety and richness of the pavements.

TWO SEASIDE VIEW VILLAS AT HERCULANEUM: THE HOUSE OF THE MOSAIC ATRIUM AND THE HOUSE OF THE STAGS

As noted in chapter 1, in many ways the House of the Mosaic Atrium and the House of the Stags were twin seaside villas. Built with a common wall and carving their spaces out of the southern end of the same insula, each took advantage of the earthquake of 62 to remodel existing atrium houses and to add substantially to them by pushing gardens, oeci, and belvederes out over the now unnecessary city wall overlooking the sea (see Figs. 141 and 147). Parallel sites and similar goals for the use of spaces brought about parallel, but distinct, solutions in these houses' plans and decorative schemes.

Axes and Decorative Ensembles in the House of the Mosaic Atrium Three axes dominate the more traditional House of the Mosaic Atrium. A long axis extends from the atrium through the garden and oecus 12 to the sea. Two axes cross this long one: one is the entryway axis, defined by the fauces and tablinum; the other extends from exedra 9 on the east across the center of the garden, or viridarium. Architectural features framed these conceptual axes to provide actual views. A window in the atrium's south wall, located on the seaward axis, marked the conceptual axis but did not provide a view of the sea. Opening *m* in the viridarium's enclosure wall, unlike the window, was situated on the built, rather than the conceptual, axis and therefore provided a view out, since the architect constructed the rooms overlooking the sea at right angles to the oblique line of the city walls. Exedra 9 both interrupts the peristyle's eastern enclosure wall and pushes a paved platform out into the garden, marking a secondary axis and proclaiming its centrality in the suite of rooms along the house's east wall.

On the basis of her study of ensembles of pavements and wall painting, Scagliarini has postulated that the House of the Mosaic Atrium had four decorative systems (Fig. 141).[104] As expressed in existing pavements and wall decoration the designer's aims were to unite spaces with similar functions and to

104. Scagliarini, "Spazio e decorazione," 24, fig. 40.

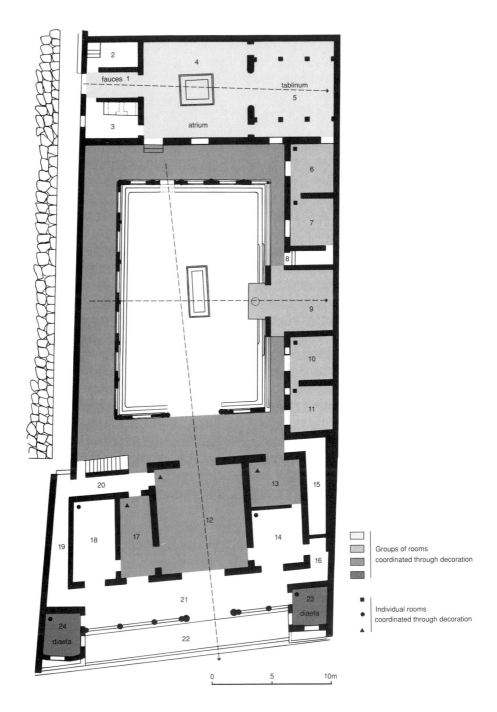

FIGURE 141. Plan of the House of the Mosaic Atrium. Four pavement systems differentiate spaces in terms of function and importance.

differentiate spaces within suites through changes in pavements and wall painting. Entering the House of the Mosaic Atrium, the lively geometry of the black-and-white mosaic of the fauces coordinates with the checkerboard pattern of the atrium in both style and opus tessellatum technique (Fig. 142). A band of vegetal tendrils at the impluvium harmonizes with the grid of the checkerboard rather than strictly framing the impluvium, off-center with respect to the atrium's axis.[105] A stylish, unusual tablinum in the form of a kind of aisled basilica (the "Egyptian oecus" mentioned by Vitruvius)[106] received a polychrome cut-marble (opus sectile) floor. Its aisles, however, must have been considered service areas, since they have humble signinum pavements. Continuing this logic, plain opus signinum floors pave the north and west passageway of the peristyle, but white tessellation paves the more important passageway (enclosed with wood and glass) forming part of the circulation of the eastern suite (6–11) and the south peristyle serving oecus 12 and its dependencies. Opus sectile pavements adorn exedra 9 and oecus 12, as well as diaetae 23 and 24; but here, too, there is a distinction: the large reception rooms received polychrome marble, whereas the tiny belvederes got simple designs in black and white marble.

Just as the designer distinguished floors according to function, using tessellation or cement in dynamic spaces and opus sectile in static ones, so the painted decoration coordinates and designates groups of rooms with related functions. Coordinating with the polychrome opus sectile and red cement floors of tablinum 5 is a predominantly white decoration on a low red socle. The east wall (Fig. 143) received metallic-looking architecture in light blue, green, and yellow. The artist defined the limits of this illusionistic architecture with a dark band at the corners. The central aedicula's fine miniature ornament includes vine shoots, sea horses, dolphins, candelabra, flowers, and carpet borders. On top of the aedicula two small caryatids that imitate little bronze sculptures support the upper zone. All of these details can be found in the equally refined painting of room *f* of the House of Octavius Quartio (see Pl. 11). If the atrium's walls were predominantly red, as seems likely, this white tablinum with light streaming down from its aisles would have created an ethereal wreath of light around the paterfamilias standing there.

Exedra 9, the important center of the eastern suite, with decorations as refined as those of tablinum 5, changes to a blue key. Its monochrome blue background harmonizes with the garden it embraces and shows off its metallic architectural forms and their ornament. Columns and aediculae decorated with garlands, griffins, candelabra topped with eagles, centaurs, and caryatids all

105. Amedeo Maiuri, *Ercolano: I nuovi scavi, 1927–1958*, 2 vols. (Rome, 1958), 1 : 283, believed the impluvium to have been a holdover from the previous design of the atrium.
106. Vitruvius *De architectura* 6.3.8–9; Wallace-Hadrill, "Social Structure," 59–60, discusses its evocation of the basilica, a public building.

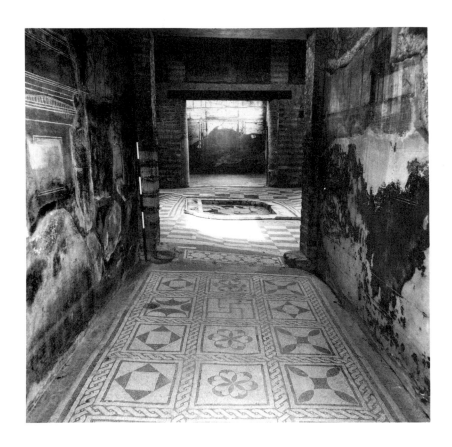

FIGURE 142. Two black-and-white tessellated patterns coordinate the spaces of fauces and atrium.

imitate bronze. Two of its central pictures remain: *Diana and Actaeon* on the north wall and *The Punishment of Dirce* on the south. This *Diana and Actaeon*, the fourth such representation we have encountered, underscores the great variety of ways artists could illustrate this myth. In contrast to the garden-painting modes expressed by the iconic Diana in the exedra of the House of the Menander (see Fig. 100), or the informally painted, nearly life-size figures on the exterior walls of room *f* of the House of Octavius Quartio, here the artist stresses the painting's miniaturism, losing the figures in the land-scape so that the viewer must look for them. A similar aesthetic applies to *The Punishment of Dirce*.[107] Two medallions with "portrait" heads occupy the me-dian zone of the short western diaphragm walls framing the garden view.

107. Leach, "Punishment of Dirce," 168–169.

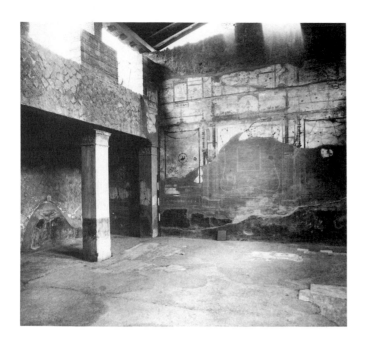

FIGURE 143. The tablinum, conceived as a regal basilica (Vitruvius's *oecus aegyptius*), boasts fine miniaturistic ornament.

Flanking rooms 6, 7, 10, and 11 constitute a unified decorative system framing exedra 9; all have the same pavements, consisting of white tessellation bordered by thin double frames of black tesserae. Painting systems pair on either side of oecus 9's axis: rooms 6 and 11 both have red median zones and white upper zones, whereas 7 pairs with 10, with both zones painted red. Although differing in decorative details, all four rooms employ the same decorative structure, with flat carpet-bordered aediculae framed by two-story white windowlike slots and flat pseudo-architecture in the upper zones. As is the usual practice, the illusionistic architecture is painted independently of the real architecture; when real doors or windows occur, the fictive openings are painted just the same. The strange resulting conflict of actual with fictive openings occurs on the north wall of 7 and the south wall of 6, where false windows appear illogically connected with actual doors.

The ceilings of rooms 7 and 10 are preserved. Room 7's ceiling employs a concentric composition around a small central Medusa's head (Fig. 144). Carpet borders, stretched and scalloped garlands, friezes of miniature dolphins, and panels with hippocamps decorate this scheme of concentric squares. Room 10's ceiling, although not as well preserved, was coffered, like that of room *f* in the House of Octavius Quartio. The divisions of its wall scheme, as in rooms 8, 37, and 38 of the Villa of Oplontis, dictate the geometric divisions of the coffered system.

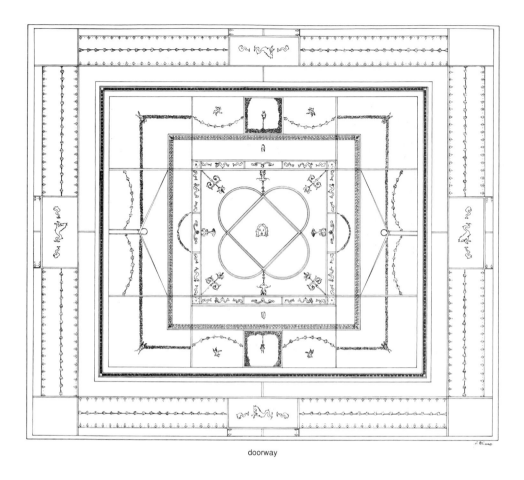

doorway

FIGURE 144. Concentric carpet borders surround a Medusa's head in the ceiling of room 7, seen right-side up from the entryway.

A fourth decorative ensemble centered on the house's largest room, oecus 12. Although its decorations are gone (most of the opus sectile floors in the house were taken by the Bourbon tunnelers), highly refined paintings in adjoining oecus 14 give a sense of its ornament (Fig. 145). Gathered curtains (*auleae*) hang between metallic stacked aediculae at the top of the median zone. The aediculae continue into the upper zone, where they delicately frame miniature flying horses (*pegasi*), Medusa heads, and dolphins. Oecus 13, separated by a thin partition, employed a similar scheme on a black ground.

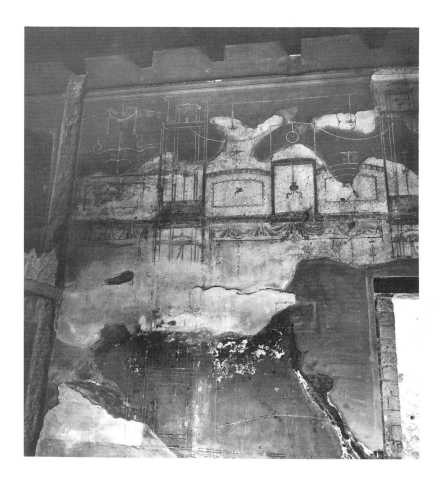

FIGURE 145. Gathered curtains (auleae) and stacked aediculae frame miniature motifs in oecus 14.

The painter's taste for restrained, monochrome, and miniaturistic decoration is a far cry from the heavy architecture, bold color contrasts, and bombastic cycles of central pictures encountered in the House of the Vettii. Cerulli-Irelli sees in the decorations of the House of the Mosaic Atrium a refined, late, stylized version of the Neronian Theatrical Manner.[108] This same artist or his workshop may have created the similarly restrained and elegant Fourth-Style paintings of the Samnite House.

108. Giuseppina Cerulli-Irelli, *Le pitture della Casa dell'Atrio a Mosaico,* Monumenti della pittura antica scoperti in Italia, sec. 3, Ercolano fasc. 1 (Rome, 1971), 48.

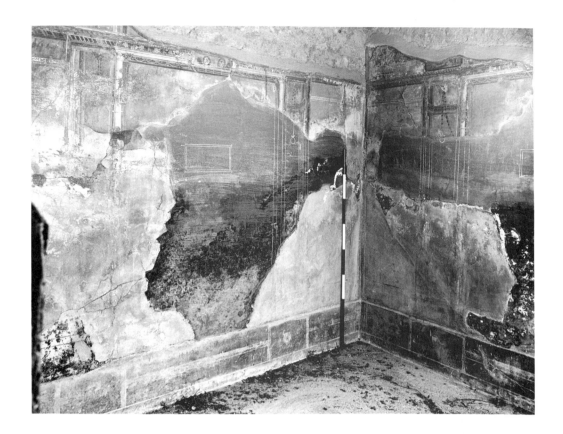

FIGURE 146. A heavier version of the Theatrical Manner in diaeta 23.

The belvederes, or diaetae 23 and 24, must have been the work of another master, for their paintings, with heavy architectural elements based on the scaenae frons, are completely different in inspiration from those of the rest of the house. In place of the thin, airy architectural fantasies appear assertive aediculae and sturdy columns supporting substantial architraves (Fig. 146). Figural motifs are larger and more heavily modeled, reminiscent of the flying maenads and hippocamps in the decoration of room *p* of the House of the Vettii (see Fig. 132).

Excepting these belvederes, the consistent use of a single style unifies the House of the Mosaic Atrium. Likewise, the recurrent decorative motifs of dolphins and hippocamps run through the decorations of this seaside villa like a leitmotif. The restraint of its walls, made up for in part by its three brilliantly

colored opus sectile floors, must have increased the House of the Mosaic Atrium's focus on the beauty of the seascape so artfully framed by its walls and windows.

Axis and Sculptural Display in the House of the Stags Ownership of the House of the Stags has been a matter of dispute in recent times. Agnes Allroggen-Bedel proposes that the owner was Quintus Granius Verus, since the mid-eighteenth-century excavators found a loaf of bread in room 17 stamped "Celer, slave of Q. Granius Verus." Stamps were used to identify loaves of bread made in the house but taken to the local bakery for baking. Celer was later manumitted, since his name is also the penultimate one on the list of augustales in Herculaneum.[109] Victor Tran-Tam-Tinh, in his recent monograph on the House of the Stags, doubts this attribution, suggesting that the proprietor was a descendant of M. Nonius Balbus.[110]

Comparison of its plan with that of the House of the Mosaic Atrium reveals a more radical and logical remodeling to take full advantage of the sea view (see Fig. 141). Unlike the House of the Mosaic Atrium, with seaside rooms laid out at right angles to the oblique line of the old city walls, a single axis runs through the House of the Stags, thereby eliminating the jogged viewing axis of its neighbor (Fig. 147). Furthermore, by doing away with the traditional domus plan and relegating the atrium to the function of a vestibule, the patron was able to face the ocean view from room 5 (Fig. 148). All semblance of a peristyle, present in part in the House of the Mosaic Atrium, disappears in favor of a cryptoporticus covered on all sides, with windows to the viridarium placed at discrete intervals.

Like the House of the Mosaic Atrium, the House of the Stags uses pavements to signal spatial function and importance. The hierarchy in the House of the Stags is more complex and finely tuned than its neighbor's, employing four types of opus sectile, from a simple basketweave pattern of gray marble rectangles to complex polychrome curvilinear designs, in addition to several patterns in opus tessellatum. The general rule remains that dynamic, passageway spaces receive the simpler, less expensive pavements, leaving the more complex and expensive pavements for static reception or dining areas. Opus signinum appears only in the atrium (where it is much worn, suggesting that it may have been kept from the previous house) and in the small area south of 22. The fauces' pavement is tessellated. White mosaic carpets scattered with colored

109. Agnes Allroggen-Bedel, "Der Hausherr der 'Casa dei Cervi' in Herculaneum," *Cronache ercolanesi* 5 (1975): 99–103. John H. D'Arms, *Romans on the Bay of Naples* (Cambridge, Mass., 1970), 22, 30, 36, 62, 125, 192, also identifies the House of the Stags as the villa of Quintus Granius Verus.
110. Victor Tran-Tam-Tinh, *La Casa dei Cervi a Herculaneum* (Rome, 1988), 122–130.

Labels visible within the plan:

13, 14, 12, 11, 10, 9, oecus, 4, 3, 8, 5, 2, 7, 6, 1 fauces

satyr ■ ■ Hercules

vase ▲

table ● ● table

stag ■ ■ stag

15, 19, 16, 17, 20

23 diaeta 18 pergola 22 diaeta

Legend:

☐ Groups of rooms coordinated through decoration

▲ Individual rooms
● coordinated through decoration

▨ Room with two way coordination system

0 5 10m

FIGURE 147. Plan of the House of the Stags. Four pavement systems differentiate spaces within the house, while symmetrically arranged sculptures and furniture frame the visual axis in the garden.

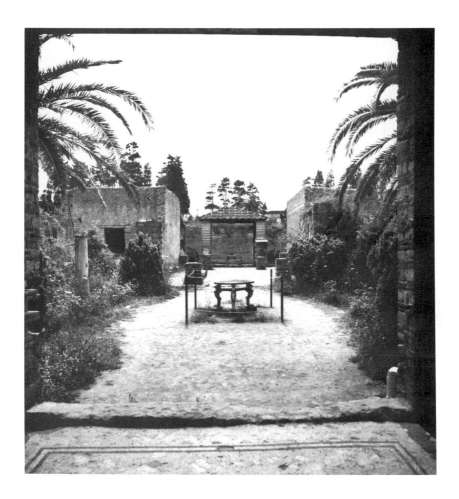

FIGURE 148. The visual axis in the House of the Stags connects the viewer with a framed prospect leading to the sea.

marble fragments and framed with double black bands pave the corridors of the cryptoporticus. That they are conceived as individual carpets and not as a uniform paving system is evident from the way they align with architectural features. For example, the edges of the carpet in front of room 5 coincide with the size of the opening in the cryptoporticus's exterior wall. The carpets stop at windows, where thick black bands correspond with the windows' placement along the corridors (Fig. 149). The most important dynamic spaces, room 4 (communicating between 5 and 3), the space between 15 and 18, pergola 18, and the loggia, all received simple opus sectile pavements. The finest opus sec-

FIGURE 149. Black mosaic bands correspond with windows along the corridors of the cryptoporticus.

tile, in diaetae 22 and 23, waited as a final surprise for the visitor who had toured the house. Room 17, although having the simplest pavement of this sort in a static space, nevertheless received marble wainscoting. A further subtlety of pavement designs assigns bright, rich colors to the northern suite, rooms 5, 7, and 10, paved in red, black, dark orange, and gold, whereas the southern suite, rooms 15, 17 (and probably 16, whose pavement is no longer extant), share delicate tones of salmon, green, and gray. The diaetae once more constitute an exception, rich in color as they are complex in design.

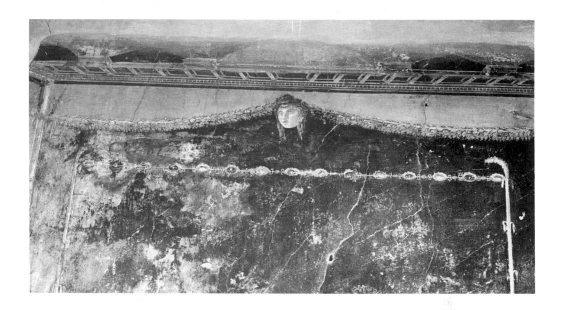

FIGURE 150. Masks at the apexes of aediculae in oecus 5 constitute the sole figural motifs in the wall decoration.

Like that of the House of the Mosaic Atrium, the painting in the House of the Stags lacks the grandiose architectural constructions of the Theatrical Manner and has preserved no central pictures copying works of the old masters. The simple aedicular scheme of the cryptoporticus is punctuated with little pictures of amorini on its north and west walls, with food still lifes, or xenia, along the south and eastern walls.[111] In decorative terms, however, the extant painting of black oecus 5 and red oecus 7 is of high quality. In oecus 5 large metallic aediculae on the center of each wall lack central pictures but have heads looking down from the midpoint of their architraves. Isolated among purely ornamental motifs, these gazing heads startle the viewer and animate the architecture (Fig. 150). With a similar effect, the head of Athena looks down at the viewer from the center of room 7's ceiling (Pl. 18). Comparison of room 7's ceiling with those preserved in the House of the Mosaic Atrium re-

111. Many paintings were removed by the Bourbon tunnelers and are in the Museo Archeologico Nazionale, Naples. See Allroggen-Bedel, "Casa dei Cervi," 99–103. For a discussion of the still-life subjects, see Jean-Michel Croiselle, *Les natures mortes campaniennes: Répertoire descriptif des peintures de nature morte du Musée National de Naples, de Pompéi, Herculanum et Stabies* (Brussels, 1965), cat. nos. 319, 320, 321, pls. 10, 18, no. 44. Allroggen-Bedel, "Casa dei Cervi," 103 note 17, restores further still lifes to the House of the Stags that are wrongly given a Pompeian provenance by Croiselle.

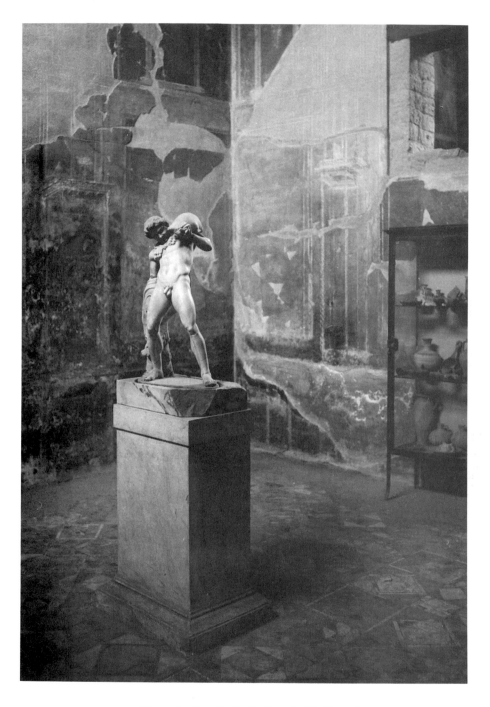

FIGURE 151. A satyr with a wineskin (h. 0.65 m) probably faced the statue of Hercules across the garden's visual axis.

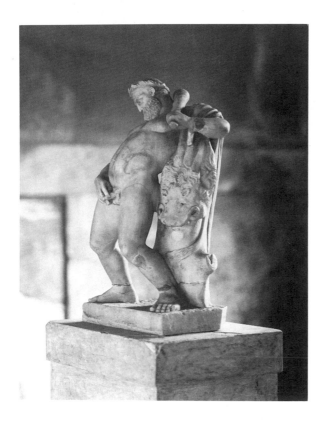

FIGURE 152. Drunken Hercules (h. 0.50 m), like the satyr, belongs in the playful world of the convivial feasts celebrated in the garden.

veals this ceiling's greater sophistication and complexity. It was, after all, a larger and much more important room than either room 7 or 9 of the House of the Mosaic Atrium, essentially passageway spaces framing exedra 9. The preserved wall decoration in room 7 of the House of the Stags indicates that it was a monochrome red room. Stacked aediculae in the median and upper zones preface the ceiling's concentric geometry. Helmeted Athena, facing the room's southern doorway, subtly signals the sea prospect awaiting the viewer.

The lack of big, engaging figural paintings in the House of the Stags was compensated by the display of marble sculpture in the viridarium. Tran-Tam-Tinh has described their original placement in the garden (see Fig. 147). Four figures faced each other along the visual axis leading from oecus 5 to the sea view: a drunken satyr with a wineskin (Fig. 151) faced a pissing Hercules (Fig. 152) over the northern part of the axis, while the two sculptures of stags

attacked by hounds—another reference to the Actaeon myth—faced each other at the southern end of the viridarium, near oecus 15. The satyr was also a fountain figure, since a richly sculpted marble vase caught the water pouring from his wineskin. This seems to have been the only fountain in the viridarium.

The straightforward arrangement of the sculpture underscores the importance of the framed visual axis; the individual pieces flank but do not mark it. Aligned walls, piers, and the pergola frame that important axial view-through, while the pediment of the origin of that axis, oecus 5, received a special decoration in its mosaic of Oceanus flanked by sea creatures. Such pediments, or *fastigia,* in private architecture may have carried regal associations.[112] Two sculptures whose subject is drinking (too much), the drunken Hercules and a satyr with a wineskin, were the perfect pair for a garden that formed the focus of convivial feasts. Placed in this enclosed garden, Hercules and the satyr would have joined the wine-drinking guests.

If the owners of the House of the Stags and the House of the Mosaic Atrium were fortunate enough to build their houses out to the sea view, there were many more inhabitants of Herculaneum in its troubled post-earthquake years who had to be content with much smaller quarters. The variety of these unconventional houses attests to the inventiveness, and at times the desperation, of city dwellers of slenderer means.

COMMERCE AND PRECIOUS PLEASURES
IN THE HOUSE OF NEPTUNE AND AMPHITRITE

The owner of the House of Neptune and Amphitrite made the most of every square foot of his modest city lot (227 m², compared with about 1,250 m² in the House of the Stags). In addition to securing an income from renting the shop flanking the street entrance, he added upper-story rooms over the street and on the south and east sides of the atrium (Fig. 153). But the care and expense lavished on the house's reception spaces reveal the patron's desire to compensate for their modest size in the refinement of their decoration.

The shop space is the best preserved from antiquity (Fig. 154). When this area of the house was filled with volcanic mud, not only the shop's wooden furnishings but also some of the foodstuffs, notably legumes, were carbonized, giving us a clear picture of the offerings of a little street-side bar. Semi-interred terra-cotta storage jars (*dolia*) near its street entrance held fava beans and chickpeas for eating (both still popular in modern Italy). Hanging racks on the south wall were found still holding the amphorae that contained the wines consumed here (Fig. 155). These details identify the shop as a *caupona,* or little

112. Wallace-Hadrill, "Social Structure," 60–64.

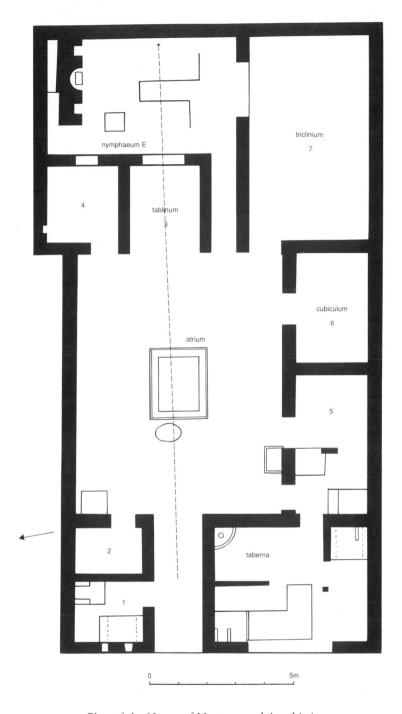

nymphaeum E

triclinium

7

4

tablinum

3

cubiculum

6

atrium

5

2

taberna

1

0 5m

FIGURE 153. Plan of the House of Neptune and Amphitrite.

FIGURE 154. A street-side caupona offered food and wine. Also visible are the Fourth-Style painted walls, a bed, and a marble table on the upper floor.

bar or tavern. Above a wooden partition, with solid panels below and lattice-work above, is a balcony, found filled with more amphorae, and in the south-eastern corner is an arched support for one of the caupona's three stoves for heating food and wine. With a cement floor and simple wall painting, this was a modest place of business. Built in the last ten years before the final disaster, this shop, although connected by a door to the House of Neptune and Amphi-trite, was unlikely to have been the owner's only means of livelihood. The richness of the decorative program within the house proper indicates a patron with a diversified income.

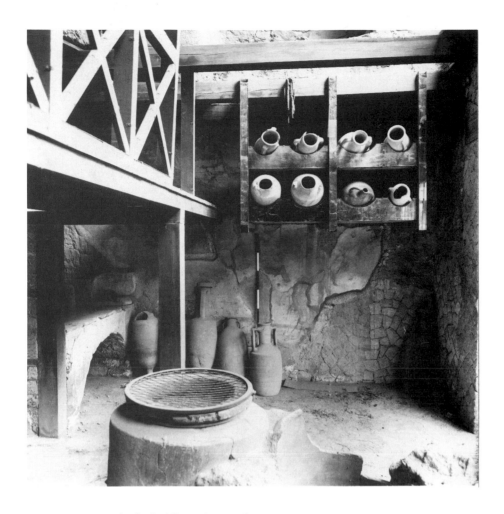

FIGURE 155. Racks for holding wine amphorae.

The exterior of the House of Neptune and Amphitrite was plastered and painted with a bright red socle surmounted with white median zones. Remains of a painted carpet border to the north of the fauces open the tantalizing possibility that decorative motifs enlivened the house's facade.[113] Like the Samnite House, the House of Neptune and Amphitrite had a balcony supporting rooms over the street facade, but here they were for the owner, not for renters. In Figure 154 one can see elements that decorated these rooms, including high-

113. Maiuri, *Ercolano,* fig. 331.

quality Fourth-Style painting in the Theatrical Manner, the corner of a fine bronze bed, and a marble table. Because this upper story, which included rooms along the sides of the atrium, had a substantially higher elevation than the rooms of the ground floor, Maiuri concluded that they housed the owner's sleeping and private living quarters.[114]

Two fragmentary marble panels, in a technique of red monochrome painting imitating Greek painting of the fifth century B.C., were found in the lararium, installed in a corner of the atrium. One bore the signature of the artist, Alexander.[115] This same signature appears on the well-preserved marble panel painted in the same technique now in the Museo Archeologico Nazionale, Naples; its subject is *The Astragal Players*.[116] Since the lararium of the House of Neptune and Amphitrite had been despoiled by the Bourbon tunnelers, it is possible that *The Astragal Players* once adorned it. At any rate, the presence of signed marble monochromes is an index of the wealth and good taste of the last owner. Extensive losses of the house's painted decoration caused by the Bourbon tunnelers are all the more lamentable in view of the high quality of the remaining fragments. Remains visible at the time of excavation on the west wall of the atrium were in the Theatrical Manner, by a painter specialized, as Maiuri notes, in baroque architectural decorations with figural and animal motifs of a complexity unlike those of other painters at Herculaneum.[117] One fragment still visible on the north wall of tiny tablinum 3 was inspired by the scaenae frons. Flanking a central picture with figures of Narcissus and the nymph (Echo?) at a fountain are two figures descending the steps of the stage, or *pulpitum*. One carries an offering tray and the other is heavily mantled. Figures descending stairs can be made out in cubiculum 4, along with statuelike figures inserted into stage architecture.

Room 7, barrel vaulted and the largest room off the atrium, must have done double service as both oecus and triclinium. Both light and the sound of splashing water flowed into room 7 from the adjoining open-air room E. White slots framed central aediculae containing paintings within its predominantly red color scheme. Of the central pictures, only a woman's face remains on the west wall. Part of an aedicula remains on the east wall, showing that its Corinthian columns were ornamented with shields. Room 7's pavement, like those of the

114. Maiuri, *Ercolano*, 401. Elevation of upper-story rooms is 3.53 m (ca. 11′5″) as opposed to the 3.18 m (10′4″) in ground-floor rooms.
115. Maiuri, *Ercolano*, 394, "Alexandros Athenaios egraphen" or "Alexander the Athenian painted me."
116. Carl Robert, *Winckelmanns-Programm* 21 (1897); 22 (1898); 23 (1899); Carl Robert, *Hermes* 36 (1901): 368ff.
117. Maiuri, *Ercolano*, 395–397.

rest of the house, is red opus signinum, probably remaining from the penulti-mate remodeling of the house in the first half of the first century.[118]

From the fauces the image of Neptune and Amphitrite (*Salacia* in Latin) an-nounces the final owner's favorite deities and his precious substitute for a peri-style and garden in room E (Figs. 156 and 157). This view, framed by the tablinum's low window, highlights the divine pair, carefully depicted in tiny polychrome tesserae in a technique approaching opus vermiculatum for the refinement of its effects of shading and coloring. Each deity takes a frontal pose, side by side, framed in an aedicula with a red and light-blue pleated and scalloped sail forming an arch over their heads. Frescoed walls with plants and fountains, painted in a style found on garden walls and peristyles throughout Pompeii and in the Villa of Oplontis complete the decoration of this east wall.[119] From room 7 the full message of the room is clear (Pl. 19). It is a foun-tain house, or *nymphaeum,* laid out like a triclinium, with couches spread around a rectangular basin for water and an elaborately decorated stage front masking the water tank that fed the fountain. The open-air room's diminutive size (5.25 x 4.05 m, or 17 x 13 ft.) makes it unlikely that it was used for dining—except perhaps for dinner for two. More likely the space was meant to be evocative of larger houses, so that it becomes a kind of wistful tableau of the haunts of the nymphs: springs and grottoes. The northern wall owes much to the theater: the niches, the center one round headed, originally held statues. Three metopelike panels (gone) were framed, like the garlands and hunting animals beneath them, by pilasters decorated with vegetal motifs. A mask of Oceanus framed by heraldic chimaeras decorates the eastern edge of the east-ern metope. Above this frieze three theatrical masks in heraldic symmetry ap-pear. A tragic mask in the center is framed by two identical masks of long-bearded satyrs.

Maiuri believed that the painted decoration preceded the mosaics, hypoth-esizing that the house's last owner had the image of Neptune and Amphitrite inserted either because his commercial success came from Neptune's protection of his shipping business or as thanksgiving for having been saved in a storm at sea.[120] His hypothesis ignores the Dionysiac subject matter of the north wall and assumes that the mosaic postdated the garden painting, which he attributes to the same master responsible for the Theatrical Manner walls of the rest of the house. It is difficult to attribute this genre of garden painting; like the paint-ing of the wild animals in paradeisoi, it looks the same wherever it occurs. The

118. Maiuri, *Ercolano,* 393, notes that radical changes, even in the bearing walls, were carried out in "post-Augustan *opus reticulatum.*"
119. Jashemski, *Gardens of Pompeii,* 307–309, figs. 470–475, 291, figs. 440–441.
120. Maiuri, *Ercolano,* 398–399.

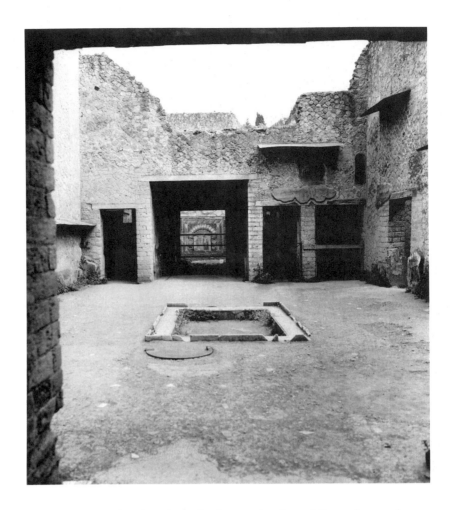

FIGURE 156. In the view from the fauces, the tiny tablinum frames the mosaic of Neptune and Amphitrite in the nymphaeum.

mosaicist who decorated the pediment framing the entrance to oecus 5 in the House of the Stags could have carried out these mosaics, so similar in motif and technique.[121] Whatever the patron's reasons for commissioning the mosaic decoration, Neptune and Amphitrite fit one of the two themes of the ensemble, that of water. The other theme, Dionysus and the theater, connects with the

121. Frank Sear, *Roman Wall and Vault Mosaics*, *Römische Mitteilungen*, Ergänzungsheft 23 (1977): 95–96, no. 71, pl. 40.

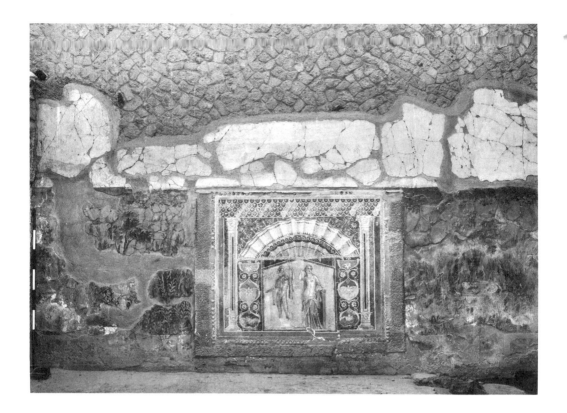

FIGURE 157. Wall paintings representing a garden, with marble fountains and birds, frame the mosaic of Neptune and Amphitrite.

convivial message to the diners in the adjacent triclinium and to the nymphs and satyrs who inhabited the space. Although Maiuri asserts that nymphaeum E is not simply a mosaic fountain, like those found in Pompeii, it comes very close in style and motifs.[122]

A CHEAP, HIGH-DENSITY TENEMENT: THE HOUSE IN OPUS CRATICIUM

As the additions of upstairs rooms with balconies overhanging the street in the Samnite House and the House of Neptune and Amphitrite have already sug-

122. Sear, *Wall and Vault Mosaics*, catalogues all mosaic fountains in Pompeii, with the exception of a newly restored one from the lowest level of the House of the Golden Bracelet (Ins. Occ. VI, 17, 42), *Rediscovering Pompeii*, exh. cat., New York (Rome, 1990), no. 194, 270–80.

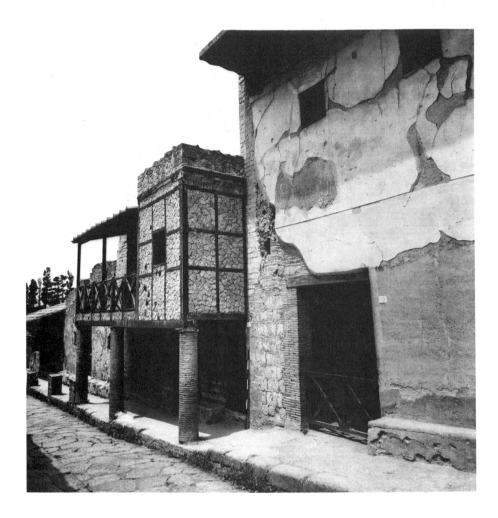

FIGURE 158. The wattle-and-daub balcony (restored) of the House in Opus Craticium projects over the sidewalk.

gested, after the earthquake of 62, many atrium houses in Herculaneum added extra living spaces within the boundaries of their existing walls. Whether they were apartments-to-let or for the owners themselves, adding these living spaces compromised both the open spaces of the atria and peristyles and the privacy associated with the traditional domus. The House in Opus Craticium represents a much more radical solution. With the original atrium house completely destroyed, either by the earthquake or by the owner, the builders inserted

two apartments into a narrow site hemmed in by atrium houses on either side. In doing so they used a rapid building technique employing cheap materials: wattle and daub, or plaster held together with a wooden framework (Fig. 158). Vitruvius condemned this so-called opus craticium technique because it was prone to collapse and catch fire easily.[123]

Graceful circulation systems, employing spaces like the atrium and the peristyle, take up a lot of space. By eliminating them and dividing their functions of providing light, air, and circulation between a central courtyard and corridors, the House in Opus Craticium saved enough space to carve two apartments and a street-side shop with three back rooms out of what would have been a very modest atrium house (Fig. 159). As we saw in chapter 1, two parallel paths lead from the doorway to the courtyard at 4. From this courtyard stairs lead to two rooms probably employed for both dining and sleeping. A large bed was preserved in room 1 (Fig. 160). Its red Fourth-Style wall painting, of relatively good quality, coordinates with the red opus signinum floors found throughout the house. The decoration of this room and the adjacent larger room 2, furnished with built-in beds, probably doubling as dining couches, raises questions about the cost of wall painting and its priority in the construction of the apartments. Perhaps the owner spent extra money to dress up the structure that cost him so little, thereby attracting higher rents. At any rate, the last occupants of these upper rooms left many possessions behind when they fled Herculaneum. In two cupboards in room 2 were found glass vases, lamps, a necklace, and eight statuettes, as well as a table support with the bust of the boy Dionysus.[124]

Independently accessed by a steep wooden stairway with its own street door at number 13, the other apartment's spaces spilled out over the street-side balcony but ended with a partition wall and a window on the courtyard. A single corridor from this window to the balcony gives access to rooms 3–6 and minor spaces a–d. The space is terribly dark and relatively airless. Even the rather odd circumstance of windows in rooms 3 and 4 taking light from the atrium of the neighboring House of the Bronze Herm (through some special arrangment with its owner, if different from the owner of the House in Opus Craticium) does little to alleviate the gloom in these two spaces. At the top of the stairs the tenants consoled themselves with a marble roundel, or *oscillum*, carved on both sides with Dionysiac images.[125]

The best room, 5, furnished with a large and a small bed, equals the size of the best room of the rear apartment, 2 (Fig. 161). Room 5 received ample light

123. Vitruvius *De architectura* 2.8.20.
124. Maiuri, *Ercolano*, 402.
125. Maiuri, *Ercolano*, 419–420, fig. 358.

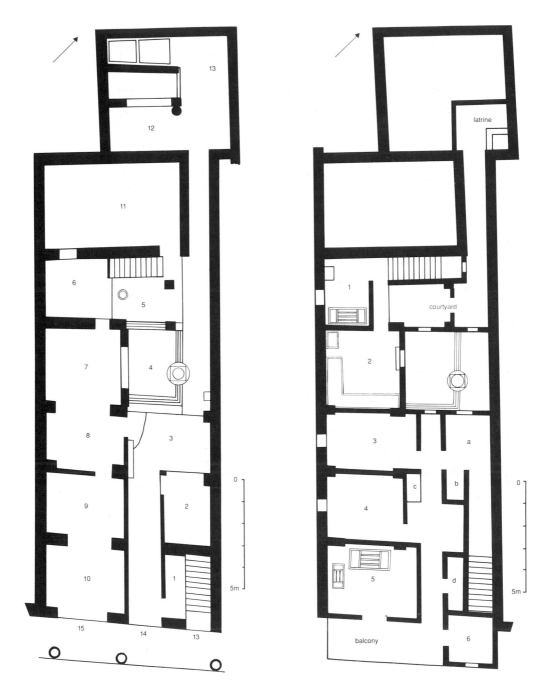

FIGURE 159a, b. Plans of the ground floor and the upper story of the House in Opus Craticium.

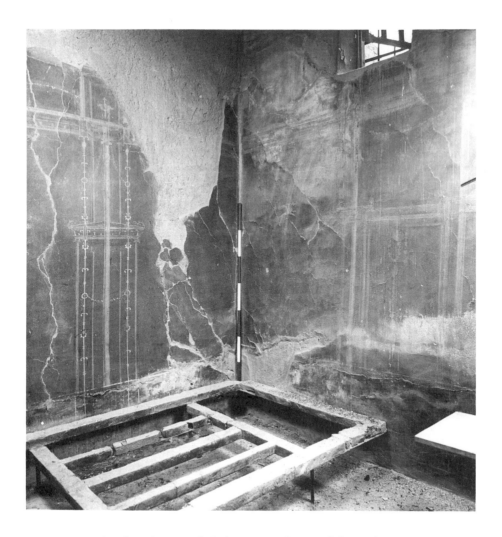

FIGURE 160. Good-quality Fourth-Style painting decorated this triclinium-cum-cubiculum in the upper-story room belonging to the ground-floor apartment.

from the balcony. Carved from the balcony and part of the space over the door to the stairway on the ground floor, room 6 was a small but charming little perch from which to watch the passers-by below (Fig. 162).

Flimsy as construction in opus craticium may have been, one obvious advantage of its lightness is in balcony structures, impossible in solid rubble-and-cement and difficult in brick-and-cement walls. In the House in Opus Cra-

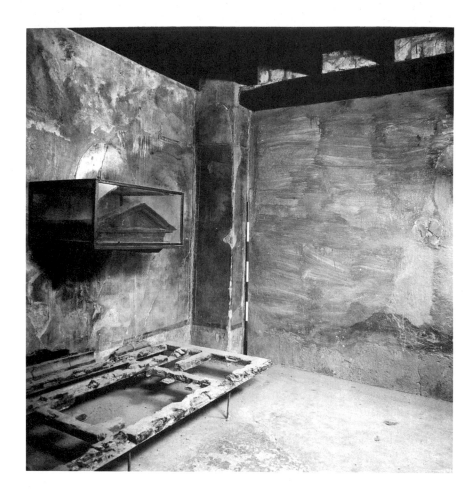

FIGURE 161. The best room of the upper-floor apartment.

ticium, partitions between upstairs rooms did not have to coincide with those of the ground floor because they were not weight bearing.[126] It has been pointed out that in the more conservative, provincial town of Pompeii only balconies employ construction in opus craticium, whereas Herculaneum, near the great city of Naples, more accurately reflects current experimentation. Just at this time vaulted, brick-faced concrete construction was being developed for multi-family dwellings. By the year 100 huge insulae built with this new, fireproof,

126. Brick piers on the ground floor support beams that run between the house's long walls. These beams in turn support the upper story's floors and partitions in opus craticium.

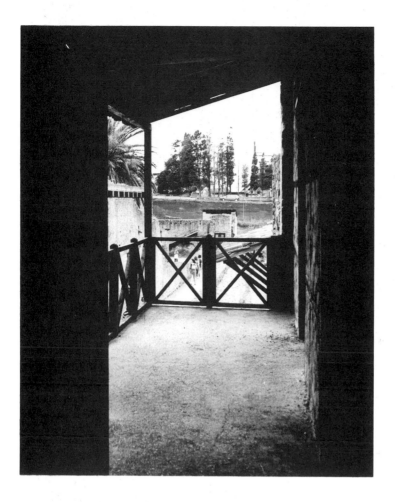

FIGURE 162. The view from a room inserted over the balcony.

and virtually indestructible technique had solved the problems of urban density and versatility that had found an intelligent but flawed solution in the House in Opus Craticium.

The period of the Fourth Style marks the turning point in the history of both Roman housing and its decoration. New forms of the private dwelling, coupled with new, eclectic approaches to their decoration, appear in both Pompeii and Herculaneum. Although the House of the Menander is the most conservative of our case-study houses, retaining a proper atrium complete with tablinum, em-

phasis on the peristyle points to the owner's avid embrace of the fashions of the very rich—including their pretensions to literary and cultural pursuits. None of our other Fourth-Style houses has a proper tablinum. Miniature villas like the House of Octavius Quartio substituted lavishly decorated gardens and waterworks, peppered with arch allusions to aristocratic country estates, for the conventional peristyle. The Vettii brothers also jettisoned the tablinum, but not the entryway sequence, because it focused all the more attention on the peristyle with its fountain- and sculpture-filled garden. Rituals of reception took place in the house's entertainment center. Clearly the Pompeians of this last period could dispense with the image of the domus to emphasize that of the villa. In all of these houses complex mythological and religious imagery challenged the visitor to match wits with the owner in deciphering it.

In Herculaneum one searches in vain for the traditional domus in this period. If the traditional entrance sequence remains in the House of the Mosaic Atrium, it is merely a leftover, unintegrated with the prized axial view to the sea. Symmetrical decorations in axially symmetrical rooms emphasize functional hierarchies. In the House of the Stags, the arrangement of sculpture, pavements, and wall and ceiling painting sweeps away the old entrance sequence in favor of a single strong axis.

Because of its proximity to the busy and densely populated city of Naples, Herculaneum experiments more freely than Pompeii with entirely new forms of housing. The little House of Neptune and Amphitrite, although resembling the domus in its retention of the fauces-tablinum axis, in every other respect is novel: its balconies over the street, luxurious living quarters on the upper floor, the tiny tablinum functioning solely as a view framer, and its miniature fountain garden are all new concepts. Most daring of all is the House in Opus Craticium, bringing us face to face with the brutal realities of the late first-century urban housing dilemma—a maze of dark, railroad-flat rooms with flimsy partitions in wattle and daub. Even the finest appointments were little comfort in apartments like these.

The overriding theme in Fourth-Style houses is the secularization of the ritual space of the domus. Instead of conveying the impression of majesty, probity, and propriety characteristic of the Late Republic and the Augustan age, the private house tended to emphasize rituals of entertainment and the ideal of bringing the country into the city. There were social reasons for these changes. The owners of these houses belonged to an entrepreneurial class of merchants and builders; many were freedmen.[127] This class, socially most active in this period, shaped the new taste.

127. Castrén, *Ordo populusque pompeianus,* 113–124; Zanker, "Villa als Vorbild," 518–523.

In the following decades the domus begins to disappear entirely both in Rome and in Ostia Antica. The new Fourth-Style attitude toward the functions, arrangements, and decorations of spaces in the house forms a precedent for the insula. Its new arrangement of spaces, multifunction rooms, and hierarchical use of wall and floor decoration build on the experiments we have investigated in the Fourth-Style houses of Pompeii and Herculaneum.

CHAPTER SIX

HADRIANIC AND EARLY ANTONINE DECORATION AT OSTIA ANTICA, A.D. 120–150

Ostia began as a military fortress (*castrum*) in the beginning of the fourth century B.C.[1] Its position, at the mouth of the Tiber, secured its importance in guarding Rome, which lay sixteen miles inland. By the second century Ostia began to function as a port for Rome; a city wall erected around 100 B.C. and enclosing about fifty hectares of land testified to its new commercial role. It was only with Augustus and his successors that the city received monumental buildings: the civic Forum with a new temple of Roma and Augustus and the theater with its own forum. Construction of a protected port under Claudius (41–54) enhanced Ostia's importance, since before its creation debris constantly blocked the passage of large boats into the mouth of the river. The principal port of Italy's west coast, at modern Pozzuoli, handled the 150,000 tons of grain brought there annually from Egypt. With the Claudian harbor, located north of Ostia and connected with the Tiber by a canal, the problem of supplying Rome was temporarily resolved. The new port caused a boom in Ostia's economy: it became the administrative center for the port, responsible for transporting goods to Rome and for storing surpluses in warehouses. The population increased, requiring drastic building programs. Most regions of the city began to be rebuilt. To create firm foundations for the tall, brick-faced concrete insulae, the level of the city was raised about a meter (3'3"), covering demolished atrium houses.

The pace of Ostia's boom quickened with the building of a second, more effective harbor by Trajan around 100 A.D. Now the grain fleet of Alexandria came to Ostia's port, rather than Pozzuoli's. Warehouses and insulae proliferated, particularly under Hadrian (118–138). By mid-century Ostia had been completely transformed from a town a bit like Pompeii, with single-family

1. For the best general history of Ostia, see Russell Meiggs, *Roman Ostia*, 2d ed., with corrections (Oxford, 1975); a concise, accurate account also in Carlo Pavolini, *Ostia*, Guida archeologica Laterza, no. 8 (Rome, 1983), 20–36; see also Carlo Pavolini, *La vita quotidiana a Ostia* (Rome, 1986), 3–165.

atrium houses and small shops, to a logically planned and densely populated city of tall insulae, warehouses, and public spaces (Map 3).

In the face of these changes, Ostia's population may have reached 50,000, a supply city for Rome's 1,200,000 inhabitants. It was a decidedly middle- and lower-class population, consisting of people who worked in the trades associated with shipping, storing, and selling all sorts of goods: principally grain, olive oil, and wine, but also more unusual goods, like the exotic beasts used in gladiatorial combats. The trades organized into *collegia,* functioning in some respects like modern labor unions. There were collegia of shipbuilders, barge towers, grain measurers, merchants, and many other professions. They and their families lived in the new insulae, built to satisfy a relatively broad range of needs, from those providing large spaces in quiet residential areas (Fig. 163) to those offering little more than two rooms and a medianum (see Fig. 194). Housing, like the collegia, was organized and stratified along a model much like that of the twentieth century.

Although new building slowed down after the last of the Antonine emperors, Commodos (180–193), Ostia remained prosperous through the Severan dynasty (193–235). Its fortunes reversed suddenly around 250, a time of political crisis in Rome, when all commercial activity transferred directly to the area of the harbor, where a second city, Portus, had developed. Although its conditions improved under the stable governments of Diocletian (283–302) and Constantine (313–337), Ostia never regained its former status. Unlike Pompeii and Herculaneum, preserved in a cataclysm, Ostia was very gradually abandoned, the last squatters leaving it by the ninth century.

Little can prepare the first-time visitor who has seen only Pompeii or Herculaneum for the vast brick-faced concrete apartment houses of Ostia Antica. Because of the durability of these structures, decorated with mosaic floors and frescoed walls, when Ostia was abandoned a surprising number of its decorative ensembles survived. Original frescoes of the second century often remained intact because of the protective coating provided by the heavy layers of plaster used in subsequent redecoration. Much of the fine detail, added in secco over the fresco layer, has disappeared both over time and, lamentably, since the discovery of these frescoes in the twentieth century. Sophisticated conservation techniques applied in the 1960s have only served to slow the inevitable loss of these precious decorations.

In this chapter we will examine two houses that retained significant ensembles of their decoration from the initial phase of Ostia's prosperity in the period of Hadrian. One vies with first-century houses like that of the Menander in the gracefulness of its spaces and the high quality of its decoration. The other is a small but carefully planned and decorated medianum house. Both reveal the new spatial and decorative sensibilities that emerged from the insula.

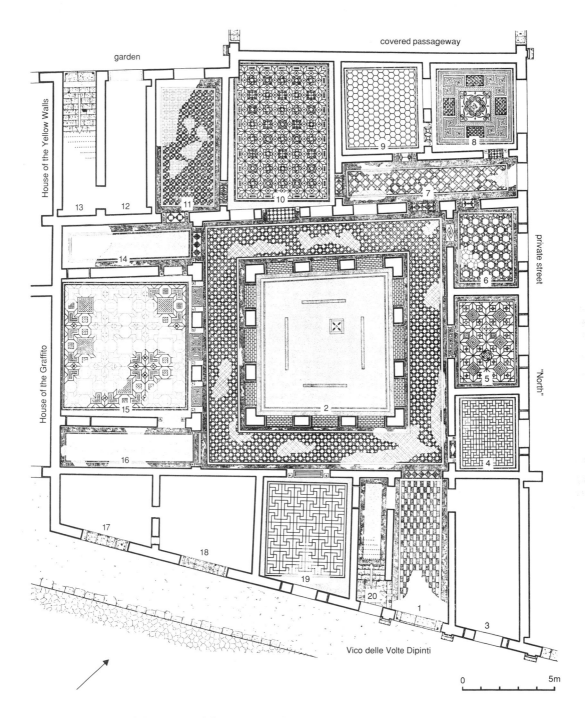

FIGURE 163. Plan of the House of the Muses with mosaics drawn in.

Located on the northeast corner of the Garden Houses complex, the House of the Muses' carefully orchestrated and generous spaces, decorated with fine mosaics and wall paintings, tell us that this was a residence for a person of means. Whether planned, like the units of the Garden Houses complex, as a luxurious, exclusive rented apartment,[2] or as the residence of the owner, the House of the Muses was certainly the best dwelling constructed at the time. Brick stamps date the building to about 128.[3]

About 749 square meters (8,157 sq. ft.) in area, the House of the Muses employs none of the space-saving compromises found in the House in Opus Craticium.[4] There are no "railroad flat" rows of passageway rooms (Fig. 163).[5] With each room autonomous in its position around the ample quadriporticus, the house retains many characteristics and special-purpose rooms of the atrium house. The brick-faced concrete quadriporticus (Fig. 164) is a perfect compromise between the grand but dark atrium and the bright colonnaded peristyle of the atrium house, which was elegant but unable to sustain the weight of substantial upper stories. Constructed in large graceful arches surrounding an ample courtyard paved in white mosaic, the quadriporticus, airier and brighter than the dark, sparsely fenestrated cryptoporticus of the House of the Stags (see Fig. 149), also frames important spaces.

In chapter 1 we mentioned that position, axial alignments, and a hierarchy

2. Meiggs, *Roman Ostia*, 139, characterizes the Garden Houses as "an ambitious composition of shops, apartments, and gardens, a garden city in miniature, which was probably a private investment." The House of the Muses could have been the residence of this investor.

3. Herbert Bloch in Guido Calza, et al., *Scavi di Ostia*, vol. 1, *Topografia generale* (Rome, 1953), 223. Bloch assigns this date on the basis of brick stamps of the years 123, 124, and 125 found in the building fabric.

4. Changes made to the plan of the House of the Muses after its walls were built but before its decoration with mosaics and paintings suggest that either the owner decided to enlarge it for himself or that a wealthy tenant wished to increase its size before moving in. A new doorway (and closure of the street opening) made room 19, originally a street-side shop like 17 and 18, part of the house. Felletti Maj suggests it was a waiting room for clients. Another exterior door, that to room 3, became a kitchen space, and 20 an interior stairway to the upper floor. This last modification added rooms from the upstairs apartments to the ground-floor suite. The stairway to the third floor was at the opposite corner of the house, in 12 and 13; its entrance was from the garden surrounding the Garden Houses and seems to have bypassed the second floor. Bianca Maria Felletti Maj and Paolo Moreno, *Le pitture della Casa delle Muse*, Monumenti della pittura antica scoperti in Italia, sec. 3, Ostia fasc. 3 (Rome, 1967), 10.

5. In this and other plans of the houses at Ostia Antica, room numbers have been changed from roman to arabic numerals. Rather than lettering individual walls with a different sequence of "a," "b," "c," and "d," I have used the cardinal directions, "north," "south," etc., to identify the wall schemes. Since true north varies somewhat from house to house, I have inserted the word "North" on the plans along the outer wall closest to true north. This north identifies the position of wall decoration on individual walls.

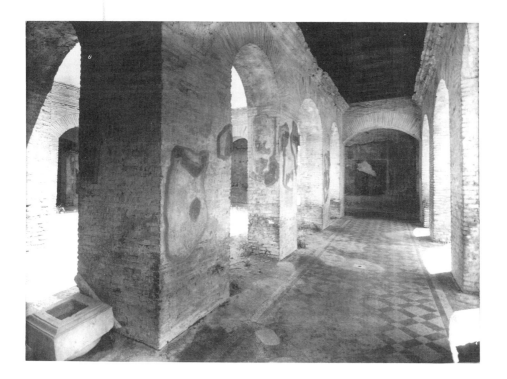

FIGURE 164. An arcaded brick-faced concrete quadriporticus takes the place of the columned peristyle.

of mosaic decoration coded spaces in the House of the Muses so that a person would understand the function of each. How exactly does this functional coding work? Detailed examination of the plan and the mosaic program will answer this question. Based on our experience of the domus, we would expect a view-through from the vestibule at 1, but instead the visitor must discover the principal axis as he or she walks along the north side of the quadriporticus. It soon becomes clear that room 15, located in the middle of the south side of the quadriporticus, is the largest and most important room. Its triple-arcaded entrance aligns with the arcades of both sides of the quadriporticus to underscore its importance. This room must have functioned as a tablinum, and its northern exposure would have made it an ideal summer triclinium. It was the only space in the house to be covered with a groin vault, since all other rooms, including the quadriporticus, had flat ceilings.

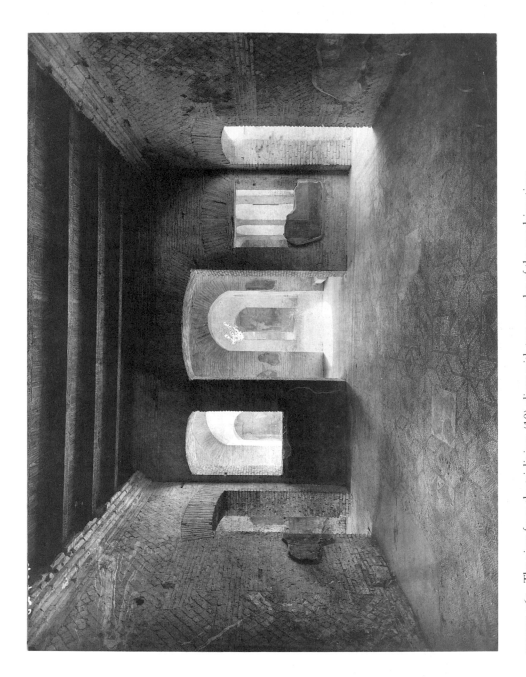

FIGURE 165. The view from the triclinium (10) aligns with two arcades of the quadriporticus.

The viewer looking at this room from the center of the northern porticus is aligned along a carefully planned axis joining room 15 with the Room of the Muses (5), an elegant sitting room on the opposite side of the quadriporticus. We will see that this axis was replete with meaning for the owner. Another privileged axial view, this time from the interior of triclinium 10, the second largest room in the house, coincides with two axially aligned arcades of the quadriporticus (Fig. 165). Such axes articulated by views framed through aligned openings, called enfilades, characterize Nero's Domus Aurea and the private apartments of Domitian's Palace.[6] In fact, the House of the Muses owes much to the success of vaulted imperial buildings in achieving majestic forms without using columns. Another imperial feature is the original form of tablinum 15. Lateral openings expanded its space into areas 14 and 16, imitating the form of the large triclinium, or *coenatio iovis,* of Domitian's Palace.[7] Later, after the wall painting and mosaics were completed, new piers that restricted these lateral openings had to be added to support the groin vault.[8]

Functional Hierarchy and Axis Marking in the Mosaic Program　The mosaic floors best demonstrate how decoration encoded messages for the viewer, for they both signaled the relative importance of a space and cued the viewer to planned viewing patterns (see Fig. 163). Wall painting followed the mosaics, and in several cases it also shared proportions and geometric divisions with the geometry of the pattern on the floor. These visual harmonies, arising from an acute awareness of how mosaic and painted decoration must complement the architecture of spaces they adorn, reveal the subtlety and sophistication of Hadrianic decorative ensembles.

The first job of pavements is to establish functional hierarchies among the spaces, divided most generally between those of dynamic and static function. The simplest pavements, in all-white tesserae, occur in the courtyard and service corridors 14 and 16, followed by the simple allover pattern in entryway 1. The same design, but used on two different scales, paves both the quadriporticus and 7, a corridor linking 8 and 9 with both triclinium 10 and the quadriporticus. Next in the functional hierarchy are allover mosaics without special features that signal axial divisions: these occur in cubicula 4, 6, and 9, and in room 11, perhaps a service room for triclinium 10. Although it is an allover pattern without a single center of interest, the mosaic of room 19 has an axial

6. William L. MacDonald, *The Architecture of the Roman Empire* (New Haven, 1965), 1:67, pl. 64.

7. Heinz Kähler, *The Art of Rome and Her Empire* (New York, 1965), 118–119.

8. The vaulted frigidarium of the Terme dei Cisiarii was similarly reinforced by piers added at a later time; see John R. Clarke, *Roman Black-and-White Figural Mosaics* (New York, 1979), 24.

center line that divides the design (and the room) into two parts along its long axis. Someone standing at the doorway would be looking down this center line. Furthermore, the grid of six by seven squares making up this carpet of interlocked meanders fits so perfectly the room's irregular dimensions that the design must have been tailor-made for the space.

Examination of the compositions of the more complex floors of tablinum 15, triclinium 10, and the Muses' room (5) makes it clear that the mosaicists paid great attention to each room's proportions and its pattern of doors and windows when designing its mosaic carpet. Room 15's pavement consists of nine squares defined by a grid and emphasized by the same angle brackets that appear in a mosaic of the *ospitalia* of Hadrian's Villa.[9] The east-west divisions of this grid align with the edges of the central doorway (Fig. 166). Triclinium 10's pavement is more complex, as the drawing illustrates (Fig. 167). Like the contemporary mosaic of the Caseggiato di Bacco e Arianna,[10] the central motifs decorating its grid (a, b, c, and d) change position on either side of the room's axis for the first three repetitions. In the final repetition, at the doorway, central motifs match on either side of the room's axis.

There are two possible explanations for the geometric divisions in the mosaic of the Room of the Muses (Fig. 168). The fact that the central motifs (six elaborated swastikas) are oriented on the bias obscures the pavement's design around a six-part grid of squares. Whereas two of these swastika squares define the room's short axis, which is also the axis of entry, two bias-laid squares, each with a different design, line up with three eight-part rosettes to define the room's long axis. Since only a window faces the incoming viewer, the long axis, connecting the important central figures in the wall painting, gets the greater emphasis. Recently Carol Watts has offered a second explanation of the mosaic, in a discussion of geometrical systems in pavement patterns.[11] She proposes that the floor composition is based on multiple overlapping squares and inscribed squares. While based on relatively few examples, her arguments for such proportioning methods are compelling.

The only mosaic with a figural motif, in room 8, may have functioned as an oecus or sitting room dependent on cubiculum 9, since the image of a bird on a branch is visible right-side up from the room's two doorways. The bird would then greet someone walking either through this anteroom to the cubiculum or vice versa. Felletti Maj suggested that this suite was for the dominus,[12] but its

9. Salvatore Aurigemma, *Villa Adriana* (Rome, 1961), 181, fig. 189.
10. Clarke, *Mosaics*, 22, figs. 18–19.
11. Carol Martin Watts, "A Pattern Language for Houses at Pompeii, Herculaneum, and Ostia" (Ph.D. diss., University of Texas at Austin, 1987), 300–306, fig. 211.
12. Felletti Maj and Moreno, *Casa delle Muse*, 10.

FIGURE 166. The mosaic's grid aligns with the central doorway in the great tablinum (15).

A a A'
c
A'd A
b
A a A'
c
B d B'
a

☐ A
▨ A'
▨ B
▨ B'

FIGURE 167. Central motifs change positions in their serial repetitions in the triclinium.

FIGURE 168. Bias-laid squares frame elaborated swastikas in the Room of the Muses (5); a common proportioning system may be the basis for both wall and floor layouts.

location and separate service corridor indicate that it was intended for intimate receptions, for either the man or the woman of the house. It compares closely in position and disposition with the private suite (s-t-u) of the House of the Vettii discussed in chapter 5.

The coding of spaces through a hierarchy of pavement systems, from simplest to most complex, and through the expression of visual and functional axes, addresses the viewer immediately through abstract but highly recognizable signs. Wall-painting programs in the House of the Muses require a different type of perception from the viewer, who must read their cultural message in the language of myth and literature.

Tradition and Continuity in the Room of the Muses If Hadrianic classicism stood for the revival of the painting and sculpture of fifth- and fourth-century B.C. Greece, the beautiful wall painting of the Room of the Muses is its perfect expression in the realm of interior decoration. In composition, color, and iconographical program this room recalls the distant Greek past while continuing decorative traditions developed from the time of Augustus, proponent of an earlier classicism.

Each wall's tripartite division both horizontally (into socle, median, and upper zones) and vertically (central aedicula with two lateral wings) continues a tradition begun in the late Second Style (Pl. 20). The black faux-marble socle highlighted in cream is interrupted by red plinths for the column bases. All architectural foreshortening converges at the eye level of the viewer standing in the center of the room, on the central star in the mosaic floor. Significantly, the system of shading on the architectural members has as its light source this same point in the room's center. As in rooms of the Second Style, bearing elements at regular intervals support the architrave to turn the room into a colonnaded pavilion; here blue pilasters fold into the corners (just visible on the southwest and northeast corners), less emphatic than the folded columns of the Second Style. Architectural elements in the upper zone, although badly damaged, include central aediculae with standing statuelike figures and lateral niches containing figures behind low fences (plutei) with foreshortened colonnades behind. Between median and upper zones is a frieze of triglyphs and metopes, but the Ionic columns and blue corner pilasters do not support it, continuing instead up through the upper zone to the ceiling. The same architectural system, expanded to cover their greater length, organizes the north and south. The northern window and southern entrance take the place of the central panels in the scheme.

Panels of color organize the decorative scheme as much as the architecture does. Gold panels with the key figures of Euterpe and Apollo organize the centers of west and east walls, flanked on either side by red panels, each with the

figure of a Muse. These red panels turn the corners behind the blue pilasters to frame the other four Muses on north and south walls. Backgrounds for these panels alternate, painted with passages of foreshortened architecture seen through slots, so that gold panels have red grounds and vice versa. At the same level as the figures of Apollo and the Muses, square blue panels, like those used in room *p* of the House of the Vettii (see Fig. 135), interrupt the background architecture. Colors reverse again in the upper zone, with red panels in the center and gold on the sides. The logic and harmony of this system create a stable yet lively structure for the refined images in the center of each panel.

The Muses, like the architecture, are meant to be seen from the center of the room. Apollo and Euterpe, on the gold central panels, are represented frontally, whereas the Muses in side panels both glance and are foreshortened to either right or left. Their lighting, however, differs from that of the architecture: with the exception of the Muse of the left panel of the west wall, the figures are always lit from the upper left. This indicates that either different patterns were used for the architecture and the figures or that two different artists executed the design; perhaps both conditions prevailed.[13] In light of the division of labor in wall painting of the first century between wall painters and picture painters, it seems likely that a specialist, rather than the artist who painted the architecture, carried out the figures. Since the figures (like much of the architectural detail) were added over the dried fresco, there are no seams around them to prove the existence of two successive painting campaigns.

The sequence of Muses reads from left to right, beginning on the left (west) of the entryway with Clio, Muse of history. Clio wears a white chiton with a light blue-green mantle, diptych in her left hand and stylus in her right. She glances to her right. Thalia, Muse of comedy, follows on the south side of the west wall. Wearing a wide-belted chiton, she holds a comic mask in her outstretched right hand and a *rotulus* (scroll) in her left. Thalia looks to her left at Euterpe, whose figure is so abraded that one can only make out the two flutes and the crown of leaves that identify her as the Muse of music. Melpomene, with club and tragic mask, balances Thalia and, like her, looks to Euterpe for inspiration (Fig. 169). She wears a long, high-belted chiton in blue green with a white mantle draped over her left shoulder. Like Euterpe, Terpsichore, Muse of the dance, is nearly destroyed. Only part of her attribute, a large cithara, is visible on the western part of the north wall. Erato, Muse of love poetry, stands opposite her on the eastern part of the same wall, with a large lyre held to her left shoulder and a pick (*plectrum*) in her right hand (Fig. 170). She glances to her right, toward the window, and wears a cream-gold gown with matching cape and a wide, blue-green belt. Polyhymnia, Muse of epic poetry, wears a

13. Felletti Maj and Moreno, *Casa delle Muse*, 23.

FIGURE 169. Melpomene, Muse of Tragedy, with tragic mask and club.

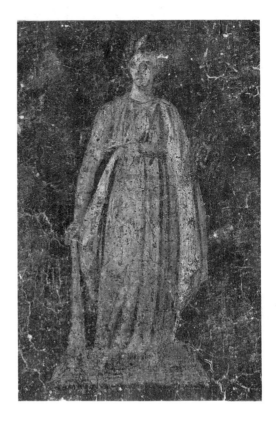

FIGURE 170. (*facing page, left*) The Muse Erato, with lyre and plectrum.

FIGURE 171. (*facing page, right*) The Muse Urania with radius and globe (compare Fig. 129).

purple-red gown with a big white mantle and holds a small, closed rotulus. Unlike the Muses flanking Euterpe on the opposite wall, both Polyhymnia and the other Muse on this wall, Urania, look away from Apollo in the center. Apollo, crowned with laurel and nude but for a light blue mantle draped over his shoulders, draws an arrow from his quiver with his right hand while holding his bow in his left (Pl. 21). The Muse of astronomy, Urania, wears a purple chiton with a white mantle and holds the globe in her left hand while pointing to it with the radius in her right (Fig. 171). The sequence ends on the south wall with Calliope, Muse of epic poetry, holding a big open rotulus. A white mantle thrown over her left shoulder sets off her powder-blue chiton.

Paolo Moreno has noted that the order of the Muses, with one exception, follows that of Hesiod's *Theogony*.[14] Euterpe should follow Clio; her central position on the west wall seems dictated by two symmetries—to balance

14. Felletti Maj and Moreno, *Casa delle Muse*, 25; Hesiod *Theogony* 77–78; the same order followed by the *Anthologia latina* 684, ed. J. Wight Duff and Arnold M. Duff, *Minor Latin Poets* (London, 1934), 634.

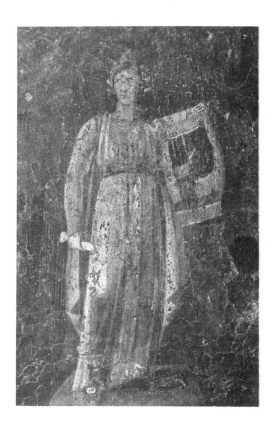 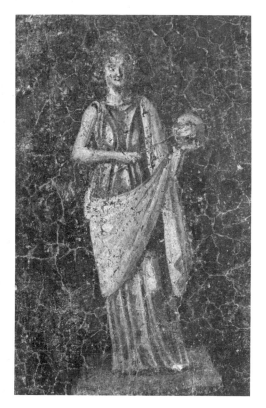

Apollo across from her and to be framed by the two opposite dramatic forms, Comedy and Tragedy. Since the rooms with Muses in Pompeii or Herculaneum neither follow this order nor have the full complement of nine Muses, this Hesiodic order must have been deliberate. In addition to the correctness of their attributes, permitting easy identification, the Muses all wear a single feather in their hair, reminder of their victory over the sirens in a musical contest vividly portrayed on later sarcophagi.[15] The feathers add to the Muses' iconography the notion of their civilized triumph over barbarism and animality. The patron must have desired this iconographical correctness, all the more impressive to his clients and friends. The room's prominent location, directly across from the tablinum, and the clarity of its iconography left no doubt in anyone's mind that this was a room devoted to the Muses and their patron

15. A good example is Metropolitan Museum inv. 10.104; see Ann Marguerite McCann, *Roman Sarcophagi in the Metropolitan Museum of Art* (New York, 1978), 46–50, fig. 48. The appearance of only one, rather than several feathers, in each Muse's hairdo, is unique to room 5. The myth is recounted in Pausanias 9.34.3.

Apollo. This museion, more than that of the House of the Menander (see Fig. 99), proclaimed to all that the owner was a person of high culture, no stranger to the arts of drama, literature, and dance. Rather than being casual symbolic figures, like the isolated figure of Urania in the peristyle of the House of the Vettii (see Fig. 129), this group of Muses with their protector had to be taken seriously.[16]

Although Moreno attributes the Muses' slender proportions, with long bodies and relatively small heads, to neo-Attic models of the second and first centuries B.C., Schefold rightly points to their closer affinity to the late Classic and early Hellenistic models that inspired Hadrianic classicism.[17] Apollo clearly evokes a fourth-century Lysippean model. Bases beneath each figure indicate that they are depictions of statues, rather than the floating or flying figures common in Fourth-Style walls (and found elsewhere in the House of the Muses). The outlines of the figures of Clio and Polyhymnia are identical, and so are those of Melpomene and Erato, suggesting that the artist used the same pattern for each pair, changing only their clothing and their attributes.[18] Another evidence of pattern-book copying is the way the lighting varies from figure to figure rather than having a single source, like the lighting of the architecture.[19]

Although the Muses' iconography is canonic, Apollo's is problematic. Rather than appearing with a lyre, as Apollo *Citharoedus*, as befits his association with the Muses, he is represented as avenger of *hybris*, drawing an arrow from his bow. These arrows brought plague into the Greek camp at the beginning of the *Iliad* and brought down the sons and daughters of boastful Niobe. Moreno attempts to solve this problem by identifying the figure of a running woman in the south part of the west wall's upper zone as a Niobid, furnishing a parallel with the representation of a nude Apollo in the Temple of Apollo Sosianus in Rome; there statues of the Niobids were arranged on the architrave of the first order of columns. Just as the Muses are the avengers of the sirens, so Apollo punishes the Niobids.[20] However, close examination of the running fig-

16. Felletti Maj and Moreno, *Casa delle Muse*, 29.
17. Karl Schefold, review of Felletti Maj and Moreno, *Casa delle Muse*, in *Gnomon* 43 (1971): 840.
18. Three rooms of the Muses in Roman houses at Ephesos span the period from ca. A.D. 60 to 450; see Volker Michael Strocka, *Die Wandmalerei der Hanghäuser in Ephesos*, Österreichisches archäologisches Institut, Vienna, Forschungen in Ephesos 8, no. 1 (Vienna, 1977): 74–79 (room H2/SR 19–20, pls. 131–136, dated 400–410); 95–96 (room H2/7, pls. 195, 197, 201, dated 60–80, restored 400–410); 126–133 (room H2/12, pl. 321 [Apollo], pl. 319 [Sappho], pl. 322 [Calliope], pl. 325 [Urania], pl. 326 [Polyhymnia], pl. 327 [Erato], pl. 238 [Terpsichore], pl. 329 [Thalia], pl. 330 [Euterpe], pl. 331 [Clio], color pls. 333–341, dated 440–450); discussion of the iconography of the Muses, 133–137.
19. Felletti Maj and Moreno, *Casa delle Muse*, 29–30.
20. Felletti Maj and Moreno, *Casa delle Muse*, 29–30; Temple of Apollo Sosianus described by Pliny the Elder *Naturalis historia* 36.34–35; Eugenio La Rocca, "Le sculture frontonali del

ure and the other badly preserved figures of the upper zone provides little evidence to secure their identity as Niobids.

Although rigorous analysis reveals formal and iconographic inconsistencies, the Room of the Muses is a precious reminder of the continuities in form, style, and meaning between Romano-Campanian decoration of the first century and Ostian painting of the second century. It communicates better than any extant wall painting the high level of quality maintained in post-Pompeian decoration and documents Roman upper-middle-class tastes, making the loss of painted decoration from imperial circles, especially that of Hadrian's Villa, all the more lamentable. Rooms 9 and 10 further emphasize these continuities and iconographical ties between first-century Pompeii and second-century Ostia.

A Dionysian White Room The designer's choice of white walls was calculated to increase the amount of light in room 9, since unlike the Room of the Muses it has no window to the outdoors; a window communicating with room 8 gives this room its second-hand illumination. On the white ground the viewer perceives an equally light, airy architecture traced in gold. Although the motifs employed have their roots in both the Tapestry Manner and the Theatrical Manner of the Fourth Style, here the emphasis is on delicacy and miniature details (Fig. 172). Two gold faux-marble panels with elaborate candelabra in front of them push up through both median and upper zones (like the columns and pilasters of room 5) to achieve each wall's tripartite vertical division into a wide central aedicula and narrower side panels (Pl. 22). These gold panels fold into the corners to continue the architectural illusion. Flanking the figures at the centers of the aediculae are ornate pavilions painted in gold, porphyry red, and green. Fanciful *acroteria* in the form of centaurs top them; the one on the east wall holds a chalice in one hand and a garland in the other. These garlands turn upward at a ninety-degree angle to form the ends of a curved portion of architrave that serves as a roof over the central figure below. Shields hang from its center. Above this airy pavilion is another one, framed this time by vertical plaques, its arched covering supported by slender vegetal columns that widen toward the top (Fig. 173). A mirror is the central motif. Its handle is in the form of a strutting peacock (like the one in Oplontis 8, see Fig. 85); beneath it appears the mirror's back, decorated with the figure of a nude female (barely visible).

In all the other figuration, Dionysus reigns. He appears in the center of the south wall. He holds a tall thyrsus in his left hand while pouring wine out of a

Tempio di Apollo Sosiano a Roma," in *Archäische und klassische griechische Plastik*, Akten des internationalen Kolloquiums, 22–25 April 1985, Athens, (Mainz, 1986), 2:51–58, identifies the male figure as Theseus in an Amazonomachy group.

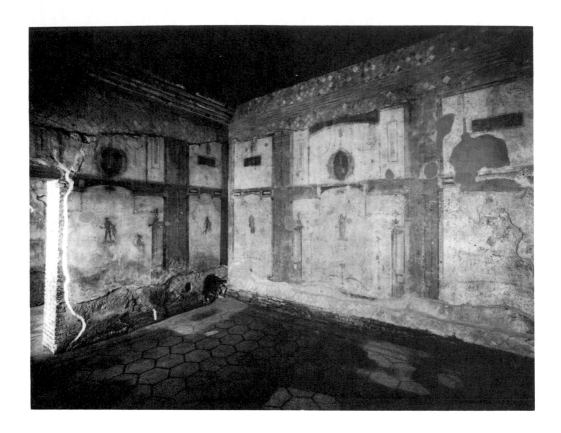

FIGURE 172. Cubiculum 9, a white room with stacked aediculae defined by gold panels, is a Hadrianic reprise of the Fourth-Style Theatrical Manner (compare Pl. 17).

tall drinking cup (*kantharos*) with his right. His chiton and overdrape are depicted in delicate shades of violet and light green. Maenads fly through the smaller, garland-swagged panels to Dionysus's right and left, as in many Fourth-Style walls. Horizontal plaques with figures standing on them occupy the same position in the upper zone. On the east wall Pan with a deerskin, or *nebris*, and a crook, or *pedum*, strides from left to right in the central aedicula. Another maenad and a pan flank the window on the room's north wall.

Room 9's white-ground decoration evokes a more whimsical spirit than the bold, solid color panels and conventional columns of room 5. It compares well, for instance, with House of the Vettii room *e* (see Pl. 17). It is Dionysus's room, but in no pedantic way: for nearly a hundred years his companions, the maenads and pans, had been depicted in wall decorations, floating on painted

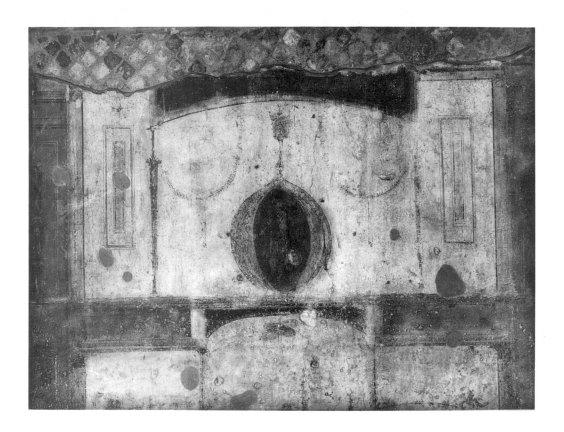

FIGURE 173. The upper pavilion frames a mirror with a peacock handle.

tapestry panels. Capricious details, like the centaur acroteria and the birds that stand on topsy-turvy tendrils beneath the central figures, resist strict interpretation. It is tempting to see in the room's imagery references to the woman of the house. Juno (the peacock), the mirror, and Dionysus with his entourage would certainly not be alien to a woman's chamber, and its position in the suite, mentioned above, seems to fit the pattern of the woman's oecus-cum-cubiculum encountered in the Villa of the Mysteries and in the House of the Vettii. But the same decorative system, with another Dionysiac symbol, the goat, appears in service corridor 16, framed by the same gold panels with architectural motifs and surrounded by plaques and floral tendrils as delicate as those of room 9 (Fig. 174). Given the use of Dionysiac imagery in these two spaces with quite different functions, it is risky to insist on identifying it as the domina's room.

FIGURE 174. Cubiculum 9's scheme applied to service corridor 16.

A Glimpse of a Second-Style Reprise Both triclinium 10 and room 19 pre-serve enough fragments of their once grand wall painting to ascertain that they revived, as do the Room of the Muses and to a certain extent room 9, the illu-sionistic architecture of the Second Style. If the Room of the Muses is intimate, triclinium 10 is grandiose and imposing (Fig. 175). Its decorative program must have been much more complex than the Room of the Muses or room 9, includ-ing a cycle of mythological central pictures. The only picture permitting identifi-cation is the one in the center of the west wall, interpreted by Felletti Maj as Andromeda being liberated by Perseus, or Hesione liberated by Hercules.[21] This central picture occupies a black panel ornamented with elaborate gold drinking cups and vine stalks in white, red, and green. Red panels with candelabra in front of them, like those in room 9, border the central panel, but the cream-

21. Felletti Maj and Moreno, *Casa delle Muse*, 49.

colored columns flanking them must have carried the architrave. Doors appear in the side panels, which are defined on their outboard sides by ornate pilasters and bordered by yellow monochrome panels with an allover pattern (the so-called *Tapetenmuster,* or wallpaper pattern common in the Fourth Style). Flanking the central aedicula on either side, they served to open the room illusionistically; on the right side a female figure is entering the open door, on the left another female seems about to step out of the picture. The closest comparison with this motif is in the Second-Style decoration at Pompeii.[22]

Above these doors were male figures representing *Atlantes,* or giants, holding up the lintel, topped by views of architecture visible through slots with white grounds, as in the Fourth-Style scheme of room *p* of the House of the Vettii (see Fig. 135). Parts of this scheme are preserved on the north and south walls: one fragment, from the south wall, shows details of the open doors framing a small, female figure, foreshortened and wearing a red chiton with a voluminous green mantle (Fig. 176). She holds a tray in her left hand. Compared with the Second-Style image in the Villa of Fabius Rufus,[23] this figure is much smaller in relation to the door, thereby emphasizing spatial depth. Gold bosses decorate the red doors, and a scalloped drape swags over the opening. A horse rears up on the left-hand side of the frieze above. Another fragment, from the north wall, shows the bottom of a slot, with a draped figure standing on a ledge. Above a black balustrade appears a row of fluted columns.

Room 19, although decorated about twenty years later, seems to have imitated the grandiose, theatrical decoration of 10. Although a somewhat simpler scheme, with panels of red, yellow, and black resting on a continuous black socle, the central mythological panels on the room's side walls emphasized the same symmetry encountered in all the rooms considered here. Felletti Maj proposed that room 19's iconographical program connected with that of 10, identifying Hesione and Andromeda in one panel and Perseus and the sea monster in the other.[24]

To find such refined decorations in a house located in a commercial supply city for Rome hints at the riches time has stolen from us. Engravings record the fine frescoes of a Hadrianic town house in Rome. Excavated in 1777 on the grounds of the Villa Negroni, the paintings themselves were subsequently lost. Hetty Joyce has pointed out the affinities between these decorations and

22. Vittorio Spinazzola, *Pompei alla luce degli scavi nuovi di via dell'Abbondanza,* 2 vols. (Rome, 1953), 1:352, fig. 400, House of Obellius Firmus; Giuseppina Cerulli-Irelli, "Le Case di M. Fabio Rufo e di C. Giulio Polibio," in *Pompei, 1748–1980: I tempi della documentazione,* ed. Irene Bragantini, Franca Parise Badoni, and Mariette de Vos, exh. cat., Pompei and Rome (Rome, 1981), 27; fig. 17 on p. 31 and fig. 2 on p. 140.

23. Cerulli-Irelli, "Fabio Rufo," fig. 17 on p. 31 and fig. 2 on p. 140.

24. Since the paintings of room 19 have been removed from the wall and stored (since 1970) on the floor of room 10, it was impossible to study them at firsthand. They have probably deteriorated beyond recognition by the time of this writing.

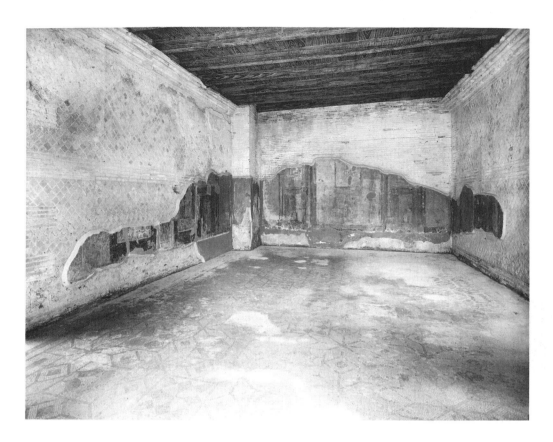

FIGURE 175. Triclinium 10's decoration recalls motifs of the Second Style.

rooms 5 and 10 of the House of the Muses.[25] In spite of such great losses, the decorative ensembles of the House of the Muses reflect accurately the tastes of Hadrianic Rome for conservative yet delicate decorations evoking illusionistic architecture as well as sculpture and painting from the Greek past. In the House of the Painted Vaults these tastes find more modest expression in decorations created for a smaller, less luxurious apartment house.

25. Hetty Joyce, "The Ancient Frescoes from the Villa Negroni and Their Influence in the Eighteenth and Nineteenth Centuries," *Art Bulletin* 65, no. 3 (1983): 435, cites other parallels: Ostia Antica, House of the Ierodule, 4 and 6; Rome, House near S. Crisogono; Rome, House beneath Baths of Caracalla, N—all dated 130–140 in Hetty Joyce, *The Decoration of Walls, Ceilings, and Floors in Italy in the Second and Third Centuries A.D.* (Rome, 1981), 46–47, figs. 43–47.

FIGURE 176. An open door frames a female figure.

EARLY ANTONINE DECORATIVE ENSEMBLES
IN THE HOUSE OF THE PAINTED VAULTS, A.D. 145–150

Across the street from the House of the Muses rises the House of the Painted Vaults, completed some eight years before its neighbor, in about 120.[26] The major part of its surviving wall and ceiling painting dates to a second decorative campaign of the mid-second century. The House of the Painted Vaults represents a startlingly modern solution to the problem of urban density. Its

26. Bianca Maria Felletti Maj, *Le pitture della Casa delle Volte Dipinte e della Casa delle Pareti Gialle*, Monumenti della pittura antica scoperti in Italia, sec. 3, Ostia fasc. 1–2 (Rome, 1961), 31; brick stamps of 115 and 117 provide a date of 120.

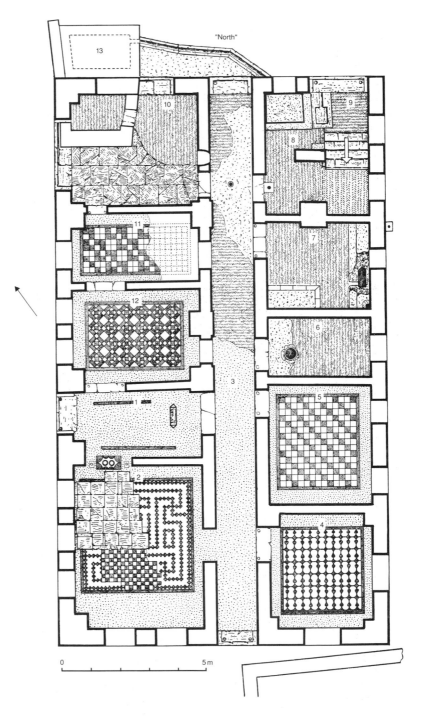

FIGURE 177. Plan of the House of the Painted Vaults with mosaics drawn in.

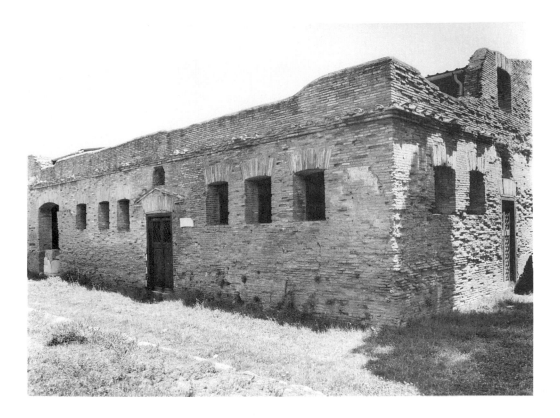

FIGURE 178. The House of the Painted Vaults from the southwest.

rational use of the new medium of brick-faced vaulted concrete construction, coupled with its equally rational plan (Fig. 177), allowed the vertical stacking of well-lit living spaces without compromising, as was done in the House in Opus Craticium, privacy and free movement both within the apartments of each floor and between one floor and another.

The building is freestanding, with windows on all sides (Fig. 178). Ground-floor windows are at an average height of 2 meters (6′6″). All ground-level spaces are covered with groin vaults, even the long corridor, 3 (Fig. 179). The vaults are adjusted to the shape of the space they cover; they stretch in the corridor's rectangular bays but have groins of equal length in square rooms like 4. Whereas corridor 3 defines the House of the Painted Vaults' long axis and allows circulation to all of its rooms, vestibule 1 provides a formal entrance, functioning like the fauces. On the exterior, originally plastered in white stucco

FIGURE 179. A series of groin vaults covers the long central corridor (3).

on west, north, and south sides, a brickwork pediment frames this formal entrance.

The stairway (9) led to the apartments of the upper floors, apparently nearly identical in plan. A door in room 8, beneath the stairs, connected with the ground-floor apartment. The architect wasted no space on interior courtyards or porticoes, yet provided the occupants with more light and air—and probably greater privacy—than they would have had with these features. As might be expected, type and quality of pavimentation signals the use and importance of all spaces in the House of the Painted Vaults (see Fig. 177).

The corridor divides the entrance (1), living room (2), and dining areas (10–12) from sleeping rooms (4–6) and the kitchen/service (7–8) areas. Its pavement changes from white tessellation to the more utilitarian herringbone brick pattern (*opus spicatum*) after the doorway to cubiculum 6. Rooms 6 through 8 also have pavements in opus spicatum. Vestibule 1 has the same pavement as the south part of corridor 3, since it, too, is a dynamic space. The finest mosaic pavements, on the other hand, are in the reception areas: 2, 11, and 12 (2 and 11 were repaired repeatedly in antiquity). None of these creates the axial alignments with doorways and the wall decoration seen in the more sophisticated House of the Muses. Nevertheless, it is a hierarchical scheme: cubicula 4 and 5 received less complex tessellated floors than those of the reception rooms. Unfortunately, the original Hadrianic wall and ceiling painting that coordinated with these pavements is for the most part gone. Substantial remains of the subsequent decoration, however, provide insight into the taste of the mid-second century.

The Living and Dining Rooms By neatly dividing the House of the Painted Vaults between sleeping and cooking on one side and reception and dining on the other, the corridor isolated functions normally distributed around the peristyle and atrium in the domus. In order to maintain this isolation in the living and dining areas, the spaces, each with separate groin vaults, had to be united by piercing their side walls. Thus rooms 10, 11, and 12 interconnect, forming a suite of rooms related to the vestibule (1) and tablinum 2 through a line of doorways. The absence of a doorsill proves there were never doors between 11 and 12. A window in room 12's wall connects with the service corridor, but it is too high (1.7 m, or 5′6″, from pavement to sill) to have served as a pass-through for food and drink from the kitchen.[27] Servants must have walked down to vestibule 1 and through the doorway of room 12 to serve food. When the outdoor pergola (10) was used as a summer triclinium, they simply exited the building at the north end of corridor 3 and served from the out-of-doors. In either case, the largest room, tablinum 2, remained isolated from traffic.

Room 2's original pavement, a design of big swastika meanders with rectangles between them, inspired the painter who redecorated this room at mid-century, for above the socle of grained yellow faux marble is a crenellated band echoing the floor pattern (Fig. 180). Executed in red imitation marble panels with blue and yellow frames, it serves as a median zone for the ample lunettes formed between the groins of the vaulted ceiling. The north lunette has at its center a black pavilion with a seated female who overlaps the center of its gable. Garlands swing to either side from this gable. Farther to the east a male

27. Contrary to Felletti Maj, *Volte Dipinte e Pareti Gialle*, 5.

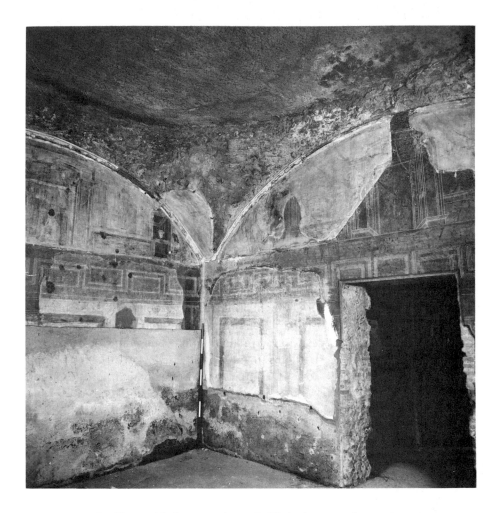

FIGURE 180. Pavilions with figures and vessels fill the lunettes of reception room 2.

nude figure on a pedestal appears against a yellow ground, with a tray in his left hand. The lunette ends with the motif of a crater on a ledge. Less remains of the eastern lunette, but at the north and south extremities the decorations that topped columns coming up from the median zone are still visible: they are goats on square capitals rendered in perspective. Fragments of stucco molding are visible on the east and south walls, consisting of a delicate ovolo band at the edge of the vault, followed by a groove painted porphyry red, and rectangular panels alternating in red and blue.

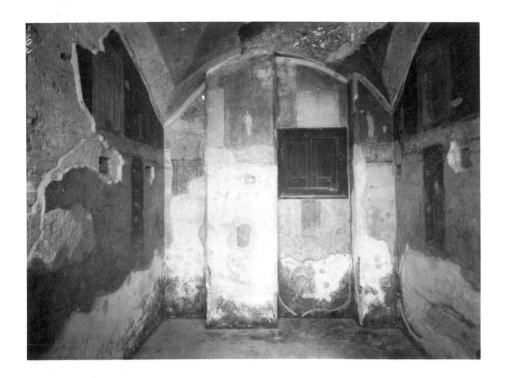

FIGURE 181. Figures meant to represent statues occupy the lunettes of
room 12, where they can be seen above the windows and doors.

Like room 2, the decorations of 11 and 12 employ aediculae with alternat-
ing red and gold backgrounds to create architectural settings for figures con-
ceived as statues. In room 11, although the lunette decoration is gone, the panel
system of the median zone survives on the north and east walls. The gold pan-
els are large aediculae flanked by columns; thin candelabra that extend above
the horizontal architrave once supported figures. On the pier interrupting the
north part of the east wall appears the faded head of Zeus-Ammon under a
square capital. This same head decorates panels in the east wall of the House of
the Menander's atrium. The vaulted ceiling coordinated in color with the walls,
with a red panel framed in gold; a floral candelabrum is still visible at the south
edge of the red panel.

Room 12's decoration, painted by the same workshop responsible for 11,[28]
alternated panels of porphyry red and gold in both median and upper zones
(Fig. 181). On the north wall highly articulated architecture decorates the red

28. Felletti Maj, *Volte Dipinte e Pareti Gialle*, 24.

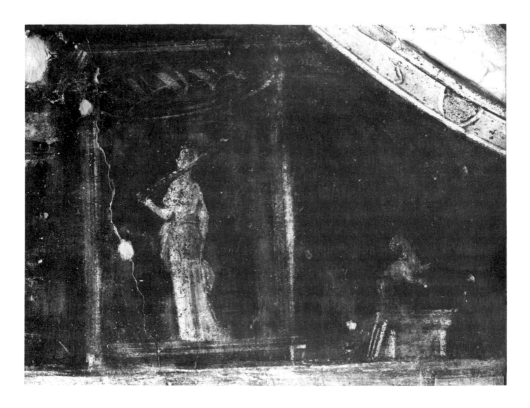

FIGURE 182. The figures' slender proportions resemble those of Tanagra figurines.

panels that frame the gold aediculae. A black architrave (now turned a milky white) separates median from upper zones and curves over the central gold aedicula. Smaller gold and porphyry red aediculae alternate in the upper zone. At the east edge of the lunette a maenad stands in a niche, and in the low space where the lunette meets the groin a feline perches on a tall pedestal. This maenad on the north wall is one of seven human figures remaining from the upper zone: there are two on the east wall and four on the south. They are meant to represent statues. In keeping with their placement more than two meters up on the wall, the figures stand on high pedestals or podia whose orthogonals slant to an eye-level line well below them (Fig. 182). Although they look in general like slender Tanagra figurines, heavily draped and rendered in twisting contrapposto stances, Felletti Maj has shown that no single type fits them.[29]

29. Felletti Maj, *Volte Dipinte e Pareti Gialle*, 26–27.

FIGURE 183. People celebrate a funeral banquet in the outdoor veranda.

There is even a figure of Priapus in the form of a bearded male herm (east wall, north part). On the south wall the effectiveness of this scheme becomes clear, for by concentrating figuration in the upper zones and the lunettes, the artist created a kind of sculpture gallery, seen from below but not interrupted by furniture placement or the two doors and three windows that pierce the socle and median zones.

The fragments remaining on the south wall of room 10, originally a porch connected with the dining suite, was later (ca. 240) detached from the house and turned into a little bar selling heated wine (*thermopolium*). What little remains of its original wall decoration reveals an entirely different aesthetic from that of the House of the Painted Vaults' interior spaces (Fig. 183). A group of people, some of whose names are written next to them, celebrates a funeral rite next to an aedicula. The deceased may be the person represented in the tondo. To modern eyes, this narrative, painted in an informal, popular style, seems out of place in an elegant little dining porch. But as we have seen, banqueting formed an integral part of Roman funeral rites in the home; furthermore, many tombs were set up for preparing and serving food for the annual celebration of the deceased's death. This little frieze may have reminded cheerful diners to toast a departed relative or friend.

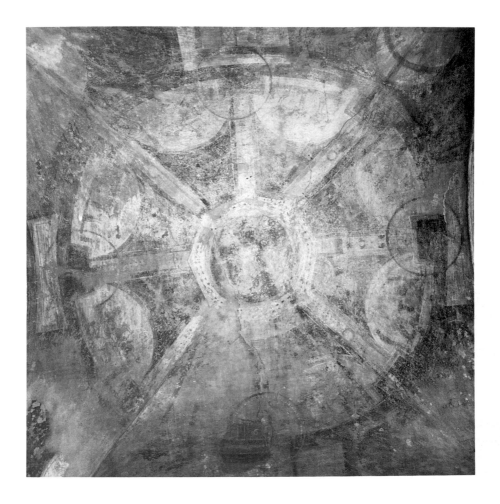

FIGURE 184. The simple Antonine scheme shows through cubiculum 4's ceiling today.

Three Monochrome Bedrooms Understandably, the wonderfully well-preserved ceiling of cubiculum 4 created a stir when it was discovered. It was the first vaulted ceiling from a residence to have survived intact; all others had come from tombs (particularly those of nearby Isola Sacra). Comparison of a photograph taken in 1987 (Fig. 184) with one from the 1950s (Fig. 185) dramatizes the inevitable loss of this ceiling, for when the artist painted it around 210, he did not roughen the surface to make the new plaster adhere

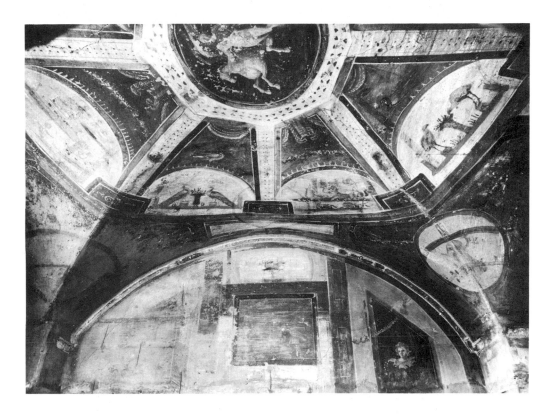

FIGURE 185. A photo of 1958, when the bold Severan scheme was intact.

properly. Instead he painted it directly over the earlier painting, a monochrome yellow decoration of the mid-second century. As more of the Severan painting falls, the early Antonine decorative scheme becomes clearer.

In its mid-second century redecoration, this cubiculum became an all-yellow room. The tradition of yellow rooms, going back to the House of Lucretius Fronto at Pompeii, and including room 4 of the House of the Muses, continues through the end of the second century at Ostia.[30] Details showing through the median zones and lunettes attest to a careful linear decoration. The Antonine artist divided the ceiling into four parts by positioning four circles nearly touching the lunettes. In the south sector, where the Severan overpainting has

30. Yellow Rooms at Pompeii: House of Lucretius Fronto, *i* (child's room); House of the Marine Venus; House of Octavius Quartio. Ostia: House of the Muses, 4; House of Jupiter and Ganymede, 9; House of the Painted Ceiling, 2.

gone, it is clear that these circles were conceived as mirror backs (like the one in the House of the Muses, room 9) with nude female figures on them; they connected with the central circle in a complex progression of decorative motifs: heraldic goats, volutes, and swans, interrupted by a little plaque. How different is this linear, miniaturistic decoration from that of sixty years later!

The Severan ceiling strives for contrasts of color and fairly bulges with figural detail. The artist divided the ceiling into eight radiating bands around the central medallion with the figure of Pegasus. Like spokes of a wheel, four of these spokes tied into the groins, and four into the rectangular panels touching the lunettes. By scalloping the edges of the red ground between the radiating spokes the artist created eight lunettes, decorated with a variety of genre scenes, including still lifes and pygmies on the Nile. As we will see in chapter 8, rooms 6, 9, and 10 of the Inn of the Peacock are contemporary and would harmonize well with this ambitious, but somewhat facile and inept, Severan-period ceiling.

Bedrooms 5 and 6, both painted around 150 by the same artist, were also monochrome, but white instead of yellow. The best-preserved wall of 5 (Fig. 186) reveals the delicate tracery of its median-zone aediculae (the broad stripes below belong to a later phase); these support or connect with the scalloped architrave of the upper zone, which starts 25 centimeters below the tympanum proper. Thin slots framing glimpses of foreshortened colonnades flank the central aedicula, with a porphyry-red podium supporting a floral candelabrum. Twin aediculae in turn flank this central structure. A tiny landscape panel hangs above the figure of a rearing goat on the right-hand side. This motif is close to the goats at either end of the east tympanum in room 2 (see Fig. 180). Fragments of this room's white ceiling suggest that the artist delighted in the same miniaturistic detail that appears on the walls: a small tract near the south wall shows tendrils framing a diminutive sea dragon (*ketos*).

Although much smaller than 5, and paved in humble opus spicatum, room 6's painted decoration is almost as refined in its detail and geometry as its next-door neighbor's. The scheme, preserved only in the upper zone, repeats on each wall, expanded on the long walls and contracted on the short ones. The west wall's colors have faded the least (Fig. 187). A central aedicula painted in gold, porphyry red, green, and white frames a fainter one in green, with a hanging object (illegible) in its center. A tragic mask once rested on the bottom of the podium supporting these aediculae. To either side birds perched on stalks face the aediculae. Two painting phases are visible on the ceiling. The concentric scheme employing red-and-green garlands belongs to this early Antonine wall decoration. Correspondences in geometry and motifs between the ceilings of these white rooms and corridor 70 of Nero's Domus Aurea in Rome reveal their essentially conservative design, modeled on a manner invented ninety

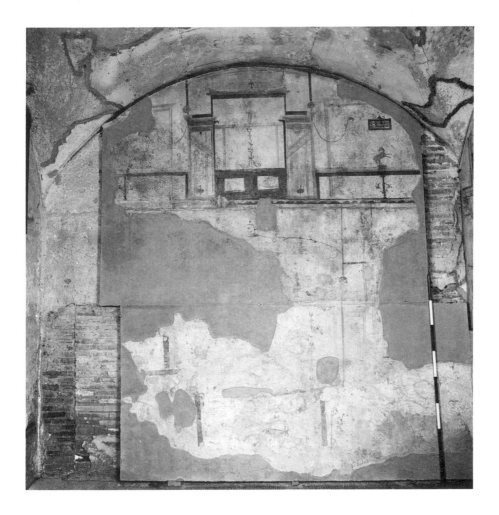

FIGURE 186. An all-white aedicula-based scheme on the walls
of cubiculum 5.

years earlier.[31] Rooms 5 and 6 are alone in having no stucco moldings; instead,
a red stripe defines the meeting of walls and vault.

The decorative ensembles of both the House of the Muses and the House of
the Painted Vaults, executed about twenty years apart and intended for patrons
with different budgets, continue many decorative schemes and motifs worked
out in the period of the Fourth Style. Our analysis has shown that there was no

31. Felletti Maj, *Volte Dipinte e Pareti Gialle*, 35.

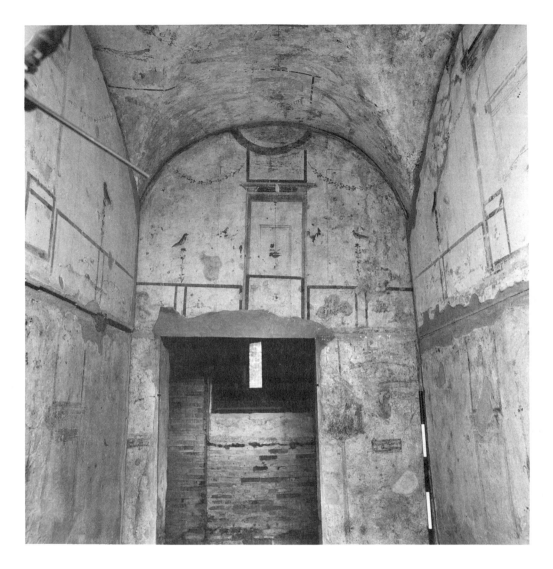

FIGURE 187. Cubiculum 6's ceiling, with concentric red-and-green garlands.

disastrous decline in quality in the fifty years that separate Pompeii and Herculaneum from the House of the Muses; high standards of workmanship and intelligently planned mosaics and wall painting shine through the destruction wrought by time and the elements. If the bourgeoisie of Ostia Antica were able to hire mosaicists, stuccoists, and wall painters of this quality, it is certain that Rome, now in the heyday of imperial prosperity, enjoyed interior decorative ensembles of the finest quality. In the last half of the century tastes turn from these rather conservative decorations to explore coloristic and figural effects that unhinge the unified wall and floor schemes we have just examined.

CHAPTER SEVEN

LATE ANTONINE DECORATIVE
ENSEMBLES AND THE BEGINNING
OF THE LATE ANTIQUE, A.D. 160–193

If Hadrianic and early Antonine decorative ensembles embody predominantly conservative tastes, recalling the architectural illusionism and refined miniaturistic decorations of the first century, in the following thirty years these revered systems loosen up. Their transformation into a decoration of optical effect parallels the stylistic changes in sculpture associated with the beginning of the Late Antique.[1] Although marked by recurrent quotations of earlier decoration, such as the concept of the colonnaded pavilion or miniaturistic aedicular schemes, late Antonine decoration was exploring new possibilities and effects that changed tradition forever.

A MIDDLE-CLASS MEDIANUM-PLAN APARTMENT: THE HOUSE OF THE YELLOW WALLS

Freestanding apartment houses like the House of the Painted Vaults were the exception rather than the rule at Ostia Antica, where living units with party walls prevailed. One of the most popular solutions to the problems of providing circulation and light without peristyles and atria was the so-called medianum plan,[2] well illustrated by the House of the Yellow Walls, built around 128 (Fig. 188).[3] In chapter 1 we discussed the way a person would perceive the spaces of the House of the Yellow Walls. The medianum (room 3), surrounded

1. For a recent reassessment of the changes in sculptural style (*Stilwandel*) that prefigure the Late Antique, see Helmut Jung, "Zur Vorgeschichte des spätantoninischen Stilwandels," *Marburger Winckelmann-Programm* (1984): 59–103.
2. Gustav Hermansen, *Ostia: Aspects of Roman City Life* (Alberta, 1981), 35, defines the medianum; Bianca Maria Felletti Maj, *Le pitture della Casa delle Volte Dipinte e della Casa delle Pareti Gialle,* Monumenti della pittura antica scoperti in Italia, sec. 3, Ostia fasc. 1–2 (Rome, 1961), 42, calls room 3 an atrium. Felletti Maj tends to be overzealous in trying to prove that the Ostian house had all the functions and the rooms of the domus.
3. Felletti Maj, *Volte Dipinte e Pareti Gialle*, 43, based on brick stamps of 123, 124, and 125.

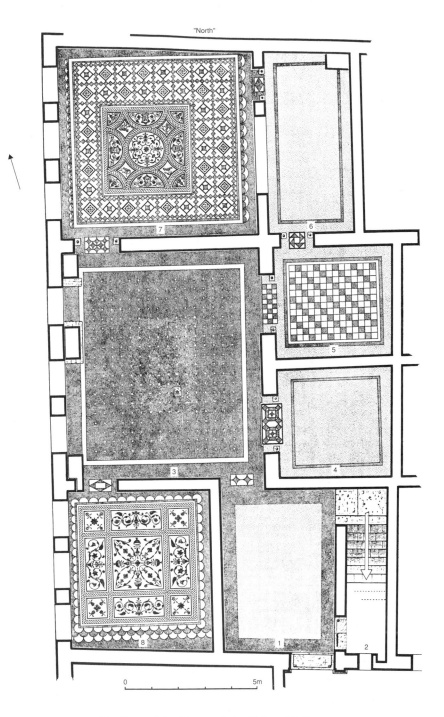

FIGURE 188. Plan of the House of the Yellow Walls, with mosaics drawn in.

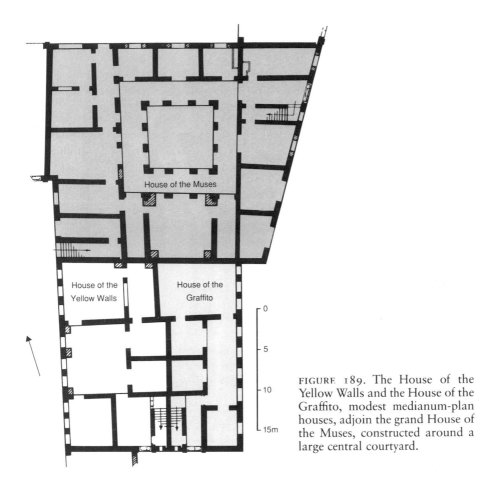

FIGURE 189. The House of the Yellow Walls and the House of the Graffito, modest medianum-plan houses, adjoin the grand House of the Muses, constructed around a large central courtyard.

by rooms on three sides and with three large windows to the exterior on the west, takes over the dynamic functions of both atrium and peristyle. This plan has several advantages over the circulation provided by the corridor that splits the House of the Painted Vaults into two files of rooms. The asymmetrically located medianum gave large reception spaces (7 and 8) ample light and isolation without having to join several small rooms (as in rooms 10–12 in the House of the Painted Vaults). Smaller rooms requiring less light, cubicula 4 and 5 and service space 6, occupied the inner part of the house. A plan showing the House of the Yellow Walls with its neighbors, the House of the Graffito to the south and the House of the Muses to the north, demonstrates how the medianum plan maximizes space without sacrificing light and privacy (Fig. 189).

The House of the Graffito and the House of the Yellow Walls share a party wall on the north with the House of the Muses, and their plans mirror each other on either side of the party wall between them. Each house has a separate entrance with a staircase leading to the sleeping and servants' quarters above,[4] with isolated reception rooms at either end of the medianum and cubicula facing its windows. In the smaller House of the Graffito, the narrow medianum approaches the dimensions of a corridor, whereas it is the largest space in the House of the Yellow Walls. This versatile yet elegant solution became quite popular for middle-class housing projects built in Ostia during the Hadrianic period.

The original late Hadrianic pavements in the House of the Yellow Walls follow the same hierarchical principles noted in the House of the Muses and the House of the Painted Vaults: whereas the dynamic spaces (1 and 2) have solid pavements, the two reception rooms (7 and 8) boast complex black-and-white mosaic carpets (see Fig. 188). In entryway 1, the only vaulted space, a wide black band running to the walls frames the all-white mosaic. This black frame remains in the medianum and in rooms 7 and 8, but in the medianum it surrounds a white-bordered black carpet gridded by a pattern of white tesserae squares. Since it was a light-flooded space, the medianum could afford to have a black pavement. There are several possible explanations for the off-center placement of the ornate central motif in room 7. If used as a dining room, the centerpiece took into account the positions of dining couches; or perhaps its position in the southwest corner of the house emphasizes the view along the visual axis that connects it with room 8. It is also clear that to place this square in the exact center of the room the mosaicist would have had to cut every square of the grid pattern around it in half. He seems to have chosen the less difficult path, leaving two rows of squares on the east and north sides of the floor and a single row west and south.

Although cubicula 4 and 5 have the same decoration, position, and dimensions, 4 has a plain white mosaic floor with a double black frame whereas 5 has a black-and-white checkerboard pattern. Room 6 has the same pavement as cubiculum 4.

Three Red-and-Gold Aedicular Decorations Despite these slight differences in their mosaic floors, the same artist or workshop, working around 170, provided unified wall paintings for rooms 4, 5, and 6. These are the so-called yellow walls that gave the house its name. Analysis of the best-preserved passage of this scheme in cubiculum 5 reveals that these were not monochrome

4. Felletti Maj, *Volte Dipinte e Pareti Gialle*, 41.

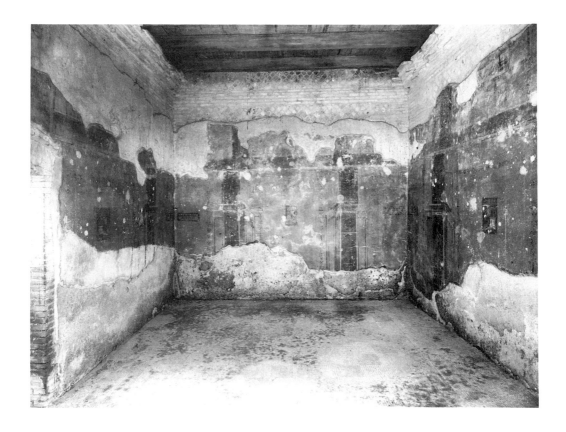

FIGURE 190. Red aediculae alternate with gold panels in cubiculum 5 of the House of the Yellow Walls.

yellow or gold rooms (Fig. 190). On a low red socle decorated with plants (still visible around the perimeter of room 6) rest two tall red aediculae that support a red cornice. The aediculae spread to either side beyond the red vertical panels that initially seem to define them. Architraves supported by thin columns invade the gold panels, carefully foreshortened toward the center of the wall on one side and parallel to it on the other.[5] In this way the aediculae act as framing devices for the vertical landscape pictures in the centers of each wall. A detail of one of these pavilions from the south wall reveals its refinement (Fig. 191). The

5. This identical aedicular scheme appears on a white ground in the south wall of the room on the via Tecta, flanking the east side of III, 10, 2, the House of the Charioteers (unpublished, Istituto centrale per il catalogo e la documentazione, Rome, ICCD neg. E 40930).

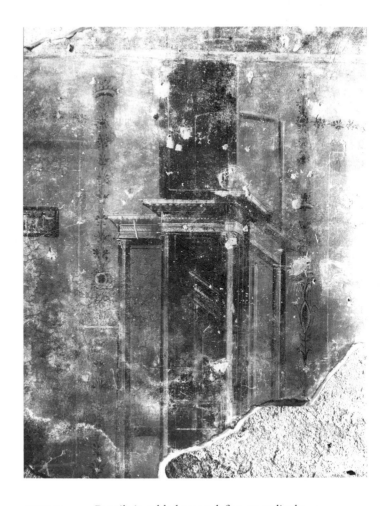

FIGURE 191. Details in added secco define an aedicula.

central pavilion's left column pushes out *en ressaut*, a motif first seen in cubiculum 16 of the Villa of the Mysteries (see Fig. 40); a sphere, symbol of the rule of the Hellenistic dynasts first appearing in the Fourth Style, tops its jutting architrave. Just visible within this pavilion is a second foreshortened architrave delineated in gold secco that follows the same orthogonals as the larger one flanking it. In fact, linear detail in added paint abounds: floral garlands punctuated by roses, lotuses, and peacock feathers frame the flanking gold panels.

From a distance the landscape panels in the centers and at the sides of each wall merely register as blue-green accents within the warm gold and red color

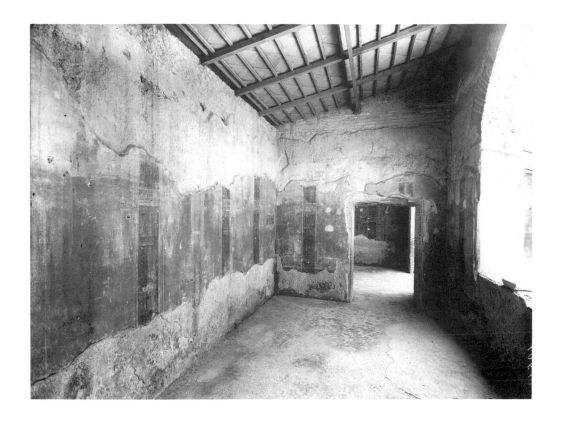

FIGURE 192. Expansion of the aedicular scheme to a service room's long walls.

scheme of these rooms. Close inspection reveals that unlike Third-Style landscape panels (e.g., those in the House of Lucretius Fronto, see Pl. 9), the landscapes in the House of the Yellow Walls are rapidly worked, impressionistic approximations, not accurately rendered topographical records. Their loose, liquid composition contrasts with the much more precise miniaturistic architecture of the aediculae that frame them. In this decoration they become color accents rather than pictures with specific themes, recognizable as landscapes but lacking precise meanings.

Room 6's scheme shows how the decorations of 4 and 5 could be expanded; its long wall, rather than being divided into three parts, is divided into five (Fig. 192). Four aediculae, two on each side, frame the wall's center. The space between the aediculae flanking the wall's center panel is 45 centimeters (about

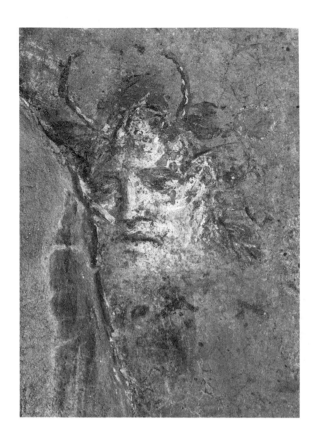

FIGURE 193. An impressionistically painted head of Oceanus, an apt reminder of the Ostian owner's dependence on the sea for a livelihood.

1′6″) less than that between aediculae and central panels in rooms 4 and 5. On the north wall there is another anomaly; behind the pier added later for support to the northeast corner was found a head of Oceanus, a fine example of the power of the late Antonine impressionistic manner so little understood because it is rarely preserved (Fig. 193). Although even here much of the secco has fallen off, his seaweed crown and lobster claws identify him. Like his lord Poseidon, Ocean is bearded and grave, but with the full lips, straight nose, and broad forehead whose ultimate source lies in Roman copies of classical Greek types.

It is these impressionistc renderings of facial types and landscapes, paired with a preference for an effect of juxtaposed colored panels, that the new aesthetic in late Antonine art surfaces. Even nostalgic returns to Hadrianic decoration, like that of room 1 in the House of the Painted Ceiling, partake of this new aesthetic. (We will return in chapter 8 to the House of the Yellow Walls to consider its third-century decoration.)

A REPRISE OF THE HADRIANIC ARCHITECTURAL MANNER
IN THE HOUSE OF THE PAINTED CEILING

Originally, the House of the Painted Ceiling was a large medianum-plan apartment with rooms on two stories (Fig. 194). In the penultimate decade of the second century the original Hadrianic structure was decidedly reduced by blocking the stairway to the upper floor, cutting off the two rooms to the north of the medianum, and building a thin partition wall in the medianum to add room 3. The new wall and ceiling decoration of room 1 that accompanied these changes consciously recalls a conservative architectural scheme of fifty years earlier. With its prominent Ionic columns and slots with foreshortened architecture, it has more in common with the Room of the Muses (see Pl. 20) than with the nearly contemporary red-and-gold aedicular decoration of the House of the Yellow Walls or the monochrome yellow decoration in room 2.

Room 1 is a small reception space with a single window providing eastern light. Someone entering from the doorway, on the north, would first see the tripartite architectural scheme of the south wall (Fig. 195). The socle alternates plates of gold and red, painted with plants—a motif that goes back to the Third Style (see Pl. 6). In the median zone the same colors alternate, but the gold panels are bordered by blue frames, added in secco over red fresco. Their innermost borders are green, added over gold fresco. The same system frames the red central panel; the aedicula's columns flank it, painted in cream added over gold and decorated with gold floral spirals that first appeared in the Second Style (see Pl. 5). These columns continue into the upper zone, where they are pink, fluted, and carry blue Ionic capitals; to either side are horizontal blue panels beneath slanting architraves; tambourines hang from the architraves. The central gold aedicula in this zone once framed the representation of a statue on a pedestal (one is visible on the north wall).

On the west wall this same scheme is widened by adding two vertical gold panels to either side of the aedicula's columns (Figs. 196 and 197). In the upper zone details of the crowning members of the Ionic capital become clear: two blocks on top support a kantharos on this wall. On the north wall (Fig. 198) the columns support spheres, as in the House of the Yellow Walls, room 5.

The photographs reproduced here, taken shortly after the excavation, reveal the enormous losses in this room. On the west wall four elegant figures, added in secco, completed the architectural scheme. Two females wearing chitons in the lateral panels (the one on the north part of the wall carried a tambourine) turned toward a nude male figure carrying a large offering tray, his mantle gathered around his right leg as he turns to the viewer. Above him, in the upper zone's central aedicula, appeared a slender, partially draped female holding a

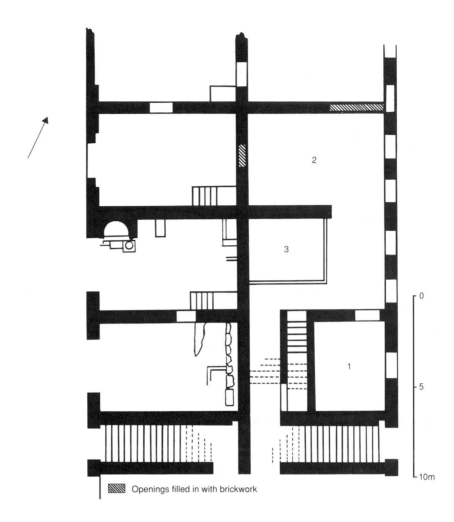

Openings filled in with brickwork

FIGURE 194. Plan of the House of the Painted Ceiling.

crown in her right hand; she may have been a Victory. In her position on the north wall apppeared a female wearing a chiton; another draped female with her arms extended was depicted on the western panel of the median zone. Scant traces of these figures remain today. Their poses and attributes show that their sources lie in the Dionysiac flying figures prevalent in Fourth-Style painting (see Fig. 135). At Ostia their closest cousins appear in room 9 of the House of the Muses (see Pl. 22).

How was this decoration united with the room's flat ceiling? The beams that supported flat ceilings at Ostia rested on brick ledges running along two op-

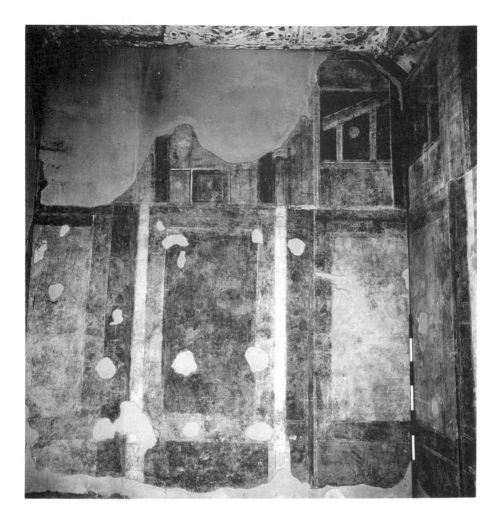

FIGURE 195. Filigreed columns divide the best room's south wall into three parts in a late-Antonine reprise of the Second Style.

posite sides of a room, in this case along the east and west walls. Tied to the beams were reeds bundled together to form the laths that held the plaster. This system, called *camera a canne*, is well documented throughout Roman Italy from the Villa of Oplontis[6] to the third-century houses at Bolsena.[7] The ledges on both sides of room 1 continue the colors of the upper-zone panels of the

6. Alfonso De Franciscis, "La villa romana di Oplontis," in *Neue Forschungen in Pompeji*, ed. Bernard Andreae and Helmut Kyrieleis (Recklinghausen, 1975), 38, fig. 38 (upper right).
7. Alix Barbet, *Bolsena V, 2: La maison aux salles souterraines, décors picturaux*, 2 vols. (Rome, 1985), 2: figs. 99–102, 112, 115, 128, 153–154.

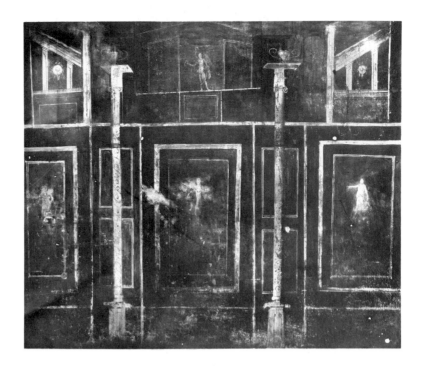

FIGURE 196. The same scheme, widened, decorates the room's long walls.

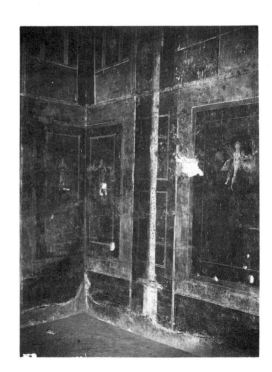

FIGURE 197. Elegant flying figures, added in secco, still remained in this photograph of the 1920s.

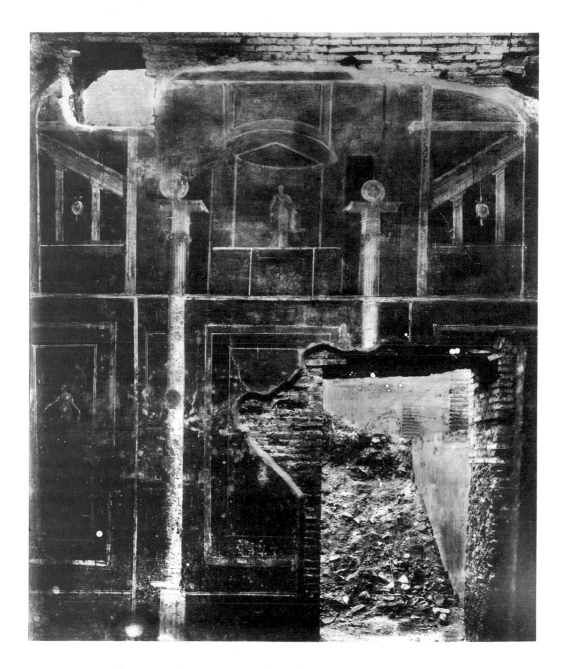

FIGURE 198. Columns on the north wall support ornamental spheres rather than a fictive architrave.

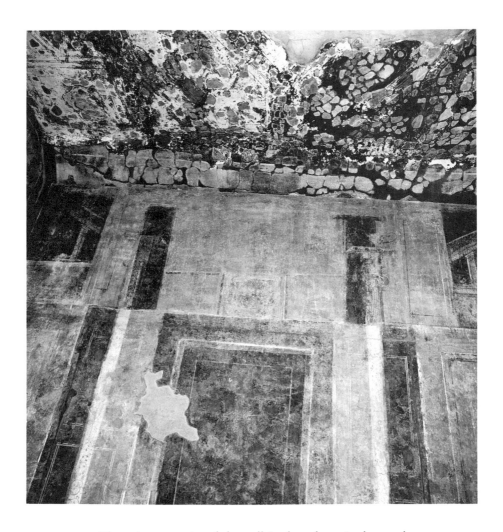

FIGURE 199. The painters continued the walls' color scheme in the panels that decorate the ledges that support the flat ceiling and the ceiling itself.

walls beneath them: the centers are red, flanked by gold and then blue. These same colors appear in the ceiling (Fig. 199). In its center appears a diamond whose angles point to the middle of each wall. Two smaller diamonds flanked by squares mark the ceiling's long axis at the north and south ends of the ceiling. The north and south panels align with the blue aediculae on the wall, continuing this architectural panel system to the ceiling. Room 1's ceiling imitates

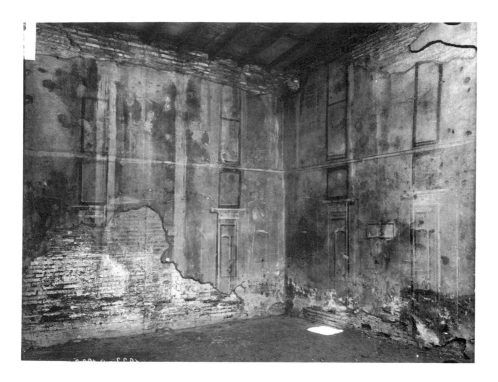

FIGURE 200. A simple scheme of stacked aediculae on an all-yellow ground adorns the less private space (2) open to the medianum.

illusionistically a structure made of beams with painted wooden panels between them, like the Second-Style ceiling in the fauces of the Samnite House (see Fig. 25) rather than the fanciful flat miniaturism of Fourth-Style ceilings. Because it is unique, the ceiling that gave the House of the Painted Ceiling its name is a precious document revealing the survival of a conservative approach to the problem of decorating the flat ceilings found in most Ostian houses.[8]

Room 2 is a reception space whose broad opening faced the windows of the medianum. It is an all-yellow room, painted with less care than room 1: there are only two zones; if there was a socle, it had to have been 5 centimeters or less in height (Fig. 200). A simple system of stacked aediculae, two to a wall, divides the decoration. The aediculae are added over the yellow fresco in white secco, shaded in red toward the center. They frame landscapes much like the

8. Between July 1983 and July 1985 the southeast quarter of this ceiling collapsed; it is still awaiting restoration.

that this was the owner's residence. In Roman times the owner or landlord preferred the ground-floor apartment, and the best of these imitate the spaciousness and formality of the traditional single-family dwelling or domus. The House of Jupiter and Ganymede originally had two separate entrances. The principal one leads to a large courtyard surrounded by a covered walkway, or *ambulacrum,* number 2 on the plan, in this way providing a circulation pattern similar to that of the domus. A secondary entry leads from the via della Casa di Diana. Furthermore, room 4, opposite the main entryway, is enormous and opulently decorated (see Fig. 203). It is about six meters (19′6″) tall, extending vertically through the second story, and is 6.75 x 8.75 meters, or 22 feet x 28 feet 6 inches. This room's great size is an indication of the wealth of the patron, particularly if we compare it with the most luxurious houses at Pompeii. It is almost a third larger than both the tablinum in the Villa of the Mysteries (5.75 x 7.25 m) and oecus *q* of the House of the Vettii in Pompeii (5 x 8 m), and only three-tenths smaller than the largest triclinium in Pompeii, that of the House of the Menander (18), which measures 11 x 7.5 meters.

The plan also illustrates, by means of parallel hatching, the modifications to this large luxury apartment in the period between 184 and 192. The graffito VII K L COMMODAS, or "on the seventh day before the Calends of Commodos," scratched on the ambulacrum's wall proves that this wall-painting campaign was completed before 192, since the emperor Commodos's proclamation of 184 renaming the month of September after himself was repealed after his murder in 192.[10] The decoration of this wall, and in fact that of all the painted wall surfaces which have survived in this house, covers the modifications to the original plan. These were six in all: (1) a wooden staircase was placed in room 11 to connect the ground-floor apartment with one of the upstairs apartments; (2) room 10 and the remainder of 11 became shops facing the street; (3) a room, unnumbered on the plan but usually called the *Gastzimmer,* or "guest room," was added at the eastern end of the ambulacrum. It had no doors, only a curtain hanging between the two partition walls framing its entrance; (4) room 13, a corner shop, was detached, and the second entrance to the ground-floor apartment was blocked; (5) probably to improve the support for the upper stories, the great door to the courtyard in front of the entrance to 9 was closed, and the door to room 4 was made into a window; and (6) room 7's door to the ambulacrum was closed and rooms 6 and 8 got new doorways to vestibule 1.

The purpose of these modifications was to enlarge the house by adding the rooms of the upstairs apartment and to gain greater control of street access by

10. A. W. van Buren, "Graffiti at Ostia," *Classical Review* 37 (1923): 163–164; Volker Michael Strocka, *Die Wandmalerei der Hanghäuser in Ephesos* (Vienna, 1977), 50, reviews the stylistic evidence for dating the painting of tablinum 4 and argues convincingly for a date in the 180s.

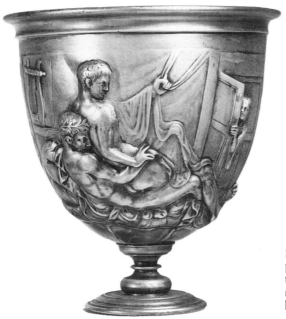

FIGURE 202. An Augustan-period silver cup includes details suggesting that the couple may be clients of a gay establishment.

closing off the secondary entrance and by opening doorways to either side of the vestibule. This new configuration of the spaces suggested to Calza a private hotel, for now the apartment was too large for a single family. Why else do away with the suite of street-side rooms except to increase the privacy of the ground-floor rooms? And why else eliminate the secondary entrance and add facing doorways at the principal entrance except to be able to monitor comings and goings? This kind of entryway, according to a recent interpretation of a red-figured Greek vase, belongs in a gay brothel.[11]

A fine silver cup of the Augustan period may portray a scene in a gay establishment (Fig. 202).[12] The clear representation of a room's interior, and the

11. Eva Keuls, *The Reign of the Phallus* (New York, 1985), 293; Keul's interpretation is not entirely convincing: see Peter H. von Blanckenhagen, "Puerilia," in *In Memoriam Otto Brendel: Essays in Archaeology and the Humanities*, ed. Larissa Bonfante and Helga von Heintze, (Mainz, 1976), 37–41.

12. The cup is in a private collection in the United States. See Cornelius Vermeule, "Augustan and Julio-Claudian Court Silver," *Antike Kunst* 6, no. 1 (1963): 39, pl. 14, 2, 4, for views of both

presence of an onlooker standing at a kind of window,[13] suggests that the love-making is taking place in a hotel or brothel. Other details make this more convincing than the vase painting as a scene in a specially designed gay hotel or house of prostitution rather than a private home. The young men occupy a bed outfitted for lovemaking, complete with a convenient strap which one of the men uses (much like the staff in the vase) to help him assume a pleasurable position. The refined relief technique and use of a precious metal indicate that this object was intended for a patron of means. The idealized bodies, Augustan hairstyles, and facial types indicate that the lovemakers are men of the upper class. Allusions to Augustus's favorite male deity, Apollo, in the lyre at the left and in the bearded male's laurel wreath, further emphasize the men's refinement.

Yet these representations simply suggest, but do not prove, the existence of gay brothels for the upper class. And if the spatial modifications to the House of Jupiter and Ganymede suggest those of a hotel, why should it be a gay hotel? For Calza, in fact, the meaning and location of the graffiti were more important than the new arrangement of spaces in convincing him that this was a well-appointed hotel for gays. On the right wall of the "guest room" are scratched pictures of several ships, a male figure, and a pair of dueling gladiators, one called TAURUS. Near these is *Ti Ermadion cinaedus,* or "You're a faggot, Ermadion." We also find two different verses superimposed in two different lettering styles. The first reads:

hic ad Callinicum futui
orem anum amicom mare . . .
nolite in aede . . . [or] *nolite cinaede . . .*

This might politely be translated: "Here I had oral and anal intercourse with my sea-going friend Callinicus. Don't do [something] in the temple . . . [or] Don't do something with or to a faggot." It is unfortunate that there are gaps in the text, for it would be interesting to know what we the readers are not supposed to do in the temple or with the homosexual. One of the orifices named in the graffito is illustrated in the U of *futui.*

scenes. Vermeule maintains that the couple illustrated here (his pl. 14, 2) have the features of Tiberius and Drusus the Younger. A modern copy of the cup in the Ashmolean Museum is illustrated in Catherine Johns, *Sex or Symbol?* (Austin, 1982), pl. 25 and fig. 84. Recently, several scholars have questioned the authenticity of this cup because of its similarity to forged Arretine pottery. See Michael Vickers, "Arretine Forgeries Revealed," *The Ashmolean* 18 (1990): 5.

13. For the representation of onlookers in Pompeian wall painting, see Dorothea Michel, "Bemerkungen über Zuschauerfiguren in pompejanischen sogenannten Tafelbildern," in *La regione sotterrata dal Vesuvio: Studi e prospettive,* Atti del Convegno Internazionale, ed. Alfonso De Franciscis, 11–15 November 1979 (Naples, 1982), 537–598.

The second graffito is equally graphic:

Livius me cunus
lincet Tertulle cunus . . .
Efesius Terisium amat

This translates, a bit less politely, "Livius that faggot [literally, "cunt," used as a synonym for faggot] licks me. Tertullus, you're a cunt, too."[14] The last line gives us another bit of sexual gossip by telling us that "Efesius [a male, presumably from Ephesus] loves Terisius [another male]." In the stairhall things seemed to be just as busy as in the "guest room." There we read that Agathopus, Primus, and Epaphroditus had a threesome and that Cepholus and Musice came together (literally).[15] The explicit meaning of the word used here, *convenire*, is established both in a famous heterosexual graffito at Pompeii (*Secundus cum Primigenia conveniunt*) and in Apuleius (*Met.* 4. 27).

Two aspects of these graffiti puzzled Calza. First, most of the graffiti from the houses at Pompeii mention sexual acts between males and females, and frequently the females mentioned are prostitutes, *ancellae* or *togatae*. The graffito naming a household slave a cinaedus, in atriolo *v* of the House of the Vettii, was subsequently scratched out, presumably by the person so named.[16] None of the graffiti in the House of Jupiter and Ganymede name females, and none of the males called faggots registered their objections by attempting to erase anything. Second, the rooms where the graffiti were found form part of the circulation system of the house; no one could be having sex in either room without the rest of the household knowing about it, for the "guest room" had no permanent door, and the stairwell room formed the only route from the ground floor to the upstairs rooms. The owner would have had to have known what these rooms were used for. If the graffiti were written by servants, why are there no female names, and why were they written in these rather public spaces?

At this point Calza abandons the physical evidence of the building and the graffiti and turns to the interpretation of the wall painting, but it is worth ask-

14. J. N. Adams, *The Latin Sexual Vocabulary* (London, 1982), 116–117, notes that *cunnus* when used of a male homosexual = *culus* and, by extension, a *cinaedus*. Here *lincet*(= *lingit*) indicates anilingus or fellatio.

15. Van Buren, "Graffiti at Ostia," 164, suggests alternate readings: for Calza's *Agathopus et Primu et Epaphroditus tre convenientes* he proposes *Agathopus et Prima et Mod[e]stus tres convenientes*, putting a female into the threesome; for *Cepholus et Musice duo convenientes* he reads *Nicephorus et Musice due convenientes*, adding that *Musice* is a female name.

16. Arnold de Vos and Mariette de Vos, *Pompei Ercolano Stabia*, Guida archeologica Laterza, no. 11 (Rome, 1982), 170.

ing further questions. Could the graffiti have belonged to a later period of economic decline, when even fine houses like this were abandoned? The answer is no, because the graffiti themselves have an upper temporal limit. They were covered when the house was replastered forty years later, in about 235–245.[17] This means that the graffiti belong to the last period of Ostia's great economic prosperity, not to the period of its decline in the later third century. In this period of prosperity there could have been a need for a hotel catering to a special sort of clientele.

How does the layout of the House of Jupiter and Ganymede fit into what we know of hotel plans in the Roman period? Tönnes Kleberg's study of hotels in Roman antiquity ignores the House of Jupiter and Ganymede in favor of smaller buildings with much simpler plans and with easy access to busy streets.[18] These cauponae, or little restaurant-bars with rooms (and often prostitutes) for rent, were decidedly for the lower classes; middle- or upper-class gentlemen would never have been seen there.[19]

Comparison of the plan of the House of Jupiter and Ganymede with that of the common whorehouses reveals little in common. The lupanar on the street of the same name at Pompeii, for instance, has about one-tenth of the space of the House of Jupiter and Ganymede. Its plan suggests that it was built for quick turnover, and its spaces are quite different from those of either the single-family domus or multifamily apartment building.[20] Instead of rooms, there are ten cubicles with flimsy partitions decorated with frank, crudely painted scenes depicting heterosexual activity like those in room x^1 of the House of the Vettii (see Fig. 130).

On the other hand, the location of the House of Jupiter and Ganymede is a good one for a hotel. All the examples of hotels noted by Kleberg at Pompeii, Herculaneum, and Ostia are near the amphitheater, forum, city gates, theater, or the baths.[21] The House of Jupiter and Ganymede is located only one block to the east of Ostia's central forum; a caupona serving wine and food is across the street from its south facade.

Second-century Ostia was a city filled with men of commerce whose concern was supplying Rome, a city of over a million inhabitants, with the goods it consumed. Some of them, probably those of the lower classes, lived there permanently, but perhaps the shippers and the owners of entrepreneurial businesses

17. Calza, "Scavi recenti," 368.
18. Tönnes Kleberg, *Hôtels, restaurants et cabarets dans l'antiquité romaine* (Uppsala, 1957), passim.
19. Kleberg, *Hôtels,* 93–94.
20. Pompeii VII, 12, 18–20; see plan in de Vos and de Vos, *Pompei Ercolano Stabia,* 197; discussed 202–204.
21. Kleberg, *Hôtels,* 49–53.

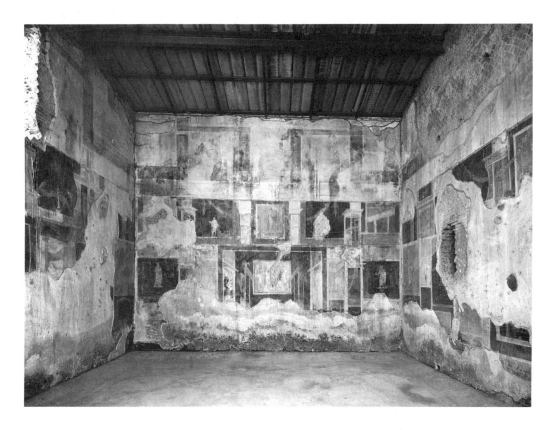

FIGURE 203. Late-Antonine decoration of the great hall (4) recalls the baroque painting of the Ixion room in the House of the Vettii (compare Fig. 135).

lived in Rome or the port supplying what they sold. If this is true, as seems likely, some of them in antiquity, as today, may have preferred a well-appointed hotel that looked with approval on their homosexual activities.

The Iconography of Leda and Ganymede in Room 4 But these arguments from topography, arrangement of spaces, and graffiti, unsubstantiated by clear comparative material, must remain speculative. The most promising evidence is the iconography of the great hall, number 4 on the plan (Fig. 203 and Pl. 23).[22]

22. For a fuller account of the iconography of Leda and Ganymede, see John R. Clarke, "The Decor of the House of Jupiter and Ganymede at Ostia Antica: Private Residence Turned Gay Hotel?" in *Roman Art in the Private Sphere*, ed. Elaine K. Gazda (Ann Arbor, Mich., 1991), 89–104.

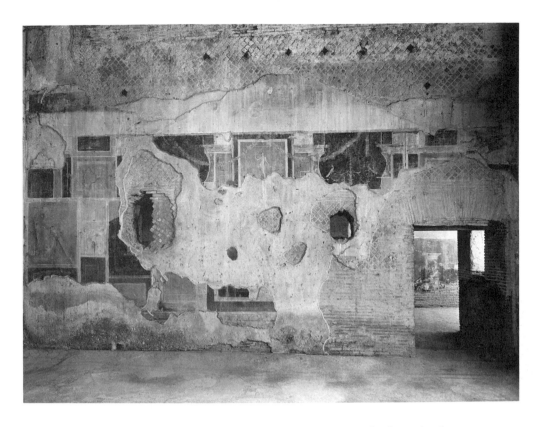

FIGURE 204. The south long wall: a nude Dionysus stands above the destroyed central picture.

The wall paintings of this room constitute the largest extant painted surface at Ostia Antica. Its ambitious decorative program consists of four horizontal registers with aediculae in the center of each wall. There were originally pictures in the centers of each aedicula. Calza described the fragments of the picture on the left-hand wall, no longer visible. One-third of the panel was preserved, showing a young, nude Dionysus standing, with his left arm folded behind the nape of his neck, a bell-shaped object (perhaps cymbals) in his right hand. He was revealing himself to a clothed female, probable a maenad.[23] In the upper zone, directly above this picture, was a representation of Flora, the Italic goddess of flowers. Calza tells us that she wore a green mantle and held a garland woven of fruit and flowers. Opposite her, in the same position on the

23. Calza, "Scavi recenti," 397.

room's right wall (Fig. 204), is a young, nude Dionysus with long, curly hair. He holds a fillet in his left hand and a bunch of grapes in his right. A red cape (chlamys) is draped over his shoulders.

The rear wall is the best preserved. Above the picture of Jupiter and Ganymede appears Venus Anadyomene. This representation of Venus rising from the sea, based on a famous painting by Apelles of Kos,[24] occurs elsewhere at Ostia in a mid-third-century painting in the Terme del Faro and in the mid-fourth-century mosaic of the House of the Dioscuri. Calza notes that all three of the divinities represented in the upper-zone panels belong to the younger Olympus, standing for eternal youth and joy.[25]

The remaining single figures represent generic types rather than specific gods and goddesses. They fit into three categories: the bearded males represent "philosophers" (Fig. 205); the beardless males are "poets" (Fig. 206); and the draped, flying females, "maenads" or "nymphs." Because of their lack of a specific pictorial context and their obviously decorative function in the ensemble, it is risky at best to assign them precise meanings.

If there is a key to the room's iconography, it must lie in the central picture of the rear wall (Fig. 207). In decorations based on the aedicula, the central picture of a room's rear wall, opposite the entry and commanding the room's axis, is the most important.[26] (The closest parallel is oecus *p* of the House of the Vettii at Pompeii [see Fig. 135], often called the Ixion Room because of the subject matter of the aedicular picture in the center of its rear wall.) What of this key picture? It must be noted at the outset that the painting has suffered greater losses than are evident even from slides and photographs. Ostian wall painting has been much maligned for its poor quality vis-à-vis Pompeii, but only very rarely do we see more than the fresco underpainting at Ostia. In this central painting, as in room 2 of the House of the Painted Ceiling discussed above, all the finished surfaces, added in secco over the dried fresco, have been lost. Bearing this in mind, the viewer studying the paintings of Roman Ostia must remember that he or she is often looking at guidelines never meant to be seen.

The tracing reproduced in Figure 208, made by placing transparent acetate directly over the painting, recovers the guidelines in the fresco underpainting and separates out the "static" caused by partially adhering upper layers, damages, calcification, and inept modern restoration.

24. Jerome J. Pollitt, *The Art of Greece, 1400–31 B.C.: Sources and Documents* (Englewood Cliffs, N.J., 1965), 165–167.
25. Calza, "Scavi recenti," 396.
26. Richard Brilliant, *Visual Narratives: Storytelling in Etruscan and Roman Art* (Ithaca, N.Y., 1985), 78.

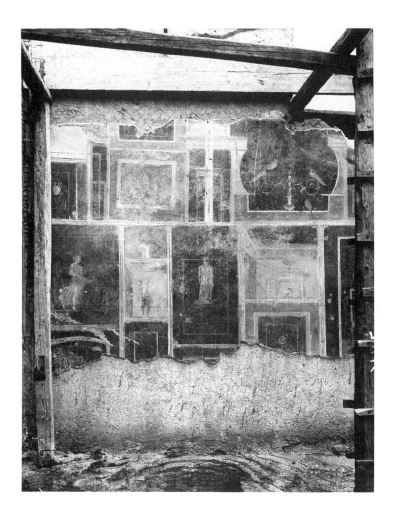

FIGURE 205. This bearded male ("philosopher") figure
floats in front of the panel meant to frame him.

All that remains of Jupiter's thunderbolt, for instance, is the fresco under-
painting in porphyry red. Jupiter is seated on a throne with a footstool. We can
see the porphyry-red underpainting of his cloak and can just make out the out-
lines of his feet. The underpainting shows that Zeus's right hand reaches to-
ward Ganymede's neck and chin. He is not caressing him on his cheek, as Calza
would have it. This gesture would never be lost on a Roman or Greek audience,
for from at least the sixth century it always signifies amorous intent. Leo Stein-
berg, who traces its survival into Renaissance religious painting, calls it the

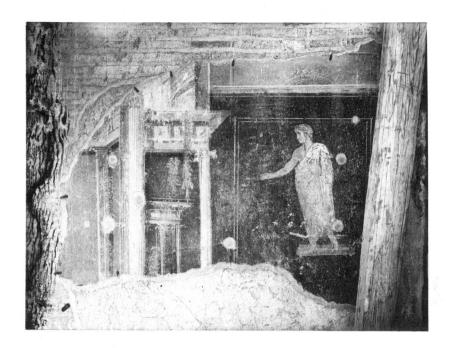

FIGURE 206. A beardless male ("poet") similarly displaced.

FIGURE 207. The central picture on the rear wall: Leda,
Ganymede, and Jupiter.

0 10 20 30m

FIGURES 208 and 209. A tracing reveals the outlines painted be-
neath the added secco; a reconstruction of the original scheme.

"chin-chuck."[27] Greek black-figured vase painting presents numerous examples of courting scenes between the bearded adult male *erastes*, or lover, and the beardless, often barely pubescent boy, the *eromenos*, or beloved. In every case the erastes touches the boy's chin in the precise way Jupiter touches Ganymede's—with the hand open, thumb near the chin and fingers at the neck. What is lacking here is the accompanying attempt to fondle the youth's genitals, which J. D. Beazley called the "up and down" pose.[28] Jupiter's seated posture here makes the attempt difficult.[29] Ganymede is reciprocating in some way. A common gesture among the courtship scenes shows the beloved responding to the chin-chuck by grasping his lover's wrist. This gesture seemed to work best in the reconstruction drawing (Fig. 209) and is suggested by the closeness of the two figures and the manner in which Ganymede leans back and tilts his head up to look at Jupiter.

Many sculptural representations of Ganymede with the eagle share several features with our painted version.[30] The Phrygian cap, the chlamys draped over the shoulders, the upturned gaze, and contrapposto stance appear in both sculpture and painting. Our painter reversed the position of the feet while retaining Ganymede's stance, and of course in the painting his right arm reaches for Jupiter. Although these parallels seem to reveal the painter's awarness of sculptural prototypes, given the enormous paint losses in this area, accurate reconstruction seems out of the question.

Whereas Ganymede's Phrygian cap, contrapposto stance, and red chlamys secure his identification, the female figure occupying the left-hand fourth of the painting is much more problematic. Calza thought she could be Aphrodite, asserting—like the Aphrodite Anadyomene above—the right of every kind of love. But he noted that her clothing and features suggested Hera, in an almost undignified attitude, in no way participating. Or perhaps she is Hebe, the former cupbearer of the gods who had lost her favor to the new boy. None of these interpretations is possible. The outlines of feathers and a swan's neck and head in her lap identify her as Leda.

There is a white form in Leda's lap. Close inspection of that white form reveals black outlines of feathers on the white plaster of the ground. The swan's head and neck are at the right, and its curved wings begin at Leda's waist. Paint

27. Leo Steinberg, *The Sexuality of Christ in Renaissance Art and in Modern Oblivion* (New York, 1983), 3.

28. J. D. Beazley, "Some Attic Vases in the Cyprus Museum," *Proceedings of the British Academy* 33 (1947): 199.

29. Gerhard Neumann, *Gesten und Gebärden in der griechischen Kunst* (Berlin, 1965), 67–69; Kenneth J. Dover, *Greek Homosexuality* (Cambridge, Mass., 1978), 93–96; Keuls, *Phallus*, 277–283.

30. Especially London, British Museum, BM Cat. Smith, vol. 3, inv. no. 1533.

losses prevent us from knowing just how large the swan was, but comparison with sculptural types makes it probable that it was lap size. This representation of Leda descends ultimately from an early fourth-century B.C. type, often attributed without foundation to Timotheos.[31] We have already seen a painted version of this early fourth-century sculptural type on the south wall of triclinium *e* of the House of the Vettii at Pompeii (see Fig. 140). There Leda occupies the center of the upper zone, facing Danae on the opposite wall, while Jupiter regards both of his mortal conquests from the west wall. Leda is clearly seated, a chair leg appearing at her left knee, her feet on a rocky footstool. Her chiton has fallen into her lap and she has drawn the protecting cloak over her head with her right arm. The swan has alighted on her left knee, his head poised as if to gaze at her or kiss her.

Whether relying on a painted or sculpted source, it is easy to see how our painter might have used this type. The half-unfastened chiton becomes a fully fastened one with two shoulder clasps. Leda's dramatic contrapposto stance also translates, albeit in a somewhat deadpan fashion, into an ambiguous, approximately seated position. Her right hand, which overlaps the picture frame, does not seem to be holding the swan. Instead the swan presses himself into her lap so that his back is toward the viewer. Leda's left arm gestures upward as in the sculpture but does not hold drapery. Instead her slightly upraised and outstretched left hand seems to be a gesture of presentation, particularly in combination with her frontal pose. She looks out at the viewer. In fact, Leda's position, crowded into the left-hand quarter of the picture, her awkward, disengaged pose, and her detachment from the courting scene as a kind of "fifth wheel" all suggest that the artist wished to express Jupiter's preference for a male mortal lover over a female one.

The painter seems to have based his representation of the swan on a ready-made type he was quite familiar with: that of the ubiquitous images of swans that appear as decorative elements in wall painting. In fact, this artist reinforced the Jupiter-Leda connection in the symbolism of the birds that frame this picture: to the right and left are Jupiter's eagles, but beneath it appears a swan. More original was the idea of putting Ganymede and Leda into the same picture,[32] deliberately underscoring the fact that Jupiter loved and made love to both male and female mortals, although here he prefers Ganymede. Rather

31. The best-known example of this type is in the Capitoline Museum at Rome, inv. no. 302.
32. Although there are no representations of Jupiter, Ganymede, and Leda in the same pictorial composition, these two mortal loves of Jupiter were often arranged as pendants in sculpture: see the silver cup from Cullera, Salomon Reinach, *Répertoire de reliefs grecs et romains* (Paris, 1912), 2:242, figs. 1–3; lost sarcophagus from Rome, Hellmut Sichtermann, "Leda und Ganymed," *Marburger Winckelmann-Programm* (1984): 43–57, figs. 1–4; sarcophagus in Budapest, Sz. Burger, *Archaeologiai értesito* 100 (1973): 42ff, figs. 1–10; double-sided pilaster, Georg Lippold, "Leda und Ganymedes," *Sitzungsberichte der bayerischen Akademie der Wissenschaften*

than registering disapproval, as Calza thought, Leda's frontal pose and open-handed gesture invite the viewer to consider the coexistence of two kinds of love—homosexual and heterosexual—in the person of the supreme Olympian deity. The artist who achieved this conflation for the central decoration of the most important room of this hotel for homosexual men knew that the message (including its ironic overtones) would not be lost on the establishment's clientele.

Conservatism and Innovation in the Jupiter and Ganymede Room In addition to its unusual iconography, room 4 represents, more than any other wall decoration at Ostia, the dual trends of reprise and revolution that characterize the end of the second century. Many aspects of Fourth-Style decoration survive a hundred years later in the Jupiter and Ganymede room, as comparison with room *p* of the House of the Vettii reveals (see Fig. 135). Both rooms are divided into three zones (with an added fourth zone in the House of Jupiter and Ganymede because of its unusually high ceiling). Central aediculae frame large pictures. Both rooms' socles consist of faux-marble revetment. In the median and upper zones appear slots with shallow architectural perspectives, interspersed with monochrome panels. On some panels appear masks, in front of others appear flying or floating figures. Above the aedicular pictures in the median zones of each wall are statuelike figures in the upper zone. All of these common elements indicate the artist's use of time-honored decorative schemes with traditional motifs. What are the revolutionary aspects of room 4's decoration?

For one thing, the illusionistic architecture of the long side walls follows a different scheme from that of the shorter rear wall. Whereas the rear wall's central picture of Jupiter, Ganymede, and Leda is flanked by relatively broad pavilions that connect to thin two-story aediculae extending into the upper zone (see Fig. 203 and Pl. 23), on the side walls there is no two-story pavilion; instead, heraldic peacocks perched on the opposed arms of floral candelabra appear in the upper zone against a red ground. Additional panels and slots with colonnades in perspective fill out the walls. The way these panels vary in size and alternate in color between red and gold also signals a new aesthetic, but perhaps the single most revolutionary characteristic is the placement of the figures in relation to their panels.

Fritz Wirth, for one, made much of the fact that most of these figures overlap the inner frames of their panels.[33] Although depicted as standing on bases,

3 (1954): 3; and Licia Guerrini, "*Las Incantadas* di Salonicco," *Archeologia classica* 13 (1961): 53–55, pl. 19, 2; for freestanding pendants, see Elaine K. Gazda, "A Marble Group of Ganymede and the Eagle from the Age of Augustine," in *Excavations at Carthage, 1977, Conducted by the University of Michigan*, vol. 7, ed. J. H. Humphrey (Ann Arbor, Mich., 1981), 177.

33. Fritz Wirth, *Römische Wandmalerei vom Untergang Pompejis bis ans Ende des dritten Jahrhunderts* (Berlin, 1934), 110–112.

the heads or feet of the poets, philosophers, and maenads touch or even overlap the double stripes that are supposed to frame them (see Fig. 205). In Wirth's view their lack of centering displaced them spatially, creating an effect of animation and contradictory movement that sabotaged the architectural logic of the wall system. Although Wirth's appraisal of room 4's revolutionary qualities is somewhat exaggerated, its new use of figural panels anticipates Severan systems using panels with similarly displaced figures. Within the next twenty years the architectural logic that proves the survival of Fourth-Style systems into the 180s disappears completely in favor of the panel system that makes its first appearance here.

Monochrome Aedicular Systems in Ambulacrum 2 and Cubiculum 9 Aediculae much like those in rooms 4–6 of the House of the Yellow Walls, but on a monochrome red ground, decorated ambulacrum 2. Although nearly erased today, from old photographs it is clear that for this dynamic space the aediculae were repeated at regular intervals without framing any single center of interest. This corridor's decoration most aptly fits Hetty Joyce's definition of "modular-aedicular" schemes.[34] Upward-curving lines of flowers and foliage connect the aediculae, and vertical floral lines mark the middle of the spaces between them. Like the aediculae in the House of the Yellow Walls, each extends to either side with thin secondary architecture painted in perspective. No traces remain of the upper zone's white-ground decoration, which continued up over the brickwork ledge that held the ceiling beams.

Some scholars date the "guest room's" white-ground decoration to the period of Antoninus Pius,[35] on the supposition that it kept its original decoration when the partition was built. There is nothing in its simple aedicular scheme that differs sufficiently from that of the red-ground decoration of the ambulacrum to indicate an earlier date, and given the fact that this is a dark windowless space, the white ground may have been motivated by a desire to increase the light.

If the aediculae of corridor 2, in their mechanical repetition, create identical units with no center of interest, the aediculae in room 9 act as framing elements for landscape panels (Fig. 210). Its monochrome yellow ground continues the tradition of all-yellow rooms discussed above. Bianchi-Bandinelli has shown that the painted decoration of room 9 connects with a Neronian invention by

34. Hetty Joyce, *The Decoration of Walls, Ceilings, and Floors in Italy in the Second and Third Centuries A.D.* (Rome, 1981), 30.
35. Carlo Pavolini, *Ostia*, Guida archeologica Laterza, no. 8 (Rome, 1983), 84; Wirth, *Römische Wandmalerei*, 114, dates the guest room to a bit earlier than 180; Joyce, *Decoration*, 30–31 note 56, dates all paintings in the house to 184–192 with the exception of the guest room's upper zone.

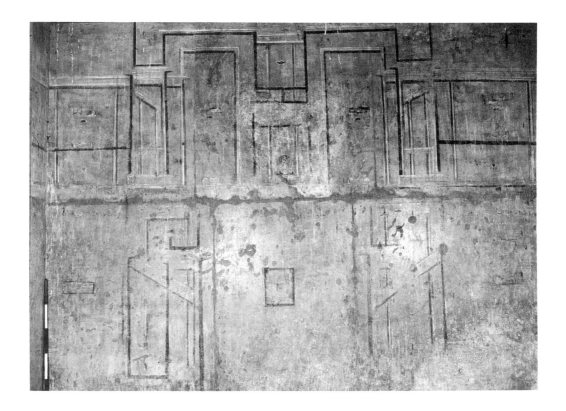

FIGURE 210. This all-yellow reception room (9) uses aediculae to frame deliberately misaligned landscape panels.

comparing it with the all-white Room of the Landscapes in the Domus Aurea.[36] All-white rooms 5 and 6 in the House of the Painted Vaults provide more recent parallels.[37] Because of enormous losses of the added secco painting, room 9's scheme seems much more abstract than was originally intended. The remaining surfaces reveal the method used by the painters to render the decoration. First they painted the yellow ground in fresco. While it was still wet, they added the architectural perspectives, the frames of the landscape paintings, garlands, and candelabra in porphyry red. Finally they rendered all the details in secco, using green and white pigments for the architraves, landscapes, garlands, and plaques. The same scheme appears on all three walls: as in the

36. Ranuccio Bianchi-Bandinelli, *Rome: The Center of Power* (New York, 1970), 328–329, figs. 368 and 370.
37. Joyce, *Decoration*, 31.

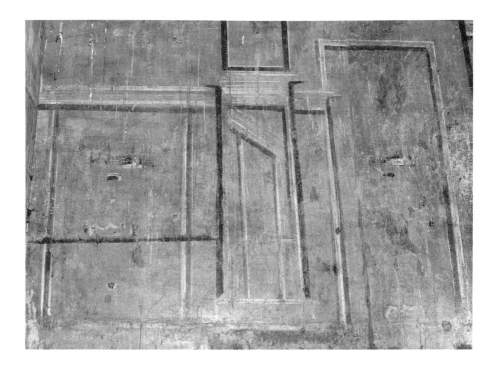

FIGURE 211. A detail of a relatively well-preserved area reveals the artist's extensive use of added secco.

"guest room" and in room 2 of the House of the Painted Vaults, the aediculae stack from the floor, with room only for a plinth of about 5 to 10 centimeters. The slanting lines in porphyry red that now illogically cut through the vertical slots of the aediculae were guidelines for the artist that were not meant to be seen in the finished painting. In several areas where the secco overpainting is preserved, the details of the aediculae, garlands, and decorative elements are still clear. In Figure 211, for example, the red guidelines are still covered with highlighted green secco to create rationally foreshortened aediculae. Likewise, the motifs hanging from the architraves appear now only in red outline: Amazon shields, or *peltae,* and theatrical masks like those appearing in room 4. Upward-curving floral garlands and borders like those of ambulacrum 2 frame the panels with landscapes in their centers.

Like the landscapes of rooms 4–6 of the House of the Yellow Walls, here the technique is liquid and impressionistic. Panels of the same size that face each other across the southeast and southwest corners are deliberately misaligned;

one is tempted to see this as a parallel to the free disposition of the panel system in room 4, but the same misalignment appears a century earlier in the Fourth-Style scheme of the Room of the Landscapes in the Domus Aurea. The rationale remains the same: avoiding alignment avoids the boredom of the evenly applied grid, adding interest to the entire composition.

In all three houses examined in this chapter, the enduring usefulness of the aedicula for decorating secondary spaces emerges. Whether in the small rooms at the back of the medianum in the House of the Yellow Walls, in the secondary reception spaces of the House of the Painted Ceiling, or in the ambulacrum and minor parlor of the House of Jupiter and Ganymede, the formulaic aedicula solved the wall painters' need for an adaptable geometric structure that could form the basis of a variety of decorative elaborations. In the simplest form of the decoration, the painters simply repeated the same aedicula along a wall, as in the dynamic space of the ambulacrum in the House of Jupiter and Ganymede. In individual rooms, whose static nature required centers of interest, the aediculae served as frames for simple motifs, such as the landscape panels in the House of the Yellow Walls and the House of Jupiter and Ganymede. The use of economical base colors—yellow or red ocher—like the relatively simple mosaic floors in these rooms, signaled their secondary importance in the houses.

Much more complex systems of color, architecture, and figural decoration characterize the best rooms in these houses. In the House of the Painted Ceiling the painters looked back in time for inspiration, recreating the richly decorated, substantial columns and the delicate floating figures of the Hadrianic period. At the same time, for the best room of the House of Jupiter and Ganymede, the wall decorators seem to be looking forward. Here, in the penultimate decade of the second century, appear in their beginning stages the tendencies that characterize Late-Antique decorative systems: dissolution of the dynamics of weight and support that made illusionistic architecture seem rational; preference for walls activated by patches of contrasting color; and the introduction of panels with detached or unframed figures in front of them. In the Severan period, decorations characterized by abstract systems and optical effects break definitively with the traditions that had tied second-century Ostian wall painting to that of the first century.

CHAPTER EIGHT

DECORATIVE STYLES FROM THE AGE OF THE SEVERANS TO THE MID-THIRD CENTURY, A.D. 193–250

Although the decorative ensembles of the Severan period are few and fragmentary, there can be no doubt that they represent a new aesthetic, willfully applied. Anomalies and deliberate peculiarities, such as the refusal to use the straightedge and plumb bob to divide walls into the perfect grids common in earlier wall painting, have caused some scholars to characterize the decoration of this age as decadent: in their view it was the end of fine decoration, which had been represented by the maintenance of first-century traditions during the first eighty years of the second. Russell Meiggs, commenting on the linear style, says: "This is not a triumph of abstract art: it seems to reflect the end of the Severan Dynasty."[1] Others, like Felletti Maj, see this same linear style as a reflection of current tastes in decoration.[2]

Perhaps the clearest pattern of change in decoration can be traced in relief sculpture and the black-and-white figural mosaics, in which two different styles appear side by side. One looks back to the volumetric modeling and elongated proportions of the Antonine period. The other casts this tradition aside in favor of optical effects. In the reliefs, bold contrasts of light and shade, obtained by using the running drill, replace the time-honored tonal range from dark to light (achieved with the chisel) that had given the figures a sense of solidity. In the mosaics, internal white lines, having nothing to do with describing the figures' anatomy, activate the surface and create the same contrasts of light and dark obtained by the running drill in sculpture.[3] These optical-style mosaics participate in a radical and irreversible rethinking of the visual arts that leads to new

1. Russell Meiggs, *Roman Ostia,* 2d ed., with corrections (Oxford, 1975), 444.
2. Bianca Maria Felletti Maj, *Le pitture della Casa delle Volte Dipinte e della Casa delle Pareti Gialle,* Monumenti della pittura antica scoperti in Italia, sec. 3, Ostia fasc. 1–2 (Rome, 1961), 52–53.
3. John R. Clarke, *Roman Black-and-White Figural Mosaics* (New York, 1979), 87–101, for full discussion of the "Optical Styles" in black-and-white figural mosaics.

forms of representation collectively labeled the "Late Antique." [4] Although these changes are at times subtler in the nonfigural mosaics and in the wall painting of this period, several houses at Ostia Antica reflect and document this new aesthetic.

SEVERAN ARCHITECTURAL AND PANEL STYLES
IN THE INN OF THE PEACOCK

Originally built as a modest private residence in the Hadrianic period, the structure known as the Inn of the Peacock was enlarged and redecorated in the Severan period. It remained a private house until about A.D. 250, when it was transformed into a tavern and inn. Although nothing of the Hadrianic decorative program survives, the pavements and wall paintings of this Severan redecoration campaign reveal the structures and aesthetics of decorative ensembles between about 200 and 220.

The two courtyards in the plan, 4 and 7 (Fig. 212), provided light for upper stories that have not survived. Courtyard 4 is essentially an expansion of long entryway corridor 1, with service rooms located along its western side (including a latrine at 5). A transverse corridor, 6, provides circulation within the private rooms of the house. Having walked down the long entry corridor, the visitor would enter the transverse corridor, where he or she has several choices: straight ahead, to the south, four steps lead down to the larger courtyard (7); to the right and south is the entrance to the reception suite, consisting of rooms 8 and 9; to the right and north lies the doorway to cubiculum 10. This combination of corridors and courtyards constitutes yet another solution to the perennial problems of providing light and circulation within a space having party walls on three sides. Although the long corridors are a less elegant solution than the medianum, the courtyards provided enclosed, private spaces open to the sky within the house itself. [5]

Although the use of the same patterns for figural and decorative motifs makes it clear that the same workshop decorated rooms 6–10 of the Inn of the Peacock, three different manners indicate that there was a hierarchy in the organization of the work. [6] The painter who produced the architectural scheme of tablinum 8 was the most conservative, steeped in the late Antonine tradition

4. Clarke, *Mosaics*, 94–97.
5. The house gets its name from the unusual lararium in the southwest corner of courtyard 7. Under a little barrel vault is painted a strutting peacock; beneath are the symbols of the lares (rather than their figures): a drinking horn (rhyton) and an offering plate (patera).
6. Carlo Gasparri, *Le pitture della Caupona del Pavone*, Monumenti della pittura antica scoperti in Italia, sec. 3, Ostia fasc. 4 (Rome, 1967), 31.

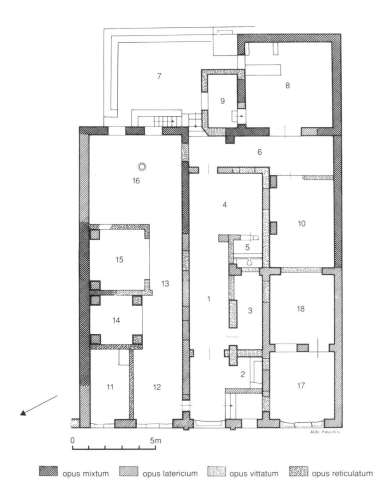

opus mixtum opus latericium opus vittatum opus reticulatum

FIGURE 212. Plan of the Inn of the Peacock.

that revived the idea of the illusionistic colonnaded pavilion. He may also have painted room 1 of the House of the Painted Ceiling. The master who painted the elegant little room 9 was equally talented but had already discarded the conservative architectural style represented by room 8's decoration; instead of relying on the armature of architectural illusionism to frame his figural panels, he employed the panels themselves as the building blocks of his wall design. Less talented or less well-trained painters carried out the decoration of corridor 6 and cubiculum 10; although they employed the new panel style, their design lacks the focus and refinement of room 9.

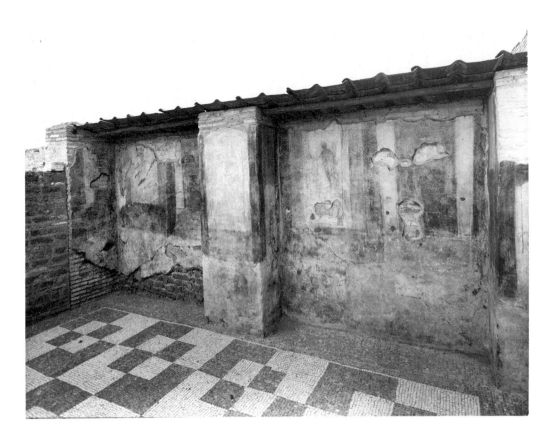

FIGURE 213. A Severan panel–style ensemble: interwoven squares in the mosaic floor coordinate with painted panels on the walls.

Aside from their proving the coexistence of two different fashions in the wall painting of the Severan period, these rooms of the Inn of the Peacock also document the pavement designs that coordinated with the wall painting.[7] This is a unique circumstance, since all the other wall decoration executed after that of the House of the Muses retained earlier, Hadrianic mosaics. Corridor 6's black-and-white mosaic floor employs a motif of repeated half-circles forming a fish-scale pattern; the black tesserae frame continues uninterrupted to the walls. Here the tesserae are much larger than those used during the Hadrianic and Antonine periods; they range in size from 1.9–2.2 centimeters as opposed

7. Giovanni Becatti, *Scavi di Ostia*, vol. 4, *Mosaici e pavimenti marmorei* (Rome, 1961), 176–177, dates all the paintings and mosaics of the Inn of the Peacock to the mid-third century. His dating must be rejected on the basis of Gasparri's analysis.

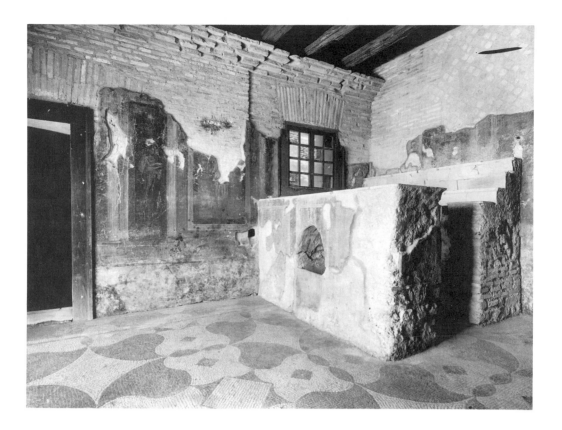

FIGURE 214. Tablinum 8's mosaic pattern is based on equivalent shapes that can be read in two ways.

to 1.2–1.5 centimeters in the earlier mosaics. Cubiculum 10's floor is more complex but composed of tesserae of the same size (Fig. 213). It is a grid-based design of four-part squares in black and white; alternately one of the four parts changes from black to white, creating a second pattern of interwoven squares containing two black and two white squares. This bold design, like the corridor's pattern, is surrounded by black tesserae without the framing stripes common in earlier periods. Its deceptively simple pattern, like that of the wall, is based on panels that can be read in two different ways: either as self-contained shapes or as parts of an interwoven grid.

The finest mosaic, in tablinum 8, has the same interchangeability of white and black forms as that of room 10 (Fig. 214). The tesserae are smaller, ranging from 1.2 to 1.8 centimeters. Both the black and the white shapes, bold and

unusual in form, take up the same amount of space in the design. Whereas the Hadrianic mosaics of the House of the Muses, for instance, were based on *lines* of tesserae that drew the grid-based designs (see Pl. 20), room 8's pavement uses black and white *shapes* that are completely equivalent. The design spreads outward from the center, which is marked by a white square, but immediately the eye has the choice of either seeing the black forms or the white ones as alternatively figure and ground. If the viewer decides that the design of four tangent black bells are the figures, then the white squares with concave sides and the white concavo-convex forms that surround them fight for equal attention as figure rather than ground.[8] Even more than is the case in room 10, this reciprocal relationship between white and black shapes destroys the grid with its big, bold, curvilinear, and eye-teasing pattern.

Another tendency in pavement styles of the period—to use marble floors instead of mosaic—makes its appearance in room 9, the tiny but elegant side room to the tablinum, paved in simple opus sectile. A circle of green marble (*verde antico*) marks the center, surrounded by an irregular pattern of gray-white, yellow (*giallo antico*), and dark gray marble. Given the room's small size, a black-and-white floor of the exuberance of 8 would have overpowered the wall painting. This colorful but neutral and abstract pavement adds to room 9's intimacy.

It is unfortunate that the wall painting of tablinum 8 was discovered in a ruined condition, since what remains suggests that it was a highly refined decoration. Resting on the socle, crudely repainted in the mid-third century to simulate yellow marble, six plinths sustain six columns that divided the room's long east and west walls into seven sections (Fig. 215). Three thin black lines topped by a thick one show through the top of the faux-marble socle; they originally defined the lower edge of the podium beneath the columns. Whereas the two pairs of columns to north and south of the center seem to have been doubled by flanking pilasters, a scheme common in the Second Style, the middle pair that frames the central panel is isolated. Surrounded by gold molding and set against a black ground, the porphyry-red central panels on the west, south, and east walls held images of male figures wearing togas. Remains of an architrave rendered in perspective over the central panels may indicate that the columns carried further perspectives in the lost upper zone. Alternately, they may have held only decorative motifs, like those of the House of the Painted Ceiling (see Fig. 196). On either side of the central panels were narrow doors. On the east wall, between the door to room 9 and the counter (added during the conversion of the house to an inn), some details of the central scheme are visible.

8. The design of the mosaic found in the Domus Aripporum et Ulpiorum Vibiorum in Rome is nearly identical: Marion E. Blake, "Mosaics of the Late Empire in Rome and Vicinity," *Memoirs of the American Academy in Rome* 17 (1940): 88, pl. 15, figs. 1–4.

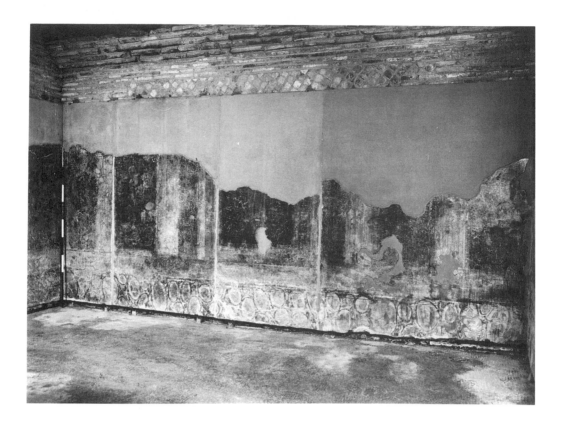

FIGURE 215. Six columns divide the long walls on the west into seven sections in a conservative scheme ultimately based on the Second Style.

(Fig. 216). On a porphyry-red panel a female figure with a light blue chiton and a white mantle moves toward the central panel, holding an object (a tambourine or a patera) in both hands. Parts of a togate male are visible in the porphyry-red central panel, and a female tragic mask rests on the architrave to its right (south). On the north (entryway) walls the edges of the same scheme are visible. On the east spur of this north wall a young male, nude but for a mantle over his left arm, flies toward the doorway (Fig. 217); in the same position on the west spur is a female figure draped in green. In the center of the south wall, partly covered by the marble bar, appeared a third male togatus. Instead of a flying human figure, a centaur moving toward the west wall occupies the right side of the central panel. Even from the eroded fragments that remain it is clear that room 8's decoration drew upon the full repertory of architectural and figural motifs first explored in the period of the Second Style

FIGURE 216. Details of the central panel on the east wall: note the tragic mask on the architrave in the upper right.

and modified in spaces like triclinium 10 of the House of the Muses during the Hadrianic period.

Like the master who produced beautiful but backward-looking relief sculpture on the Arch of Septimius Severus at Rome, or the mosaicist who executed one of the mosaics of the Terme Marittime at Ostia, the artist who painted room 8 was steeped in a tradition that was on the way out. And like these two other masters working in the Antonine style thirty years after it had run its course, the Old Master of the Inn of the Peacock worked side by side, in fact in the same workshop, with an artist employing the contemporary style, a "New Master." The patron's acceptance of the completely different styles of these two painters underscores the pluralism of styles practiced in the Severan period; if Septimius Severus could accept two different figural styles for his arch in the

FIGURE 217. A nude male floating figure repeated exactly in other rooms.

Roman forum[9] and, as it turned out, for his own portrait sculpture, this "inequality of contemporaneous products in Roman art," as Otto Brendel termed it, was itself a fashion.[10] The visitor to the Inn of the Peacock immediately saw the alternative to the Old Master's designs when he or she descended the two steps into room 9.

Constructed by robbing space from courtyard 7, room 9 had a higher ceiling than tablinum 8; the New Master designed a wall decoration with an especially tall median zone consisting of two orders of panels to compensate for this added height (Pl. 24). The lost upper zone would have extended over the beveled ledge that held the ceiling. It is immediately evident that the artist has done

9. Per Gustav Hamberg, *Studies in Roman Imperial Art* (Uppsala, 1945), 148.
10. Otto Brendel, *Prolegomena to the Study of Roman Art* (New Haven, 1979), 127; for an account of this pluralism of styles in mosaics, see Clarke, *Mosaics*, 91–96.

away with the columns, pilasters, architraves, and false doors that structured the decoration of tablinum 8. Instead, panels of different colors, sizes, and shapes activate the walls like the patches of a quilt. Although the short north and south walls have essentially the same scheme, organized around a white panel below, the big white panels are not centered on the walls, and the panels above do not match each other with the kind of axial symmetry that had governed Roman wall-decorative schemes since the first century B.C. The tendency to dismantle this age-old tradition of axial symmetry, already nascent in the tablinum of the House of Jupiter and Ganymede, asserts itself stridently in this intimate room.

The black-speckled gray socle, deliberately flat and neutral, coordinates with the floor without representing a podium. Asymmetry, rather than the foursquare division of the wall with the plumb bob and straightedge, rules the size and placement of the panels. The color scheme, like that of late Antonine decoration, is predominantly warm, the panels alternating between porphyry red and gold, some framed in cream white and blue-green. Several panels of the upper level have curved tops, and the panel on the north wall with a male in a white toga is out of square. These asymmetries and misalignments have the effect of detaching the panels from the flat surface of the wall. The greater the irregularities in respect to the imaginary grid of perfect horizontals and verticals, the more animated the panels—and the figures on them—become. Like the eighteenth- and nineteenth-century galleries with pictures stacked vertically from floor to ceiling, the oddly sized and shaped panels in this room are like tesserae in a mosaic of pictures that covers the walls. Their variety of shapes and occasional misalignments emphasize that they are autonomous, individual units rather than parts of a preconceived, flat grid.

As in tablinum 8, the figural and decorative motifs come from a variety of sources. In the largest panel of the north wall stands a tall female holding a tambourine with both hands. She looks to her right, her face carefully foreshortened and skillfully rendered in chiaroscuro. She wears a bracelet (*armilla*) on her right arm. In the lower panel to the right (east) is an orb with a vegetal crown, above it a tragic mask, and in the upper panel to the left, a bird. In the upper level the best-preserved figure is that of a togate male standing on a green plinth. A female in a red peplos occupies the panel to the left (west), and in a small panel to the right appears a gorgon's head (*gorgoneion*). The space above was once occupied by a little window providing light for corridor 6. The vertical panel on the extreme right (east) frames a man's head above the crowned orb in the panel below. The south wall, less well preserved, follows the north wall's scheme, except that no window interrupted its upper part, which is divided into three instead of four panels. The only new motif here is the represen-

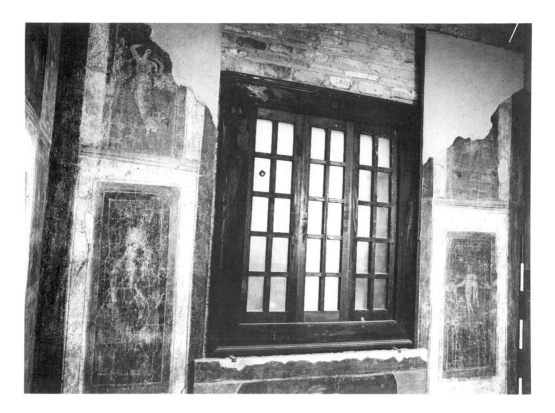

FIGURE 218. The panel system of the east wall of salon 9 surrounds a window.

tation in the upper zone of a grain measure (*modius*) resting on a leafy crown with a sheaf of grain above it.

Although room 9's west wall suffered severe losses, the scheme of the east wall, worked around the window, is clear (Fig. 218). Two panels of equal size, arranged one on top of the other, flank the window; a dolphin occupies a small panel beneath it. Two nude male figures, like the one on the north wall of 8, fill the lower panels; they fly from left to right, mantles over their left arms, both carrying an object in their right hands. Gasparri has suggested that they might be modeled on the spirits, or genii, of the seasons.[11] The figure on the north part of the wall carrying a rabbit would be the genius of Autumn; that on the

11. Gasparri, *Caupona del Pavone*, 28.

FIGURE 219. A female figure from the left-hand upper panel of Fig. 218.

south part of the same wall, also belonging to the Dionysiac repertory, carries a panpipe, or syrinx. In the upper left (north) panel, a graceful female figure wearing a flowing blue chiton flies in the same direction as the males (Fig. 219). She glances to her left while raising her right arm over her head. Enough remains of the figure on the other side of the window to see that she was flying in the opposite direction.

If room 9's decoration represents, at a high level of accomplishment, the aesthetics of the new Severan panel style, the equally animated but less expert paintings of corridor 6 and cubiculum 10 reflect, but do not attain, those aesthetic effects. The north wall of corridor 6 retained its Severan-period median zone when the socle was repainted with a banal plant motif. The drawing conveys its design at the time of excavation (Fig. 220). In the center panel appears a flying male figure; the artist based this figure on the same pattern used by more able painters of the workshop in rooms 8 and 9. The panels alternate in color between gold, porphyry red, and white, with a matching scheme on the south wall of the corridor. In cubiculum 10 this same system extends along the partially preserved east wall. The artists adapted the panel system to accommodate

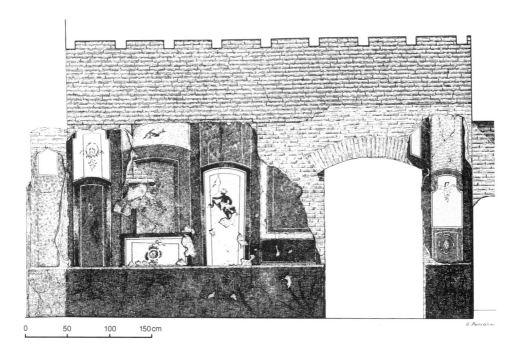

0 50 100 150cm

G. Pascolini

FIGURE 220. Less-accomplished painters worked out the scheme for corridor 6, basing their design on room 9.

the two large piers that interrupt this wall, decorating them with vertical white panels framed in porphyry red and containing vegetal motifs and dolphins. The flying nude male who appears in the central bay is also based on the same cartoon as those found in both rooms 8 and 9.

The decorative ensembles of the Severan period in the Inn of the Peacock document, like the figurative arts of the time, the coexistence of two different aesthetics. Gasparri's characterization of the master working in room 9 underscores his participation in a new fashion:

> At the same time in room 9 a painter with different—and probably more recent—training is working. The disappearance of architecture is not only a result of the small size of the space, but bears witness to a different taste, here manifested in a completely coherent fashion. In this style the convention of the wall conceived as illusionistically open and articulated by architecture is broken, composing upon it instead panels and pictures as in a piece of fabric or a multicolored carpet.[12]

12. Gasparri, *Caupona del Pavone*, 32, author's translation.

Other examples of the Severan panel style at Ostia Antica, because of their fragmentary condition, add little to the information provided by room 9 of the Inn of the Peacock. The most lamentable loss is that of the panel-style ceiling of room 4 of the House of the Painted Vaults, discussed in chapter 6, now preserved only in photographs (see Fig. 185). Although produced by a less-talented artist than the New Master of the Inn of the Peacock, this ceiling espoused the same aesthetics of bold shapes in porphyry red, gold, and white that animate room 9 in the Inn of the Peacock.

In the House of the Yellow Walls a Severan-period redecoration program of its two reception spaces combines elements of both the architectural and the panel styles found in the Inn of the Peacock.

ARCHITECTURAL AND PANEL STYLES
IN THE HOUSE OF THE YELLOW WALLS

Although Felletti Maj dates the wall paintings on the south wall of triclinium 7 and the north and east walls of reception room 8 to the period between 238 and 249,[13] in style and taste they seem much more at home in the first two decades of the third century. Countering the earlier dates suggested by Wirth[14] and van Essen,[15] Felletti Maj based her dating on the hairdo of the maenad on the north wall of room 8 (Fig. 221), similar to the coiffures of the women of the courts of Gordian (238–244) and of Philip the Arab (249–251). It is unlikely that the maenad's hairstyle deliberately and accurately reflects a court fashion; furthermore, the decorative systems themselves belong with the architectural and panel styles of the beginning decades of the century just seen in the Inn of the Peacock.

Old photographs demonstrate that the south wall of triclinium 7, although nearly illegible today, had an architectural system (Fig. 222). Upon the red-and-black socle rest porphyry-red panels with black frames; they alternate with gold panels with green borders. Fluted columns form monumental frames for the large red panel on the south wall. Remains of black and green paint indicate that it may have held a landscape. Although this scheme is fragmentary, the fact that there are no pilasters or columns folded into the southeast corner, and the seeming lack of bases for the columns, indicates that like the

13. Felletti Maj, *Volte Dipinte e Pareti Gialle*, 52.
14. Fritz Wirth, *Römische Wandmalerei vom Untergang Pompejis bis ans Ende des dritten Jahrhunderts* (Berlin, 1934), 104–106, "A.D. 160–170."
15. Carlo C. van Essen, "Studio cronologico sulle pitture parietali di Ostia," *Bullettino della Commissione archeologica comunale di Roma* 76 (1956–1958): 163, "period of Antoninus Pius" (A.D. 138–160).

FIGURE 221. Detail of a maenad in the Severan panel–style painting of tablinum 8 in the House of the Yellow Walls.

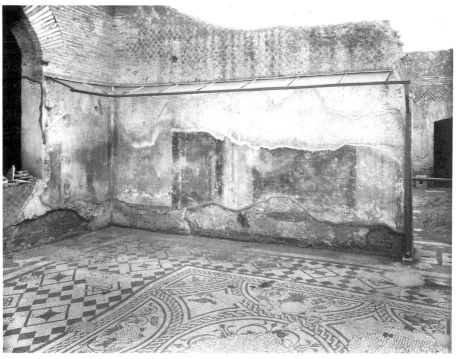

FIGURE 222. An old photograph reveals the fluted columns of a Severan-period architectural scheme in triclinium 7.

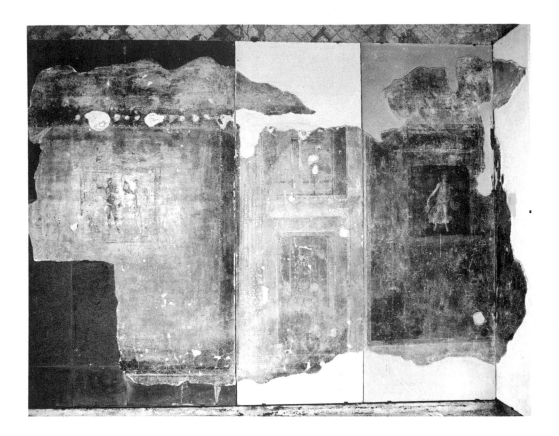

FIGURE 223. The tablinum's north wall alternates panels with columns.

columns of the House of the Painted Ceiling they probably did not support an architrave.

Enough remains of the wall painting on the east and north walls of room 8 to determine that it, too, had an architectural scheme intermixed with panels. On the north wall a fluted column flanks the wall's centerpiece, a gold panel with a central painting of the battle between Hercules and Achelaos (Fig. 223). Two small vertical panels follow, with a large red panel completing the scheme on the far right. This last has a maenad (see Fig. 221) walking to the viewer's right, holding a tambourine in her left hand. On the east wall little remains other than a fragment of a porphyry-red panel framed in green against a gold ground, located on the far south portion of the wall. Placed off center is the image of a naked, half-bald Silenus with a wineskin.

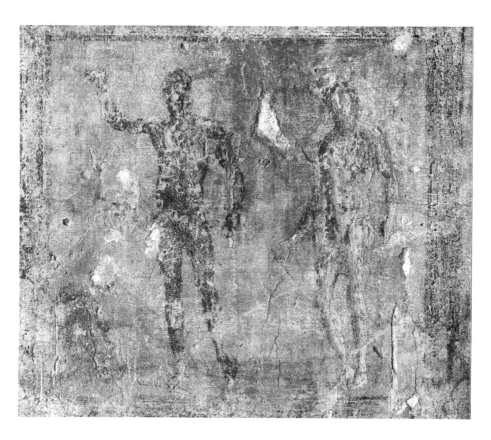

FIGURE 224. The central picture of the north wall: Hercules has defeated Achelaos.

Although found in a ruined state, the central mythological picture is not without interest (Fig. 224). Hercules, identified by the club in his left hand and the lion skin in the lower left corner, triumphantly holds the river god's left horn in his right hand. The battle is already over; strength has already left Achelaos, painted in the light flesh tones reserved for women. A few attributes and the figures' poses and colors both identify them and tell the story; this essentially economical, presentational mode is a far cry from the elaborately staged and costumed theatrical scenes characteristic of Fourth-Style painting.

These two wall-painting schemes in the House of the Yellow Walls share with tablinum 8 of the Inn of the Peacock the prevalence of the figured panel over the fictive architecture. The panels outweigh the columns in this syntax, yet their very presence here, as well as the use of the central picture on room 8's

north wall, indicates an aesthetic poised between the conservatism of the Old Master of the Inn of the Peacock and the trendiness of the New Master. With the linear-style decorations in both houses the break with tradition was dramatic and undeniable.

THE LINEAR STYLE: TRIUMPH OF ABSTRACTION OR DECLINE?

No fine examples of the Linear Style have survived at Ostia; one must turn to catacomb painting or to the Villa Piccola under the church of San Sebastiano in Rome to get a sense of its aesthetics (Fig. 225). The best description is Hetty Joyce's:

> The panels are painted wherever and however they fit. A *horror vacui* seems to have taken possession of the decorator, so that every niche and angle is filled, if not by motifs taken from the standard repertory, then by a dash, arc, or angle, with the result that the eye rests nowhere. Even the orthogonals that do organize the decoration appear lost and tangled in the cobwebs which cover the wall.[16]

Wirth's appreciation of this same decoration, although somewhat more reverent, reaches the same conclusion: in place of the rational division of space by fictive architecture, or even by panels that covered the walls, the linear style makes the walls and ceilings vibrate with competing stripes against the white ground.[17] The German term for the linear style, *Streifendekoration,* or "striped decoration," emphasizes the fact that in good examples of this style, the lines are doubled, typically in the colors red and green. The optical vibration of these complementary colors increases the wall painting's restlessness, which is already activated by the skein of competing lines on the white background.

How could wall decoration change so rapidly and so radically? Examination of the two traditions, the long-standing tradition of the all-white room and the more recent development of the panel style, shows that this change was neither sudden nor revolutionary.

All-white rooms began with Nero's Domus Aurea and were immediately copied in houses like that of Octavius Quartio (see Pl. 11). By the time of Hadrian, their representations of the scaenae frons become reduced to elegant schemes of aediculae with single figural motifs in their centers (see Fig. 172). The Severan panel style loosened up the axial symmetry and rectilinear grids

16. Hetty Joyce, *The Decoration of Walls, Ceilings, and Floors in Italy in the Second and Third Centuries A.D.* (Rome, 1981), 44.
17. Wirth, *Römische Wandmalerei,* 166.

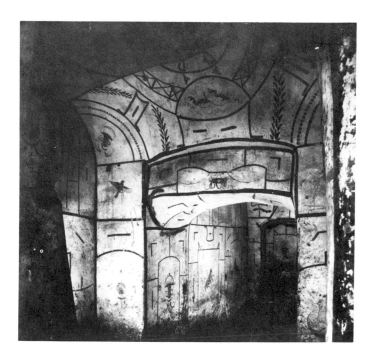

FIGURE 225. The Linear Style in the Villa Piccola under San Sebastiano: abstraction of architecture in optically vibrating red and green stripes.

that had been the rule for centuries, so that now the artist's touch was evident in the freehand division of the wall surface into panels. What could have been more daring and stimulating than to put the two together in a scheme of obviously improvised panels and aediculae vibrating on an airy white background? The linear style must have been seen as a reaction against the style that had insisted on filling the walls with gold and red panels for almost a century.

Wall and floor decoration follow the model of fashion rather than that of high art;[18] change is more rapid and less permanent than in easel painting or sculpture. Our own century saw a startling all-white revolution in interior decoration in the 1950s and 1960s that seems to have been inspired by Betty Parsons's all-white art gallery in New York in the mid-1940s. In the 1970s postmodern interior decoration mined the recent past for colors and shapes ranging from thirties Art Deco to fifties *moderne*. If there is a rationale for the origin of the Severan linear style, it cannot be that money ran out and times were

18. George Kubler, *The Shape of Time* (New Haven, 1962), 38–39, 101.

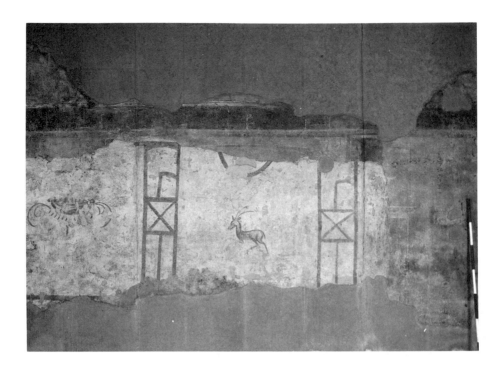

FIGURE 226. A mediocre reflection of the Linear Style painted over the Antonine decoration of cubiculum 4 in the House of the Yellow Walls.

tough—the tack taken by Meiggs. No one can deny that Ostia experienced a decline after 235; the many maladroit versions of the linear style on its walls bear witness to the city's reversed economic fortunes rather than to a widespread decadence in wall painting. The fragment of the linear-style wall preserved in the House of the Yellow Walls (Fig. 226) shares some of the characteristics of the finer decoration of the Villa Piccola under San Sebastiano, particularly the aediculae painted in broad, freehand stripes framing rapidly sketched animal and vegetal central motifs, but it represents an impoverished reduction rather than a reflection of the full-blown linear style. The same is true of room 14 of the Inn of the Peacock (Fig. 227), painted around 250 when the house became a caupona. Even though its red-and-green striped decoration has greatly deteriorated since the room's excavation, the source is in rooms like those of the Villa Piccola. The skeletal aedicula-based scheme frames familiar motifs, including the orb above a foliate crown employed in several panels of room 8 and corridor 6. At best, room 14 is a distant reflection of a style that, in the hands of expert painters, must have pleased wealthy Roman patrons with its novelty.

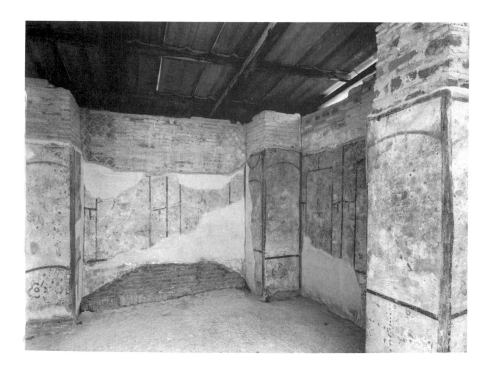

FIGURE 227. This Linear-Style decoration dates to the mid-third century, when the previously decorated private house was converted to a caupona.

Ostia's heyday was over by the time the Inn of the Peacock got its new linear-style decoration, and time has not preserved a more prosperous Italian city to fill in the gap between 250 and the period between 350 and 400, when Ostia experienced a brief renewal.[19] Just as the focus of imperial attention shifted away from Rome to four new capitals in the period of the Tetrarchy, so the history of Late-Antique decorative ensembles lies in sites beyond the regions of central Italy: in Sicily, North Africa,[20] Greece, Turkey, and the Middle East, as well as in the northern provinces in modern-day Germany, France, and England. At this turning point in the politics and fortunes of the city of Rome, this history of decorative ensembles in Roman Italy concludes. Fashions in wall, floor, and ceiling decoration, in their humble way, also followed the vicissitudes of Rome.

19. Giovanni Becatti, "Case ostiensi del tardo impero," *Bollettino d'arte* 33 (1948): 117–221.
20. For an excellent characterization of North African domestic architecture, see Yvon Thebert, "Private Life and Domestic Architecture in Roman Africa," in *From Pagan Rome to Byzantium*, vol. 1 of *A History of Private Life*, ed. Paul Veyne (Cambridge, Mass., 1987), 313–409.

CONCLUSION

By focusing on a small number of houses over a long period of time, this study has emphasized both the distinctive characteristics of their spaces and their decoration and the persistence of decorative traditions over the centuries. Modern attempts to arrive at precise chronologies for the various styles of decoration have ignored the particular and the traditional in order to arrive at universal dating criteria based on the analysis of "systems of decoration."[1] Such studies have tended to exclude the peculiarities of the patrons, the decorators, and the houses themselves in an effort to show how formal characteristics, often epitomized by some sort of least common denominator (such as organization around a central aedicula or the appearance of concentric patterns), constituted the "style" at a given time. This study has examined representative decorative ensembles in the context of the function and arrangement of the spaces they adorned and in light of the meanings these decorations may have had for the patron. With this methodology patterns of continuity in both iconography and decorative systems appear.

RITUAL AND SPACE

Few houses in this study fit the ideas of the ritual spaces gleaned from a close reading of ancient sources. By the first century B.C., strictly patriarchal houses seem to have been few in number at Pompeii and Herculaneum. In this period the atrium came to be thought of as an anteroom to the Hellenistically inspired

1. The most recent of these, Alix Barbet, *La peinture murale romaine: Les styles décoratifs pompéiens* (Paris, 1985), covers the period of the Four Styles only but has the virtue of emphasizing coordination of wall and ceiling decoration. For a rather astounding list of errors in the book, however, see Mariette de Vos, *Dialoghi di archeologia*, ser. 3, vol. 4 (1986): 309–313.

rooms around the peristyle. A hundred years later, the House of the Vettii dispensed with the tablinum entirely, converting the great oecus q into a dual-purpose room serving the rituals of both the salutatio and the convivial feast. Perhaps the House of Octavius Quartio goes furthest among the houses in this study in shifting ritual focus to the garden, although comparison of the House of the Mosaic Atrium with the House of the Stags points to a different kind of ritual taking over the function of the focal patriarchal tablinum: the owner of the House of the Stags abandons the traditional axis to command the cherished view out to the sea.

Smaller, less regular houses at Pompeii and Herculaneum force us to enlarge our conception of ritual toward the notion of habitual, rather than prescribed, use. The elegant House of Neptune and Amphitrite provides the entering visitor with a long axial view through the tablinum, but the tablinum is so tiny that it must have served merely to mark the view rather than to receive guests. Pressures of population density forced the builders of the House in Opus Craticium to rethink priorities: instead of the view-through with the axis marking rituals of entrance, circulation, and reception, builders designed rooms that provided the basics: light, air, circulation, and privacy.

By the time the House of the Muses was built, the experimental spatial rearrangements of the late first century had resulted in the brick-faced concrete apartment house, a malleable alternative to the single-family domus and the jerrybuilt tenement that took as many forms as the inventiveness of the architect and the budget of the owner allowed. Instead of identifying spaces that housed the rituals associated with the atrium, tablinum, and triclinium of old, the student of Roman architecture must search for survivals of spatial patterns, as Watts has done in her admirable study.[2] Whereas the rich owner of the House of the Muses was able to combine the elegance of the peristyle with a clear axis between the largest reception room and the precious Room of the Muses, he or she had to sacrifice the pattern of the on-axis sequence from the fauces to the tablinum that had characterized the domus. And while the medianum created abundant light and air for the more modest House of the Yellow Walls, its placement in relation to both the entry and the house's two best rooms meant changing the traditional paths that both owner and visitor took when entering the house and using its rooms. It is logical to see in these second-century houses at Ostia the traces of rituals that changed with shifting economic and social forces; the nature of these changes can only, it seems, be understood on a case-by-case basis. If they resist attempts, like those of Felletti

2. Carol Martin Watts, "A Pattern Language for Houses at Pompeii, Herculaneum, and Ostia," (Ph.D. diss., University of Texas at Austin, 1987), 307–368.

Maj,[3] to read into them the ritual use associated with the Republican Roman house, they give us a glimpse of the Romans' practicality and modernity.

ICONOGRAPHICAL AND DECORATIVE CONTINUITIES FROM POMPEII TO OSTIA

The supposed decadence of post-Pompeian decoration has much more to do with the scarcity and poor state of preservation of the material evidence than with a decline in the skills of the decorators. Whereas Rome provides high-quality decoration from the First, Second, and early Third Styles, nothing of a like quality has survived from the second and third centuries. Long and careful looking at fair- to good-quality wall painting of the second and early third centuries at Ostia Antica reveals the endurance of the iconographical motifs inherited from the first-century decorations: maenads, pans, satyrs, and Dionysus; muses, poets, philosophers, and Apollo; central pictures presenting sometimes novel representations of the Olympian deities; others recalling well-known myths. In one case, in the House of the Muses, an interpretation more sophisticated and nuanced than any Pompeian example underscores the originality, or at least the striving for "correctness," of the artists who conceived it.

Perhaps even more surprising is the endurance of decorative schemes. The conceit of transforming a room into a columned pavilion makes its debut in the beginning of the first century B.C., develops in the Second Style, and does not disappear until the second quarter of the third century of our era. True, elements of the original schemes, such as the omnipresent columns or pilasters folded into the corners, or even the illusionistic architraves they seemed to support, are often omitted. Nevertheless, both the spatial illusion and the regal associations of the fictive colonnade endure.

Like the colonnaded pavilion, the aedicula as a central focus, introduced in the dawning of the age of Augustus, survives all the vicissitudes of wall decoration in Roman Italy. Whether appearing alone in the center of a wall to frame pictures or repeated as a modular decorative unit without a central focus, the aedicula never disappears. Even the perversely abstract schemes of the Severan linear style pay homage to the aedicula.

Many decorative motifs that appear at Pompeii make their way to Ostia in the black-and-white mosaics that complemented wall and ceiling painting. Since mosaic pavements have survived throughout the Roman empire in far

3. For instance, in Bianca Maria Felletti Maj, "Ostia, la Casa delle Volte Dipinte: Contributo all'edilizia romana imperiale," *Bollettino d'arte* 45 (1960): 45.

greater numbers and over a much longer period than corresponding wall decorations, it is possible to envision a repertory of motifs shared by mosaicists far beyond the confines of Roman Italy. To cite one example, the motif of the eight-pointed lozenge star alternating with Solomon's knots and swastikas paving the Room of the Muses (see Pl. 20) appears in Tunisia in the third century[4] and again in the sixth.[5]

Although the black tessera, made of basalt or *selce*, and the white limestone or marble tessera remain the primary materials of mosaics from Pompeii to Ostia, they increase in size from the first through the third centuries. As a general rule, in decorative pavements Pompeian tesserae keep well under a centimeter on each side, increasing to 1.2 centimeters in the second century, and reaching an average of around 2 centimeters in the late second and early third centuries. Accompanying these largest tesserae of the last period were designs conceived as contrasting shapes rather than linear patterns. These shape-generated designs could be easily carried out with any size tesserae, unlike the intricate linear patterns of the Hadrianic period that required smaller and more precisely cut tesserae.

CHANGES AND CONTINUITY IN TECHNIQUE AND DIVISION OF LABOR

Shortcuts such as the use of larger tesserae in floor mosaics and the adoption of a uniform white ground in the painting of the Severan linear style would have both speeded up the work and reduced the time needed by the master mosaicist (*musivarius*) and the picture painter (*imaginarius*). Yet these specialists were still clearly divided from less skilled craftsmen, since the very proof that hierarchies existed comes from an imperial edict of 301.[6] Both economic and aesthetic considerations seem to have eliminated figural emblemata, particularly polychrome ones, from the houses of the second and third centuries at Ostia. Elsewhere in the Empire, particularly in North Africa, they develop and begin to flourish in this same period. While obviously more economical to execute both by reason of the materials and required skills, the black-and-white mosaics also seem to have been conceived as sober complements to the brightly colored wall and ceiling decorations.[7]

4. Nabiha Jeddi, "La Maison de Dionysus à Thaenae," in *Acts of the Fifth International Colloquium on Ancient Mosaics*, Bath, 5–12 September 1987 (in press).

5. Mongi Ennaifer, "La mosaïque africaine à l'époque medievale," in *Acts of the Fifth International Colloquium on Ancient Mosaics*, Bath, 5–12 September 1987 (in press).

6. Tenney Frank, *An Economic Survey of Ancient Rome* (Baltimore, 1940), 5:338–339. This interpretation is followed by Eugenio La Rocca, Mariette de Vos, and Arnold de Vos, *Guida archeologica di Pompei*, ed. Filippo Coarelli (Milan, 1976), 63.

7. Hetty Joyce, *The Decoration of Walls, Ceilings, and Floors in Italy in the Second and Third Centuries A.D.* (Rome, 1981), 113–114, notes that the black-and-white mosaic patterns themselves are often jarring in their contrast of black and white.

At Ostia there is ample evidence for the continued division of labor between picture painters and ordinary wall painters. Since figures and pictures were no longer executed entirely in fresco technique, one cannot find seams separating the plaster of the decorative portions of a wall from that beneath figures or central pictures. But the figural elements added in secco, like those of the central picture of Jupiter, Ganymede, and Leda of the House of Jupiter and Ganymede (see Fig. 207), often rest on rapidly sketched outlines executed in porphyry-red paint. These rapid sketches have taken the place of the lines incised in the still-damp plaster routinely used by picture and figure painters of the Fourth Style, like the master of the Menander in the House of the Menander (see Fig. 106). In the Room of the Muses two different schemes of illumination, one for the figures and another for the decorative background, betray a division of labor between the painter responsible for the decorative framework and the figure painter.

LOCATION OF IMAGERY

An enduring pattern in the houses of Roman Italy is that of functional hierarchy. From the early domus through the late insula, dynamic circulation spaces consistently receive simpler decoration than static rooms. Within the hierarchy, reception and dining rooms, meant to impress guests, received the best decoration. Here the pavements are richest, and the wall and ceiling schemes are as fine as the owner could afford, with architectural perspectives, central pictures, complex decorative schemes, and figural imagery painted by specialists. Bedrooms occupied a position in between the regally decorated reception spaces and the circulation spaces, sometimes embellished with erotic pictures meant for private viewing.

Perhaps no art is more private than erotic art, especially when created for a domestic context. The notion that the House of Jupiter and Ganymede became a gay hotel arises primarily from analysis of the most important painting in its major space—a unique painting with specific homoerotic meanings. Viewed in the context of Roman wall decoration of the Imperial period, this image both fits into a frequently evoked genre and forms an exception to the rule that seems to have limited wall paintings to images of heterosexual dalliance.

The finest erotic paintings come from cubicula D and E of the Villa under the Farnesina.[8] Meant to be seen by the couples who slept there, the paintings both form part of an elegant late Second-Style decoration and underscore the

8. Irene Bragantini and Mariette de Vos, *Le decorazioni della villa romana della Farnesina*, Museo Nazionale Romano, vol. 2, pt. 1: Le pitture (Rome, 1982), room D: 189, pls. 85–86; room E: 285–286, pl. 174.

relation of this subject to the room's function. Whatever the source for this practice of illustrating acts of lovemaking in little bedroom paintings, it is a tradition with a long life. The cubiculum in the southwest part of the House of the Centenary at Pompeii has two explicit scenes of sexual intercourse in a bedroom,[9] and as late as A.D. 250 similar pictures adorned bedroom 5 of the House of the Painted Vaults.[10]

An interesting variation on these *Kama-Sutra*–like pictures of couples— presumably married ones—enjoying the pleasures of sex are the more explicit paintings from Pompeii's lupanar. These paintings are more like advertisements of what was available to clients than marital aids for couples and are executed in a frank and artless way, with a reduced palette and a minimum of ambience.[11] Nevertheless, room x^1 of an elegant private house, that of the Vettii, received three paintings in this exact style, perhaps by the same artist (see Fig. 130).[12] Both the poor quality of the painting and the room's location, in a cul-de-sac next to the kitchen, suggest that the paintings were meant for the eyes of a favorite servant (perhaps the cook) rather than for the masters of the house.

The varying quality of the wall painting, from the naive scrawlings of the lupanar artist to the elegant boudoir painting of the Farnesina painter—as well as a great number of portable objects—proves that erotic representations crossed class boundaries.[13] Nevertheless, the prominent placement, large size, and homoerotic subject matter of the Jupiter and Ganymede painting form an exception to the norm for erotic painting in private houses.

PATRONAGE

When rich and varied choices of imagery can be analyzed with information, however incomplete, about the owner, decoration provides a profile of the individual(s) who commissioned it and lived with it. Such is the case with the houses decorated in Pompeii's last few decades: the Trimalchio-like Vettii,

9. Michael Grant, *Eros in Pompeii* (New York, 1975), 36; Arnold de Vos and Mariette de Vos, *Pompei Ercolano Stabia*, Guida archeologica Laterza, no. 11 (Rome, 1982), 213; plan, 215; Irene Bragantini, Franca Parise Badoni, and Mariette de Vos, eds., *Pompei, 1748–1980: I tempi della documentazione*, exh. cat., Pompei and Rome (Rome, 1981), 174, fig. 36B.
10. Bianca Maria Felletti Maj, *Le pitture della Casa delle Volte Dipinte e della Casa delle Pareti Gialle*, Monumenti della pittura antica scoperti in Italia, sec. 3, Ostia fasc. 1–2 (Rome, 1961), 38, dates these paintings to A.D. 240–250, illustrated in figs. 8 and 9, pls. 5, 1 and 6, 3.
11. Grant, *Eros in Pompeii*, 32–33.
12. See also Grant, *Eros in Pompeii*, 52.
13. E.g., the sophisticated representations of lovemaking on fine silver vessels from the Augustan period: in the silver hoard of the House of the Menander, Amedeo Maiuri, *La Casa del Menandro e il suo tesoro di argenteria*, 2 vols. (Rome, 1933), 1:321–330, figs. 125–128; 2:pls.

freedmen whose eclectic and tendentious choices betray their desire to impress their clients and guests with their newly won wealth and erudition; or Octavius Quartio, whose wide-ranging enthusiasms inspired him to convert his backyard into a mini-Nile and his dining room into a hero's hall.

Efforts by scholars to reconstruct lost original paintings on the basis of the pictures that formed the foci of wall decorations prove that patrons were rarely aware of the models; they readily accepted corrupted, conflated, or simply fashionable versions of themes and imagery made famous by works of the great Greek masters of the fifth and fourth centuries.[14] The three paintings of theatrical moments from the Fall of Troy in the House of the Menander point to a patron whose interest in the subject must have come from popular contemporary dramas rather than from a precise reading of literary texts. Yet some sort of literary guide inspired the patron who commissioned the Room of the Muses, since the goddesses appear in the canonical order of Hesiod. In the House of Jupiter and Ganymede grafitti and the unusual iconography of the best room's central picture point to the owner's, or perhaps his clients', gay identity.

UTILITAS, DECOR, AND OSTENTATION

The ideal espoused by Vitruvius for the proper decoration of a domus was a marriage of *utilitas* and *decor:* pavements, walls, stucco moldings, and ceilings should be both pleasing to the eye and practical.[15] In theory this was all very well, but the practice often contradicted common sense in favor of making a splashy effect. Although wall painters followed Vitruvius's practical admonitions, such as avoiding the use of costly cinnabar red in peristyles or other areas where light would blacken it and preparing their surfaces with at least three of the prescribed layers of plaster, the subjects they painted on the walls and the perspective effects they produced often went beyond the bounds of Vitruvian probity. The smaller the house the greater the danger of placing overblown decoration in spaces too small to hold it.

The history of the Second Style represents a coming-to-terms with the fact

31–35; the silver vessel discussed above (see Fig. 202) is, like the Menander cups, Augustan in style and meant for a cultured, wealthy patron. In the same period numerous Arretine-ware vessels with erotic representations were manufactured for persons of slenderer means. On an even less-refined level belong the ubiquitous lamps with artless scenes of coupling that may have been meant for illuminating bedchambers; seven examples pictured in Grant, *Eros in Pompeii,* 106–107.

14. Notable examples include Georg Lippold, *Antike Gemäldekopien* (Munich, 1951); Peter H. von Blanckenhagen, "Daedalus and Icarus on Pompeian Walls," *Römische Mitteilungen* 75 (1968): 106–143.

15. Vitruvius *De architectura* 1.2.5, for definition of *decor;* 1.3.2, for the principles of *firmitas, utilitas,* and *venustas* (or strength, utility, and grace); 6.5.3, for *decor* in relation to the status of the owner.

that the walls of rooms in houses were relatively small, flat surfaces that could carry only a limited burden of illusionistic perspectives without straining the credibility of the viewer. Mosaic pictures on the floor proved impractical for different reasons: they created illusionistic holes that both disturbed the flatness of the surface underfoot and provided imagery that was difficult to view. With the advent of the Third Style pictures migrated to the walls, and the Roman patrons were quick to seize this new opportunity to embellish their spaces with imagery.

Although the picture painter's products were a far cry from the famous masterpieces of the past they imitated, they seemed to have satisfied their patrons' desires. Although we can only guess at the nature of those wishes from the subject matter of pictures from Pompeii, Herculaneum, and Ostia, it is safe to say that these artists' approximations were concerned first with subject matter and second with the style of the original. Free and often clumsy imitations of their models in the art of Apelles or Zeuxis, contaminated by generations of copyists' additions and omissions, these wall decorators' pictures seemed to have pleased their patrons when they telegraphed the essentials of a scene from Euripides or an Ovidian metamorphosis.

Seen from this point of view of Roman homeowners, Vitruvius's dismay at the new fashions in wall painting was reactionary. From the invention of the Third Style on, the desire for showy effects and ostentation made homeowners avid buyers of both these pictures and the intricate decorative systems that framed them. Utility, common sense, and good taste had nothing to do with it; the owner wanted to outdo his or her peers.

The men and women who lived in the houses that accidents have preserved for us lived in a world connected by very thin threads of resonance to ours. They worked, feasted, loved, and died in their houses surrounded by images of their gods and goddesses, their myths, their stories, and their fantasies. For them, like us, decoration was meant to delight and amuse the occupants, to impress guests, and to provide a background for the owner's daily routine. But we have seen that it is a mistake to imagine the Roman house to be like the modern home, a private retreat for the family, removed from the workplace. In the Romans' preindustrial society, the house embraced most business activities, ranging from the routine greeting of a distant client to the intimate private meeting with a social equal. These extended uses of the Roman house gave rise to architectural and decorative forms that were much more focused and loaded in their meanings than ours.

Forces of religion and superstition, as well as rituals of domestic worship and business, inform the arrangement of spaces and the imagery decorating the Roman house. We no longer believe so much in the power of painted and sculp-

tured images. Although we encode our spaces with hierarchies, have pictures on our walls and perhaps sculpture on pedestals, the imagery we attend to is very different from that of the ancient Romans: it is the sound and video of the electronic media, with their ever-changing but somehow consistently vapid imagery. The "talking" decoration of the houses of Roman Italy takes us back to a world where religious, business, and social rituals still lived within the home, so that the spaces of ancient Roman houses and their decoration speak to us not only of the past but also of fundamental transformations in human consciousness.

GLOSSARY

Most Latin and Greek words appear with their plurals; Greek, French, and Italian terms are so labeled.

acroterium (*-a*) sculpture or ornament that crowns the apex and angles of a pediment

aedicula (*-ae*) pavilionlike structure, modeled on a temple front, used by itself, or to frame a picture or figure

ala (*-ae*) the wing of the atrium, a recess or recesses located at its sides

ambulacrum (*-a*) a corridor

amicus (*-i*) literally, "friend"; the social and political ally of the paterfamilias

amphithalamos (*-oi*) bedroom with two alcoves for beds (Greek)

amphora (-ae) conical storage vase with two handles

anta (*-ae*) piers framing openings

apodyterium (*-a*) dressing room of the bath

arca (*-ae*) strongbox

archaistic recalling art of the Greek archaic period (sixth century B.C.)

architrave horizontal beam or lintel supported by the capitals of the columns; the lower member of the entablature

arcuated a structure using arches

ashlar masonry consisting of rectangular blocks laid in horizontal courses

atriolo little or secondary atrium (Italian)

atrium (-a) central hall of the domus, usually having a single central opening in the roof to capture rain water

	(compluvium) with a corresponding catch basin in the floor beneath (impluvium)
aula (*-ae*)	great hall
aulea (*-ae*)	hanging or swagged drapery
bacchant	follower of Dionysus (Bacchus)
basilica (-ae)	public building, often used for legal hearings
biclinium (*-a*)	dining room designed for two couches (klinai); *see* triclinium
bucranium (*-a*)	sacrificed oxen's skull used as an ornament
bulla (*-ae*)	amulet worn by Roman boy
caldarium (*-a*)	the hot room of the bath
cartibulum (*-a*)	marble table often found in atrium
caryatid	figure employed as architectural support, often in place of column
castrum (*-a*)	Roman camp
caupona (*-ae*)	tavern
cinaedus (*-i*)	male homosexual
cithara (-ae)	a kind of lyre
clientela	the clients or dependents of a paterfamilias
cocciopesto	red cement floor made with crushed terra-cotta (Italian); opus signinum
columns *en ressaut*	columns placed in front of the supporting wall to form a decorative screen; they carry an entablature but do not support the building (French)
compluvium	opening in the roof of the atrium designed to catch rain water
cryptoporticus (*-i*)	underground or partially hidden corridor
cubiculum (*-a*)	bedroom
dentils	a row of little cubes decorating the underside of a cornice
diaeta (*-ae*)	a daytime resting room, often with a view; belvedere
diptych	a picture with two panels
domina	mistress of the house
dominus	master of the house
domus (*-us*)	the traditional atrium house, especially of the Republican period
emblema (*-ta*)	a transportable mosaic, made of fine tesserae (*see* opus vermiculatum) on a terra-cotta or travertine tray, for insertion into a floor

entablature	the horizontal structure carried by a colonnade, consisting of architrave, frieze, and cornice
euripus (*-i*)	a decorative canal in a garden
exedra (-ae)	a rectangular or semicircular room fully open on one side and usually located on the peristyle
fastigium (*-a*)	a decorative temple front, with columns, architrave, and pediment
fauces	(plural), literally, "jaws"; the entryway passage of a house
fresco	wall painting in which the pigment is applied to the wet plaster so that it is incorporated (carbonated) into the final plaster layer (Italian)
frigidarium (*-a*)	the cold room of the bath
gens (*-tes*)	clan; extended family of the paterfamilias
gynaeceum (*-a*)	a separate area of a house reserved for women
herm	stone pillar topped by sculpted head or torso
hermaphrodite	person with both male and female sexual characteristics
hippocamp	sea horse
hortus (*-us*)	garden
imago (*-ines*) *clipeata* (*-ae*)	portrait painted or sculpted on a shield
impluvium (*-a*)	catch basin in center of atrium floor to receive water from the compluvium
insula (*-ae*)	city block; a multiapartment building
intrados	the inside surface of a vault
kline (*-ai*)	dining couch (Greek)
klismos (*-oi*)	chair (Greek)
lacunar	coffer; ceiling motif consisting of successively smaller recesses, often of square or rectangular shape; a coffered ceiling
lararium (*-a*)	shrine to the lares, and other household gods
lares	household gods, usually represented in pairs as youths wearing kilts and holding rhyta, worshiped in the lararium
lavapesta	black cement floor made from crushed lava (Italian)
loggia	second-floor open gallery surrounding a courtyard or room (Italian)
lunette	semicircular area formed by a vaulted ceiling
maenad	female devotee of Dionysus (Bacchus)

materfamilias	female head of the extended family
medianum (-a)	courtyard surrounded on three sides by the rooms of a house but lit by street-side windows on the fourth side
megalographia	wall painting representing large figures, often looking like statues on a platform
metope	one of the panels between the triglyphs in the frieze of an entablature of the Doric order
modius (-ii)	a bushel measure for grain
natatio (-nes)	swimming pool
nereid	female sea spirit
nymph	female water spirit living at springs, in the water
nymphaeum (-a)	decorative fountain or whole room dedicated to a fountain
oecus (-i)	reception room often used for dining and entertainment
opus craticium	wattle-and-daub construction
opus incertum	irregular facing for concrete wall made of fist-size stones; earliest Roman facing, ca. 150 B.C.–55 B.C.
opus sectile	floor or wall decoration made of marble cut into fancy shapes and figures
opus signinum	*see* cocciopesto
opus spicatum	pavement made of brick arranged in a herringbone pattern
opus tessellatum	mosaic technique employing tesserae of uniform size arranged in regular rows; literally, "woven style"
opus vermiculatum	mosaic technique employing tiny tesserae arranged in rows that imitate the brushstrokes of painting; literally, "wormlike style"
orthostate	a vertical panel or block in a real or imitation masonry wall
panisca (-ae)	female counterpart of a pan
paradeisos (-oi)	originally a lavish animal park; imitated in garden wall painting (Greek)
patera (-ae)	dish used for pouring libations
paterfamilias	male head of the gens, or extended family
patronus (-i)	benefactor, patron in the Roman patron-client relationship

pelta (*-ae*)	Amazon shield; decorative shield having a crescent shape with one or two scallops cut into its upper edge
penates	deities who protect the household
peristyle	garden or courtyard surrounded by a colonnade
pilaster	flat, vertical member projecting slightly from the wall and divided like a column into base, shaft, and capital
pinacotheca (*-ae*)	picture gallery
pinax (*-kes*)	panel painting, often with wooden shutters
plinth	base of a statue; lowest part of a painted wall, beneath the socle
pluteus (*-i*)	a low wall running between the columns of a peristyle
porphyry	a deep purple-red color (adj.)
porticus (*-i*)	a column-supported roofed space, open or partly closed
predella	narrow frieze between socle and median zone of a painted wall (Italian)
propylon	projecting entrance gateway
psyche (*-ai*)	female counterpart of Cupid, distinguished by her moth's wings
quadriporticus (*-i*)	a four-sided *porticus*, distinguished from peristyle because it lacks the colonnade
quoin	dressed stones at corners of a building, laid so that their faces are alternately large and small; bricks used in this manner
revetment	veneer
rhyton (*-a*)	horn-shaped drinking cup
rotulus (*-i*)	scroll
sacellum (*-a*)	shrine
sacro-idyllic	also sacral-idyllic; of a landscape painting picturing a mixture of bucolic scenes and rustic shrines
salutatio (*-nes*)	morning greeting of a client to the paterfamilias
scaenae (*-arum*) *frons* (*-tes*)	stage building of the Roman theater, decorated with columns, aediculae, and niches with statues
scendiletto (*-i*)	bedside runner or thin bedside carpet (Italian) (*-i*)
secco	in contrast to fresco painting; pigment added after the plaster has partially dried (Italian)
sinopia	in fresco painting, reddish brown drawing made on

	the penultimate layer of plaster to establish the main parts of the composition before the final layer of plaster is applied (Italian)
socle	bottom zone of a wall painting
stucco	fine lime plaster used for decorative work in relief
tablinum (*-a*)	main reception room of the domus, focal point of the axis running from the fauces through the atrium
tepidarium (*-a*)	the warm room of the bath
tessera (-ae)	the individual unit of the mosaic, made of stone or (more rarely) glass paste
thermopolium (*-a*)	tavern serving heated wine and food
tholus (*-i*)	small, round building, usually supported by columns
thyrsus (-i)	wand carried by devotees of Dionysus
triclinium (-a)	dining hall with three couches (klinai) arranged against the side and rear walls
triglyph	vertical block cut with three channels that alternate with the metopes in the entablature of the Doric order
trompe l'oeil	said of paintings that fool the eye by means of illusion (French)
tufa	a soft volcanic stone, tuff (Italian, *tufo*)
tympanum (-a)	triangular or semicircular field of a pediment
viridarium (*-a*)	an interior garden
volute	ornament resembling a rolled scroll, especially on the capitals of the Ionic order
xenium (*-a*)	gift of fine food offered to a guest upon arrival; a painting representing the food

BIBLIOGRAPHY

GENERAL

Adams, J. N. *The Latin Sexual Vocabulary*. London, 1982.

Alföldi, Andreas. "Gewaltherrscher und Theaterkönig. Die Auseinandersetzung einer attischen Ideenprägung mit persischen Repräsentationsformen im politischen Denken und in der Kunst bis zur Schwelle des Mittelalters." In *Late Classical and Mediaeval Studies in Honor of Albert Mathias Friend, Jr.*, edited by Kurt Weitzmann, 15–55. Princeton, N.J., 1955.

Andreau, Jean P. *Les affaires de Monsieur Jucundus*. Rome, 1974.

———. "Histoire des séismes et histoire économique: Le tremblement de terre de Pompéi (62 ap. J.-C.)." *Annales: Economies, sociétés, civilisations* 28 (1973): 369–395.

———. "Il liberto." In *L'uomo romano*, edited by Andrea Giardina, 186–213. Rome, 1989.

———. "Remarques sur la société pompéienne." *Dialoghi di archeologia* 7 (1973): 213–254.

Bastet, Frédéric. "*Fabularum dispositas explicationes.*" *Bulletin antieke Beschaving* 49 (1974): 206–240.

Bek, Lise. "Antithesis." In *Studia Romana in honorem Petri Krarup septuagenarii*, 154–166. Odense, 1976.

Beyen, Hendrick G. "Les *domini* de la Villa de la Farnesine." In *Studia varia Carolo Guilielmo Vollgraff a discipulis oblata*, 3–21. Amsterdam, 1948.

Bianchi-Bandinelli, Ranuccio. *Rome: The Center of Power*. New York, 1970.

Boyce, George K. "Corpus of the Lararia of Pompeii." *Memoirs of the American Academy in Rome* 14 (1937).

Bragantini, Irene, Franca Parise Badoni, and Mariette de Vos, eds. *Pompei, 1748–1980: I tempi della documentazione*. Exh. cat., Pompei and Rome. Rome, 1981.

Brendel, Otto. *Prolegomena to the Study of Roman Art.* New Haven, 1979.

Brilliant, Richard. *Visual Narratives: Storytelling in Etruscan and Roman Art.* Ithaca, N.Y., 1984.

Carrington, R. C. *Pompeii.* London, 1974.

Castrén, Paavo. *Ordo populusque pompeianus: Polity and Society in Roman Pompeii.* Acta Instituti romani finlandiae, no. 8. Rome, 1975.

Cerulli-Irelli, Giuseppina. "Le case di M. Fabio Rufo e di C. Giulio Polibio." In *Pompei, 1748–1980: I tempi della documentazione,* edited by Irene Bragantini, Franca Parise Badoni, and Mariette de Vos, 22–33. Exh. cat., Pompei and Rome. Rome, 1981.

Coarelli, Filippo. *Guida archeologica di Roma.* Verona, 1974.

D'Arms, John H. *Commerce and Social Standing in Ancient Rome.* Cambridge, Mass., 1981.

———. *Romans on the Bay of Naples.* Cambridge, Mass., 1970.

D'Avino, Michele. *The Women of Pompeii.* Translated by Monica Hope Jones and Luigi Nusco. Naples, 1967.

De Caro, Stefano. "The Sculptures of the Villa of Poppaea at Oplontis: A Preliminary Report." In *Ancient Roman Villa Gardens,* edited by Elisabeth B. MacDougall, 77–133. Washington, D.C., 1987.

Della Corte, Matteo. *Case ed abitanti di Pompei.* 3rd ed. Naples, 1965.

———. "I MM. Lorei Tiburtini di Pompei." *Atti e memorie della Società tiburtina di storia e d'arte* 11–12 (1931–1932): 182–216.

de Vos, Arnold, and Mariette de Vos. *Pompei Ercolano Stabia.* Guida archeologica Laterza, no. 11. Rome, 1982.

Dover, Kenneth J. *Greek Homosexuality.* Cambridge, Mass., 1978.

Enciclopedia dell'arte antica. Rome, 1961–.

Etienne, Robert. *La vie quotidienne à Pompéi.* Paris, 1962.

Frank, Tenney. *An Economic Survey of Ancient Rome.* Vol. 5. Baltimore, 1940.

Franklin, James L., Jr. *Pompeii: The Electoral Programmata: Campaigns and Politics, A.D. 71–79.* Papers and Monographs of the American Academy in Rome, no. 28. Rome, 1980.

Gazda, Elaine K. "A Marble Group of Ganymede and the Eagle from the Age of Augustine." In *Excavations at Carthage, 1977, Conducted by the University of Michigan,* vol. 7, edited by J. H. Humphrey, 125–178. Ann Arbor, Mich., 1981.

Giordano, Carlo. "Poppea e Nerone tra Oplontis e Pompei." *Sylva Mala* 3, nos. 1–6 (1982): 2–8.

Grant, Michael. *Eros in Pompeii.* New York, 1975.

Grimal, Pierre. *Les jardins romains à la fin de la république et aux deux premiers siècles de l'empire.* Paris, 1943.

Hamberg, Per Gustav. *Studies in Roman Imperial Art.* Uppsala, 1945.

Harmon, Daniel P. "The Family Festivals of Rome." In *Aufstieg und Niedergang der römischen Welt*, edited by Wolfgang Haase, pt. 2, vol. 16, no. 2, pp. 1592–1603. Berlin, 1978.

Heyob, Sharon Kelly. *The Cult of Isis among Women in the Graeco-Roman World*. Leiden, 1975.

Jashemski, Wilhelmina. *The Gardens of Pompeii, Herculaneum, and the Villas Destroyed by Vesuvius*. New Rochelle, N.Y., 1979.

Jung, Helmut. "Zur Vorgeschichte des spätantoninischen Stilwandels." *Marburger Winckelmann-Programm* (1984): 59–103.

Kähler, Heinz. *The Art of Rome and Her Empire*. New York, 1965.

Kaschnitz von Weinberg, Guido. *Die mittelmeerischen Grundlagen der antiken Kunst*. Frankfurt, 1944.

Keuls, Eva. *The Reign of the Phallus*. New York, 1985.

Kleberg, Tönnes. *Hôtels, restaurants et cabarets dan l'antiquité romaine*. Uppsala, 1957.

Kubler, George. *The Shape of Time*. New Haven, 1962.

La Rocca, Eugenio, Mariette de Vos, and Arnold de Vos. *Guida archeologica di Pompei*. Edited by Filippo Coarelli. Milan, 1976.

Ling, Roger. "Pompeii and Herculaneum: Recent Research and New Prospects." In *Papers in Italian Archaeology*, vol. 1, pt. 2, pp. 153–174. Oxford, 1978.

Marquardt, Joachim, and August Mau. *Das Privatleben der Römer*. Leipzig, 1886. Reprint. Darmstadt, 1964.

Mau, August. *Pompeii: Its Life and Art*. Translated by Francis W. Kelsey. Rev. ed. New York, 1902. Reprint. New Rochelle, N.Y., 1982.

McCann, Ann Marguerite. *Roman Sarcophagi in the Metropolitan Museum of Art*. New York, 1978.

McIlwaine, I. C. *Herculaneum: A Guide to Printed Sources*. Naples, 1988.

Meiggs, Russell. *Roman Ostia*. 2d ed., with corrections. Oxford, 1975.

Mingazzini, Paolino. "Una copia dell'Alexandros Keraunophoros di Apelle." *Jahrbuch der Berliner Museen* 3 (1961): 7–17.

Neudecker, Richard. *Die Skulpturen-Ausstattung römischen Villen in Italien*. Mainz, 1988.

Neumann, Gerhard. *Gesten und Gebärden in der griechischen Kunst*. Berlin, 1965.

Orr, David G. "Roman Domestic Religion: The Evidence of the Household Shrines." *Aufstieg und Niedergang der römischen Welt*, edited by Wolfgang Haase, pt. 2, vol. 16, no. 2, pp. 1557–1591. Berlin, 1978.

———. "Roman Domestic Religion: A Study of the Roman Household Deities and Their Shrines at Pompeii and Herculaneum." Ph.D. diss., University of Maryland, 1973.

Pallottino, Massimo. *The Etruscans*. Rev. ed. Bloomington, Ind., 1975.

Paulys Real-Encyclopädie der classischen Altertumswissenschaft. Edited by George Wissowa. Stuttgart, 1894–1978.

Pavolini, Carlo. *Ostia*. Guida archeologica Laterza, no. 8. Rome, 1983.

———. *La vita quotidiana a Ostia*. Rome, 1986.

Pollitt, Jerome J. *The Art of Greece, 1400–31 B.C.: Sources and Documents*. Englewood Cliffs, N.J., 1965.

———. *Art in the Hellenistic Age*. Cambridge, 1986.

———. *The Art of Rome, ca. 753 B.C.–337 A.D.: Sources and Documents*. Englewood Cliffs, N.J., 1966.

Pomeroy, Sarah B. *Goddesses, Whores, Wives, and Slaves*. New York, 1975.

Rice, Ellen E. *The Grand Procession of Ptolemy Philadelphus*. Oxford, 1983.

Richter, Gisela M. A. *The Portraits of the Greeks*. 2 vols. London, 1965.

Rostovtzeff, Mikhail. *The Social and Economic History of the Roman Empire*. 2d ed. Oxford, 1957.

Schneider, Lambert. *Die Domäne als Weltbild: Wirkungsstrukturen der spätantiken Bildersprache*. Wiesbaden, 1983.

Scully, Vincent. *The Earth, the Temple, and the Gods*. Rev. ed. New York, 1969.

Spinazzola, Vittorio. *Pompei alla luce degli scavi nuovi di via dell'Abbondanza*. 2 vols. Rome, 1953.

Stambaugh, John E. *The Ancient Roman City*. Baltimore, 1988.

Thompson, Lloyd A. *Romans and Blacks*. Norman, Oklahoma, 1989.

Toynbee, Jocelyn. *The Hadrianic Style: A Chapter in the History of Greek Art*. Cambridge, 1934.

Tran-Tam-Tinh, Victor. *Essai sur la culte d'Isis à Pompéi*. Paris, 1964.

Van Essen, C. C. "La découverte de la Domus Aurea." *Mededelingen van het Nederlands Instituut te Rome* 18 (1955): 291–308.

Wallace-Hadrill, Andrew. "The Social Structure of the Roman House." *Papers of the British School at Rome* 56 (1988): 43–97.

———, ed. *Patronage in Ancient Society*. New York, 1989.

Ward-Perkins, John, and Amanda Claridge. *Pompeii, A.D. 79*. 2 vols. Boston, 1978.

Weitzmann, Kurt. *Illustrations in Roll and Codex*. Princeton, N.J., 1947.

Wild, Robert. *Water in the Cultic Worship of Isis and Sarapis*. Etudes préliminaires aux religions orientales dans l'empire romain, no. 87. Leiden, 1981.

Winkes, Rolf. "Pliny's Chapter on Roman Funeral Customs in Light of the 'Clipeatae Imagines.'" *American Journal of Archaeology* 83 (1979): 481–484.

Wiseman, Timothy P. "*Pete nobiles amicos:* Poets and Patrons in Late Republi-

can Rome." In *Literary and Artistic Patronage in Ancient Rome,* edited by Barbara K. Gold, 28–31. Austin, 1982.

Witt, R. E. *Isis in the Graeco-Roman World.* Ithaca, N.Y., 1971.

Zanker, Paul. *Pompeji: Stadtbilder als Spiegel von Gesellschaft und Herrschaftsform.* Mainz, 1988.

———. *The Power of Images in the Age of Augustus.* Ann Arbor, Mich., 1988.

———. "Die Villa als Vorbild des späten pompejanischen Wohngeschmacks." *Jahrbuch des deutschen archäologischen Instituts* 94 (1979): 460–523.

ARCHITECTURE

Allroggen-Bedel, Agnes. "Der Hausherr der 'Casa dei Cervi' in Herculaneum." *Cronache ercolanesi* 5 (1975): 99–103.

Barbet, Alix. "Quelques rapports entre mosaïques et peintures murales à l'époque romaine." In *Mosaïque: Recueil d'hommages à Henri Stern,* edited by René Ginouvès, 43–53. Paris, 1983.

Becatti, Giovanni. "Case ostiensi del tardo impero." *Bollettino d'arte* 33 (1948): 117–221.

Bek, Lise. "Questiones conviviales: The Idea of the Triclinium and the Staging of Convivial Ceremony from Rome to Byzantium." *Analecta romana Instituti danici* 12 (1983): 81–107.

———. *Towards Paradise on Earth: Modern Space Conception in Architecture: A Creation of Renaissance Humanism. Analecta romana Instituti danici,* supplement 9. Rome, 1980.

———. "Ut ars natura—ut natura ars." *Analecta romana Instituti danici* 7 (1974): 109–156.

———. "Venusta species: A Hellenistic Rhetorical Concept as the Aesthetic Principle in Roman Townscape." *Analecta romana Instituti danici* 14 (1985): 139–148.

Blanckenhagen, Peter H. von. *Die flavische Architektur und ihre Dekoration.* Berlin, 1940.

Bloomer, Kent, and Charles Moore. *The Body, Memory, and Architecture.* New Haven, 1977.

Boëthius, Axel. *The Golden House of Nero.* Ann Arbor, Mich., 1960.

Brown, Frank E. *Roman Architecture.* New York, 1961.

Bruneau, Philippe. *L'Ilot de la Maison des Comédiens.* Exploration archéologique de Delos, no. 27. Paris, 1970.

Calza, Guido. "Gli scavi recenti nell'abitato di Ostia." *Monumenti antichi* 26 (1920): 322–430.

Calza, Guido, et al. *Scavi di Ostia*. Vol. 1, *Topografia generale*. Rome, 1953.

Carandini, Andrea, and Salvatore Settis. *Schiavi e padrone nell'Etruria romana*. Venice, 1979.

Carandini, Andrea, and Salvatore Settis, eds. *Settefinestre: Una villa schiavistica nell'Etruria romana*. 3 vols. Modena, 1985.

Chiolini, Paolo. *I caratteri distributivi degli antichi edifici*. Milan, 1959.

Clarke, John R. "Notes on the Coordination of Wall, Floor, and Ceiling Decoration in the Houses of Roman Italy, 100 BCE–235 CE." In *IL 60: Essays Honoring Irving Lavin on His Sixtieth Birthday*, edited by Marilyn Aronberg Lavin, 1–29. New York, 1990.

———. "Relationships between Floor, Wall, and Ceiling Decoration at Rome and Ostia Antica: Some Case Studies." *Bulletin de l'Association internationale pour l'étude de la mosaïque antique* 10 (1985): 93–103.

Coarelli, Filippo. "Architettura sacra e architettura privata nella tarda repubblica." In *Architecture et société*. Collection de l'Ecole française de Rome, no. 66 (1983): 191–217.

Cotton, M. Aylwin, and Guy P. R. Métraux. *The San Rocco Villa at Francolise*. Hertford, 1985.

De Albertiis, Emidio. *La casa dei romani*. Rome, 1990.

Drerup, Heinrich. *Zum Auststattungsluxus in der römischen Architektur*. Münster, 1957.

———. "Bildraum und Realraum in der römischen Architektur." *Römische Mitteilungen* 66 (1959): 145–174.

———. "Die römische Villa." *Marburger Winckelmann-Programm* (1959): 1–24.

Dwyer, Eugene. *Pompeian Domestic Sculpture: A Study of Five Pompeian Houses and Their Contents*. Rome, 1982.

Ecole nationale supérieure des beaux-arts. *Pompéi: Travaux et envois des architectes français au XIXe siècle*. Exh. cat., Naples and Paris. Rome, 1980.

Elia, Olga. "I cubicoli nelle case di Pompei." *Historia* 6 (1932): 412–417.

Felletti Maj, Bianca Maria. "Ostia, la Casa delle Volte Dipinte: Contributo all'edilizia privata imperiale." *Bollettino d'arte* 45 (1960): 45–65.

Ginouvès, René, and Roland Martin. *Dictionnaire méthodique de l'architecture grecque et romaine*. Vol. 1. Rome, 1985.

Harsh, Phillip. "The Origins of the Insulae at Ostia." *Memoirs of the American Academy in Rome* 12 (1935): 7–66.

Hermansen, Gustav. *Ostia: Aspects of Roman City Life*. Alberta, 1981.

Hoffmann, A. "Ein Rekonstruktionsproblem der Casa del Fauno." *Bericht Koldewey-Gesellschaft* (1978): 35–41.

Jung, Franz. "Gebaute Bilder." *Antike Kunst* 27 (1984): 71–122.

Lauter, Hans. "Les éléments de la *regia* hellénistique." In *Le système palatial en Orient, en Grèce et à Rome.* Actes du Colloque de Strasbourg, 19–22 June 1985, 345–355. Leiden, 1987.

Ling, Roger. "The Insula of the Menander at Pompeii: Interim Report." *Antiquaries Journal* 63 (1983): 34–57.

MacDonald, William L. *The Architecture of the Roman Empire.* Vol. 1. New Haven, 1965.

MacDougall, Elisabeth B., ed. *Ancient Roman Villa Gardens.* Dumbarton Oaks Colloquium on the History of Landscape Architecture, 10. Washington, D.C., 1987.

Maiuri, Amedeo. *La Casa del Menandro e il suo tesoro di argenteria.* 2 vols. Vol. 1, text; vol. 2, plates. Rome, 1933.

———. *Ercolano: I nuovi scavi (1927–1958).* 2 vols. Rome, 1958.

———. "Ginecèo e 'hospitium' nella casa pompeiana." *Memorie: Atti della Accademia nazionale dei Lincei,* ser. 8, vol. 5 (1954): 449–467.

———. *L'ultima fase edilizia di Pompei.* Rome, 1942.

———. *La Villa dei Misteri.* 2 vols. Vol. 1, text; vol. 2, plates. Rome, 1931.

Makaronas, Charalambos I., and Stella G. Miller. "The Tomb of Lyson and Kallikles." *Archaeology* 27 (1974): 248–259.

Mau, August. "Scavi di Pompei, 1894–95, reg. VI, isola ad E della 11 [Casa dei Vettii]." *Römische Mitteilungen* 11 (1896): 3–97.

Mielsch, Harald. *Die römische Villa: Architektur und Lebensform.* Munich, 1987.

Miller, Stella G. "Macedonian Tombs: Their Architecture and Architectural Decoration." In *Macedonia and Greece in Late Classical and Early Hellenistic Times.* Studies in the History of Art, no. 10, edited by Beryl Barr-Sharrar and Eugene N. Borza, 153–171. Washington, D.C., 1982.

Noack, Ferdinand, and Karl Lehmann-Hartleben. *Baugeschichtliche Untersuchungen am Stadtrand von Pompeji.* Berlin, 1936.

Packer, James E. "The Insulae of Imperial Ostia." *Memoirs of the American Academy in Rome* 31 (1971).

———. "Middle- and Lower-Class Housing in Pompeii: A Preliminary Survey." In *Neue Forschungen in Pompeji,* edited by Bernard Andreae and Helmut Kyrieleis, 133–146. Recklinghausen, 1975.

Purcell, Nicholas. "Town in Country and Country in Town." In *Ancient Roman Villa Gardens,* edited by Elisabeth B. MacDougall, 185–203. Washington, D.C., 1987.

Richardson, Lawrence, Jr. *Pompeii: An Architectural History.* Baltimore, 1988.

Sogliano, A. "La Casa dei Vettii in Pompei." *Monumenti antichi dell'Accademia dei Lincei* 8 (1898): cols. 233–416.

Thébert, Yvon. "Private Life and Domestic Architecture in Roman Africa." In *From Pagan Rome to Byzantium*, 313–409. Vol. 1 of *A History of Private Life*, edited by Paul Veyne. Cambridge, Mass., 1987.

Tran-Tam-Tinh, Victor. *La Casa dei Cervi a Herculaneum*. Rome, 1988.

Ward-Perkins, John. *Roman Imperial Architecture*. Harmondsworth, 1981.

Watts, Carol Martin. "A Pattern Language for Houses at Pompeii, Herculaneum, and Ostia." Ph.D. diss., University of Texas at Austin, 1987.

Watts, Donald J., and Carol Martin Watts. "A Roman Apartment Complex." *Scientific American* 255, no. 6 (December 1986): 132–139.

Wiseman, Timothy P. "*Conspicui postes tectaque digna deo:* The Public Image of Aristocratic and Imperial Houses in the Late Republic and Early Empire. In *L'urbs: Espace urbain et histoire (I^er siècle av. J.-C.–III^e siècle ap. J.-C.* Collection de l'Ecole française de Rome, no. 98 (1987): 393–413.

PAINTING AND STUCCO

Allag, Claudine, and Alix Barbet. "Les bordures ajourées dans le IV^e style de Pompéi." *Mélanges de l'Ecole française de Rome, Antiquité* 93 (1981): 917–942.

———. "Techniques de préparation des parois dans la peinture murale romaine." *Mélanges de l'Ecole française de Rome, Antiquité* 84, no. 2 (1972): 935–1069.

Allroggen-Bedel, Agnes. "Zur Datierung der Wandmalereien in der Villa Imperiale in Pompeji." *Bulletin antieke Beschaving* 50 (1975): 225–236.

Andersen, Flemming G. "Pompeian Painting: Some Practical Aspects of Its Creation." *Analecta romana Instituti danici* 14 (1985): 113–128.

Archer, William Carthon. "The Paintings in the Alae of the Casa dei Vettii and a Definition of the Fourth Pompeian Style." *American Journal of Archaeology* 94, no. 1 (1990): 95–123.

———. "The Paintings of the Casa dei Vettii in Pompeii." 2 vols. Ph.D. diss., University of Virginia, 1981.

Barbet, Alix. *Bolsena V, 2: La maison aux salles souterraines, décors picturaux*. 2 vols. Rome, 1985.

———. *La peinture murale romaine: Les styles décoratifs pompéiens*. Paris, 1985.

Bastet, Frédéric, and Mariette de Vos. *Proposta per una classificazione del terzo stile pompeiano*. Archeologische Studiën van het Nederlands Instituut te Rome, no. 4. The Hague, 1979.

Bergmann, Bettina. "Painted Perspectives of a Villa Visit." In *Roman Art in the Private Sphere*, edited by Elaine Gazda, 49–70. Ann Arbor, Mich., 1991.

Beyen, Hendrick G. "Die grüne Dekoration des Oecus am Peristyl der Casa del Menandro." *Nederlands kunsthistorisch Jaarboek* 5 (1954): 199–210.

———. "Pompeiani, stili." In *Enciclopedia dell'arte antica*, s.v.

———. *Pompejanische Wanddekoration vom zweiten bis zum vierten Stil.* Vol. 1. The Hague, 1938. Vol. 2. The Hague, 1960.

———. "Das stilistische und chronologische Verhältnis der letzten drei pompejanischen Stile." *Antiquity and Survival* 2, no. 4 (1958): 349–363.

———. "The Workshops of the 'Fourth Style' at Pompeii and Its Neighbourhood." In *Studia archaeologica Gerardo van Hoorn oblata*, 43–65. Leiden, 1951.

Bianchi-Bandinelli, Ranuccio. *Storicità dell'arte classica.* 2 vols. Florence, 1950.

Bieber, Margarete. "Die Mysteriensaal der Villa Item." *Jahrbuch des deutschen archäologischen Instituts*, vol. 43, pt. 1, no. 2 (1928): 298–330.

Blanckenhagen, Peter H. von. "Daedalus and Icarus on Pompeian Walls." *Römische Mitteilungen* 75 (1968): 106–143.

———. "Puerilia." In *In Memoriam Otto Brendel*, 37–41. Mainz, 1976.

Blanckenhagen, Peter H. von, and Christine Alexander. *The Paintings from Boscotrecase. Römische Mitteilungen*, Ergänzungsheft 6 (1962).

Borbein, Adolf H. "Zur Deutung von Scherwand und Durchblick auf dem Wandgemälden des zweiten pompejanischen Stils." In *Neue Forschungen in Pompeji*, edited by Bernard Andreae and Helmut Kyrieleis, 61–70. Recklinghausen, 1975.

Borda, Maurizio. *La pittura romana.* Milan, 1958.

Bragantini, Irene. "Tra il III e il IV stile: Ipotesi per l'identificazione di una fase della pittura pompeiana." In *Pompei, 1748–1980: I tempi della documentazione*, edited by Irene Bragantini, Franca Parise Badoni, and Mariette de Vos, 106–118. Exh. cat., Pompei and Rome. Rome, 1981.

Bragantini, Irene, and Mariette de Vos. *Le decorazioni della Villa romana della Farnesina.* Museo Nazionale Romano, vol. 2, pt. 1: Le pitture. Rome, 1982.

Bragantini, Irene, Mariette de Vos, and Franca Parise Badoni. *Pitture e pavimenti di Pompei.* Repertorio delle fotografie del Gabinetto Fotografico Nazionale. Istituto Centrale per il Catalogo e la Documentazione. 3 vols. Rome, 1981–1986.

Bruno, Vincent J. "Antecedents of the Pompeian First Style." *American Journal of Archaeology* 73 (1969): 305–317.

Carettoni, Gianfilippo. "La decorazione pittorica della Casa di Augusto sul Palatino." *Römische Mitteilungen* 90 (1983): 323–419.

Cerulli-Irelli, Giuseppina. "Le Case di M. Fabio Rufo e di C. Guilio Polibio." In *Pompei, 1748–1980: I tempi della documentazione*, edited by Irene Bragantini, Franca Parise Badoni, and Mariette de Vos, 22–33. Exh. cat., Pompei and Rome. Rome, 1981.

———. *Le pitture della Casa dell'Atrio a Mosaico*. Monumenti della pittura antica scoperti in Italia, sec. 3, Ercolano fasc. 1. Rome, 1971.

Clarke, John R. "The Decor of the House of Jupiter and Ganymede at Ostia Antica: Private Residence Turned Gay Hotel?" In *Roman Art in the Private Sphere*, edited by Elaine K. Gazda, 89–104. Ann Arbor, Mich., 1991.

———. "The Early Third Style at the Villa of Oplontis." *Römische Mitteilungen* 94 (1987): 267–294.

Coarelli, Filippo. "Discussione: Lettura ed interpretazione della produzione pittorica dal IV sec. a. C. all'ellenismo." *Dialoghi di archeologia* 2, no. 2 (1984): 151–155.

Croiselle, Jean-Michel. *Les natures mortes campaniennes: Répertoire descriptif des peintures de nature morte du Musée National de Naples, de Pompéi, Herculanum et Stabies*. Brussels, 1965.

Curtius, Ludwig. *Die Wandmalerei Pompejis*. Hildesheim, 1960.

Dacos, Nicole. "Fabullus et l'autre peintre de la Domus Aurea." *Dialoghi di archeologia* 2, no. 2 (1968): 72–87.

De Franciscis, Alfonso. "La villa romana di Oplontis." In *Neue Forschungen in Pompeji*, edited by Bernard Andreae and Helmut Kyrieleis, 9–38. Recklinghausen, 1975.

de Vos, Mariette. "La bottega di pittori di via di Castricio." In *Pompei, 1748–1980: I tempi della documentazione*, edited by Irene Bragantini, Franca Parise Badoni, and Mariette de Vos, 119–130. Exh. cat., Pompei and Rome. Rome, 1981.

———. "Die Casa di Ganimede in Pompeji VII 13, 4: Pavimenti e pitture: Terzo e quarto stile negli scarichi trovati sotto i pavimenti." *Römische Mitteilungen* 89 (1982): 315–352.

———. *L'egittomania in pitture e mosaici romano-campani della prima età imperiale*. Etudes préliminaires aux religions orientales dans l'empire romain, no. 84. Leiden, 1980.

———. "Funzione e decorazione dell'Auditorium di Mecenate." In *Roma capitale, 1870–1911: L'archeologia in Roma capitale tra sterro e scavo*, edited by Giuseppina Pisani Sartorio and Lorenzo Quilici, 231–247. Venice, 1983.

———. "Primo stile e maturo quarto stile negli scarichi provenienti dalle macerie del terremoto del 62 d. C. a Pompei." *Mededelingen van het Nederlands Instituut te Rome* 39 (1977): 29–47.

————. "Scavi nuovi sconosciuti (I 9,13): Pitture e pavimenti della Casa di Cerere a Pompei." *Mededelingen van het Nederlands Instituut te Rome*, 38 (1976): 37–75.

————. "Tecnica e tipologia dei rivestimenti pavimentali e parietali." In *Settefinestre: Una villa schiavistica nell'Etruria romana*, edited by Andrea Carandini and Salvatore Settis, vol. 1, 74–90. Modena, 1985.

de Vos, Mariette, and Arnold de Vos. "Scavi nuovi sconosciuti (I 11, 14; I 11, 12): Pitture memorande di Pompei, con una tipologia provvisoria dello stile a candelabri." *Mededelingen van het Nederlands Instituut te Rome* 37 (1975): 47–85.

de Vos, Mariette, and Archer Martin. "La pittura ellenistica a Pompei in decorazioni scomparse documentate da uno studio dell'architetto russo A. Parland." *Dialoghi d'archeologia* 2, no. 2 (1984): 131–140.

Descoeudres, Jean-Paul. "The Australian Expedition to Pompeii: Contributions to the Chronology of the Fourth Pompeian Style." In *Pictores per provincias: Aventicum V. Cahiers d'archéologie romande*, no. 43, 135–147. Avenches, Switz., 1987.

Dexter, Caroline E. "The Casa di L. Cecilio Giocondo in Pompeii." Ph.D. diss., Duke University, 1974.

Ehrhardt, Wolfgang. *Stilgeschichtliche Untersuchungen an römischen Wandmalereien von der späten Republik bis zur Zeit Neros*. Mainz, 1987.

Elia, Olga. *Le pitture del Tempio di Iside*. Monumenti della pittura antica scoperti in Italia, sec. 3, Pompei fasc. 3–4. Rome, 1941.

Engemann, Josef. *Architecturdarstellungen des frühen zweiten Stils. Römische Mitteilungen*, Ergänzungsheft 12 (1967).

Felletti Maj, Bianca Maria. *Le pitture della Casa delle Volte Dipinte e della Casa delle Pareti Gialle*. Monumenti della pittura antica scoperti in Italia, sec. 3, Ostia fasc. 1–2. Rome, 1961.

Felletti Maj, Bianca Maria, and Paolo Moreno. *Le pitture della Casa delle Muse*. Monumenti della pittura antica scoperti in Italia, sec. 3, Ostia fasc. 3. Rome, 1967.

Fittschen, Klaus. "Zur Herkunft und Entstehung des 2. Stils—Probleme und Argumente." In *Hellenismus in Mittelitalien*, Kolloquium Göttingen 1974, edited by Paul Zanker. *Abhandlungen der Akademie der Wissenschaften in Göttingen* 97 (1976): 539–563.

Gasparri, Carlo. *Le pitture della Caupona del Pavone*. Monumenti della pittura antica scoperti in Italia, sec. 3, Ostia fasc. 4. Rome, 1970.

Gury, Françoise. "La forge du destin: A propos d'une série de peintures pompéiennes du IVᵉ style." *Mélanges de l'Ecole française de Rome, Antiquité* 98 (1986): 427–489.

Herbig, Reinhard. *Neue Beobachtungen an Fries der Mysterienvilla in Pompeji: Ein Beitrag zur römischen Wandmalerei in Campanien.* Baden-Baden, 1958.

Holloway, R. Ross. "Conventions of Etruscan Painting in the Tomb of Hunting and Fishing at Tarquinii." *American Journal of Archaeology* 69 (1965): 341–347.

Houtzager, Jacobus. *De grote wandschildering in de Villa dei Misteri bij Pompeii en haar verhouding tot de monumenten der vroegere kunst.* The Hague, 1963.

Joyce, Hetty. "The Ancient Frescoes from the Villa Negroni and Their Influence in the Eighteenth and Nineteenth Centuries." *Art Bulletin* 65, no. 3 (1983): 423–440.

———. *The Decoration of Walls, Ceilings, and Floors in Italy in the Second and Third Centuries A.D.* Rome, 1981.

Laidlaw, Anne. *The First Style in Pompeii: Painting and Architecture.* Rome, 1985.

Lauter-Bufe, Heide. "Zur Stilgeschichte der figürlichen pompejanischen Fresken." Ph.D. diss., Cologne, 1967.

Leach, Eleanor Winsor. "Metamorphoses of the Acteon Myth in Campanian Painting." *Römische Mitteilungen* 88 (1981): 307–327.

———. "Patrons, Painters, and Patterns: The Anonymity of Romano-Campanian Painting and the Transition from the Second to the Third Style." In *Literary and Artistic Patronage in Ancient Rome,* edited by Barbara K. Gold, 135–173. Austin, 1982.

———. "The Punishment of Dirce: A Newly Discovered Painting in the Casa di Giulio Polibio and Its Significance within the Visual Tradition." *Römische Mitteilungen* 93 (1986): 157–182.

———. *The Rhetoric of Space.* Princeton, N.J., 1988.

Lehmann, Karl. "The *Imagines* of Philostratus the Elder." *Art Bulletin* 23, no. 1 (1941): 16–44.

Lehmann, Phyllis Williams. "Lefkadia and the Second Style." In *Studies in Classical Art and Archaeology: A Tribute to Peter Heinrich von Blanckenhagen,* edited by Günter Kopcke and Mary B. Moore, 225–229. New York, 1979.

———. *Roman Wall Paintings from Boscoreale in the Metropolitan Museum of Art.* Cambridge, Mass., 1953.

Ling, Roger. *Roman Painting.* Cambridge, 1991.

———. "Gli stucchi." In *Pompei 79,* edited by Fausto Zevi, 145–160. Naples, 1979.

———. "Stuccowork." In *Roman Crafts,* edited by Donald Strong and David Brown, 209–221. New York, 1976.

———. "Studius and the Beginnings of Roman Landscape Painting." *Journal of Roman Studies* 67 (1977): 1–16.

Lippold, Georg. *Antike Gemäldekopien.* Munich, 1951.

Little, Alan M. G. *A Roman Bridal Drama at the Villa of the Mysteries.* Kennebunk, Me., 1972.

———. *Roman Perspective Painting and the Ancient Stage.* Kennebunk, Me., 1971.

Macchioro, Vittorio. *Zagreus: Studi sull'orfismo.* Bari, 1920.

Maiuri, Amedeo. *Le pitture delle Case di "M. Fabius Amandio" del "Sacerdos Amandus" e di "P. Cornelius Teges".* Monumenti della pittura antica scoperti in Italia, sec. 3, Pompei fasc. 2. Rome, 1938.

———. *Roman Painting.* Geneva, 1953.

Mau, August. *Die Geschichte der dekorativen Wandmalerei in Pompeji.* Leipzig, 1882.

Meiss, Millard. *The Painting of the Life of St. Francis in Assisi.* New York, 1962.

Michel, Dorothea. "Bemerkungen über Zuschauerfiguren in pompejanischen sogenannten Tafelbildern." In *La regione sotterrata dal Vesuvio: Studi e prospettive.* Atti del Convegno Internazionale, 11–15 November 1979, 537–598. Naples, 1982.

———. "Pompejanische Gartenmalerei." In *Taenia: Festschrift für Roland Hampe,* edited by Herbert A. Cahn and Erika Simon, 373–404. Mainz, 1980.

Mielsch, Harald. "Funde und Forschungen zur Wandmalerei der Prinzipatszeit von 1945 bis 1975, mit einem Nachtrag 1980." In *Aufstieg und Niedergang der römischen Welt,* edited by Hildegard Temporini, pt. 2, vol. 12, no. 2, 157–264. Berlin, 1981.

———. *Die römische Stuckreliefs. Römische Mitteilungen,* Ergänzungsheft 21 (1975).

Mingazzini, Paolino. "Una copia dell'Alexandros Keraunophoros di Apelle." *Jahrbuch der Berliner Museen* 3 (1961): 7–17.

Nodelman, Sheldon. "Roman Illusionism: Thoughts on the Birth of Western Spatiality." *Art News Annual* 37 (1971): 27–38.

Pappalardo, Umberto. "Beobachtungen am Fries der Mysterien-Villa in Pompeji." *Antike Welt* 13, no. 2 (1982): 10–20.

———. "Nuove osservazioni sul fregio della Villa dei Misteri." *La regione sotterrata dal Vesuvio: Studi e prospettive.* Atti del Convegno Internazionale, 11–15 November 1979, 599–634. Naples, 1982.

Peters, W. J. T. "La composizione delle pareti dipinte nella Casa dei Vetti a Pompei." *Mededelingen van het Nederlands Instituut te Rome* 39 (1977): 95–128.

———. "La composizione delle pitture parietali di IV stile a Rome e in Campania." In *La regione sotterrata dal Vesuvio: Studi e prospettive.* Atti del Convegno Internazionale, 11–15 November 1979, 635–645. Naples, 1982.

———. *Landscape in Romano-Campanian Mural Painting.* Assen, 1963.

Picard, Gilbert. *Roman Painting.* New York, 1968.

Pictores per provincias: Aventicum V. Actes du 3ᵉ Colloque Internationale sur la peinture murale romaine. Cahiers d'archéologie romande, no. 43. Avenches, Switz., 1987.

Ragghianti, Carlo. "Personalità di pittori a Pompei." *Critica dell'arte* 1 (1954): 202–238.

———. *I pittori di Pompei.* Milan, 1963.

Richardson, Lawrence, Jr. "Pompeii: The Casa dei Dioscuri and Its Painters." *Memoirs of the American Academy in Rome* 23 (1955).

Riemenschneider, Ulrike. "Pompejanische Ornamentbänder des vierten Stils." *Boreas* 9 (1986): 105–112.

———. *Pompejanische Stuckgesimse des dritten und vierten Stils.* Frankfurt, 1986.

Rizzo, Giulio Emanuele. *Le pitture dell'Aula Isiaca di Caligola.* Monumenti della pittura antica scoperti in Italia, sec. 3, Roma fasc. 2. Rome, 1936.

———. *Le pitture della Casa dei Grifi.* Monumenti della pittura antica scoperti in Italia, sec. 3, Roma fasc. 1. Rome, 1936.

———. *Le pitture della 'Casa di Livia.'* Monumenti della pittura antica scoperti in Italia, sec. 3, Roma fasc. 3. Rome, 1936.

Sauron, Gilles. "Nature et signification de la mégalographie dionysiaque de Pompéi." *Compte rendus des séances de l'Académie des inscriptions et belles-lettres* (1984): 151–174.

Scagliarini, Daniela Corlàita. "Spazio e decorazione nella pittura pompeiana." *Palladio* 23–25 (1974–1976): 3–44.

Schefold, Karl. "Die Troiasage in Pompeji." *Nederlands kunsthistorisch Jaarboek* 5 (1954): 211–224.

———. "Zur Chronologie der Dekorationen im Hause der Vettier." *Römische Mitteilungen* 64 (1957): 149–153.

———. "The Origins of Roman Landscape Painting." *Art Bulletin* 42, no. 2 (1960): 87–96.

———. *La peinture pompéienne: Essai sur l'évolution de sa signification.* Brussels, 1972.

———. *Pompejanische Malerei.* Berlin, 1972.

———. *Vergessenes Pompeji.* Bern, 1962.

———. *Die Wände Pompejis: Topographisches Verzeichnis der Bildmotive.* Berlin, 1957.

Strocka, Volker Michael. *Casa del Principe di Napoli (VI 15, 7–8)*. Deutsches archäologisches Institut. *Häuser in Pompeji*, vol. 1. Tübingen, 1984.

———. "Ein missverstandener Terminus des vierten Stils: Die Casa del Sacello Iliaco in Pompeji (I 6, 4)." *Römische Mitteilungen* 91 (1984): 125–140.

———. "Die römische Wandmalerei von Tiberius bis Nero." In *Pictores per provincias: Aventicum V*. Cahiers d'archéologie romande, no. 43, 29–44. Avenches, Switz., 1987.

———. *Die Wandmalerei der Hanghäuser in Ephesos*. Österreichisches archäologisches Institut, Vienna. Forschungen in Ephesos 8, 1. Vienna, 1977.

Thompson, Mary Lee. "Programmatic Painting in Pompeii." Ph.D. diss., New York University, 1960.

———. "The Monumental and Literary Evidence for Programmatic Painting in Antiquity." *Marsyas* 9 (1960–1961): 36–77.

Van Essen, Carlo C. "Studio cronologico sulle pitture parietali di Ostia." *Bullettino della Commissione archeologica comunale di Roma* 76 (1956–1958): 155–181.

Vlad Borelli, Licia. "Le pitture e la tecnica della conservazione." In *Pompei, 1748–1980: I tempi della documentazione*, edited by Irene Bragantini, Franca Parise Badoni, and Mariette de Vos, 81–87. Exh. cat., Pompei and Rome. Rome, 1981.

———. "Sinopia." *Enciclopedia dell'arte antica. Supplemento* (1970), s.v.

Wesenberg, Burkhardt. "Zur asymmetrischen Perspektive in der Wanddekoration des zweiten pompejanischen Stils." *Marburger Winckelmann-Programm* (1968): 102–109.

———. "Römische Wandmalerei am Ausgang der Republik: Der zweite pompejanische Stil." *Gymnasium* 92 (1985): 470–488.

Wirth, Fritz. *Römische Wandmalerei vom Untergang Pompejis bis ans Ende des dritten Jahrhunderts*. Berlin, 1934.

Wirth, Theo. "Zum Bildprogramm in der Casa dei Vettii." *Römische Mitteilungen* 90 (1983): 449–455.

MOSAIC

Andreae, Bernard. *Das Alexandermosaik aus Pompeii*. Recklinghausen, 1977.

Aurigemma, Salvatore. *Villa Adriana*. Rome, 1961.

Becatti, Giovanni. *Scavi di Ostia*. Vol. 4. *Mosaici e pavimenti marmorei*. Rome, 1961.

Blake, Marion E. "Mosaics of the Late Empire in Rome and Vicinity." *Memoirs of the American Academy in Rome* 17 (1940): 31–120.

————. "Roman Mosaics of the Second Century in Italy." *Memoirs of the American Academy in Rome* 13 (1936): 67–214.

Clarke, John R. "Mosaic Workshops at Pompeii and Ostia Antica." *Acts of the Fifth International Colloquium on Ancient Mosaics*. Bath, England, 5–12 September 1987. In press.

————. "The Non-Alignment of Functional Dividers in Mosaic and Wall Painting at Pompeii." *Bulletin de l'Association internationale pour l'étude de la mosaïque antique* 12 (1989): 313–321.

————. "The Origins of Black-and-White Figural Mosaics in the Region Destroyed by Vesuvius." In *La regione sotterrata dal Vesuvio: Studi e prospettive*. Atti del Convegno Internazionale, 11–15 November 1979, 661–688. Naples, 1982.

————. *Roman Black-and-White Figural Mosaics*. New York, 1979.

de Vos, Mariette. "Pavimenti e mosaici." In *Pompei 79*, edited by Fausto Zevi, 161–176. Naples, 1979.

Dunbabin, Katherine M. D. *The Mosaics of Roman North Africa: Studies in Iconography and Patronage*. Oxford, 1978.

————. "Technique and Materials of Hellenistic Mosaics." *American Journal of Archaeology* 83, no. 3 (1979): 265–277.

Gullini, Giorgio. *I mosaici di Palestrina*. Rome, 1956.

Joyce, Hetty. "Form, Function, and Technique in the Pavements of Delos and Pompeii." *American Journal of Archaeology* 83, no. 3 (1979): 253–263.

Lavin, Irving. "The Antioch Hunting Mosaics and Their Sources: A Study of Compositional Principles in the Development of Early Medieval Style." *Dumbarton Oaks Papers* 18 (1963): 179–286.

Levi, Doro. "Mosaico." In *Enciclopedia dell'arte antica*, s.v.

Morricone Matini, Maria Luisa. "Mosaico." In *Enciclopedia dell'arte antica, Supplemento* (1970), s.v.

————. *Scutulata pavimenta*. Rome, 1980.

Pernice, Erich. *Die hellenistische Kunst in Pompeji: Pavimente und figürliche Mosaiken*. Berlin, 1938.

Robotti, Ciro. "Una sinopia musiva pavimentale a Stabia." *Bollettino d'arte* 43 (1973): 42–44.

Sear, Frank. *Roman Wall and Vault Mosaics. Römische Mitteilungen*, Ergänzungsheft 23 (1977).

ANCIENT SOURCES

Anthologia latina. Minor Latin Poets, edited by J. Wight Duff and Arnold M. Duff. London, 1934.

Athenaeus Sophistes. *Deipnosophistae.* Loeb Classical Library. Translated by Charles Burton Gulick. Cambridge, Mass., 1928.

Cicero. *Letters to Quintus, Brutus, and Others.* Loeb Classical Library, vol. 4. *The Letters to His Brother Quintus.* Translated by W. Glynn Williams. Cambridge, Mass., 1922.

Hesiod. *Theogony.* Greek ed. Edited by Martin L. West. Oxford, 1966.

Homer. *The Iliad.* Greek: *Homeri opera.* Edited by David B. Monro and Thomas W. Allen. Vols. 1–2. 2d ed. Oxford, 1917. English: *The Iliad of Homer.* Translated by Richmond Lattimore. Chicago, 1951.

Homer. *The Odyssey.* Greek: *Homeri opera.* Edited by David B. Monro and Thomas W. Allen. Vols. 3–4. 2d ed. Oxford, 1917. English: *The Odyssey of Homer.* Translated by Richmond Lattimore. New York, 1965.

Horace. *Satires.* In *The Satires and Epistles of Horace.* Translated by Smith Palmer Bovie. Chicago, 1959.

Isiadorus Hispalensis. *Libri Originum.* Latin ed. Edited by W. M. Lindsay. Oxford, 1911.

Ovid. *Metamorphoses.* Loeb Classical Library. Translated by Frank Justus Miller. Cambridge, Mass., 1916.

Persius. *The Satires.* Text with translation and notes by J. R. Jenkinson. Warminster, 1980.

———. *The Satires of Persius.* Translated by W. S. Merwin. London, 1981.

Petronius Arbiter. *Cena Trimalchionis.* Edited by Martin S. Smith. Oxford, 1975.

———. *Satyricon.* Translated by J. P. Sullivan. Harmondsworth, 1986.

Pliny the Elder. *Naturalis historia.* Loeb Classical Library. Translated by H. Rackham. 10 vols. Cambridge, Mass., 1952.

Pliny the Younger. *Epistulae.* Loeb Classical Library. Translated by William Mellmoth. Rev. ed. by W. M. L. Hutchinson. London and New York, 1915.

Polybius. *The Histories.* Loeb Classical Library. Translated by W. R. Paton. 6 vols. Cambridge, Mass., 1923.

Priapea: Poems for a Phallic God. Introduced, translated, and edited, with notes and commentary, by W. H. S. Parker. London and Sydney, 1988.

Propertius. Loeb Classical Library. Translated by H. E. Butler. London and Cambridge, Mass., 1976.

———. *The Poems of Sextus Propertius.* Translated by J. P. McCulloch. Berkeley, 1972.

Publius Papinius Statius. *Silvae.* Loeb Classical Library. Translated by J. H. Mozley. 2 vols. London and Cambridge, Mass., 1967.

Servius. *On the Aeneid.* Latin ed.: *Servi grammatici.* Edited by Georgius Thilo. Leipzig, 1881.

Thucydides. *The History of the Peloponnesian War.* Translated by Richard Livingstone. New York, 1943.

Vitruvius. *De architectura.* Loeb Classical Library. Translated by Frank Granger. 2 vols. Cambridge, Mass., 1934.

GENERAL INDEX

aedicula (-ae), 24, 50–53, 64, 129 (round-headed), 167, 168, 255 (with sail arch), 365
aedicular scheme, 247
aedile, 158–159
Aeneid, 156, 177
Aeschylus, 191
Agrippa, 55
ala, 6
Alcibiades, 212
Alexander (artist's signature), 254
Alexander mosaic, 41, 81, 83
Alexandria, 45
Alexandrian grain fleet, 267
Alföldi, Andreas, 48
allover patterns, 40, 63, 71, 74, 84, 273
Allroggen-Bedel, Agnes, 243
altars, portable, 7
ambulacrum, 322, 336, 339
ambulatio, 19
amoenitas, 20
amphithalamos, 96
Amulius Faventinus Tiburs, 197
ancella (-ae), 325
ancestors, worship of, 6–7, 12
ancestral images, 192
animal parks, 25, 162–163, 256
anta (-ae), columns in antis, 84, 90, 92, 171
Antoninus Pius, 336
apartment house, 26–29, 257–263, 265, 267, 268, 289–292, 320–322, 364
Apelles of Kos, 230, 329, 370
apodyterium, 13
Apollo and Dionysus, balance between, 157–158
apotropaic images, 212
Apuleius, 325
aqueduct, Pompeii, 165
arca (-ae), 212, 223
Arch of Septimius Severus, Rome, 348
archaism, Augustan, 158

Architectural Style, Hellenistic, 38
Aristophanes, 191
Art Deco, 359
ashlars, 87, 90, 92, 93
asymmetrical perspective, 41–45, 50–51, 105–107
Athenaeus, 66–67
Athens, 45
atriolo, 187
atrium house, covered, 27
atrium testudinatum, 27
atrium, 2–4, 12, 21, 25, 147 (origin in word *ater,* meaning black), 208 (servants'), 220 (servants'), 243 (becomes vestibule)
Atticus, 20
augustalis (-es), 208, 243
Augustus, 48, 49, 50, 123, 125–126, 158 (as new Apollo), 267, 278, 324, 365
Aula Isiaca, Rome, 55–56
axis, framing of, 4–5, 14, 16, 87, 201, 205, 208, 235, 250, 264, 273
axis, from fauces to tablinum, 2–4, 12, 14, 21, 25, 87, 235, 264, 364
axis, marking of, 4, 12, 43, 219, 271–273, 273–278
axis, secondary, 16, 192, 235
axis, visual, 14–16, 22, 28, 29, 40, 83, 113, 146, 201, 208, 249–250, 308

balconies, 87, 252, 253, 259, 264
banquet, funeral, 12
Barberini mosaic, Praeneste, 94, 122
basilicas, 40
Bastet, Frédéric, 55–56, 104
baths, private, 13, 94, 128–130, 171, 185–188
Beazley, J. D., 333
beds (preserved furniture), 259
Bek, Lise, 14, 17, 29, 208
belvedere. *See* diaeta
benches for clientela, 87, 95

Beyen, Hendrick, 47, 54
Bianchi-Bandinelli, Ranuccio, 336–337
biclinium, 24, 162, 194, 199
Bion of Borysthenes, 48
Blanckenhagen, Peter von, 54–55
Boëthius, Axel, 29
Bolsena, 315
Bosch, Hieronymus, 155
Boulanger, François-Florimond, 81
Bourbon excavators, 240, 254
Bragantini, Irene, 56
brick stamps, 270, 320
brick-faced concrete construction, 26, 28,
 267–268, 270, 289–291, 364
brickwork, 140
brothel, gay, 323–324
bucranium (-a), 170
bulla, 9

Caesar, 156
caldarium, 13, 62, 128–130
Calza, Guido, 320, 328, 329, 330, 333
camera a canne, 315
canals, 23–24, 194, 201
capitals, 39, 83 (tufa), 87 (tufa)
Caprarola, 234
carbonized foodstuffs, 250
caricature, 187
Caro, Annibale, 234
carpet borders, 66, 167, 170, 173, 229, 237,
 239, 253
carpets, imitated in pavements, 40
cartibulum, 146
cartoons, 46
Caseggiato di Bacco e Arianna, Ostia Antica
 (III, 17, 5), 274
Castrén, Paavo, 79, 125–126
castrum, 267
caupona, 250–252, 326, 360
ceiling decoration: Second-Style, 109,
 121–122; Fourth-Style, 168–170, 239,
 247–249; Hadrianic, 73–74; early An-
 tonine, 295, 299–300; late Antonine,
 314–319; Severan, 300
Celer, 243
cement pavements, 40
Cerulli-Irelli, Giuseppina, 241
child's room, 159
chin-chuck gesture, 333
Cicero, 20, 24, 46
cinaedus (-i), 320
cisterns, in domus, 4
classicism, Hadrianic, 72–73, 278, 282
Claudius, 267
clientela, 4, 214
cocciopesto, 40, 87. See also opus signinum
coding of spaces through decoration. See
 functional hierarchy
coenatio iovis, 273

collaboration, painters and architects, 45
collaborationist families in Pompeii,
 125–126, 158
collegia, 268
Colonia Cornelia Veneria Pompeianorum,
 80
color schemes, reciprocal, 171, 239
Commodos, 268, 322
compass, 59
compluvium, 4, 27
conservation of paintings and mosaics, xxv,
 xxvi, 268, 298
Constantine, 268
construction, of Roman house, 32–33
construction, post-and-lintel, 50, 90–92
context of interior decoration, xxiii–xxv
continuities from Pompeii to Ostia,
 365–366
contractors, 47
contrapposto, 333, 334
cook's room, 220–221
copies, of same central picture, 156–157
courtyards, in insula, 27, 342
Crispinius Caepio, A., 55
cryptoporticus, 19, 243
cubicularius (-i), 13
cubiculum (-a), 12, 28
cubiculum (-a) diurnum (-a), 13, 142
Curtius, 48
Curtius, Ludwig, 156–157

Dacos, Nicole, 71
de Vos, Arnold and Mariette, 47, 79
de Vos, Mariette, 48, 56, 68
death masks, 192–193
decor, 369
decoration, and function of space, 2, 28, 29,
 40
decorative ensembles, role in establishing
 spatial hierarchies, 27, 29, 235–237,
 239–240, 242–243, 243–249
decorative ensembles, role in modifying per-
 ception, 29, 31
deities, household, 7–10
Della Corte, Matteo, 196
Delos, 12, 85
dentil range, 87, 88, 120
diaeta (-ae), 13, 20, 24, 194, 237, 242, 246
Didumai (The Twins), 188
Diocletian, 268
Diphilus, 46
Disneyland, 24, 207
divi parentes, 12. See ancestors
division, of wall-painting scheme: horizontal,
 58–59, 278; vertical, 59, 147–148, 168,
 278, 283
division of labor: in painting, 57–61, 76,
 367; in mosaics, 61–63, 366
dolium (-a), 250

domina, 95, 104, 201, 285
dominus, 29, 274
Domitian's Palace, Rome, 273
domus, 2–4, 27, 264 (rare at Herculaneum)
Domus Aurea, Rome, xxiii, 71, 179, 273, 300, 337 (Room of the Landscapes), 339 (Room of the Landscapes), 358 (white rooms)
Domus Transitoria, Rome, 71
domus-with-peristyle, 12–19, 28
drama, dramatic events in paintings, 163, 176–184
Drerup, Heinrich, 14
duovir, 158–159
Durchblick. *See* view-through
dynamic spaces, 16, 28, 29, 84, 150, 172–173, 237, 273, 307, 308, 367

earthquake of A.D. 62, Pompeii, 165, 166
Ecole des Beaux-Arts, 81
Edict of Diocletian on Maximum Prices, 57–58
Egypt, 56, 66, 194
Egyptian oecus, 237
Egyptianizing ornament, 52, 56, 126, 144
electoral slogans, 158
emblema (-ta), 40–41, 63, 64, 81, 83, 90, 366
enfilades, 273
Engemann, Josef, 43, 47
ensemble, decorative, xxiii, xxv; First-Style, 93; coordination in Second Style, 118–122; coordination in House of the Muses, 273–278; coordination in Severan period, 344–346
envois, 81
Ephesus, 325
erastes, 333
eromenos, 333
Etruscan divination practices, 6–7
Euripides, 188–191, 370
euripus, 24
exedra (-ae), 13

Fabullus, 71
facades: tufa, 83; red and gold plaster, 87; red socle with white median zone, 253
false doors, 75, 105, 113–114
false windows, 239
farm quarters, 170, 171
fastigium (-a), 250
fauces, 2–6
faux-marble, 32–33, 39–40, 46, 69, 87–88, 202, 227, 278, 293, 335, 346
Felletti Maj, Bianca Maria, 274, 286, 287, 296, 341, 354, 364–365
fertility, 214, 234
filigree borders. *See* carpet borders
First Style, 33–34, 38, 39–41, 81–93

fish pond, 24
Fittschen, Klaus, 38, 47
flagellation, 103–104
fountains, 17, 24, 201, 202 (fountain houses), 209, 255–257 (fountain house or nymphaeum)
Four Styles, 31, 363
Fourth Style: Tapestry Manner, 65–68, 158–163, 166–170, 283 (revival); Plain Manner, 68–69; Theatrical Manner, 69–72; "baroque" aspects, 71–72, 227, 254, 283 (revival)
freedmen, 4, 165–166, 170, 208, 221, 234, 264; as new social class, 25, 369
freedwomen, 221
fresco technique (buon fresco), 58–59, 65, 268, 279, 313, 319–320, 329, 337, 367
friezes, directional reading patterns: Dionysian, Villa of the Mysteries, 101–105; Hercules cycle, House of Octavius Quartio, 203–207; Iliad cycle, House of Octavius Quartio, 203–207
frigidarium, 13
frons (frontes) scaenae (scaenarum), 38, 48, 69, 117, 153, 230, 254, 255
fullers, 215
fullones, 215
functional division (of spaces by decoration), 96–97, 105–107, 107–108, 118–122, 131, 136, 171, 214–215, 235–237, 239–243, 243–246
functional hierarchy, 13, 29, 236–237, 243–246, 264, 265, 270–278, 292–293

game preserves, 162–163
Garden Houses, Ostia Antica, 270
gardens, with representations of gardens painted on walls, 22–23, 257
Gasparri, Carlo, 353
genius (-i), 7, 9, 212 (agricultural)
gens Iulia, 156
gens Poppaea, 170
gens, 9
giornata (-e), 58–59
Golden House, Rome, xxiii, 71, 179, 273, 337 (Room of the Landscapes)
Gordian, 354
graffiti, 159, 214, 221, 320, 322, 324–326, 369
grids of squares in painting, 45–46
grottoes, 24, 255
guidelines: for painting, 45, 59, 189–191, 320, 329, 338, 367; for mosaic, 61–62
gymnasia, 40
gynaeceum, 208, 221

Hadrian, 267, 268
Hadrian's Villa, Tivoli, 72, 274
harbor, Claudian, Ostia Antica, 267

harbor, Trajanic, Ostia Antica, 267
haruspex, 6
Herculaneum, economy and social organization, 80–81
herms, 212, 213 (double)
Hesiod, 280, 369
Heyob, Sharon Kelly, 201
hierarchies, spatial, 27, 146
hierarchy, of spaces, 13, 29, 236–237, 243–246, 264, 265, 270–278, 292–293
Homer, 206
homines novi, 166
homosexuals, male, 320
Horace, 17
Horti Lamiani, Rome, 115
hortus, 6, 12
hotels, gay, 320, 322–323, 326–327, 367
House I, 7, 19, Pompeii, 156–157
House in *Opus Craticium,* Herculaneum (III, 13–15), 26, 87, 257–263, 264, 270, 364
House of Augustus, Rome, 52
House of Caesius Blandius, Pompeii (VII, 1, 40), sinopia in oecus, 46
House of Ceres, Pompeii (I, 9, 13), 46
House of Iulius Polybius, Pompeii (IX, 13, 1–3), 113
House of Jupiter and Ganymede, Ostia Antica (I, 4, 2), 74–75, 94, 320–339, 367, 369
House of L. Caecilius Iucundus, Pompeii (V, 1, 26), 156
House of Livia, Rome, 50–52, 125, 129
House of Lucretius Fronto, Pompeii (V, 4, a), 22, 59, 61, 64, 126, 176, 311; late Third-Style ensembles, 146–158; Fourth Style ensembles, 158–163
House of Marcus Lucretius, Pompeii (IX, 3, 5), 157
House of Neptune and Amphitrite, Herculaneum (V, 6–7), 250–257, 264, 364
House of Octavius Quartio, Pompeii (II, 2, 2), 23–24, 162, 193–207, 209, 230, 234, 237, 238, 239, 264, 358, 364
House of Pansa, Pompeii (VI, 6, 1), 2
House of Pinarius Cerialis, Pompeii (III, 4, b), 69
House of Sallust, Pompeii (VI, 2, 4), 2
House of the Bronze Herm, Herculaneum (III, 16), 259
House of the Centenary, Pompeii (IX, 8, 6), 368
House of the Cryptoporticus, Pompeii (I, 6, 2), 62
House of the Dioscuri, Ostia Antica (III, 9, 1), 329
House of the Faun, Pompeii (VI, 12, 2), 41, 79, 81–85, 90
House of the Graffito, Ostia Antica (III, 9, 21), 307, 308

House of the Griffins, Rome, 39, 41–43, 80
House of the Labyrinth, Pompeii (VI, 11, 10): sinopia in oecus 43, 46; workshop responsible for paintings, 47, 111
House of the Large Portal, Herculaneum (V, 35), 85
House of the Lovers, Pompeii (I, 10, 11), 171
House of the Menander, Pompeii (I, 10, 4), 14–16, 22, 25, 62, 94, 170–193, 194, 207, 208, 227, 238, 263, 268, 282, 295, 322, 367, 369
House of the Mosaic Atrium, Herculaneum (IV, 1–2), 21, 235–243, 247, 249, 264, 364
House of the Muses, Ostia Antica (III, 9, 22), 28–29, 28–29, 73, 270–288, 300, 301, 303, 307, 308, 314, 346, 364, 365
House of the Painted Ceiling, Ostia Antica (II, 6, 6), 75, 313–320, 329, 339, 346, 356
House of the Painted Vaults, Ostia Antica (III, 5, 1), 74, 289–303, 307, 337, 338, 354, 368
House of the Priest Amandus, Pompeii (I, 7, 7), 180
House of the Prince of Naples, Pompeii (VI, 15, 7–8), 26
House of the Sacello Iliaco, Pompeii (I, 6, 4), 58–59
House of the Stags, Herculaneum (IV, 21), 21, 235, 243–250, 264, 270, 364
House of the Surgeon, Pompeii (VI, 1, 10), 2
House of the Vettii, Pompeii (VI, 15, 1), xxvi, 71, 193, 207, 208–235, 234 (workshop responsible for paintings), 241, 242, 278, 282, 284, 285, 287, 322, 325, 326, 329, 334, 335, 364, 368
House of the Yellow Walls, Ostia Antica (III, 9, 12), 28, 74, 94, 305–312, 313, 336, 339, 354–358, 360, 364
House, Pompeii (VI, 14, 39), 90
house, as place of business, 12
house, as place of worship, 12
House, Samnite. *See* Samnite House, Herculaneum
houses, case-study, 2
houses, types at Pompeii, 79–80
humor, 185–188
hybris, 282

Iliad, 206–207, 282
illusionism, in First Style, 39
imagines maiorum, 192
imago (-ines) clipeata (-ae), 113
imitation of earlier painting styles: Fourth-Style imitation of Third, 129, 166–167
impluvium, 4
impluvium as axis marker, 19

motifs (*continued*)
239, 242; horse, 287; hunting dogs, 150, 255; ibis, 198; lobster claws, 312; marine bull, 168; octopi, 63; owl, 221; panther's heads, 148, 158; panthers, 151, 171, 174, 227; peacocks, 116, 167 (frontal), 283 (strutting), 196 (heraldic), 335 (heraldic); pegasus, 174, 240, 300; rabbit, 351; sea dragon (ketos), 300; snail, 148; swans pulling carts, 151, 158; swans, 170, 229, 300, 333, 333; titmouse, 148

motifs, architectural: acroteria (in form of centaurs), 283, 285; Atlantes, 287; auleae (gathered curtains), 240; caryatids, 237; cityscape, 49; fountains, 38, 151; friezes with palmettes, rosettes, and Isiac symbols, 52; frontes scaenarum, 38; illusionistic doors, 75, 105, 113–114, 287, 346; lacunars, 121–122; lacunary vaults, 108; lotus-bud capitals, 52; pergola, 45; peristyles, 49; pilasters, 108, 131, 132, 133; ressauts, 110, 310; rustic shrines, 133–134; sanctuaries, 45; temple front, 88; tholus, 45, 49, 110; villas, 151, 172

motifs, decorative: angle brackets, 274; basketweave, 142, 243; candelabra, 127, 170, 237, 283, 295, 295 (floral), 300 (floral), 335 (floral); checkerboard, 237, 308; crosses, 108, 147, 154–155; dart, 138; diamonds and squares, 108; diamonds, 101; eight-pointed lozenge star, 366; fish-scales, 139, 344; heart-shaped volutes, 138, 300; interwoven squares, 345; kantharos, 229, 284, 313; lattice, 109; lozenges, 93; meander alternating swastikas and squares, 87, 90, 293; meander, 93, 202, 214, 274 (interlocked), 274; monochrome cubes in perspective, 156; palmettes, 93, 139, 229; palmettes, open-looped, 127, 138; polychrome cubes in perspective, 43, 61; polychrome diamonds in lattice, 119; polychrome hexagon, 61; rosette of radiate lozenges, 93; semicircles framing trefoils, 168; Solomon's knots, 94; squares with concave sides and an L in center, 131–132; squares with concave sides, 346; step triangles, 108, 130; stucco rosettes, 109; swagged drapery, 203; swastikas, 274, 366; tongue molding, 229; triangles, 96; trompe l'oeil meanders, 61; two-stranded braid, 90, 147; white tesserae diamonds framed by black slate, 176

motifs, divinities (including mythological personages and personifications): Achilles, 206, 221; Actaeon, 182–183; Aeneas, 156, 157, 178; Agave, 227; Ajax (son of Oïleus, Little Ajax), 177; Ajax (son of Telamon, Great Ajax), 206; Alcmene, 226; Amphion, 182, 227; Amphitrion, 226; Amphitrite, 255, 256; Andromeda, 180; Antiope, 227; Aphrodite, 231, 333; Apollo and Dionysus (balance between), 157–158, 218, 232; Apollo, 28, 116, 126, 159, 206, 218, 229, 278, 279, 280, 281, 282 (Cithaeroedus), 365; Ariadne, 61; Artemis, 24; Athena, 178, 224, 247 (head), 249 (head); Auge, 221; Autumn, 197; bacchants, 24, 227; Bes, 198; Cassandra, 177, 178; centaurs, 185, 188, 237, 283, 347; Cephas, 180; chimaeras, 255; cupids (amorini), 100, 156, 214–217, 223, 234, 247; Cyparissus, 229; Daedalus, 224, 233; Danae, 230, 334; Diana, 24, 182–184, 191, 199; Dionysus and Ariadne, 99–105, 157, 213, 225, 229; Dionysus leaning on satyr, 97; Dionysus, 24, 61, 97, 191, 211, 213, 214, 215, 225, 227, 257, 283, 328, 329, 365; Dirce, 180–181, 227; Echo, 159, 254; Eros, 229; Flora, 328; Fortuna, 223, 234; Ganymede, 327, 329, 330, 333, 334, 335, 367; genii of the seasons, 351–352; gorgon's heads, 174, 350; griffins, 237; Hebe, 333; Hector, 206, Helen of Troy, 157, 178; Hephaestus, 156–157, 225; Hera, 225, 225, 333; Hercules, 129, 167, 205–207 (narrative cycle), 221, 226 (infant); Hermaphrodite, 24, 213, 218 (ithyphallic), 234; Hermes, 156, 225; herms, 46, 297; Hymen, 157; Iris, 225; Isis, 24; Ixion, 71, 224, 234, 329; Juno, 116; Jupiter, 224, 329, 330, 333, 334, 335, 367; Laocoon, 177; Laomedon, 206; Lapith women, 185–186, 188; Leda, 230, 231, 327, 333, 334, 335, 367; maenads, 76, 97, 105, 213, 242, 284, 296, 328, 329, 336, 354, 365; Mars, 24, 61, 156 (Ultor), 157; Medusa's head (gorgon), 111, 174, 229, 239; Menelaos, 178; Mercury, 24, 159 (as boy), 211–214, 223; Micon, 159; Minotaur, 187, 224; Muses, 24, 28, 182, 182 (Erato), 201 (Polyhymnia), 201 (Erato), 219 (Urania), 218, 278 (Euterpe), 279–282, 279 (Euterpe), 279 (Clio), 279 (Thalia), 279 (Melpomene), 279 (Terpsichore), 279 (Erato), 279 (Polyhymnia), 280 (Polyhymnia), 280 (Urania), 280 (Calliope), 280 (Euterpe), 280 (Clio), 282 (Urania), 365; Narcissus, 159, 207, 254; Nemesis, 159; Neoptolemos, 159; Nephele, 225; Neptune, 255, 256; nereid, 168; Niobe, 282; nymphs, 184, 196, 229, 255, 329;

Social War, 80
socle, 39, 58–59, 129, 140, 144, 171
sollemnitas togae purae, 9
space, encoded in house, 2
spaces, dynamic, 16, 28, 29, 84, 150, 172–173, 237, 273, 307, 308, 367
spaces, static, 16–17, 28, 29, 150, 237, 243, 273, 308, 339, 367
Spinazzola, Vittorio, 206
stables, 14, 171
stage backdrops, 38, 48, 69, 117, 153
stage decoration: 47; tragic, comic, and satyric, 49
stage pattern, 47, 113. *See also* scaenae frons
standards, measurement, xxvi
static spaces, 16–17, 28, 29, 150, 237, 243, 273, 308, 339, 367
Statius, 20
statuary, use of in gardens, 24
Steinberg, Leo, 330
Streifendekoration, 358
stucco: Second-Style cornices, 109, 114–115, 119–121; Third-Style cornice, 136; Fourth-Style, 72, 128, 168, 170, 202, 229–230 (between median and upper zone); Hadrianic, 73–74; early Antonine moldings, 294
stuccoists, 39, 47
Studius, 56–57
sudatio, 62
Suetonius, 48
suites of rooms, 13, 28, 94–96, 134–135, 142, 221 (gynaeceum?), 274–278, 285, 293
Sulla, 80, 125
swimming pool, 22, 23, 166

tablinum, 4, 6, 13, 208 (lack of), 214 (lack of), 237 (in form of Egyptian oecus), 237, 264 (lack of), 364
Tanagra figurines, 296
Tapetenmuster, 287
taste, 65, 288
Temple of Apollo Sosianus, Rome, 282
Temple of Diana, Ephesus, 231
Temple of Isis, Pompeii (VIII, 7, 28), 165, 199
Temple of Mars Ultor, Rome, 156
Temple of Roma and Augustus, Ostia Antica, 267
Temple of Venus Genetrix, Rome, 156
templum, 6
tenement, 257, 364
tepidarium, 13
Terme del Faro, Ostia Antica (IV, 2, 1), 329
Terme Marittime, Ostia Antica (III, 8, 2), 348
tessera (-ae), size of, 40–41 (first century B.C.), 344–345 (change from second to third century), 366 (change)

Tetrarchy, 361
theater and forum, Ostia Antica, 267
Thebes, 182
Theogony, 280
thermopolium, 297
Third Style: origins, 54–57; reading patterns, 126; early, 126–146; late, 146–158; "baroque" aspects of late, 152–153
threshold band, 87
Tiber, 267
Tiburs, 197
Timotheos, 334
Tivoli, 197, 274
toga, 4
toga virilis, 10
togata (-ae), 325
Tomb of Lyson and Kallikles, Lefkadia, 37–38, 42, 107
Tomb of the Lionesses, Tarquinia, 35–37
town house, 2. *See also* domus
Trajan, 267
Tran-Tam-Tinh, Victor, 243, 249
Triangular Forum, Pompeii (VIII, 7), 199
triclinium, 12, 16
triclinium, seating of guests, 16–17
Trimalchio, 220, 234, 368
trompe l'oeil architecture, 34–38
trompe l'oeil illusionism, 117–118
Troy, 157, 176–180, 203–207 (Trojan cycles)
tufa reticulate, 140
Tyche-Fortuna, 48
tympanum, 37, 122

upper zone, 39–59, 69, 136
upper-story rooms, 87, 250, 259–261, 264
utilitas, 369

van Essen, Carlo C., 354
vanishing points, 42–43, 44, 45
vault, barrel, 42, 63, 120, 254
vault, groin, 271, 273, 291–292, 293
vaulting, 26, 28, 202 (segmental), 289–291
Vergil, 156
vestibules, 25
Vesuvius, 31, 81
veterans, 80
Vettius Conviva, A., 208
Vettius Restitutus, A., 208
view, framed by windows, 19–20, 22–23
view, from fauces to peristyle, 20, 146, 188
view, oblique, 17, 28
view, of landscape, 19–22, 243 (of sea)
view out of: triclinium, 17, 273, 308; oecus, 201–202, 205, 219
view planning, 17, 23, 29, 243
view-through, 14, 271
viewer, experience of architecture, 24

viewer address, 43, 98–105, 203, 205–207, 278

viewing position: unemphasized in First-Style ensembles, 40; difficult for emblemata, 41, 84, 370; difficult for landscape in fauces, 88–89; difficult for landscape in atrium, 172–173; in asymmetrical perspective, 43–44; for Third-Style ensembles, 63–65, 136, 144–146, 148, 150–151, 158; for Fourth-Style Tapestry Manner, 68, 174; for Fourth-Style Theatrical Manner, 69–71; from oecus *h* of the House of Octavius Quartio, 201, 205–206; for epic cycles in oecus *h* of the House of Octavius Quartio, 205–207; for Hadrianic wall painting, 73; for mosaics in House of the Muses, 273–278; for Muses in Room of the Muses, 279; for late Antonine wall painting, 75; for Panel Style, 76; for mosaics of Severan period, 76; in Room of the Mysteries, 98–105; for mosaic in dining room 7 of the House of the Muses, 308; for central picture in room 4 of the House of Jupiter and Ganymede, 329

villa, as model for middle-class houses, 23–25
villa, imitation of, 23–25, 166, 193, 264
villa, miniature, 23–25, 166, 193, 264
villa, seaside, 21–23, 235
villa, suburban, 19
villa, urban, 21
Villa at Settefinestre, 61–62
Villa Negroni, Rome, 287
Villa of Agrippa Postumus, Boscotrecase, 125; red cubiculum, 52–53, 129; workshop responsible for paintings, 55, 130 (same workshop for Oplontis 8); dating, 54–55; landscape paintings, 129
Villa of Oplontis, Torre Annunziata, 13, 21–23, 25, 45–46, 68, 80, 89–90, 107, 122, 126, 170, 176, 239, 255, 315; workshop responsible for paintings, 47, 111; Second-Style ensembles, 113–123; early Third-Style ensembles, 126–140; Fourth-Style ensembles, 166–170
Villa of P. Fannius Sinistor, Boscoreale, 199; cubiculum, 37–38, 44–45, 46, 47, 49; workshop responsible for paintings, 47, 111; megalography, 98
Villa of the Mysteries, Pompeii, 13, 19–20, 80, 90, 90, 114, 115, 116, 119, 122, 127, 135, 147, 171, 285, 310, 322; workshop responsible for paintings, 47,

111; Dionysian frieze, 58, 98–105, 157, 158, 203; Second-Style ensembles, 94–111; early Third-Style ensembles, 140–146
Villa of the Papyri, Herculaneum, 80–81
Villa Piccola under San Sebastiano, Rome, 358, 360
villa rustica, 94
Villa under the Farnesina, Rome, 52, 55 (workshop responsible for paintings), 61, 125, 130, 134, 367–368
vineyards, 171
viridarium, 22, 202, 243, 249
Vitruvius, 2, 12–13, 14, 19, 20–21, 25, 49–50, 55, 57, 58, 98, 116, 207, 237, 259, 369, 370

wainscoting, 202, 246
Wallace-Hadrill, Andrew, 13
wallpaper pattern, 287
warehouses, 267, 268
waterworks, 194, 264
wattle and daub, 26, 128, 259, 261–262, 264
Watts, Carol, 27, 59, 274, 364
Watts, Donald, 59
Weitzmann, Kurt, 206
Wesenberg, Burkhardt, 43
whorehouse, 221, 326
widows, in insula, 27
Wirth, Fritz, 335, 336, 354, 358
Wirth, Theo, 224
women, roles, 201 (cult of Isis), 221 (sexual exploitation)
women's rooms, 157, 285
workshops of painters, 47, 111; Studius', 57; of via Castricio, 68; of Fourth-Style painting in the House of Octavius Quartio, 207; House of the Vettii, 234; House of the Painted Vaults, 295; House of the Yellow Walls, 308; House of the Painted Ceiling, 320, 343; Inn of the Peacock, three painters, 342–343
worship, domestic, 1
wreaths to announce birth, 10

xenium (-a), 151, 247

Zanker, Paul, 23–24
Zeuxis, 117, 227, 370
zone, median, 39, 58–59, 69
zone, upper, 39, 58–59, 69, 136
zones, of painted wall, 57–58
Zuccaro, Taddeo, 234

TOPOGRAPHICAL INDEX

ensembles, 126–140; Fourth-Style
 ensembles, 166–170
Troy, 157, 176–180, 203–207 (Trojan
 cycles)

Vesuvius, 31, 81